Acclaim for Robert Hughes's

Things I Didn't Know

"Masterful. . . . [Hughes] tells this story in laconic prose coated with humor as dry as a fine Soave [and] makes for a reading experience to be savored just as one would relish seeing the *Laocoön* at the Vatican or Michelangelo's *David* for the first time." —*Milwaukee Journal Sentinel*

"Articulate, pugnacious and blunt. . . . This book hops, skips and swims through memories of family, work, art, architecture, sex and love." —*Rocky Mountain News*

"Engaging. . . . An entertaining portrait of the professional curmudgeon as a young man." —*San Antonio Express-News*

"Extraordinarily candid and sometimes boisterously funny. . . . An illuminating self-portrait and chronicle of the postwar art world up to 1970." —*The Dallas Morning News*

"Splendid. . . . A great work of reportage, tragic yet laced with human comedy." —*Los Angeles Times*

"Absorbing. . . . Often funny and almost always enjoyable." —*Chicago Tribune*

"An informative, entertaining chronicle of intellectual growth." —*The Plain Dealer*

"[*Things I Didn't Know*] reminds us what good company Hughes can be and illuminates all too briefly the making—rather than the unraveling—of a fine critical intelligence." —*Financial Times*

Robert Hughes
Things I Didn't Know

Robert Hughes was born in Australia in 1938. Since 1970 he has lived and worked in the United States, where until 2001 he was chief art critic for *Time*, to which he still contributes. His books include *The Shock of the New*, *The Fatal Shore*, *Nothing If Not Critical*, *Barcelona*, *The Culture of Complaint*, and *American Visions*. He is the recipient of numerous awards and prizes for his work.

The Art of Australia (1966)

Heaven and Hell in Western Art (1969)

The Shock of the New (1980)

The Fatal Shore (1987)

Lucian Freud (1988)

Frank Auerbach (1990)

Nothing If Not Critical (1990)

Barcelona (1992)

The Culture of Complaint (1993)

American Visions (1997)

Goya (2003)

Things I Didn't Know

Things I Didn't Know

A MEMOIR

Robert Hughes

Vintage Books
A Division of Random House, Inc.
New York

FIRST VINTAGE BOOKS EDITION, DECEMBER 2007

Grateful acknowledgment is made to the following for permission to reprint previously published
material:

David Higham Associates: Excerpt from *Autumn Journal: A Poem* by Louis MacNeice, (Faber &
Faber, London, 1939). Copyright © 1939 by Louis MacNeice. Reprinted by permission of David
Higham Associates.

Faber and Faber Ltd.: Excerpt from "In Parenthesis" from *In Parenthesis* by David Jones.
Reprinted by permission of Faber and Faber Ltd.

New Directions Publishing Corp. and Faber and Faber Ltd.: Excerpt from "Hugh Selwyn
Mauberley V" from *Personae* by Ezra Pound. Copyright © 1926 by Ezra Pound. Reprinted by
permission of New Directions Publishing Corp. and Faber and Faber Ltd.

Scribner and AP Watt Ltd.: Excerpt from "Sailing to Byzantium" from *The Collected Works of
W. B. Yeats, Volume I: The Poems, Revised*, edited by Richard J. Finneran. Copyright © 1928 by
The Macmillan Company, copyright renewed © 1956 by George Yeats. Reprinted by permission
of Scribner, an imprint of Simon & Schuster Adult Publishing Group and AP Watt Ltd., London,
on behalf of Michael B. Yeats.

The Library of Congress has cataloged the Knopf edition as follows:
Hughes, Robert, [date]
Things I didn't know : a memoir / by Robert Hughes.
p. cm.
1. Hughes, Robert, [date]. 2. Art critics—Australia—Biography.
3. Art critics—United States—Biography. I. Title.
N7483.H84A3 2006
709.2—dc22
2006040968

Vintage ISBN: 978-0-307-38598-7

Book design by Peter A. Andersen

www.vintagebooks.com

Printed in the United States of America
10 9 8 7 6 5 4 3 2 1

For Lucy, Daisy, Alex, and Malcolm,
with WU's love and gratitude

CONTENTS

I would like particularly to thank my sister, Constance Hughes, and my brother, Thomas Hughes, QC, for sharing their reminiscences of my parents and of family life in Australia with me. Susanne Lloyd-Jones, tireless researcher, was able to find me previously unavailable material concerning the Eucharistic Congress and my father's role in its celebrations. My chief debt, in addition, is to Mark Hildebrand, director of the Mitchell Library in Sydney, where the archive of the Hughes family—in particular, the correspondence between my father, Geoffrey Hughes, and his father, Sir Thomas Hughes—is preserved.

Things I Didn't Know

CHAPTER ONE

A Bloody Expat

The most extreme change in my life occurred, out of a blue sky, on the 30th of May, 1999, a little short of my sixty-first birthday.

I was in Western Australia, where I had been making a TV series about my native country. I had taken a couple of days off, and chosen to spend them fishing off the shore of a resort named Eco Beach with a friend, Danny O'Sullivan, a professional guide. We went after small offshore tuna, with fly rods, in an open skiff. It had been a wonderful day: fish breaking everywhere, fighting fiercely when hooked, and one—a small bluefin, about twenty pounds—kept to be eaten later with the crew in Broome.

Now, after a nap, I was on my way back to the Northern Highway, which parallels the huge flat biscuit of a coast where the desert breaks off into the Indian Ocean.

After about ten kilometers, the red dirt road from Eco Beach ended in a cattle gate. I stopped short of it, got out of the car, unhooked the latching chain, swung the gate open. I got back in the car, drove through, stopped again, got out, and closed the gate behind me. Then I hopped back in the car again and drove out onto the tar and concrete of the Great Northern Highway, cautiously looking both ways in the bright, almost horizontal evening light. No road trains galloping toward me: nothing except emptiness. I turned left, heading north for Broome, on the left side of the road, as people have in Australia ever since 1815, when its colonial governor, an autocratic laird named Lachlan Macquarie, decreed that Australians must henceforth ride and drive on the same side as people did in his native Scotland.

It was still daylight, but only just. I flipped my lights on.

There was no crash, no impact, no pain. It was as though nothing had happened. I just drove off the edge of the world, feeling nothing.

I do not know how fast I was going.

I am not a fast driver, or in any way a daring one. Driving has never been second nature to me. I am pawky, old-maidish, behind the wheel. But I collided, head-on, with another car, a Holden Commodore with two people in the front seat and one in the back. It was dusk, about 6:30 p.m. This was the first auto accident I ever had in my life, and I retain absolutely no memory of it. Try as I may, I can dredge nothing up, not even the memory of fear. The slate is wiped clean, as by a damp rag.

I was probably on the wrong (that is, the right-hand) side of the road, over the yellow line—though not very far over. I say "probably" because, at my trial a year later, the magistrate did not find that there was enough evidence to prove, beyond reasonable doubt, that I had been. The Commodore was coming on at some 90 m.p.h., possibly more. I was approaching it at about 50 m.p.h.. Things happen very quickly when two cars have a closing speed of more than 130 m.p.h. It only takes a second for them to get seventy feet closer to one another. No matter how hard you hit the brakes, there isn't much you can do.

We plowed straight into one another, Commodore registered 7EX 954 into Nissan Pulsar registered 9 YR 650: two red cars in the desert, driver's side to driver's side, right headlamp to right headlamp. I have no memory of this. From the moment of impact for weeks to come, I would have no short-term memory of anything. All I know about the actual collision, until after almost a year, when I saw the remains of my rented car in a junkyard in Broome, is what I was told by others.

The other car spun off the highway, skidded down a shallow dirt slope, and ended up half-hidden in the low desert scrub. Its three occupants were injured, two not seriously. Darren William Kelly, thirty-two, the driver, had just come off a stint working on a fishing boat and was heading south to Port Hedland to find any work he could get. He had a broken tibia. Colin Craig Bowe, thirty-six, a builder's laborer, was riding in the front seat and sustained a broken ankle. Darryn George Bennett, twenty-four, had been working as a deckhand on the same boat as Kelly, the *True Blue*. Kelly and Bowe were mates; they had known each other for two years. Neither had known Bennett before. He had heard they were driving south to Port Hedland, and

he asked for a ride. He was a young itinerant worker in his midtwenties, whose main skill was bricklaying.

Their encounter with the world of writing only added to their misfortunes. All three were addicts and at least two were part-time drug dealers. At the moment of the crash, Bennett, in the backseat, was rolling a "cone" of marijuana, a joint. It may or may not have been the first one to be smoked on what was meant to be a thousand-kilometer drive south.

In any case, they had things in common. They had all done jail time. They were young working-class men living now on that side of the law, now on this: sometimes feral, sometimes bewildered, seldom knowing what the next month, let alone the next birthday, would bring.

Not long after he had recovered from the injuries of the collision, Bennett tried to tear the face off an enemy in a bar with a broken bottle. Bowe, as soon as his injuries had healed, attempted an armed robbery, but was arrested, tried, and sentenced to ten years in jail.

Bennett was by far the worst hurt of the three. The impact catapulted him forward against the restraint of the seat belt and gave him a perforated bowel. He had no skeletal damage. All three of them were able to struggle out of the wreck of the Commodore, which had not rolled over. The effort of doing so was agonizing for Bennett, who collapsed on the verge of the road, his guts flooded with pain.

If the Commodore was badly smashed up, my Nissan Pulsar was an inchoate mass of red metal and broken glass, barely recognizable as having once been a car. When at last I saw it in Broome on the eve of my trial, eleven months later, I couldn't see how a cockroach could have survived that wreck, let alone a human being.

The car had telescoped. The driver's seat had slammed forward, pinning me against the steering wheel, which was twisted out of shape by the impact of my body, nearly impaling me on the steering column. Much of the driver's side of the Pulsar's body had been ripped away, whether by the initial impact or, later, by the hydraulic tools used by the fire brigade and ambulance crew in their long struggle to free me from the wreckage. It looked like a half-car. It was as though the fat, giant foot of God from the old *Monty Python* graphics had stamped on it and ground it into the concrete. Later, I would make derogatory noises about "that piece of Jap shit" I'd been driving. I was wrong, of course. The damage had saved my life: the gradual collapse and

telescoping of the Nissan's body, compressed into milliseconds, had absorbed and dissipated far more of the impact energy than a more rigid frame could have done.

Now it was folded around me like crude origami. I could scarcely move a finger. Trapped, intermittently conscious, deep in shock and bloodier than Banquo, I had only the vaguest notion of what had happened to me. Whatever it might have been, it was far beyond my experience. I did not recognize my own injuries, and had no idea how bad they were. As it turned out, they were bad enough. Under extreme impact, bones may not break neatly. They can explode into fragments, like a cookie hit by a hammer, and that's what happened to several of mine.

The catalog of trauma turned out to be long. Most of it was concentrated on the right-hand side of my body—the side that bore the brunt of the collision. As the front of the Nissan collapsed, my right foot was forced through the floor and doubled underneath me; hours later, when my rescuers were at last able to get a partial glimpse of it, they thought the whole foot had been sheared off at the ankle. The chief leg bones below my right knee, the tibia and the fibula, were broken into five pieces. The knee structure was more or less intact, but my right femur, or thigh bone, was broken twice, and the ball joint that connected it to my hip was damaged. Four ribs on my right side had snapped and their sharp ends had driven through the tissue of my lungs, lacerating them and causing pneumothorax, a deflation of the lungs and the dangerous escape of air into the chest cavity. My right collarbone and my sternum were broken. The once rigid frame of my chest had turned wobbly, its structural integrity gone, like a crushed birdcage. My right arm was a wreck—the elbow joint had taken some of the direct impact, and its bones were now a mosaic of breakages. But I am left-handed, and the left arm was in better shape, except for the hand, which had been (in the expressive technical term used by doctors) "de-gloved," stripped of its skin and much of the muscular structure around the thumb.

But I had been lucky. Almost all the damage was skeletal. The internal soft tissues, liver, spleen, heart, were undamaged, or at worst merely bruised and shocked. My brain was intact—although it wasn't working very well—and the most important part of my bone structure, the spine, was untouched.

That was a near miracle. Spines go out of service all too easily. The merest hairline crack in the spine can turn a healthy, reasonably athletic man into

a paralyzed cripple: this is what happened to poor Christopher Reeve, the former Superman, in a fall from a horse, and it eventually killed him. The idea of being what specialists laconically call a "high quad"—paraplegic from the neck down, unable even to write your own end by loading a shotgun and sticking its muzzle in your mouth—has always appalled me.

But I wasn't thinking clearly enough to be afraid of that. What I was afraid of, and mortally, was burning to death. Some are afraid of heights, others of rats, or mad dogs, or of death by drowning. My especial terror is fire, and now I realized that my nostrils were full of the banal stench of gasoline. Somewhere in the Nissan a line had ruptured. I could not move. I could only wait. There seemed to be little point in praying; in any case, there is no entity I believe in enough to pray to. Samuel Johnson once said that the prospect of being hanged concentrates a man's mind wonderfully. The prospect, extended over hours, of dying in a gasoline fireball does much the same. It dissolves your more commonplace troubles—money, divorce, the difficulty of writing—and shows you what you really want to use your life for.

At one point I saw Death. He was sitting at a desk, like a banker. He made no gesture, but he opened his mouth and I looked right down his throat, which distended to become a tunnel: the *bocca d'inferno* of old Christian art. He expected me to yield, to go in. This filled me with abhorrence, a hatred of nonbeing. Not fear, exactly: more like passionate revolt. In that moment I realized that there is nothing whatever outside of the life we have; that the "meaning of life" is nothing other than life itself, obstinately asserting itself against emptiness and nullity. Life was so powerful, so demanding, and in my concussion and delirium, even as my systems were shutting down, I wanted it so much. Whatever this was, it was nothing like the nice, uplifting kind of near-death experience that religious writers, particularly those of an American-style fundamentalist bent, like to effuse about. Perhaps the simple truth is that, near death, you have visions and hallucinations of what most preoccupies you in life. I am a skeptic to whom the idea that a benign God created us and watches over us is something between a fairy story and a bad joke. People of a religious bent, however, are apt under such conditions to see the familiar kitsch of near-death experience—the tunnel of white light with Jesus at the end, as featured in the uplifting accounts of a score of American Kmart mystics. Jesus must have been busy with them when my

time came: he didn't show. There was, as far as I could tell, absolutely nothing on the other side.

So I was stuck; unable to move, and no more than intermittently conscious. Later, Kelly would testify that despite the injury to his leg he was able to make his way to my car and ask me what had happened; that I asked him the same question, and said, "I'm sorry, mate, I'm terribly sorry, I'm not sure if I fell asleep." It has always been my habit to apologize first and ask questions later, and Sgt. Matt Turner, the Broome officer who was the first policeman at the scene, would later recount that I showed an almost silly degree of courtesy as rescue workers tried to extract me from the wreck, apologizing again and again for the inconvenience I was causing him and them.

It would be some hours before these rescuers got to the crash site. The person who set the machinery of rescue going had already been there. He was a middle-aged Aborigine named, rather fittingly, Joe Fishhook. He and his family lived nearby, at an Aboriginal settlement not far from Eco Beach named Bidyadanga. He was driving south in his truck, with his wife, Angie Wilridge, and their teenage daughter Ruth, along with a few members of their extended family, when the Commodore overtook them, zooming past at what he guessed to be about a hundred miles an hour. (Later, a police observer at the scene of the crash looked at the speedometer of the Commodore and saw that the needle was stuck by the collision impact at 150 k.p.h., about 90 m.p.h.)

Shortly afterward Fishhook came upon the wreck and saw the remains of my Pulsar straddling the center line of the highway. He stopped, got out, and tried but failed to free me from the wreck. I was crushed into it, like a sardine in a can squashed by a hammer. Fishhook gingerly checked that I was still breathing, but he couldn't find any document that identified me. He checked the back of the Pulsar—the hatch door, at least, opened—and looked inside the cooler, finding the little tuna. Something snagged his attention. The fish was fresh, newly caught, but there was no tackle in the car. So I must have been fishing with someone else's gear. That meant a professional guide. And how many such pros were there on this stretch of coast? Only one that Fishhook knew of—Danny O'Sullivan, a few kilometers away at Eco Beach, which was also where the nearest phone was.

After this excellent deduction, leaving his wife and daughter at the wreck, Fishhook spun a U-turn and drove back to the Eco turnoff. Twenty minutes

later, burning red gravel all the way, he found Danny in the resort bar. Did he have a client who was taking a little bluefin home to Broome? Sure, said Danny: my mate Bob Hughes. Well, said Joey Fishhook equably, you better get up the road quick smart: he's wrecked on the highway, he's in deep shit, your mate is.

Danny rang the Broome police. He rang the Broome hospital. He sprinted downstairs, with Joey Fishhook close behind him. The two men took off in their cars, Danny accompanied by a former ambulance officer who now worked at the Eco Beach resort, Lorraine Lee. When the heat is on, Danny has a foot on the accelerator heavier than a rhino's, and he reached the crash site in almost no time at all, by 6:45 p.m. He checked me out. I was as white as dirty skim milk and my breathing was shallow; I was sliding into a coma. "Bob, Bob mate, come on, bastard, wake up." I could hear him, but he seemed very far away, as though we were in mutually distant rooms of a large, echoing house.

Lorraine Lee had brought some towels, with which she stanched the flow of blood from my head and left hand. I kept straining to hear Danny, but the effort was frustrated by waves of pain from my collarbone. Danny has a hand tough enough to strangle a crocodile. Fishing with him in the past, I have seen him reach lightning fast into a small line of breaking water and seize a passing shovelnose shark by the tail, hoicking it out of the wave with a feral grin of pleasure. Unfortunately, he now had my shoulder in a vise-like grip. It was meant to be comradely and reassuring, but he was squeezing broken bone. "You're going to be fine, mate," he was saying encouragingly. The pain was taking me over. "Oh Danny," I whined, "it hurts, it hurts so much, it's really bad, make it stop." He kept squeezing the broken bone, sending bolts of fresh anguish through me. "She'll be right, cobber," he said. "She's going to be right as rain. Just hang in there." Squeeze from him, squawk from me. It took a few minutes to get cause and effect straightened out.

Then something passed between us that may never have happened; I am still not sure. I kept passing out and waking woozily up, and whenever I surfaced into consciousness I could still smell the petrol, that sickly smell building up to finish me off with one spark. I didn't want to die at all, but most of all I didn't want to die that way. I thought Danny owned a .38, and I implored him to finish me off if the car blew. "Just kill me," I kept saying, or thought I did. "Just take me out, one shot, you know what to do." And he, I think,

swore that he would. But I do not know, and, looking back on it, I realize that I had asked the morally impossible of my friend, so perhaps I had never really asked it at all. I don't know, and on a very deep level I remain uncertain and afraid to ask. But the desire to die before I could burn was very strong.

The absurdity made me sick. I thought of dying without ever seeing my sweetheart Doris again, never feeling that silky skin or hearing that soft voice in my ear. Instead there would be the opposite of paradise. It wasn't dying as such that I feared, but dying in a hot blast, the air sucked out of my lungs, strangling on flame inside an uprushing column of unbearable heat: everything the Jesuits had told me about the crackling and eternal terrors of Hell now came back, across a chasm of fifty years. I could envision this. It would look like one of the Limbourg brothers' illustrations to the *Très Riches Heures du Duc de Berry*—the picture of Satan bound down on a fiery grid, exhaling a spiral of helpless little burned souls into the air.

But the fire didn't come. Neither did the fire brigade, nor the police, nor an ambulance. Some passing traffic stopped, including a semitrailer truck. Quite an array of vehicles was beginning to build up to the north and south of my Nissan, and these included some cars and four-wheel-drive pickups (known in Australia as "utes," short for "utility vehicles") driven by Aborigines. It being Friday night, there was meant to be a dance at the Bidyadanga settlement, and by twos and threes a curious group of Aborigines began to accumulate by the wreck.

They were behind me, so I couldn't see them. I could hear them, though: a thin chanting, to the beat of handclaps, to which I could attach no meaning. Later I was told that the Aborigines had assembled in a half-circle behind my car, and were trying to sing me back to life. It must have seemed unlikely that they would succeed, but one person who was convinced they would was Joey Fishhook's teenage daughter. She later said she saw what she stubbornly insisted was a spirit-apparition, not far from the Nissan. It was of no particular color. It looked in all respects human, except that it moved through the bush soundlessly, with a sort of elusive lightness.

This creature, or entity, is known to Aborigines as a feather-foot. It is not easy to say what a feather-foot is, or what it does. It is definitely not an animal spirit. It is a native equivalent of the Greek manifestation of Hermes

as an emissary of Hades, in his role as Hermes Psychopompos, the "guider of souls." It is neither hostile nor friendly: it just turns up at the site of an impending or possible death, and passes judgment on the soul and its prospects of survival in further incarnations. I didn't see it, of course; even if it had been there, my vision was too blurred to see anything quick moving, and I couldn't turn my head. But I like to think that perhaps it was a feather-foot, and that it had not found me altogether unacceptable.

Whether it could boast a real feather-foot or not, the Bidyadanga settlement did have its own nurse, a Filipina Catholic religious sister named Juliana Custodio. As soon as word about the collision reached her at Bidyadanga, she drove to the site to see if there was anything she could do. In the event, there wasn't much. She found me, according to the police report, "trapped in the car, awake and talking, asking about his fish, swearing with the pain and then apologizing. Juliana said, 'He was such a gentleman!' She saw that his hip and chest bones were out of alignment . . . he was sweating and cold but his heart and pulse rate were very strong and his blood pressure normal."

Sister Juliana did her best to get a saline IV into one of my veins, but they had collapsed. She wiped off the worst of the blood and applied some dressings to my head wounds. I kept sliding into patches of insensibility and she struggled to keep me awake, not with drugs, but simply by talking to me. Our conversation can't have kept my wandering attention, because I soon gave up on it and started, as I was told later, to count aloud, backward from a hundred, one number slurring into the next—"forry-five, forry-four, forry-three . . ." Then I would lose track and have to start again, at a hundred. I thought I was trying to stay conscious, but Sister Juliana thought I was counting off my last moments; bystanders saw this good and devoted woman weeping with pity and frustration. Maybe we were both right. Later she would ask the Catholic priest at Bidyadanga, Father Patrick da Silva, to say a Mass for my recovery. "Juliana rang the hospital in Perth a few times during his stay," the police report concludes, "and followed his progress with interest. She kept saying, 'He was such a gentleman!' "

Meanwhile, a sea fog had rolled in from the Indian Ocean, slowing the sparse traffic to a crawl. It must have been two hours after the crash, close to nine o'clock, when a rescue team of volunteers from the Broome Fire Brigade

at last reached the spot. Its men tugged and twisted at the door, but it would hardly budge. Eventually, they brought out the drastic solution to crushed car bodies—the so-called Jaws of Life, a massive pair of shears powered by hydraulic pressure. I was only dimly aware of this tool as it chomped through the Pulsar; I felt apprehensive but curiously distant as its blades groaned against the metal. Would they slip and chew my leg off? I didn't much care; all I wanted was to be out of the danger of fire, away from the reek of gasoline. I was vaguely aware of skilled hands wiggling the lower parts of my legs, working them free. I felt, rather than heard, a resonant crunch deep down in my frame, at some level of my skeleton that had never been disturbed before, like the deep crack of an extracted tooth breaking free from the jawbone, as the shears bit off the spokes of the steering wheel whose rim was crushed into my thorax. The wheel was lifted free; one of the firemen tossed it in the back of the car, where I would find it nearly a year later. My whole chest felt light and empty now that the pressure was off. There was surprisingly little pain in it: this was due to shock, of course. Concerned faces were all around me. "I'm sorry about this," I kept babbling. "I'm sorry to be so much trouble." "You'll be right, mate," one of the firemen kept saying. "We'll have you out of this in two ticks." And they did, to my eternal gratitude. I felt a delirious sensation of lightness as I was lifted clear of the car. They slid a stretcher under me. My head felt swollen on its feeble stalk of a neck, lolling like a melon. Was my neck broken? I couldn't frame the words of the question. At least I knew I could see and feel, and was alive. Luminescence was all around me: flashing, stuttering lights, red and orange punctuated by magnesium flashes, burning in haloes through the fog. In their intermittent flare I saw the face of Danny O'Sullivan, bending over me. His mouth turned down hideously—no, it was upside down, so he must be smiling.

"You'd have to be the toughest old bastard I know, cobber," he said encouragingly.

Oh no, Danny, I wanted to say; you know dozens of guys who are tougher than me; dear God, I'm old and fat and I'm not going to last it through. "No, no, bullshit," I managed to croak.

Danny reflected for a moment. "Ah well," he conceded, "you'd have to be the toughest old art critic, anyway."

That'll do for me, I thought, and promptly swooned, like some crinolined

Virginian lady in a novel. The stretcher locked onto its rails in the ambu-lance; it slid in with a clunk, the door slammed, and the medicos bent over me. I would not wake up for several weeks.

The first doctor to reach me from Broome had been Dr. Barbara Jarad, who was on call for the Aboriginal Medical Services at the Broome hospital that night. She had set off with the police in what she laughingly called "a high-speed pursuit vehicle"—creeping along, because of the fog, at 60 k.p.h. (40 m.p.h.). She talked on the police radio with Sister Juliana, who said she'd had difficulty getting a needle into me to administer saline. My veins are weak and recessive; under shock, they become almost impossible to find, rolling away from the needle. In the ambulance, Dr. Jarad got a saline needle in my arm, but on the road it ceased to work long before we reached the Broome hospital; I wasn't tied down properly and the rolling of my body and the jolts of the vehicle kept pulling the needle out of the vein. I kept talk-ing, not very lucidly; I gave the doctor my name and a few other details, but told her I had been born in 1995. It's normal procedure to keep a trauma patient talking if you can, so that you can easily tell if he passes out. At the hospital the medical head, Dr. Tony Franklin, got another saline feed in my other arm, and Dr. Jarad did what she called a cut-down on my left, intact ankle, opening up the skin and flesh with a scalpel to expose a vein; not the easiest of maneuvers with a fleshy, overweight subject like myself.

It was now somewhat past midnight, almost six hours since the crash. The Broome hospital had been on the radio to the Flying Doctor Service. It could fly me more than 1,000 miles south to Perth, the capital of Western Australia, which had a bigger hospital than Broome's—one that included an Intensive Care Unit.

And intensive care was what I was going to need. The doctors in Perth had me on the operating table for thirteen hours straight and, I was told much later, they nearly lost me several times. Their work was extraordinary. All the odds, I take it, were against my survival, and without these doctors and the immense devotion and skill of their work I could not possibly have survived. I ended up in semi-stable condition, with tubes running in and out of me, and a ventilator doing my breathing.

I was in intensive care for five weeks, in a semiconscious delirium, while the doctors and nurses of Royal Perth Hospital labored to put me together

ck, detail by detail, to life. I don't know that I'd recommend
eigner that he or she ought to live in West Australia. But I do
at, if one has the misfortune to undergo a near-fatal car smash, West
Australia—and, specifically, the Royal Perth Hospital—is an extremely
good place to be.

"And then he knew no more." It was the standard exit from an action para-
graph in the books of my childhood: Bulldog Drummond is sapped on the
back of the head, Hero X falls through a trapdoor, Macho Y realizes, all too
late, that the tea he has sipped in the villain's Shanghai parlor contained a
powerful drug. The room spins, consciousness goes. We wake (if we are
lucky) remembering nothing. Not an erasure, in which the traces of an ear-
lier design may, however vaguely, be discerned. Instead, a whiteout.

If only.

The word "coma," if my experience is any guide, covers a host of states
that slide into one another unpredictably.

If "coma" means the cessation of awareness or internal consciousness—
the black hole, the blank wall—then I wasn't in a coma for those five and a
half weeks in the Intensive Care Unit of Royal Perth.

On the contrary: at least some of the time I was living with (literally) fan-
tastic intensity, my mind pervaded by narrative phantasms of extreme clarity
and unshakeable, Daliesque vividness. But I couldn't communicate them to
the outside world, or to anyone in it, including the doctors, the nurses, and
my worried and puzzled friends. I was sealed off, boiling with hallucination.

I don't remember feeling frustrated by this: in some way I knew that even
if I had been able to describe these states and narratives, these loved ones
could not have understood their import. It would have taken too much
explaining. This, you might say, was my unconscious mind being smart, sav-
ing its energies as best it could. To explain the details, to show by what twist-
ing, metaphor-ridden paths they led back to core experiences whose nature
was barely evident even to me, would have been a hopeless task; I lay in the
middle of these narratives like a man who has cut the binding strings on a
coil of fencing wire which, springing anarchically from confinement, now
has him in its tangled embrace. These dreams were tenacious. Normally I

dream in a fairly episodic way, and the thread easily gets lost. But in the coma, I had the frightening sensation of being lost in an exceptionally, crazily vivid parallel life, one that had cross-connections to my own but which could not be set aside—because, I realized later, I was close to death and could not get a grip on any reality that could pull me out of hallucination. I was not aware that I was not alone: my fantasies were too thickly peopled to let in real people who were close to me.

Yet some were there, even though I was not aware of it. The first was Doris. On the weekend the accident occurred, she was relaxing with her youngest son and their black spaniel, Boo, in the garden of my house on Shelter Island. The telephone rang. It was Lucy Turnbull, my niece, in Australia. She explained that I had had a bad car accident; that I was in intensive care in the Perth hospital; that I might or might not pull through. Doris was horrified by the news but she didn't hesitate. With much help from our friend in Washington, D.C., the Australian ambassador Andrew Peacock, she was able to get a last-minute seat on an American Airlines flight to Sydney, and then on to Perth. Doris has a way of going into overdrive when insoluble problems present themselves, and this time she all but volatilized them. When, after crossing two continents, the world's largest ocean and a plethora of time zones, she staggered off the plane in Perth and was driven to Royal Perth Hospital, she was expecting not only to see me but to be able to talk with me. No such luck. I was unconscious most of the time and, when not wholly incapable of speech, incoherent. Both Lucy and Malcolm Turnbull were already there, having dropped everything in their extremely crowded lives and left at once for Perth. They were able to comfort her and help make sense of what the doctors were saying. It seemed that I had convinced myself that the chief doctor in charge of my case was in fact a Roman Catholic priest, whom I expected to give me Extreme Unction—the terminal sacrament for the dying. I kept addressing him as "Father," and eventually he tired of correcting me: "Your uncle," he said to Lucy, "is an extremely persuasive man." I retain no memory of talking to Doris, but clearly I knew she was there; I seized her hand and would not let go of it, I gave every sign of terror at the possibility that she might leave the room, and when finally she did leave it—exhausted by jet lag and emotion, and desperately in need of a few hours' sleep in the Perth hotel—I hysterically begged

the nurses on duty to bring her back. These were awful hours and during them, because I was full of tranquilizing drugs, I was undoubtedly the one who suffered least. One thing Doris and Lucy found particularly alarming was that, when they were at my bedside, I kept wordlessly and obsessively pointing upward to the ceiling or perhaps the sky. This they took to mean that they thought my soul was about to depart. I do not remember thinking so.

For as long as I can remember, I have been visited by dreams about losing power over my life. These nightmares of dependency (often involving a hostile institution of some kind, which no doubt were amplified by the years I spent under Jesuit discipline in a boarding school) must have been reawoken by the systems of intensive care, which dissolve the patient's will in a sort of therapeutic absolutism.

Much of the time (whatever "time" meant in this context) I was terrified. When my dear friend the writer Cathy Lumby came to see me in the Intensive Care Unit in Perth, soon after Lucy and Malcolm had gone back to Sydney, she found me in a state of dread verging on speechless hysteria, like a prisoner mouthing through the glass of a soundproof enclosure: "You couldn't speak, obviously," she wrote to me later, "because you were intubated. But you tried nevertheless—in fact you spent hours trying to converse during the four days I spent with you and it was never clear if you really understood that no-one could hear you." And then,

> *It quickly became clear that you were in the grip of some frightening hallucinations . . . you motioned frantically for the phone and began mouthing "Lucy" to me and "Help me, please help me." I got Lucy on the phone for you and put the earpiece next to your ear—you went on "talking" to her though she heard nothing. After she said goodbye you became extremely agitated and tried to lever yourself out of bed and pull out the tube which was carrying oxygen directly into your windpipe. [The nurse gave you a sedative injection, but then] You woke, a look of utter terror on your face, and on seeing me, motioned me over . . . and mouthed quite clearly "Please shoot me" and then began trying to disconnect all the various tubes which were keeping you physically stable. . . . It became clearer and clearer to me that you saw yourself as a captive of the doctors and nurses and believed them to be torturing you, perhaps even slowly killing you. At times I*

watched while you held up your shattered arm and stared in horrified amazement at the pins protruding from it. You'd look at it, then turn to me with an imploring look. I really got the sense that you thought the contraption was some kind of elaborate mediaeval device. The sense of being trapped—and your awful repeated request "Please shoot me"—is of course a terrible echo of those hours you spent in the car.

There was, however, one light moment in this grim and drawn-out scenario. At a certain point, Cathy reported, I started signaling wildly, miming the act of writing. Pencil and paper were brought, and with a shaking left hand I managed to write a sentence in Spanish—a language that neither Cathy nor any of the doctors and nurses understood. Eventually a Filipino wardsman was found. "I am dissatisfied with these accommodations," my note read, rather formally. "Please call a taxi and take me to a good hotel."

Some of my coma dreams were fairly hellish.

One was particularly bloody and persistent.

Crewing on a Torres Strait pearling lugger (don't ask me why this fantasy popped up with the solidity of real memory; I have never set foot on a pearling vessel in my life, though a now dead friend of mine, an Australian painter named Donald Friend, had often done so in the 1940s when living in the Torres Strait, so his stories must have made more of an impression on me than I ever realized), I had been captured by pirates and found myself bound, chained, and stacked like a piece of cordwood in the hold of a Chinese slaving junk, looking—for I saw myself from above, as though in a technical plan—exactly like the diagrams of eighteenth-century slave shipments that I had studied, years before, in researching *The Fatal Shore*. Something weird had been fixed to my right arm, driven into the flesh, immobilizing me. I realized (in the dream) that it had been surgically implanted there by two fiendish Chinese doctors who were not only slave traffickers but Maoist spies. Their names were Dr. Wong and Dr. Fong. Their gadget (in the dream) was a broadcasting unit. In reality—for there was just such a gadget fixed to my arm by two stainless-steel posts, one screwed into the humerus and the other into the ulna—it was an "external fixator," applied by a quite nonfiendish and certainly non-Maoist Irish doctor. Its purpose was to "fixate" or immobilize my right arm, whose elbow had been smashed into a mosaic of bone fragments by the impact, so that the

array of metal plates, wires, and rods under the skin could not be pulled out of line by muscular movement. Naturally, being out of my wits on drugs and having no idea about such orthopedic procedures, I interpreted this as a fearful constraint, an instrument of torture.

So there I was, in a slaver's hold under the four all-seeing eyes of imaginary Dr. Fong and nonexistent Dr. Wong—eight eyes, if you added the lenses of their glittering spectacles. The human stack of which I was a part was slippery with its own lost blood—a transfer, I suppose, from the copious bleeding of my accident—and I managed to wriggle free from it, over the side and into the ocean. My fetters fell off and sank away from me into the vertical blue, the junk sailed on: and, right before my eyes, there was my means of escape, the sort of wonderful airplane that had often filled my good childhood dreams of delivery and redemption because it and its sister craft were always landing and taking off in Rose Bay, below my house.

It was a World War II flying boat: the high-wing, twin-engine PBY Catalina, with its bony Art Deco lines and its twin gunners' blisters on the fuselage—to me, one of the most elegant aircraft ever designed, right up there along with the Supermarine Spitfire and the twin-boom Lockheed P-38. I was on board her, as though plucked from the salt by an invisible hand, before I quite realized that she was empty, rocking on the deep-water swells. But she was not the Catalina of my childhood. She was tattered and sooty, her skin faded and laced with dried-out fish guts. Her fabric was torn. Odd designs and images had been painted on her: stones, a fish, a falling parachutist, a ladder-back chair. Who had done this? Who but the artist I most admired among all the living—my dear, benign friend of twenty-five years, Bob Rauschenberg.

Inside, the Catalina—whose interior spaces lengthened irrationally into tunnels and broadened into halls as I gingerly explored it—was a small Rauschenberg museum, full of combines, cardboard assemblages, cast-off truck tires and even a stuffed goat, cousin of the emblematic beast from Bob's great signature piece of 1955, *Monogram*. It became clear to me that my task would be to fly the Catalina and its contents from island to island around the Pacific, a small traveling retrospective, landing in lagoons, mooring at rickety jetties, semaphoring the message of American art from the second half of the twentieth century to peoples who had no reason to give a damn about it. Here I would be, a sort of loony and parodical cultural mis-

sionary on the run—not a bad figure, perhaps, for the art critic of *Time*, the international newsmagazine. What would this mean to the Maori, the Trobriand Islanders, the Fijians, the coastal people of New Guinea, who, in my dream, were at least a century more "primitive," further back in undisturbed tribal life than they are now? But I was worrying about the Chinese slavers and how I had to get away from them.

I was going to fly the museum out of their reach. I settled into the cockpit and started flipping switches. Above and behind my head, the Catalina's twin Pratt & Whitneys (*The Pratt & Whitney Museum of American Art!*, I thought) coughed, burped black smoke, and began to roar. As I waggled the control yoke with a mixture of terror and glee, the Catalina gathered speed and went jouncing from one wave crest to the next. Then the bumping stopped. I, and it, were flying. Not by very much—we were no more than ten feet above the water and its lurking coral heads, and no matter how far I pushed the throttle lever I couldn't induce the plane, at sixty-five even older than I, to claw her way any higher—but enough to be reasonably sure that we were out of reach of the junk.

There were some dreams that bore even more directly on the experience of confinement and surrender of the will that is at the core of intensive-care therapy. One of them involved yet another artist: Goya. For several years I had been trying, and failing, to write what I indistinctly thought of as a political biography of Francisco de Goya y Lucientes, the dark prototypical genius who can be seen as the very first modern artist. In his self-portrait with candles round the brim of his hat, painting himself as a *majo*, a tough young Madrid hipster, Goya wasn't joking: that was how he saw himself, as a show-off, a wide boy, an instinctive bohemian.

I was scared of him, and he didn't like me much. Neither did his friends, a gang of enigmatic Andalusian street toughs. For some reason the dream brought us together in Seville, not in Madrid. It was in an airport. I was trying to escape from some unnamed menace, without a ticket. I thought I could get on a plane (Iberia, domestic) by crawling under a fence and then crawling across the runway, dragging behind me my leg, which was swollen and infected, swaddled in flyblown rags, just like one of Goya's own beggars. They will never let you on the flight like that, said Goya, materializing from behind a Formica sales counter. You are an *inglés asqueroso*—a disgusting Englishman. Best if you come with me. We will fix you up, me and my

friends. And they did. Amid bouts of ruthless, unseemly laughter—very unseemly, I thought, not to say ungrateful, coming as it did from an artist I helplessly adored—they proceeded to divest my leg of its bandages and clamp it in a sort of birdcage, a monstrous and encumbering fetter of wires and iron prongs that went into my flesh and clamped onto the bones of my lower leg, the tibia and the fibula.

Outside the dream, in the hospital, the doctors *had* been installing a device on my leg. It was an array of concentric, rigid Bakelite rings that encircled my calf, shin, and ankle. Metal spikes stuck inward from them; their points were screwed into the fragments of my tibia and fibula, holding them rigidly in correct anatomical alignment to one another so that, eventually and with a lot of luck and patience, they could heal. This medieval-looking contraption had actually been devised by a late-nineteenth-century Russian orthopedist, and bore his name: an Isikoff brace. It would stay on my leg for months to come, a painful encumbrance. It wasn't that the gimlet points stuck in the bones hurt: I couldn't feel them. The trouble was that, as the penetration wounds tried to heal, the flesh would grow tight-clenched to the spikes where they entered the skin, and every couple of days it had to be pressed down to loosen it: the nurses did this as gently as they could, but it wasn't pleasant. Still, the bones eventually did knit, and they would have had little hope of doing so without Dr. Isikoff's invention.

There followed seven months in hospitals in Australia and New York, more operations than I could count, and a gradual recovery, not yet complete, lasting five years. In Sydney, the doctors who operated on me at St. Vincent's Hospital, headed by Michael Neil, of blessed memory, had "rodded me up"—installed a lengthy titanium pin inside the shattered, hollow femur of my right leg, reaching from the hip to the knee, and thus reinforcing the ruined bone. By the time he had finished with me, the X-rays disclosed what appeared to be a military junkyard inside my body—a profusion of plates, squiggly wires, bolts, screws, studs, clips, and other mysterious-looking little objects, all holding parts of me together.

I could not stay in the hospital indefinitely, but I was not well enough to return to New York. Lucy and Malcolm Turnbull stepped in—with a charity and patience that still seem to me not only exemplary but near-incredible—to solve this problem. Lucy, at the time, was running for office as the mayor of Sydney; Malcolm was heading up the campaign to make

Australia a republic, by replacing the Queen with an elected Australian as our head of state. The Turnbull family was already an extremely busy one, but they added me to their workload without the least hesitation. I would convalesce with them. Their house at Point Piper, a little headland projecting into the harbor next to Rose Bay, where I had been raised, had several rooms on the upper floor that they proposed knocking together to form a large, airy chamber with its own balcony, its own view of the blue, ferry-stitched waters of the harbor. And this was done: an amazingly generous gesture, which also, to no small extent, saved my sanity by reuniting me with the soothing, idealized seascape of my childhood memories, with its seaplanes, passing launches, and flocks of leaning white sails, right below my window.

I would be less than candid if I claimed that I was the easiest guest or least problematic kind of patient. I developed peculiar cravings, for a start. My much-loved grandniece, Daisy Turnbull, then in her mid-teens, was extremely troubled by my consumption of ice cream, a foodstuff I had never been all that mad about in the past. Daisy is one of those iron-willed girls whom you cannot defy; you can only hope (and not very successfully) to evade her when she gets on a campaign. She was convinced that the ice cream was going to make me as fat as a pig, especially since, with my leg, exercise was out of the question. She therefore went to great lengths to ban ice cream from the house, while I went to equal extremes to harry, beg, and cajole the various freelance Irish nurses whom the Turnbulls had engaged into slipping out and smuggling me back buckets of the stuff.

Since for the first few weeks I couldn't get myself up or down the stairs without great pain—not to mention the danger of falling down them—Malcolm came up with a device for shifting me that he christened the Hannibal Lecter trolley. It was a contraption used by professional movers to shift large, heavy refrigerators. It had wheels on the bottom which, theoretically, could negotiate the stairs while supporting a load and keeping it immobile. But it was so large and clumsy as to be frightening, for although a fall downstairs would have injured me, such a fall under the weight of the Hannibal Lecter trolley would surely have finished me off. Today it still reposes, unused, in a corner of the Turnbull garage.

All this painstaking medical work, all the weeks of recuperation, went for almost nothing after I was cleared to return to America. I still couldn't walk,

but I could get around on crutches, and I had to get back to New York—first because I was desperate to be reunited with Doris, second because I had been away from work for so many months, and third because my now ex-wife, Victoria, had won an essentially uncontested alimony award (it is a marvel, what we ex-Catholics will give up when prompted by guilt) whose terms had to be met every month until I reached seventy-five. However, at least I could get around. But not for long. One freezing winter day I had gingerly picked my way on my two sticks down to the corner bodega on Prince Street in SoHo to buy some milk and eggs. Clutching the bag, I backed out of the swing door when I heard a cry of *Yo!* followed, an instant later, by a numbing impact. I went flying on the ice and raised my half-stunned head off the road just in time to see a black youth on a bicycle disappearing around the corner, still riding on the sidewalk. Merciful strangers helped me to my feet, which immediately slid from underneath me. My right leg seemed to be dangling on a string.

Eventually I got back to my loft, and with the help of handfuls of opiates—Hydrocodone, Vicodin—the pain withdrew. But a couple of weeks later it was still lying in wait, claws out. Very luckily for me, my dear friend and longtime fishing buddy, the bandleader Peter Duchin, saw my plight and recommended a doctor, David Helfet, who presided over the Hospital for Special Surgery. I lurched on crutches into Dr. Helfet's consulting rooms; an X-ray was made; a fingersnap later, or so it seemed, my grubby jeans and moleskin shirt had been stuffed in an iron locker and I was going into surgery with yet another catheter in my much-punctured arm. The impact of the bike had displaced the rod in my femur and a massive infection of *staphylococcus aureus,* the much-feared Golden Staph, had set in. A few more untreated days of that, Dr. Helfet told me later, and I could well have been dead. There was so much pus and purulent muck in there that he could scoop it out with a teaspoon.

Over the next few weeks, as I lay in my bed in the Hospital for Special Surgery, gazing lightheadedly through an opiate fog down at the flow of traffic on the West Side Highway, with gallons of antibiotics slowly percolating into my arm and through my system, the forces for justice of the West Australian judiciary were not idle.

Some consideration, I was told later, had been given to not prosecuting me for dangerous driving. But it was indubitably true that the wreckage of

my car was found on the wrong side of the road and that, although I was by far the worst injured, the passenger in the back of the other car, Bennett, had been quite seriously hurt—badly enough for his injuries to qualify as GBH, or "grievous bodily harm." The director of public prosecutions, Robert Cock, could have used his discretion not to bring proceedings, but he chose to charge me with dangerous driving occasioning grievous bodily harm. The distinction between "bodily harm" and "grievous bodily harm" was somewhat tenuous; in practice, bodily harm is "grievous" if, left untreated, it could be a cause of death. This is a somewhat subjective criterion—after all, there are many injuries and infections that might or might not kill you if nothing is done about them. However, the injury to Darryn Bennett's bowel, caused by his stomach's impact against the seat belt that, fortunately, he was wearing, was held to fit this standard.

I remembered nothing about the accident. The slate is wiped clean, as by a damp rag; I felt, and still feel, no sense of either guilt or innocence. But I was puzzled: how could my car have come to be on the wrong side of the road?

One explanation was that I had dozed off. But only a few minutes before the impact I had got out of my car, opened a gate, driven through it, got out of the car again, closed the gate, got back in the car and turned onto the road. It seemed most unlikely that I would have immediately gone to sleep, particularly since I had had a siesta after lunch and nothing to drink with that meal except a single can of lager.

Another possibility was that, having lived for some thirty years in America, I was so used to driving on the right-hand side of the road that I had mistakenly and reflexively turned into the right-hand lane, which, in Australia, is the wrong side. However, the coastal highway was straight—dead straight, a monotonous line for hundreds of miles. It was dusk. The other car should have had its lights on. Once I saw them—and I could hardly have done otherwise—I would have turned back onto the left side of the road.

The third possibility was suggested by a legal investigator whom my lawyers later dispatched to the crash site. He noticed that the highway and its verges were strewn with the cast-off treads of tires from the giant road trains that are such a feature (and menace) of traffic there. Suppose that one of these objects, caught in the beam of my headlights, had suggested

an animal—perhaps one of the marsupials with which the desert was infested—and caused me to spin the wheel and swerve into the oncoming lane, which had no highway divider, only a painted line on the concrete? That, too, was possible, but there was no knowing if it had been true. And certainly it could not have been produced in court as anything more than a hypothesis.

None of this stacked up. But it all discouraged me from pleading guilty. Coming as I do from a family of lawyers, pleading guilty goes against my grain. It is, as Mark Twain observed about confessions, good for the soul but bad for the reputation. There was little likelihood that, if guilty, I would receive a "custodial sentence," legal jargon for being flung in the pokey; that would be too much for a traffic accident.

The maximum fine the law provided was about $2,500, but the airfare from New York to Broome—which Dr. Helfet warned me had to be first class, so that my leg wouldn't condemn me to fourteen hours of intermittent torment and cramp in a coach-class seat—was some twelve thousand dollars. This seemed wildly disproportionate, but I had no choice about it, and I was not going to let a hostile Australian press attack me as a scofflaw. And since I was going, I decided, I ought to plead innocent, in accordance with my conscience. This proved to be a bad mistake.

Meanwhile, Kelly and Bowe, the riders in the front seat of the Commodore, both of whom had long police records for theft, drug-dealing, and other offenses, approached my lawyers in Perth through an intermediary. The message was that since they had heard I was a "rich prick from Sydney," they would be only too happy to perjure themselves and to swear in court that I had done nothing against the traffic laws—so long as I gave each of them fifty thousand dollars. At an incredulous laugh from my attorney, the figure came down in one bump to thirty thousand. They were not very good negotiators, it seemed.

Since neither my lawyers nor I were convinced that the accident had been caused by my carelessness, we were on the point of flatly refusing to pay when one lawyer, more cunning than I, perceived the possibility of a sting. He contacted the go-between, a shady individual, and said that we would play along and that an emissary from our office would meet him in the domestic waiting lounge of the Perth airport, with the first installment of the money. At the appointed hour, both men showed up. Our man, wearing

a wire, handed over a wad of money in a brown-paper lunch bag. The go-between was eagerly counting it when, in a mildly farcical scene reminiscent of a movie featuring Peter Sellers as Inspector Clouseau, several plain-clothes detectives sprang from behind the airport's potted palms and nubble-weave curtains and arrested him.

At this point, the Crown prosecutors could well have dropped the case. What were they trying to prove? Of course there had been an accident, but were my injuries not enough punishment? (In terms of pain, that accident was the gift that keeps on giving; I cannot run or wade a trout river, and even now, more than six years later, there are days when I can hardly stand up. Nor, maddeningly, can I do a long walk through a museum. But when it is a choice between deep pain and opiate addiction, there is really no choice. You deal with the pain.) And who was going to believe the men in the other car? They had shown clearly that their testimony was for sale.

But such practical considerations made no difference; my trial must go on. So back to Australia I went, and in due course fetched up in my wheelchair outside the Victorian courthouse in Broome, a handsome prefabricated tropi-cal structure of cast iron and teak planks, which had originally been meant for some imperial settlement in Africa but, due to a series of administrative blunders, had been sent in its crates, in kit form, to the edge of the Indian Ocean in this faraway part of Northwestern Australia.

Its lawn, steps, and veranda were swarming with photographers and reporters, and the detonation of flashbulbs almost whited-out the mild tropi-cal sunlight. I was quite unprepared for this and at first thought it was some kind of elaborate practical joke, or that we had mistaken the date and arrived for the trial of some important serial killer. As a defense I took out my own camera and photographed them, intending to impress friends later with the size of the Meejah mob, but actually hoping that the sight of my own minia-ture Canon Elf would have some apotropaic effect and dispel them. It did not. Siobhan Grant, my Irish nurse, who had resolutely flown all the way from Sydney to look after me (and turned out to be the best of company, a sturdy point of humor and irony in the midst of all this Meejah hysteria), pushed the chair through the crowd and helped me clomp on my sticks up the iron courthouse steps.

The magistrate, Anton Bloeman, clearly did not want lengthy proceed-ings. The prosecution did not trust the pair who might have been its star wit-

nesses, Kelly and Bowe, and declined to present them in the prosecution case; understandably, Cock and his lawyer feared that Bloeman might not have accepted the sworn word of two minor crims with long police records. Their larger aim was to deprive us of the opportunity to cross-examine them. They did put Darryn Bennett on the stand, where he testified under oath that he had seen my headlights coming straight at them on the wrong side of the road for fully a mile before the collision. Bloeman did not seem to believe this, and neither did I. It simply didn't make sense: if I could see them coming and they me, why would I have stayed on the wrong side of the road? And why would they have stayed on theirs?

During the pauses in the proceedings, Bloeman would retire to the back of the courthouse while everyone else went out on the veranda for air. There, I would find myself pursued by the photographers, headed up by a scowling blonde with rat-colored roots and a howitzer-lensed Nikon who had pursued me since my plane landed in Broome two days before. She kept shoving the camera in my face and clicking, clicking, clicking; she must have had two hundred close-ups of me by the end of the trial. Never in my life before had I realized the exact truth of a remark by that greatest of documentary photographers, Henri Cartier-Bresson: that photographic portraiture is always an invasion, and if done without the subject's permission it is a violation.

I did chat, quite amicably and politely, I thought, with a Broome journalist whom I had not met before but who months later declared to a reporter from the *Sydney Morning Herald* that "there was a conscious aloofness" about me "that many found nauseating." He added that I believed "the cops, the judiciary, the journos—we were all neanderthals, a lesser form of life. Before he arrived we were already cast." Of course I felt nothing of the sort, but evidently I should have laid aside my crutches in a transport of mateship and greeted this (to me) unknown scribbler as my previously unmet brother. But then, he would have told his fellow-reporters that I was manipulatively sucking up to the Meejah. Maybe if you are full of strong opiate painkillers and being tried before a maggie, with the Meejah scrambling and pawing behind, you do feel a little aloof, or at least floatily detached.

The trial was over in short order; too short, as it turned out—in just two days—and resulted in the finding that there was "no case" to answer. Bloeman decided that no court could find me guilty beyond a reasonable doubt on the prosecution case alone; so we did not have to present our own evi-

dence. He sharply criticized Cock and his lawyer for wasting his time with such a poorly prepared case—as a radio interviewer for the ABC, Liam Bartlett, remarked the next morning, "Many people in the legal profession would see this as a great embarrassment for our director of public prosecutions' office." I was not called upon to testify. When the case was dismissed, my lawyers immediately asked for the award of defense costs, which Bloeman immediately granted—some $36,000, of which I was never to see a penny, since the Crown immediately appealed.

Feeling miserably weak from the combination of pain in my unhealed bones and the effects of the Vicodins I had been gobbling (six hours a day in a hard courtroom chair with incompletely healed femoral fractures is no fun), I levered myself upright to thank the magistrate for his Solomonic verdict and found I could hardly speak or stand; I began helplessly to cry, and in that reduced state I managed to make my exit from the Broome courthouse, only to be confronted by what seemed to be less a mere phalanx than a bison-like horde of reporters stampeding toward me, brandishing their notebooks, cameras, microphones, and tape recorders. How d'ya feel, Mr. Hughes? *Bloody awful, go away, leave me be.* No, but seriously? *Deeply relieved, dear colleague and fellow-writer, that Justice has taken her impartial course.*

And what about the guys in the other car?

I drew a shallow breath and thought of Kelly and Bowe, who had cooked up their naïve, bungled plot to perjure themselves if I paid them to.

And with unerring aim, I shot myself in the already too-much-violated foot. "They are low-life scum," I said. True; but then I realized that this would be taken to include Bennett, who had not been a party to the extortion scheme, and I added a few bumbling sentences to the effect that I didn't mean him, that he was innocent—just a harmless kid junkie—and that I regretted his injuries.

This was ignored. The trouble was that neither the extortion scheme nor the arrest of those involved had been made public yet, still less come to trial. It did so in February 2002, and Bowe was convicted of corruption, receiving a sentence of eighteen months' jail to be served cumulatively on top of the ten-year, maximum-security prison sentence he had already managed to incur for armed robbery, almost as soon as his ankle had recovered from our unpleasant meeting on the highway. So what the assembled Meejah saw was the intensely gratifying sight of the wealthy, stuck-up Eastern expat, who

had run over these honest young Australian workers, lads who labored on a trawler to bring us our daily fish fingers (not, please observe, effetely casting flies to tuna just for fun, with a five-hundred-dollar rod and a seven-hundred-dollar reel), adding insult to their injuries by calling them "low-life scum." What an object lesson in hateful snobbery! From then on, my fate was sealed. The question of what else one might call Bowe and his accomplice was not addressed by the Australian press. Better two extortionists than one elitist.

Some nasty post-trial exchanges ensued, and I found myself being sued for defamation by the director of public prosecutions and his lawyer. I believed at the time, and said so, that this public servant had chosen to pursue me with such dogged zeal on charges of dangerous driving because I was what Western Australians imagined to be a "high-profile" person, and he wanted to make a little political capital by lopping the poppy. Moreover, a local reporter—a stringer for two influential Eastern papers, the *Sydney Morning Herald* and the *Melbourne Age*—had concocted an interview with me that actually never took place, saying I had referred to the lawyer (who was descended from Indian migrants to Australia) as "a curry-muncher." I had never heard of this picturesque term before, still less used it; when challenged to produce some note or recording which supported his claim that I had done so, the reporter could show nothing, not an inch of cassette tape or even a jotted word, and refused to make any reply to my e-mails. Later, he averred that he was "so shocked" by what I had said that he had not written it down but of course could not forget it: it had branded itself forever on his ethnically sensitive brain. The *West Australian*, which had bravely taken the lead in rebuking me for my racism and elitism, ran a front-page story urging me to leave the state and not come back, and illustrated it with a full-page-deep caricature of me brandishing my crutches and firing machine-gun bullets from them at unidentified victims.

But by then, this kind of mendacity didn't seem to matter. The hacks of Australia—none of whom bothered to check the allegation, least of all with me—copied the "curry-muncher" quote from one another. That is the way most journalism works, in Australia or out of it. The Australian papers are perhaps no worse than the London tabloids—hardly a surprising fact, since most of them are owned by the same people, and some are edited by other

Australians. One goat mimes another, nobody bothers to check (since the editorial expense of maintaining a checking department, as at the *New York Times*, *Time* magazine or *The New Yorker*, is considered optional in Australia), and thus lies and fancies become truth. Not one of the journalists who repeated the "curry-muncher" quote had been in Perth, let alone spoken to me, still less asked for or received an interview. But although "curry-muncher" is not, perhaps, the deadliest of insults, I resented being tarred with the brush of racism since—as my writings on art over the last forty years would prove—I have never written one disparaging word about that great subcontinent, its peoples, its culture, or even about the prosecution's barrister, who admittedly struck me in court as a pompous prat, but for reasons quite unconnected with his Indian ancestry. The only reference I made to curry at all was to say, in an admittedly feeble joke to a radio interviewer, that the magistrate had given the prosecution "curry," which is Australian for a robust lambasting. As indeed he had.

Then the "curry-muncher" non-quote made its way onto the Internet, which gave me more things to straighten out with puzzled *Time* staffers, headed by an indignant Japanese-American, who felt *his* ancestry was being impugned. And before long, the whole fictional imbroglio descended into pure farce, when a newly opened Indian restaurant in Melbourne called itself the Curry-Muncher—which in itself might have weakened the contention that Indians found the phrase insulting.

Another reporter, this time from the *West Australian*, produced the further extraordinary fiction that I had accused members of the Broome Fire Department of theft, that they had "stolen" the tuna out of the back of the car. Of course, I had never said or even suggested anything of the sort; what I did say was that I hoped they *had* taken the fish and that some of them might have enjoyed it for dinner.

Of course, in the midst of all this turmoil, we had fallen into a legal trap. Bloeman's decision that there was no case to answer was a finding of law and thus readily appealable. With the benefit of hindsight, it seems obvious that we should have pressed on and insisted on giving our evidence. Bloeman then would almost certainly have acquitted me and an appeal would have been well-nigh impossible. An acquittal cannot be appealed; but a "no case" verdict is not an acquittal. The Crown can still appeal it.

And Cock had a sound legal point. How could there be no case to answer, no case at all, when my car had been found on the wrong side of the road? The fairies wouldn't have dropped it there.

Cock could have chosen to leave well enough alone, but media coverage, extensive and often hostile to me, together with my own reflections on his motives and the award of costs all virtually ensured that he would appeal to the Supreme Court. And so he did. (Rather confusingly, the Supreme Court is not the highest court in Australia. That is the High Court in Canberra. But it is still extremely unusual for a traffic case to go there.)

This didn't matter. Australian journalists are apt to write whatever they want, and now these ones wanted what Vladimir Nabokov once so expressively termed the writer's "pale and glaring head" on a platter. All of a sudden the Australian media, which had previously been sympathetic to neutral, decided that it was, in that salty national phrase, my turn in the barrel at long last. I was a vile elitist, without gratitude to his rescuers. (Some truly bizarre stories, saying that I had spoken contemptuously of the Broome Volunteer Fire Department, were circulated by the Australian press. None of them contained a vestige of truth.) All across the country, editors sat up at the prospect of getting some circulation-building blood in the water. Young journos with reputations to make (and a few older ones, too, without much time left to make one before mandatory retirement) seized the chance to denounce a writer whose offense was to have become too well-known in his native country and had then sold out, first to the Poms, then to the Yanks. This process, known as "cutting down the tall poppy," is one of the enduring institutions of cultural life in Australia, and perhaps I was lucky to have escaped it for so long.

It is true that I had not been very reverent in my comments on Robert Cock's actions and motives. But then, he was a public official, and in most democracies those who act in the people's name are expected to take the rough side of the people's tongue together with the smooth: their actions are open to adverse commentary, like any other government agent. Not, apparently, in Western Australia, where they feel entitled to an almost diva-like deference from the press. So when Cock and his barrister turned on their radios and heard me saying in a post-trial interview that they had brought the prosecution so as to politically grandstand, they saw an opportunity.

They sued me in the civil courts for defamation, and eventually won.

In the end, which took years to reach, they got a good deal less money than their lawyers were demanding (under the terms of the out-of-court settlement I am not allowed to reveal the amount). But this must have been one of the few instances in Australian law where a public prosecutor could (a) prosecute someone in the magistrate's court on a traffic offense while (b) claiming personal civil damages from the same defendant in the Supreme Court at the same time. You might have supposed a whiff of conflict of interest here, but not, apparently, in West Australia.

Sanity (of a kind) prevailed, in the end. I settled the defamation case, and when the traffic case came back to the magistrate's court I did what I should have done to begin with: for the sake of closure, I pleaded guilty, was excused attendance at the court, and paid a fine. It was $2,520, and—just in case I was seized with nostalgia for the delights of the state—I was solemnly debarred from applying for a driver's license in Western Australia for a period whose length I forget. The legal and travel costs, in the end, amounted to more than $250,000—perhaps not adequate punishment, but at least a fitting knock on the knuckles for a fucking elitist cunt like me.

For of course I am completely an elitist, in the cultural but emphatically not the social sense. I prefer the good to the bad, the articulate to the mumbling, the esthetically developed to the merely primitive, and full to partial consciousness. I love the spectacle of skill, whether it's an expert gardener at work, or a good carpenter chopping dovetails, or someone tying a Bimini hitch that won't slip. I don't think stupid or ill-read people are as good to be with as wise and fully literate ones. I would rather watch a great tennis player than a mediocre one, unless the latter is a friend or a relative. Consequently, most of the human race doesn't matter much to me, outside the normal and necessary frame of courtesy and the obligation to respect human rights. I see no reason to squirm around apologizing for this. I am, after all, a cultural critic, and my main job is to distinguish the good from the second-rate, pretentious, sentimental, and boring stuff that saturates culture today, more (perhaps) than it ever has. I hate populist kitsch, no matter how much of the demos loves it. To me, it is a form of manufactured tyranny. Some Australians feel this is a confession of antidemocratic sin; but I am no democrat in the field of the arts, the only area—other than sports—in which human inequality can be displayed and celebrated without doing social harm. I have never looked down on spectator sports or on those who enjoy them—it's

just that, due perhaps to some deformity in my upbringing, I've never been particularly keen on watching them or felt concerned about which team, crew, or side won. The long bus ride out to the banks of the Nepean River for the inter-school regattas, and the tedium of sitting on an ant-infested grass slope waiting for the fours and eights to slide distantly past, could send me into a coma. I loathed playing Rugby football—"the muddied oafs at the goals"—and disliked watching it only slightly less. I once, and once only, went to a racetrack; this was in Brisbane, in 1962, where I lost five pounds on an animal named Flake White (unwisely chosen merely because that was the name of a kind of artist's pigment) and then went back to the city on a bus, none the wiser about horses. I used to like playing golf, but watching it on TV puts me to sleep. And only once, in a third of a century in America, have I actually gone to watch a baseball game, a pastime whose rules I only vaguely understand. (The late artist Saul Steinberg once said to me that baseball was the great moral allegory of American life, but I have never grasped what he meant.) No doubt this is my loss, but I am powerless to feel otherwise. Perhaps I am not a "true" Australian, as my antipodean critics have indeed been known to claim.

Australians have no difficulty with elitism in sports. On the contrary, it fuels their imaginations, it blots up their leisure time, and they prize it as their chief claim to national distinction, especially since their political and economic importance is so unfairly slight in most of the world's eyes. When John Howard's Liberal Party was returned to power once more after a wretchedly bungled campaign by Labour in the 2004 elections, the event made it only to page 16 of the *New York Times* and seemed to excite no further comment or analysis. Events in Haiti automatically get ten times the column inches and air seconds of those in Australia; and those in Israel, of course, a hundred times. There is no Australia Lobby in New York to make politicians and Meejah proprietors feel guilty and open their capacious wallets. Australia rarely pops up before the world's Meejah; at best it doesn't matter much to them, and most of the time it doesn't matter at all.

Generally speaking, if an Australian event doesn't involve a monster crocodile, a giant shark, or Nicole Kidman, it won't go anywhere in America. KILLER CROC CHOMPS NICOLE: a good Murdochian headline, almost rivaling his *New York Post*'s classic HEADLESS BODY IN TOPLESS BAR.

Competitive sports is not just an example, but the very essence, of elitist

activity: by its nature, a competition can yield only one winner as against any number of losers. But if the harmless culture elitist is not a sport elitist, and unwisely confesses that he doesn't care who wins what at any Olympic Games, then woe betide him. There is bound to be something un-Australian in his makeup. Nobody is more hypocritical about "elitism" than your average Australian journalist.

By the time this bleary fiesta of humbug and abuse, with all its fabrication of quotes, had run its course, I had indeed lost the rather innocent and nostalgic love of Australia that I had retained for nearly forty years, ever since I left for Europe. I had never for a moment contemplated changing my citizenship. Now I was reluctantly thinking about it. The spate of inaccurate reports, the op-ed articles about my supposed disloyalty as an expatriate, the clamor of bawling stupidity on the call-in radio shows, the reluctance of all except a tiny handful of Australian writers to speak up in my defense (a handful of two, really—the writers Peter Craven and Cathy Lumby) and the general level of rancorous prejudice—all this had made me wonder if in fact there was anything to be gained by remaining a "patriot," whatever that now meant. What penance was I meant to do? Did Australian culture, let alone its Meejah, have anything further to offer me? Conversely, did I owe Australia anything, having lived outside it for more than forty years and only lived in it for twenty-six? Was I fated always to owe the place something for the mere fact of being born and raised in it? Was my Australian-ness the most important thing about me, or was it only one of the attributes of an evolving life, one that could be left behind without bitterness on either side, even though my Australian accent, like the smile of the Cheshire Cat, lingered in the branches of the gum tree? I badly needed a settling of accounts.

Father, I Hardly Knew You

We all come into the world with baggage which, in the end, we have no hope of reclaiming. The main item in mine was my father, Geoffrey Eyre Forrest Hughes (1895–1951), whom I knew slightly as a child and not at all as an adult: he died when I was only twelve. He lingered in my life as a threat to childish delinquency, a not altogether easygoing phantom. He was entirely real to my elder brothers, Thomas (b. 1924) and Geoffrey (b. 1928), and to my sister Constance (b. 1926), who had known him in a way that I hardly did. I do not even recall the timbre of his voice or the color of his eyes. Did he have a strong Australian accent? Probably not, because of his education and upbringing, but I don't really know. My most vivid memory of him stems from when I was about ten, around 1947.

There was a woodpile in the garage yard of the house we lived in at 26 Cranbrook Road, Rose Bay, Sydney. One warm morning, I had woken up soon after dawn, to the cackle of a kookaburra on a nearby telephone pole. I had pulled on my shorts and gone down to the woodpile. What a fine thing it would be, I thought, to chop some kindling wood and add it to the pile, a small but noticeable domestic service which would please my parents, particularly my father—firewood being in the "male" preserve of domestic life, as helping wash up was in the "female." I got out the splitting axe, with its smooth, curved handle. I honed its edge as I had been taught, with a few scraping strokes of the dark-gray, gritty oilstone, balanced one of the crook-grained baulks of eucalyptus wood on the chopping block, and swung. Before long, a nice little pile of split kindling had begun to accumulate. But then something quite unlooked-for happened. In the still indistinct early

light, a figure appeared in the yard, a man in flapping striped pyjamas—my father, his face set in angry disapproval. I had never seen him in pyjamas before—because I was never allowed into my parents' bedroom—only fully dressed, either in shirt and work shorts, or in his Air Force uniform, or, more usually, in one of the suits he wore to the office. And he was furious. He and Mum had been woken by the clack-thump of the axe on the block, and he had had to come down to see what the hell was happening. Far from being pleased at my little spurt of industry, he was livid. *Get back to bed at once*, he snapped. *What time of the day do you think this is?* Mute and terrified, I propped the axe against the wall inside the toolroom and fled upstairs. And to this day, when I try to summon up a mental picture of outraged authority, its first male representative is always wearing not a military uniform, not a priest's habit, not a policeman's tunic, but striped Viyella pyjamas.

If I had known him as an adult, his memory would have been less scary and much closer. *Manes Palinuri placandi sunt.* By now, in my late sixties— ten years older than he was when he died—I am resigned to the fact that I shall never placate that ghost: that I cannot be, in my siblings' view, anything like the man G.E.F. Hughes was: that he constitutes a sort of one-man tribunal from whose now unenforceable verdicts there is no appeal. What is worse, not being able to know what he was like, I cannot be really sure what I am meant to be living up to. I know that I am imperfect and a sinner. Did Dad ever sin? Maybe not: my brother Geoffrey in effect canonized him after he died. Dad could do no wrong; there was no possible inadequacy of which he could be accused. He could not have been called "only" human; he was *supremely* human, a hero beyond ordinary humanity, without remembered weaknesses. My other brother, Tom, saw him as a somewhat more fallible creature, and I have no doubt at all that this helped to save my fraternal relationship with Tom, which, despite its intermittent difficulties, took on a sweetness and fellowship that I seldom felt with Geoffrey.

There are three things I am sure he would have wanted me to do: remain a Catholic, become a lawyer, and stay in Australia. I did none of them. I now realize that, on a deep subliminal level, the desire to escape this righteous and inflexible man, a brave warrior but not a professional soldier, a war hero who shot down eleven German planes in the First World War, a fiercely orthodox Catholic, and an intense patriot, determined the direction and conditions of

my life. It was at least partly in reaction against him, and what he stood for, that I became an expatriate, a political skeptic, an atheist, a liberal, a voluptuary, and, in most ways, a disappointment to the ethos he lived by. And, perhaps no more creditable than these, a writer about art.

Not that Dad despised art. He was by no means an aggressive philistine, unlike so many Australians of his generation. I never heard him say anything about the visual arts, but then, I was a small boy, and it is not unusual that he did not talk to me about them. In fact, he had seen quite a lot of European art, at a much earlier age than I ever would, during a Grand Tour he took with his brother, Roger, and their parents, Sir Thomas and Lady Hughes, in the last years of the great Edwardian peace.

They took a liner from Australia in 1911, when Dad was sixteen and Roger twenty, and toured England and the Continent for several months. This was a huge step for an Australian teenager and, obviously, few got to take it.

The Hugheses did not travel cheap. (There wasn't much cheap travel available then, certainly not at the level of comfort a soon-to-be-knighted Lord Mayor would have found tolerable.) They stayed in good-to-excellent hotels, the Hotel Metropole et de Ville in Naples, with its views across the bay, the Baglioni in Florence, the Danieli in Venice ("very nice indeed," Dad thought), and others in Paris, Brussels, and Berlin. They fed well, too. Almost every night in Paris the four of them ate dinner *en famille* at the Véfour, then and still one of the grandest of all French restaurants, with its exquisite eighteenth-century décor that Jean Cocteau, after World War II, predicted with dread would be sold to some American. Alas, my adolescent father-to-be was not sufficiently interested in food to write down in his pocket diary just what they tasted there. But I can hardly blame him for failing to satisfy my curiosity. He did not like everything; the Hugheses, for instance, went to see Richard Strauss conduct his *Rosenkavalier* in Vienna and came out "thoroughly disgusted both with the opera & the manners of the Germans [*sic*]." Roger's diary (April 10, 1911) casts some light on why this was so: they only had standing room and "at the interval people moved away and we got front places—still only standing room at the back of the gods—but these infernal Austrians came back and demanded their places. So we took second row. But others claimed their standing room there too!—and one cad took Mother by the arm to move her!—there was very nearly a

free fight between him and me, but we had to give way. I am sure he understood enough English to know what I meant when I called him a German pig. We went out soon after, disgusted with everything including the so-called music which was rotten." Nevertheless, the young Hugheses were impressed with most of the art they saw.

They knew few people in Europe, but in Rome, because of Grandfather's eminence as a Catholic layman, an Irish Jesuit he knew arranged for them to be presented to the Pope, Pius X, who as Giuseppe Sarto had been elected to the fisherman's chair by his fellow *porporati* ("purple-wearers," or cardinals) in 1903. He was, even by the papal standards of the day, an inordinately conservative figure and one who disliked and distrusted civil governments—not that that mattered to the Hugheses. Although this was a fairly routine audience, the sight was extraordinarily impressive, especially for two boys from Sydney who had never seen what ceremony could really be. "The Vatican guards," wrote Geoffrey, "were a blaze of glory. So were the footmen who took our coats . . . The Pope was very kind & nice & made us sit round in a semicircle and talked French to us. He is an old man, not tall, with white hair & thick features but very kindly eyes." Geoffrey visited the Pantheon, where King Umberto was attending a memorial service for his father. "We saw him drive away without any ceremony, amid absolute silence. No-one took off a hat or gave a cheer. We stood in the rain for an hour to see this. These Italians are weird people!"

His diary was sketchy but he kept it, faithfully, every day. Its pages give the impression that he worked his way through his Baedeker, star by star, noting the commended things he saw and ought to have seen, without recording any personal reaction to them. In the Vatican Museum "we walked through miles of sculpture Galleries & saw the Laocoon, Apollo Belvedere, the Perseus & Ariadne & other great works. Also the Torso of Hercules over which Michael Angelo when he was blind used to pass his fingers to feel its beautiful form." He sees Fra Angelicos (the Capella Niccolo V), Raphaels (the Loggie, the Stanze), the Sistine Chapel ("wonderful"), and squeezes in afternoon tea before scooting off to the Gesù Nuova to view the sarcophagus of St. Ignatius and "the incorrupt arm of St. Francis Xavier."

And so it went, city after city. In Tivoli, they were picked up by an ancient guide who "told us he had 'otto Bambini' so Father gave him a good deal over his proper pay." In Naples, there was the Dancing Faun and an electric

tram to Pompeii, of course, where he viewed the Casa dei Vetti, the houses of Diomedes and of the Faun, the forum, and, better than so many works of art, the fascinating plaster casts of the ash-smothered dead, their limbs splayed starkly out like the barbecued corpses of wallabies in the wake of an Australian bushfire. In Florence, "the most beautiful place I have seen," there was the Piazza della Signoria, "where Savonarola was burned, a beautiful square & surrounded by lovely buildings." He visited the Duomo, the Baptistery, Santa Croce, Santa Maria Novella, San Marco with its Fra Angelico frescoes, and the "old and dilapidated Church of San Miniato." He admired the Orcagna shrine inside Orsanmichele and the Donatello St. George on its outside wall, the Michelangelo *Dawn, Dusk, Night,* and *Morning* on the Medici tombs in the Sagrestia Nuova, and Giambologna's *Mercury* in the Bargello, though "We had not time to do it as thoroughly as we would have liked." In Pisa, he is impressed by the Leaning Tower (many years later, I would see an intricate alabaster miniature of it in a curio-cabinet at home, almost the only surviving souvenir of that trip, with all its tiny columns intact). He loves the Baptistery but "it contains nothing extraordinary except a wonderful echo."

As for the Campo Santo, it is "disappointing, except for some very amusing frescoes of Hell." This is a puzzle: Dad never misses Mass, he is always looking for a church that has an anglophone priest to hear his confession, he believes in every skerrick of Catholic doctrine, and yet he finds the Campo Santo frescoes of eternal damnation—which filled me with a kind of retrospective dread when I saw them fifty years later, worms, flames, skulls, and all—not just absurd or crazy but "very amusing." And what was so funny? Perhaps it was the sheer unfamiliarity of this dreadful imagery, to which no equivalent existed in the suburban milk-and-Madonna iconography he was accustomed to in Australia. Perhaps it was the gross and terrible physicality of the scene, whereas Dad may have had a more metaphysical idea of Hell as constituted by the anguish of the damned souls who, theology tells us, having briefly experienced the ecstasy of seeing God at the Judgment, were now eternally tormented by its eternal denial. In any case, the amusement remains a mystery to me. It's the sort of remark you can hear a religious skeptic making, but Dad at sixteen was no kind of skeptic.

Leafing through this notebook with its firm, immature script, nearly a century old, I am struck by Dad's sheer determination as a boy; I know that,

when I was sixteen, I would not have had the stamina for so much look-ing. But once Dad was focused on something, he was not easily distractable. And he clearly enjoyed his art-looking, and was not just doing it to please his parents.

Still, I do not think he would have placed writing about art very far up on his scale of human achievement. Not that we ever discussed it; it had never occurred to me to do so, since I wasn't interested in art, still less in writing about it. I knew with perfect certainty that I wanted to be a lawyer like him, like his two sons Tom and Geoffrey, and like his father.

The Hughes family was Irish, root and branch. We came from that eco-nomically backward, unromantic and culturally undistinguished quarter of the Emerald Isle, County Roscommon. We were not horse thieves, rick-burners, footpads, or nationalist rebels. We were not, as Irish people in Aus-tralia were commonly assumed to have been, "transported beyond the seas" for this crime or that. No surly bushrangers perched romantically in our family tree.

Quite the contrary: the Hughes clan, as far as it need be traced, begins with Michael Patrick Hughes, merchant and modest landowner, of Lisheen House in Roscommon, born in 1760. He married the widow of a British Army general in 1819. Their eldest son was Thomas Hughes (1801–63), gro-cer, of the obscure village of Drumshambo in Roscommon, whose eldest son (of six children, three boys and three girls) was John Hughes (1825–85). In 1839, the whole Hughes family, hoping to escape the limited horizons of Drumshambo, set sail as free emigrants to Australia on board the passenger ship *Centurion*. The mother, Maria Cogan, did not weather the harsh voyage well and died soon after the ship made port in Sydney. Thomas Hughes and his brood, however, prospered. He set up his grocery business and, cun-ningly, made himself an administrative post with the Darlinghurst Jail in Sydney.

Even as late as the 1840s, the colonial microcosm of Sydney had a sub-stantial industry: the production and punishment of crime. One of its prin-cipal civic monuments was the Darlinghurst Jail, and Thomas Hughes of Drumshambo saw it as a ladder on which an ambitious man might rise; before long, and no doubt by using his Irish connections for all they were

worth, he had won himself a position as its superintendent. He can hardly have been indifferent to the advantages of being a grocer and running a jail that bought food in bulk. But one insight in particular made his fortune.

This was mustard. In an age before refrigeration or canning, mustard was in big demand to disguise off-flavors in meat. And Australians were extreme carnivores: it was a meat-and-potatoes, corned-beef-and-cabbage culture. Through a carefully maintained relationship with the firm of Keen's, Britain's chief mustard manufacturer, great-great-grandfather Thomas Hughes turned himself into the Mustard King of Sydney and, indeed, of Australia. He then took the profits and plowed them into inner-city real estate. So by 1863, when he died, he left a fortune in property to his children, especially his eldest son, John. John Hughes, in turn, expanded the family holdings— he even bought a sheep station, "Narramine," near Dubbo in New South Wales, and joined the ranks of Australia's landed gentry.

His son, my grandfather Sir Thomas Hughes, had an enormous collection of medals, all of them except one bought from dealers in Europe. They ranged down from two VCs and a Blue Max (the *Pour le Mérite*, Germany's highest order for valor) to a clutter of miscellaneous awards for gallantry won by others wherever in Africa the Union Jack had flown, from Benin to the Sudan, not forgetting numerous fields of glory in the Boer War. My mother, who had no emotional attachment to these somewhat abstract emblems of valor, put them all in a box after my father died, in 1951, and gave them, no strings attached, to the Australian War Memorial in Canberra, where I believe they still are. There was a time when that annoyed me, since Dad's will had left them to be equally divided among his four children. But in the end, none of us did anything to reclaim what should have been our property.

The one medal that Bappa, as his offspring called him, had actually won himself was an obscure award called the Order of Polonia Restituta, given by the Polish authorities for spiritual valor in the face of anti-Catholic prejudice. He had never been to Poland and spoke not a syllable of its language.

He had also been made a Knight-Commander of the Order of St. Gregory, like his brother, John Hughes (1857–1912)—an award from the Pope commonly given, when such gongs mattered more than they do today, to rich and charitable Catholic Irishmen.

He was not the first mayor of Sydney, but he was its first *Lord* Mayor,

although the difference between the two now eludes me. He was a big, handsome, well-proportioned figure with swept-back hair and a waxed moustache—the sort of person whom Edwardians referred to as "a fine figure of a man." He is said to have had a resonant speaking voice, always an asset for a politician in those days before microphones. His wife, Louisa Gilhooley, could not have been called a beauty—her photographs suggest someone who forged steadfastly, rather than tripped daintily, along the street—but she did have a hobby which must have seemed unusual among the wives of the gratin of Sydney: she loved doing woodwork, and had a set of chisels, veiners, sweeps, and gouges which she kept in a small chest with a hinged lid. With these she made a number of pieces of furniture, the largest of which was an ornamental hall settee, some six feet long, with a hinged seat and a back elaborately carved, in relief, with a design of knotting and twisting Celtic dragons, all in black-stained bog oak. Relegated at last to the veranda, it came in handy when you were a small agile boy playing hide-and-seek. The only other piece of her furniture that I can remember was a Gothic refectory cupboard, likewise in oak, which she had made for use in the dining room and which bore, in a frieze of contorted Celto-Gothic letters, the admonition "Whatever fare you hap to find, take welcome for the best," which may—though here childish memory wavers—have been one of the improving slogans that Bappa picked up in his school days at Stonyhurst. From this I deduce that neither Sir Thomas nor Lady Hughes (my grandmother, whom we knew as Ganny-Gan) was any kind of a foodie.

What is quite certain is that, especially after Bappa's death, in 1930, she was not a happy woman. She spent the last quarter century of her life in a state of moping depression, a semi-invalid. My father, whose devotion to family duty was rock solid, would usually visit her twice a day, once on the way to the office and once on the way back. I never met her, since she died—perhaps luckily for me—before I was born.

By no stretch of the imagination could Sir Thomas have been called an Irish nationalist, either. On the contrary, he was a flinty and unyielding British imperialist. He was completely on the side of England during the Great War: hence his knighthood. He supported conscription and agitated for it, thus incurring the enmity of Australia's most political Catholic prelate, the Irish cardinal Daniel Mannix. Bappa was so conservative that,

when a delegation from the radically socialist IWW (International Workers of the World, or "Wobblies," whose American leader was an Australian expatriate) came shouting slogans at the gate of his home in Elizabeth Bay during a general strike in 1917, he was later alleged to have ordered his manservant to disperse the socialist rabble by firing a warning shot over its heads with one of his Greener 12-bores. If this encounter actually took place, which I disbelieve—it was related by a noted Stalinist writer, who also had a more lurid version of it that claimed Bappa's servant had actually shot and killed a Wobbly at the gate that day—I have found no mention of it in the newspapers of the time. The Stalinist was a great raconteur but not the most unprejudiced source on the doings of Australian Catholic nobs in the early part of the twentieth century.

Yet there may have been some mysterious ghost of such an impulse to seigneurial defense, buried in his genes and transmitted downward through them. In 1970, his grandson Thomas Hughes, my eldest brother, was serving as Australia's attorney general. Tom was a hawk on Vietnam, though he later changed his mind about that immoral and misbegotten war. He publicly supported the policy of sending Australian troops to fight in support of the Americans, and so inevitably he became a target of protest. A demonstration of some two hundred Vietnam protesters wound its way up Bellevue Road to Tom's house, and spread out in front of its short driveway, shouting slogans and demanding to see him. Tom has never been one to cower behind a skirt or a tree (let alone a manservant, which he did not have). At the time, his eldest son, Tom Junior (who was then eight), remembers, my brother was taking a siesta in an upstairs bedroom when the confused shouting of the demonstrators awoke him.

At first he had no idea of what was going on, but when he realized the implausible fact that his front drive as well as the street outside the house were full of people, and hostile ones at that, he shouted to his kid, "A weapon—get me a weapon!" Little Tom scampered downstairs but could find only two possible weapons in the hall closet: an axe and his own junior-size cricket bat. Sensibly rejecting the notion of giving his father an axe at such a moment, he brought him the cricket bat—and a pair of cricket pads, the ribbed, protective leg armor which all batsmen wear to protect their shins against low fast balls. The attorney general strapped these on and, brandishing the bat as he shook the woozy vestiges of postprandial sleep from his

head, strode out the front door to confront the dumbfounded Lefties. I was not there to see it, but I am told it was a truly impressive spectacle. Since Tom's steely glare can be demoralizing even without a cricket bat, it must have been quite terrifying with one. The Sydney press got a good deal of mileage out of this event.

When grandfather Thomas was knighted, half a century before, in 1915, he had the Royal College of Heralds design him a crest. Its imposing heraldic description was "On a wreath of the colors, a lion rampant argent, charged on the shoulder with a rose as in the arms, and holding between its paws a thunderbolt gules. Motto: 'Fortiter et vigilanter.' " Unfortunately, his descendants were not entitled to bear these arms, although I have sometimes thought with mild regret that a prancing lion holding the thunderbolt of vengeance (complete with wings, barbed lightning flashes and the motto "Strongly and vigilantly") might, despite its soupçon of overkill, be a not-bad device for a cultural critic. For a short time in the early 1970s, I thought of defying the College of Heralds and painting it, not *too* large, of course, on the air-filter cover of my motorcycle, a rumbustious but purring Honda CB750, but then I gave up the idea—mainly because some passerby might have mistaken it for the kind of phony armorial bearings vulgarly affected at the time by Ralph Lauren and other distinctly unarmigerous Americans in their ad campaigns.

The Hughes family was often supposed, by other Australians, to be rich. We had been once, or fairly so, but now were not: "comfortably off " was the phrase, but when Dad died he left an estate of only about thirty thousand pounds (though the pound, of course, was worth far more than today's Australian dollar), a moderately large house with five bedrooms and servants' quarters in a fashionable suburb of Sydney, and a dark-green 1950 Chevrolet. Thus we lived semi-rich, but he was never able to retire on accumulated capital. He sat on various solid and reputable boards (Toohey's Breweries, the Commercial Banking Company of Sydney), but he did so more in a spirit of public service than anything else, and the idea of profiting by insider knowledge of impending financial deals, as is so common in the financial world of Australia today, would have filled him with moral disgust.

Father had been educated at a Jesuit boarding school, St. Ignatius' College, on an arm of Sydney Harbor far up the Lane Cove River; so, in due course, were his three sons, Tom, Geoffrey, and myself; sister Constance

went to school in what had once been the family house but was now owned by the Sisters of the Sacred Heart, at Elizabeth Bay, a prime waterfront site worth incalculable millions today but not then.

The Sisters of the Sacred Heart were a family aberration. They owed the presence of their order in Australia to the Hugheses, and they had somewhat impoverished us. In some overflow of religious zeal my great-grandfather John had decided to show his Catholic piety by importing them from Ireland. Once in Sydney, they devastated the family fortunes rather as the imported rabbit had devastated the graziers of New South Wales, who had only wanted to behave like squireens by bringing in something to shoot and then discovered to their horror that not all the ammunition in Australia could possibly deal with the plague of rabbits.

Why John Hughes should have thought, looking around the immature community of Sydney, that what it most needed was a bunch of nuns is no mystery; as an intensely devout Irish Catholic, he wanted to widen the scope of Catholic education for girls; so his grand Victorian demesne on the waterfront, known as Kincoppal (Gaelic for "horse's head," which one of the rocks on its foreshore was thought to resemble), passed to his two daughters. Since they were either so pious or so ugly as to be unmarriagable (the surviving photos are not conclusive), they entered the Order of the Sacred Heart as nuns.

When you become a nun you espouse Christ, and all your property goes to Hubby. Thus the Hugheses lost one of their two big city properties, which became God's dowry. I have often looked at its gates with envy, especially since the 1960s, when the Sisters of the Sacred Heart astutely reaped millions by developing the land as high-rise condominiums for the rich. Gone the fern grottoes and boskage in which their predecessors were optimistically supposed by great-grandfather Hughes to wander meditatively about, reflecting on the mysteries of Faith.

Then the second big property, the present site of Rose Bay Convent, also went to the Sisters of the Sacred Heart. All I got out of that bequest, as a child, was the obligation—irksomely enforced—to go up the hill and visit a great-aunt whose name I forget, a very senior sister. There would be stilted and pointless conversations, through a smell of Sunlight Soap (mixed with a faint whiff of old lady's pee) struggling against the pervasive odor of floor polish. At the end of these audiences I would be expected to kiss her, which

meant craning my neck to get my lips inside her elaborately starched and goffered ruff, its hive-like cells prepared, no doubt, by some wretched, rosary-clicking slavey of a postulant sister with the kind of iron last manufactured in the 1920s. Its rigid linen edges were as sharp as celluloid. I would plant a fugitive peck on the translucent skin of her prow of a nose, she would creak out a dry blessing, and I would escape with relief. I hated the afternoons wasted on these visits, and so, I presume, did she.

We had never been sheep barons or any of the other exotic things Australians were popularly supposed, by foreigners and Englishmen, to be. Dad was a city solicitor—a lawyer who prepared briefs but did not argue them in court, as distinct from the barrister, who performed that office. But the family was, to some degree, prominent, at least as Irish families went, which wasn't necessarily all that far. A lot of prejudice existed against the Irish in Australian colonial days. Its odor still remained, like the musty aroma from a neglected basement, in the Sydney of my grandfather's time. It was, in large part, a legacy of Australia's infamous "system," the role the colony played as a dumping ground for convicted criminals after its foundation, in 1788.

Of these, the English authorities generally agreed, the worst, the most rebellious, vicious, and irreformable, were the Irish. The general English (that is, colonial ruling-class) opinion of Irish convictry in Australia was set forth, as vividly as anyone could wish, by the sadistic cleric who helped rule the early colony, the "Flogging Parson," the Rev. Samuel Marsden (1764–1838). To this choleric bigot the Irish were "the most wild, ignorant and savage race that were ever favored with the light of Civilization," given to "every horrid Crime . . . capable of perpetrating the most nefarious Acts in cool Blood . . . superstitious, artful and treacherous." Thus, the Irish were much more than mere dumb paddies, they were a cancer in the ill-protected community. This belief, held by many Australian Protestants, led to unyielding prejudice against the Irish and extreme reluctance to allow their descendants any authority within the colony.

The savagery of this prejudice abated. Still, it followed that if an Irishman wanted to enjoy prominence and power in Australia, even as late as 1900, he must meet certain criteria. He must be well-off, and preferably rich. He should not be of working-class origin, because Irish workers were always suspected of unionism, even a sort of primitive republicanism: the iron of convict suffering was seared deep into the collective memory of Australian

workers, often mythologized and sentimentalized, but never entirely absent. His money must come from impeccable sources—in other words, no crooks or bookmakers need apply, a policy that would be benignly relaxed in a later New South Wales. He should be eminent in charitable work, and not only in contributions to Catholic charities. And he must, above all, be Anglophile, more British than the British themselves, and shun all relationships with Irish nationalist societies, with Irish *identity* as such.

Thomas Hughes met all these requirements perfectly. His brother John had cut a considerable figure in Sydney's municipal politics before he died, in 1912; Thomas enlarged this role. He headed up a citizens' reform movement to deal with the corruption in Sydney's finances (1898), and in 1900 he helped organize a Citizens' Vigilante Committee to control an outbreak of bubonic plague. He held office as Mayor of Sydney in 1902, and became the city's first Lord Mayor from 1902 to 1903 and again from 1907 to 1908. He was extremely public-spirited; he saw to the upgrading of Sydney's water supply, and as the chair of a Royal Commission he worked for the widening of the city streets, for the building of underground electric rail systems, and a host of other amenities. He was also said by ill-wishers to be one of the dullest men in Sydney—though, in view of the probable competition, I am not sure of that. Certainly he wrote interesting letters containing plenty of feeling, in a strong flowing hand.

Not once in his political career, which lasted until his death, in 1930, did Thomas Hughes feign nostalgia for the Ould Sod. He did not care too much about the Irish vote. His education was entirely English; like his elder brother John, he had been a boarder at one of the major English Catholic schools, Stonyhurst College in Lancashire. Both boys matriculated for the University of London. John returned to Australia and was articled to a Sydney solicitor. Thomas toured Europe, came back to Sydney and in 1887 joined with his brother in founding what became the family law firm, Hughes & Hughes. John married Mary Rose Gilhooley, the daughter of a Sydney doctor; Thomas married her younger sister Louisa. The brothers were as matched as two peas in a pod, at least until John died unexpectedly of his chronic asthma in 1912.

Irish had married Irish, but Thomas Hughes seems never to have visited Ireland. His Catholic faith was unwavering, but it was not projected into any kind of Irish nationalism. His politics were not Irish-Australian but English-

Australian. He was absolutely an imperialist and wholly a warmonger. Thus, at the time of World War I, he advocated conscription (as did a highly nationalist conservative politician named William Morris "Billy" Hughes, no relation) in the very teeth of opposition from Australia's chief political Catholic churchman, Archbishop Mannix, who did not want to see a drop of blood coerced from the veins of Irish-Australian workers in what he viewed, correctly enough, as a war forced on them by the ruling class. The enmity between Lord Mayor Hughes and Archbishop Mannix, on this issue at least, was complete. Nobody could accuse the Hughes family of reluctance in offering its own offspring to the national interest, either. Of John Hughes's six sons by Mary Rose Gilhooley, four served overseas in World War I and one was killed in action.

My father Geoffrey was one of Sir Thomas's two boys, both of whom also fought in World War I. The elder, my uncle Roger, had been a classical scholar who went on to study medicine. As a fledgling doctor, he volunteered for medical duty, and in 1916 enlisted in the 1st Field Ambulance Corps of the Australian Army Medical Corps. Roger was immediately posted to the front, but he only survived there for five days. Working in an advanced dressing station in Bull Trench, near the remains of the town of Flers, in France, he was attending to a wounded man when a shell burst directly on the primitive surgery. The patient was killed outright. Roger, with both his legs shredded, was taken to 36 Casualty Clearing Station near the village of Heilly. And there, one of those awful, near-miraculous coincidences that sometimes do happen in a war took place. His brother, Geoffrey, who had been posted to France with 10 Squadron, was stationed with his squadron on an improvised airfield at Choques, near Bethune—a landscape of hell, traversed by barbed wire, greasy duckboards, and stinking craters full of rainwater and the corpses of animals and men. Dad had heard on the grapevine that Roger had been posted to France. Where, he had no idea. But he took a guess and got a seat in a car that was going south from Choques, in the hope of picking up Roger's unit and finding a lead to him. "I had no idea when I left the squadron of his actual whereabouts," he wrote later, "and merely took the chance of visiting . . . Heilly in the hope of finding out where his unit was so that I might be able to visit him later, not having seen him since I left Australia in March 1916. It was a most amazing thing," Dad added with some understatement, "that knowing nothing of his where-

abouts or of the fact that he had been wounded I should actually arrive in the village where he was dying."

Roger was lying unconscious when Dad was directed to his bedside. It was dark—the sixty-mile car journey from the aerodrome to the base hospital at Heilly had taken more than five hours, at a crawl through ruts and past shell craters—and he was, as he afterward wrote to their parents, "nearly mad with anxiety . . . I was utterly stunned and shaken by the shock of the whole thing . . . I prayed to God to spare Roger and thanked Him for bringing me to him." It must indeed have seemed to Dad that some higher will had brought the brothers together, against all the overwhelming odds: either that or some strange chance, and he was not a believer in chance—not, at least, where God might have taken a hand. On reaching Roger's side, "I said 'Roger, you dear old chap, how are you?' For a moment his eyes opened and he said, 'Geoffrey, you dear old chap.' Then he lapsed into unconsciousness again and lay there breathing peacefully. I knelt down beside him and prayed to God for him and you and Eileen. I begged God to spare him if it were possible, but added what has become my frequent prayer since I have had to face death—'Thy holy will, O Lord, not mine be done!' "

Dad went out into the night to find the comrade who had driven the car from the aerodrome to Heilly, Arthur "Anzac" Wood. "He was a brick to me. I was nearly frantic with anxiety and he was like a father to me." But when he returned to Roger's bedside he found that his brother, in that short interval, had died. "I had not thought the darling old chap would die so soon . . . He was lying as I had left him a short time before—but oh how different! His face was beautiful and he was smiling with indescribable happiness. I have never seen anything so beautiful as that smile of glorious happiness on his face. My darling Mother and Father, in this terrible sorrow God has given you this great consolation. Roger received the Last Sacraments that afternoon, and died as he had lived, a noble Catholic, strengthened and blessed by all the comforts of our Faith. When I saw him I thanked God for His mercy."

The death of Roger thus became the chief defining moment in my father's young life, fixing forever his ideas about brotherly love, sacrifice, and the habit of rationalizing ghastly personal loss as God's will. Roger became his master image of male human virtue. Above him were only St. Ignatius and Christ.

Dad placed truth above all things, but you can almost hear his teeth grinding with effort at the awful task of telling his parents about their other son's death. I am sure that he left some things out to spare their feelings. I would not be surprised if the beatific smile he saw on his dead brother's face owed as much to morphine as to spiritual resolution. Knowing as I do now what the pain of shattered bones and the effects of massive tissue shock can be, I naturally hope that the doctors who attended him were not niggardly with their injections. If Dad succeeded in conveying the image of Roger as a *preux chevalier,* it is mainly thanks to the firm and completely sincere transcendency of his own religious faith. Can I imagine myself reacting in this way to the death of a brother, even supposing I had ever had a brother whom I loved and idealized as Dad did Roger? Can I imagine extracting from such a hateful and utterly useless death—the random killing of a young noncombatant engaged in a brave act of mercy—some idea of God's benevolence? I do not believe so. I could not have consoled myself with thoughts about the mystery of the divine plan, or the Almighty's care for His creations. I would have cursed God as Roger died, had I believed in God. But since, as far as I know, I do not believe there is a God as Catholics define him, I would have been far more likely to experience Roger's death as one more horrible proof of the conclusion pressed on so many of my father's generation by the mass slaughters of the Great War: that, as Samuel Beckett once put it, our mothers bear us astride an open grave: one brief flare of light, and then darkness again; that all appeals to divine intention are vanity and unjustified hope, when they are not outright lies; that nobody and nothing is watching over us; and that not even the fittest necessarily survive. How one would wish to think otherwise! How immeasurably fortunate my father was in his faith!

Roger's line died out. His wife Eileen bore a son after he died—Peter Roger Hughes, born in 1917. He, in turn, was to enlist in the Australian Air Force in the early days of World War II, and die in Darwin when his plane, a notoriously slow and under-powered kite of Australian manufacture known as a Wirraway, crashed through some mechanical defect. Later, Eileen took the long road north to visit her son's grave. In Darwin she got a lift from a truck driver; the truck crashed on the way to the cemetery, and killed them both.

Dad survived the Great War, but I have no idea what he really thought about it: veterans of the air did not talk about such things to their twelve-

year-old sons. It seemed incommunicable, as terror and danger tend to be. Veterans only talked to one another. And sometimes they did not talk at all, if they were veterans of different wars.

My brother Tom, for instance, served a full term of duty as the pilot of a Sunderland flying boat, making antisubmarine patrols over the North Sea in World War II. Yet after he came home—he had not seen or sunk any submarines in two years, and mercifully, no nimble German fighter-bombers had spotted his big, lumbering plane above the gray heaving wastes of water—he could never get our father to talk openly to him about his own wartime flying experiences a quarter of a century earlier. Tom did not interpret this as a rejection, as he understandably might have done; he recognized that on some very deep level Dad found the nature of war in the air in 1918 incommunicable to someone who had not been through it, even though that person was his own son, even though that son had himself flown in combat.

Dad was a hero, and not just to me. In the world of today's journalism, heroism is cheap—all you need to do is pull a child out of the path of a runaway truck, or try to put out a fire. But Dad had signed up with the Royal Flying Corps in 1917, when he was twenty-two years old, and his interest in flying started long before then. He used to haunt the sand hills when an Australian inventor named Hargrave, who nearly but not quite beat the Wright brothers into manned heavier-than-air flight, was lofting his enormous box kites in the Pacific wind. In Europe in 1911 he never missed a chance to see an aerial gymkhana or a flying meet, writing down the names of the pilots. He saw a pilot named Weiss flying over Naples—aircraft then were so uncommon that the young aficionado would know a man's name from the design of his plane. In Paris that May he went to the Bois de Boulogne, where "we saw all the kids flying their model aeroplanes—they were beauties." Heading up the Rhine on a steamer from Koblenz he was thrilled to see the zeppelin *Schwaben* pass overhead, and in London he spent a whole guinea on an airplane kit at Bassett-Lowke, the toy and model shop on Oxford Street. That May 1911 he visited the aerodrome at Hendon, paid a shilling, and was allowed into the hangars, "studying the different machines, Bleriot, Farman and Graham White [*sic*], before there was any flying." He had learned to fly on a fiendishly unstable trainer called a Maurice Farman Longhorn (so called because the pilot was carried, sometimes to his death, on a sort of wickerwork cantilever out front with the pusher engine in back), and later gradu-

ated to those deadlier but (to their pilots) somewhat less dangerous classics of early aviation the Sopwith Pup, the Sopwith Camel, and, most of all, the SE5 or "Bristol Fighter," and its successor the SE5A.

He was a brilliant pilot, a natural talent; I say this unprompted by filial loyalty. The life expectation of a front-line RFC fighter pilot over France in World War I was horribly short, an average of two months. Die they did. But not Dad. Group-Captain G. E. F. Hughes, winner of the Military Cross and the Australian Flying Cross, was one of the few pilots in 62 Squadron who didn't have to be replaced. He entered active combat in the spring of 1918, as a boy of twenty-two; shot at by numerous Germans, he was never touched. He was demonically lucky. He had nine lives, a dozen, a score. He was also quite a shot, and downed no fewer than eleven Boche aircraft, Pfalzes, Fokkers, Taubes, and others, not counting the "probables," during that brief spring before the Armistice. His citation for the Military Cross, awarded in May 1918, reads in part:

> For conspicuous gallantry and devotion to duty. While leading his formation over the enemy's lines he was attacked by twelve enemy machines, two of which he shot down. On the following day, when in charge of a patrol, he attacked seven enemy triplanes, drove one down out of control, and forced three others to land. On another occasion, while in charge of a patrol, he was attacked by a large number of enemy scouts . . . he always showed the greatest courage and coolness in action.

One of them, a Fokker Dr.1, the triplane of the Flying Circus, with which 62 Squadron got into more than one dogfight, was flown by the famous Red Baron's brother, Lothar von Richthofen. The Dr.1 was a great little plane with a dodgy reputation. Only 320 of them were ever built, but the more daring German fighter pilots liked the Dr.1 because, in the Red Baron's words, it "climbed like a monkey and maneuvered like the devil." But they distrusted its fragility. Its gross weight was half a ton less than the SE5A's. Being a triplane its wingspan was only twenty-four feet as against the SE5A's thirty-nine, so it was much easier to throw around the sky. But it was also lighter armed (two 7.62 mm. Spandaus with a synchronizing link to the propeller shaft, firing forward through the propeller) and, without wing-bracing wires, it came apart more readily under the stress of combat, the

plunges and screaming turns. The SE5A, by contrast, was more like a car with wings, a solid gun platform boring through the air, although it, too, by comparison with fighters of a later generation, seems willfully fragile: very little metal apart from the big 270-horsepower Rolls engine, and no armor at all. The Bristol was faster than the Fokker (200 kilometers per hour against 165) and could fly a little higher (21,000 feet versus 20,000).

Dad and his rear-cockpit gunner Hugh Claye encountered Lothar and several of his wingmates in Jasta *(Jagdstaffel)* 11, whose command Lothar had taken over from the *graf* Manfred. They were patrolling east of Cambrai in the spring of 1918. Though Lothar was not quite the archetypal ace that his brother was, he was a very formidable enemy. Manfred von Richthofen downed eighty-two Allied aircraft, but Lothar accounted for forty, still a prodigious number of kills. Dad did not kill the twenty-three-year-old ace, but he shot him down, with some help from a Sopwith Camel pilot named Augustus Orlebar. Lothar crash-landed. He was still recuperating from his wounds in the hospital a few months later when he heard of the death of Manfred. He would survive his encounter with my father, fight on—scoring ten more kills before the Armistice—and eventually die of the long-term effect of his wounds, in his bed in the family *schloss* in Fuhlsbuettel.

The war in the air had elements of chivalry that it would never acquire again. These were certainly exaggerated, for propaganda purposes on both sides, but there is no doubt that the courage demanded of the pilots, up there in the sky without parachutes, protected by nothing but wood, wire, and doped canvas, teeth bared in a rictus of fear and cold, eyes watering and vision blurring as the icy slipstream searched out every tiny chink between goggles and skin, was extreme. The Flying Corps didn't even issue decent goggles to protect your eyes; you had to buy motorcycle goggles in London, and these did not always work. Half the time you were flying almost blind, your eyelids glued down by frozen tears. Against the 150-m.p.h. prop-wash, the only thing that could keep a pilot from freezing in his own open cockpit was a suit he supplied himself, with his own underwear, preferably fur-lined, or at the very least made of lamb's wool. The great Manfred von Richthofen wore his wool pyjamas under his flying suit, which at least made it easier to do a scramble in the morning.

My father's letters to his parents disclose how grateful he was to his mother, who was always sending him knitted wool socks—sometimes, in

wintry weather, he would wear no fewer than six pairs under his flying boots. Ernst Udet, the highest-scoring German ace to survive the war, later to become a great figure in Hitler's *Luftwaffe,* made a point of always going up in his best dress uniform, with ribbons: that way, he figured, he would cut more of a dash with the Parisiennes if he was captured. Pilots wore silk scarves, not because they wanted to look dashing, but because they needed some protection from the chafing on their necks caused by constantly swiveling to look for enemies behind. The silk also served to wipe the engine's castor oil off their goggles. (With some engine designs, such as the notoriously unreliable French Gnome-Rhone Rotary, castor oil was premixed with the fuel and spewed out as exhaust gas; the pilots breathed it and presently found themselves flying in a puddle of their own liquid shit.)

Worst of all, of course, was the Allied high command's point-blank refusal to issue its pilots with parachutes. The official line was that such safety devices (for they existed, and the artillery spotters in observation balloons were issued with them) would reduce the fighting spirit of the pilots by giving them an easy way out. This appalling callousness condemned many pilots to be roasted alive, thousands of feet in the air, as their stricken little planes spiraled helplessly to earth, their cockpits turned into blast furnaces by the rushing air. Some pilots bailed out without parachutes, preferring a relatively quick death with less sacrificial agony. Those who could do so were the luckier ones.

Many fliers took lucky charms with them. A. A. Kazakov, the Russian "ace of aces," never took off without an icon of St. Nicholas in the cockpit. Albert Ball took a slice of his mother's plum cake, which went down with him under Lothar von Richthofen's guns; the French ace Jean Navarre, a girl's silk stocking.

My father, as far as I know, took nothing—although it wouldn't surprise me if there had been a crucifix or a rosary somewhere on him—certainly not some girl's oo-la-la garter. For his flying skills and samurai-like bravery he won the Military Cross. He despised the word "ace," denouncing it for what it was—the showy invention of American public-relations flacks, a word no serious air fighter could honorably bring himself to use. I suppose, though I do not know, that he would even have viewed the romanticizing of World War I pilots—as exemplified by his fellow Australian Errol Flynn or that thrilling, ridiculous movie *Hell's Angels,* produced by his unrelated namesake Howard Hughes—as slightly obscene. Indeed, he poured scorn on it in

a speech he gave to his graduating class of young pilots at the flying school he commanded in Narrandera in New South Wales in 1940:

> Above all things in the Service is the "Hot Air Merchant" likely to become an object of suspicion and contempt . . . Much has been written and screened that might give the impression that the grand man of the Service is a hard-fighting, hard-drinking, devil-may-care sort of fellow who periodically snaps out of a life devoted to incredible binges and what one writer euphemistically described as "horizontal refreshment" to accomplish the most amazing deeds of daring. So graphically has this type been portrayed in print and on the screen that it may well be that some of the younger generation may really believe that it is an essential part of the game. . . . We did meet some of that type in the last war, but my experience was that they were rarely successful and never a credit to the Service.

Dad was a survivor, beyond doubt—he got through the war that annihilated so many Australian men of his generation. I cannot imagine that he liked war, and yet it must have filled him, sometimes, with an exhilaration far beyond the limits of ordinary life, very different to crouching in the wet filth of the trenches with the shells screeching overhead and the stench of rotting human meat and lyddite all around, a scene that horrified pilots as it horrified everyone else. Mickey Mannock, the fearless Irish air fighter who racked up seventy-three kills and delighted in "sending the German vermin to hell in flames," wrote of the "nauseating" journey to the trenches—"dead men's legs sticking through the sides with puttees and boots still on—bits of bones and skulls with the hair pulling off . . . the strong graveyard stench and the dead and mangled bodies combined to upset me for days." This was a place where the only victors were the rats, which the poet David Jones—like all others in the trenches—heard feasting obscenely on corpses, tunneling and mining at night:

> *You can hear the silence of it:*
> *You can hear the rat of no-man's-land*
> *Rut-out intricacies,*
> *Weasel-out his patient workings,*
> *Scrut, scrut, scrut,*

Harrow-out earthly, trowel his cunning paw,
Redeem the time of our uncharity, to sap his own
amphibious paradise.
You can hear his carrying-parties rustle our corruptions through the night-
 weeds—contest the choicest morsels in his tiny conduits, bead-eyed feast
 on us; by a rule of his nature, at night-feast on the broken of us.

At least the pilots did not have to live, sleep, and eat in this trench night-mare: theirs had the reputation of being a cleaner war, despite its danger and its terrors. Perhaps it was too early in the history of flight for poets to be inspired by it, as they were (so dreadfully) by the carnage, filth, and indignity below. As to the exhilaration flight could produce, one need only read some of the letters Dad wrote home to his parents. Dad was no poet, but he tried, for instance, to convey to them the effect of antiaircraft fire, or "Archy," directed on RFC planes crossing the line of the trenches. The German ground gunners were sometimes extremely accurate, bracketing the little planes with black bursts from fragmentation shells. Sometimes an aircraft would stagger back to base, shot to ribbons with twenty or thirty shrapnel hits; but some of these, because they were only fabric tears and punctures whose missiles went straight through the cloth without hitting any structural member, could be mended by a rigger with nothing more than a canvas patch and some cellulose dope. Other planes, less fortunate, did not get back at all, ending in a crumpled wreck in the mud between the lines. It was a terrifying gauntlet that every pilot had to run. "I will never forget my first experience of 'Archy,' " he wrote to them in 1917.

It was one mad burst of speed—running for dear life. The engine was roar-
ing, every strut & wire was shrieking with the rush of air, and then there
was the rattle of the machine gun, but above all was the sinister crump
of the shells. It was a glorious moment . . . something worth living for. I
was horribly frightened & nervous till the first shell came & then I just felt
quite all right, and started to fly the machine in a way I never dreamt of
before. . . . What makes the whole business worthwhile is the glorious feeling
of elation after you get clear.

To get a more homely simile, one that might have been more comprehensible to people who had never been up in a plane, let alone fought in one, he

compared the contest with Archy to cricket: "It is just like batting when a new bowler is put on and you are not yet set. You have to wait for the first ball, wondering all the time about what it is going to be like. You are all on edge but once it comes you know what you are up against."

"Something worth living for"—who but another pilot could possibly understand such a description of near-death? The ethos my father adhered to, without the slightest trace of pose or of self-consciousness, was not that of the soldier but that of the warrior, in the archaic and noble sense of the term. Warriorhood was not bred into him—there had never been a military Hughes before. But it came naturally to him. Soldiers fought because governments compelled them to. The warrior had no such compulsion. He fought because a sense of his standing, his moral obligations to class, family, and belief as he understood them, obliged him to do so. I believe that such people had more than a little in common with the samurai who were the heroes of Japanese authority until the end of the Edo period. They did not, of course, have a social ethos molded around them in the way that the Japanese absolutely did. Nor were they scholar-poets, as samurai so often were. But in the First World War the pilots on both sides derived a sense of high and perilous mission from the untested, always experimental nature of their combat, and its difference from the hideous and degrading conditions of trench warfare. Because they had this in common, the comradeship of pilots was very real indeed, far more intense than anything you could have experienced on the cricket field, in politics, or in church. "For he today that sheds his blood with me / Shall be my brother; be he ne'er so vile, / This day shall gentle his condition. / And gentlemen in England now abed / Shall think themselves accurs'd they were not here / And hold their manhoods cheap whiles any speaks / That fought with us upon St. Crispin's day." King Harry's words to his troops had a special resonance for fliers like my father. It never seems to have occurred to any of them that there was, or could be, anything ignoble about *their* war—and it was the sheer ignobility of the trenches, a dreadful waste and sordidness lit by comradeship and intermittent flashes of courage and determination, that provided the theme for most of the serious writing on both sides of the trenches in 1914–18. There seems to have been no room for irony in the Royal Flying Corps. I could never, and still cannot, imagine my father sitting down with his mates in the squadron

mess and belting out one of those bitterly dissenting songs that were sung by men in the trenches, like the immortal "I Don't Want to Be a Soldier":

> *I don't want to be a soldier,*
> *I don't want to go to war,*
> *I'd much prefer to hang around*
> *The Piccadilly Underground,*
> *A-livin' on the earnings of a whore:*
> *I don't want a bayonet up my arse-hole,*
> *I don't want my ballocks shot away:*
> *I'd rather stay in England,*
> *In merry, merry England,*
> *And fuck my bloody life away.*

Quite simply, Dad loved flying and could not be denied his relentless passion. I am told that he mocked the patriotic imagery of the Knights of the Air, believing (correctly) that its use as propaganda was kitsch, a German-American invention; and yet on some level he strongly, if tacitly, believed that the air war offered him a nobility that could come from no other source in the whole ghastly conflict. This kept him going, through the foulness and desolation. And when it was all over, when the last trench mortar had been fired and the last strafing run taken over the German lines, he could not share or even pretend to summon up the cheap jingo sentiment of the "maffickers," named after the ostentatiously patriotic louts and tarts who had gone wild in the streets after the relief of Mafeking during the Boer War: the civilians who had not fought and would never know what fighting had been like, but who celebrated a victory that was not really theirs. He wrote to his parents from his bed in London, having been temporarily brought down by the flu:

> *A quiet sigh of relief more than anything else expresses it. I was in bed with influenza on the famous Monday when the news came and it was not such a trial as one would have thought to miss all the wild celebration of victory. After the sorrows this war has brought us we cannot feel any inclination to join the mad crowd of "Maffikers" racing through the streets blowing penny trumpets and waving Union Jacks. Such wild irresponsible jubilation*

seems hopelessly out of place and even sacrilegious! It is hard to celebrate such a wonderful victory fittingly.

It does one good to hear the devils of Huns whining and howling for food. Any pity that one could feel for a fallen enemy is killed by the horrors they are inflicting on our wretched prisoners, turned loose without food or clothing to find their own way home!

At exactly the same time, his father in Australia, who to his distaste had found himself on the same street as another crowd celebrating the Armistice, refused to join their festivities—"I went home, rather than mix in the yelling 'mafficking' mob, full of shirkers." He could not have known the poetry of Wilfred Owen or Siegfried Sassoon—none was published until well after the Armistice—but he would certainly have recognized, without necessarily declaring it, the raging contempt Sassoon expressed in "Blighters" for the cackling jingoes in the London theaters of the day: "I'd like to see a Tank come down the stalls, / Lurching to rag-time tunes, or 'Home, Sweet Home,' / And there'd be no more jokes in Music-halls / To mock the riddled corpses round Bapaume."

The only people Dad despised more than Huns and noncombatant jingoes were the "traitor" Irish, for whom he shared every ounce of his father's detestation. The news of the Irish Republican rising at the Post Office in Dublin in 1916 filled him with disgust, which reached a rhetorical pitch in his letters home. He regarded Irish Catholic nationalists as a fifth column, as vermin, as scum; and like many another fighting volunteer, his loathing for those who opposed conscription and sided with the Mannix Catholics back in Australia had no limits. He raged against the Wobblies and all socialists in his letters home. "What a filthy crowd of black-hearted traitors those IWW"—International Workers of the World—"are," he wrote in 1916, from England. "I would like to get some of the swine out here & show them what Australia's fate could have been and may yet be if those animals were to have their way." And again, the next year:

I know that the best and finest of the Irish race are fighting today for our common cause . . . But the sad fact is that of the rest of their people the great majority today are bitter, bigoted and disloyal. This is a hard & bitter thing for a man of Irish descent to admit but it is absolutely, undeniably true. . . . To me it is nothing short of criminal for any priest to use the influ-

ence that has come to him through his spiritual office to sway the minds of ignorant people. . . . The priests in Australia who have been doing this have done more harm to the cause of Catholicity in Australia than the bitterest Orangeman could ever do. . . . If I can help it I will never speak to or associate with any man who has shown black treachery and done his best to betray my own dear brother and thousands of others.

The Hughes escutcheon did, however, have a blot of its very own, in the form of Dad's cousin John Hughes, the nephew of his father Sir Thomas. When I was small I became aware that this person was a genuine black sheep, not to be asked about too inquisitively, never to be joked about: a virulent strain of vice in the midst of so much familial virtue. Naturally I was fascinated by the thought of him but he turned out, alas, not to be any kind of a monster, just a con man. But his uncle Sir Thomas was almost as horrified by him as he might have been by a nephew who was a murderer. He had bilked various acquaintances of amounts totaling 5,088 pounds, all done by trading, so to speak, on the Hughes name. It seems that he was that most commonplace of Australians, a loser at gambling, an addict. The horses ruled him. "Australia is too hot for him," wrote Bappa to Geoffrey, who was still in England, in 1919,

and for the good of his health he has cleared out . . . The things he has done to get the money do not bear repetition . . . I advised him to get out of the country at once, and to stop out of it. The first boat was the Runic from Melbourne to London via Panama, which was to leave on 21st December . . . Our one great regret was that he could not have been dumped in Vancouver to earn his bread by the sweat of his brow instead of traveling luxuriously to London where he will be a danger and a disgrace to everyone he meets. . . . The things John has done here put him outside the pale of decent people. I am desperately sorry to have to say this of my brother's son, but it is the truth. He has not only swallowed up his share in his father's estate, but he has beggared his own wife . . . Nothing he says can be trusted, and he is simply an accomplished swindler, with only one end ahead of him unless we still live in the age of miracles. Let nothing he says or does deceive you, and on no account have any money dealings or allow your friends to have any with him, and lastly for the sake of the name you bear, don't introduce him to people, because he will prey on them. I am extremely sorry to think he is

going to England because he will befoul his father's name amongst the Australian colony there. America would be the best place for him . . .

To which Dad rejoined, "The whole story is so sordid and shameful that I can scarcely believe it. It is hateful to think that such noble characters as our beloved Roger should be dead, while another has lived to bring shame and disgrace on the name they were so proud of."

The war, it seems, defined our family. The War, the War, that was what it was called throughout my childhood and adolescence, so long after it had ended and another had begun: the Great War, capital G capital W, as if there had been no other.

And that was in a sense true: there had been no other like it. Though it was fought so far from Australia, young Australians went to it in extraordinary numbers. Ghastly as World War II was, it was also justified: Hitler had to be stopped, and his defeat did save the human race from unimaginably worse slaughters. No such historical necessity excused the deaths of the millions of boys in 1914–18. Because of the killing by a Serbian terrorist of an Austrian archduke whose life wasn't worth a jackeroo's finger, because of the ineptitude of Europe's civil and military leaders and the indifference of old men to the fate of the young, they were sucked into the immense vortex of the most vilely useless mass conflict in modern history; the conflict, in fact, that initiated "modernity" itself, the great chasm that split the two sides of historical understanding. They were impartially slaughtered, and for nothing: a flag, an anthem, a speech stuffed with stale exhortations. They were brave and innocent, cheerful and loyal to Britain, and they were massacred for their bad mother. They "walked eye-deep in hell, believing in old men's lies," wrote Ezra Pound, and

> *There died a myriad,*
> *And of the best, among them,*
> *For an old bitch gone in the teeth,*
> *For a botched civilization,*
>
> *Charm, smiling at the good mouth,*
> *Quick eyes gone under earth's lid . . .*

I am told that more Australians died in World War I, per head of male civilian population, than the young nationals of any other country, and I can

well believe it. Sixty thousand dead, out of a population of five million. Every country town had and still has its war memorial, recording the names of the dead, surmounted by a bronze (or in the small-town economy version, cast cement) statue of a handsome boy in puttees, at the charge, his Lee-Enfield .303 with bayonet fixed. The names of the war's battle sites—Ypres, the Somme, Passchendaele, Verdun, and, for Australians especially, Gallipoli—would define our very conception of history, even of selfhood. The coercive rhetoric of ruthless old men (and younger ones, too, like Winston Churchill) left no room for dissent.

We Hugheses were among the many who believed every word of it.

The War, the unique War, continued to permeate our lives with its memories or, if we were too young to remember it, with its looming presence as heroic ideology and with the physical traces that cluttered the house at 26 Cranbrook Road, Rose Bay. My mother simply called it the War; its successor, World War II, was known as The Last War.

The house had many souvenirs of wartime mingling with the religious objects and ex-votos within. The God stuff was vulgar *bondieuserie,* except for a few old and meticulously, freshly colored Arundel prints made after paintings by Raphael and others. The war stuff was a different matter.

There were shells, not from the seashore, but from Flanders, some of the smaller ones unexploded and, I was sternly warned, likely to go off if I played with them. I foolishly ignored this, out of a child's hubristic curiosity, and I think the luckiest escape of my life up to now was not that I survived that road accident in Western Australia. It was when I put one of these rounds of ammo, a small one whose brass casing was about an inch in diameter, in a vise in the garage and drilled into it to see what it contained. It held stuff like gray pencil lead: cordite, undoubtedly as unstable from age as an explosive can be. By the merest luck it did not explode and blind or decapitate me.

The house had twisted lumps of shrapnel as paperweights (and what would one of those have done to your childish flesh?). It had training posters in grainy oak frames that once hung in the squadron mess. One showed a Camel in close-up, pilot unconcerned, the Boche pilot closing in on him out of the solar glare behind: BEWARE OF THE HUN IN THE SUN. Another, which I possess, warned pilots against triumphal stunts that might expose unnoticed damage to their planes: entitled "The Last Loop," it shows a German triplane going into its death spin but, above it, the English victor's SE5A

going down as well, its weakened tail unit sheared off. And in the playroom, where the ping-pong table was and where I spent hour on hour with school friends polishing my deadly backspin with those now long-obsolete plywood bats, obverse face in thin red-pimpled rubber, reverse in sandpaper, there were three relics.

The first was the rudder of the biplane Dad had flown against the Boche in 1918, his Bristol SE5, the browny-gray fabric rubbed and dinged but otherwise intact, which he had lugged all the way back from France.

The second was the highly varnished hub of a laminated wooden propeller, whose center had been hollowed out and now held ping-pong balls.

The third, and most poignant, was a strut from his Bristol Fighter, brutally gouged and nearly cut in half by a bullet from, he believed, the 7.62 mm. Spandau of the red Fokker triplane flown by none other than Manfred von Richthofen, the Red Baron himself, during an engagement with the Flying Circus over France. Later an English war artist did a watercolor of this duel in the sky. Like doubting Thomas pushing his hand into Christ's wound, I would finger that splintery slash and reflect that, if it had gone a quarter inch or so to the left (so tiny a deflection in so vast a French sky!) the wings would have folded and I would not exist. And what would it be like not to be, to not-exist? A chilling philosophical problem for a ten-year-old. I mulled it over endlessly, even obsessively, but found no answer. If that had happened, none of us would have existed. Except my mother, who would have, but in ignorance that Dad had ever lived.

My mother was the daughter of a C. of E. rector, Margaret Sealey Vidal (1899–1963), teenage spinster, of Barnsley: a tall, bony beauty with red hair and greenish hazel eyes. Lanky and, even then, morose (for years after Dad's death, in 1951, she would succumb to terrible fits of menopausal despair, her "turns"), she would have made quite a model, if there had been models in those days. She had an unpretty older sister, Mary, a.k.a. my adored Aunty Mim, who lacked any kind of glamour and was to play a very large part in my childhood—larger in some respects than Mum's.

Mum and Dad had met at a squadron dance—Barnsley was 62 Squadron's English base—and fallen gradually in love. It was not one of those lightning courtships in which the boy concentrated exclusively on the girl. He felt obliged, being a gentleman, to court the entire family, including Mum's

mother, who wrote to my grandmother in October of 1917 in Australia expressing her liking and admiration for him:

> *He is just one of the finest characters we have ever met and we all simply love him. He is old for his age and I fancy the death of his brother must have aged him considerably . . . he very often sits in front of the fire on the floor and then we all talk and he says it's the bit of home that he does so love. I wish you could see him flying. He is quite wonderful but he never does anything reckless. He drops notes to say whether he is able to come to us, or not, and we all rush out into the garden directly we hear his engine. The British Fighter is very noisy, but he seems able to manage it quite easily. . . . We have two girls, one Mary is driving an RFC tender at Netheravon on Salisburg Plain. Margaret who was 18 on Octr. 5th . . . was to have gone to Oxford, and there work for a History degree, but that is all stopped and she felt she must do her little bit.*

My mother was never to receive a university education. The Vidals would entertain my father, and sometimes other young airmen from the base, with parties at the rectory, where they would dance to the sounds of cylindrical records played on a wind-up horn Victrola and play after-dinner games like "Sardines," which ended up with everyone crowded and trying to hold their breath in a cupboard.

Sometimes they would all meet in London for evenings at the theater. When Mum and Dad were more on their own in the country he wooed her, not that she needed much wooing by then, by taking her for bone-dissolving fast runs on his 1916 Harley-Davidson, and by flying his biplane over the rectory (later the home of the English TV gardening guru Rosemary Verey) and dropping mash notes in a weighted message-sock onto the lawn, good practice for the runs with antipersonnel bombs he would sometimes make on the enemy trenches. (His Bristol Fighter carried 240 pounds of these squibs in racks on either side of the rear cockpit, where the observer sat, dropping them by hand.) My future mother, who had been hearing (from others, only rarely from him) about his military exploits, must have felt almost paralyzed with incipiently sexual delight: it was like being visited by the crew of a lunar module, only much more so. How many of the girls she would have known in Barnsley had beaux with both a motorbike *and* a plane?

She was Church of England. He was Irish Catholic. Australian Irish Catholics, especially ones named Hughes, and most especially ones who descended from John Hughes, merchant and migrant, did not "convert," and they did not make "mixed marriages." That was laid down precisely and eternally in the molecular structure of the known universe, and Dad was not about to get mixed up in some cockamamy effort to change it. So it was Mum who converted. I never had the impression that she was religious by nature, and so the switch cannot have cost her too much sleep. She wanted her man.

Her clergyman father did not object, partly because he seems to have been a pleasantly tolerant and studious man, not some Low Church anti-Catholic bigot, and perhaps partly, too, because his prospective son-in-law was Australian and most Englishmen in the nineteen-teens took it for granted that any Australian, particularly one with such a war record, was likely to be land rich, the master of (or heir presumptive to) hundreds of thousands of acres of outback, every one crawling with merino sheep. That was what Australians did: they slew Boches and Turks in hecatombs, cracked their stock whips, charged up hills on foot or horseback in the face of fearful odds, inherited vast tracts of continent and carried your virgin roses off to honorable matrimony in places with absurd names like Windibindipindi Creek. I don't know if Grandfather Vidal, who died before I was born, believed this, but I suspect he may have; if so, he would have been disappointed. I hope my mother didn't, because the long voyage on the P&O liner took her to a far more modest place. She disembarked in Sydney in 1923, and they were married almost immediately. She made a very pretty bride, and the Sydney papers reported the event in some detail: Mum wore "a picture gown of ivory white charmeuse embroidered in opalescent beads and pearls, showing at each side panels of exquisite lace. The train of brocaded ninon on velvet was mounted on pale pink and finished with lace butterflies, and a beautiful veil of old Carrickmacross lace (lent by Lady Hughes) was held in place by a crown of white heather and pearls."

Dad was not a country boy. On the contrary, he was a young city lawyer, and since he was temperamentally incapable of boasting about anything, I doubt that, in England, he could have even fractionally misled my mother about who he was or what he did in civilian life. He loved the bush but only as a place to visit, and he couldn't have shorn a sheep if his life depended on it, which, luckily for Mum and for us, it did not. Once the two of them were

securely hitched in St. Canice's—a neo-Gothic pile paid for by great-grandfather John Hughes, featuring stained-glass windows that depicted dead Hugheses, Roger conspicuous among them, kneeling in knightly style before the throne of the Lord—they settled down in Sydney to the production of a medium-sized family: Tom in 1924, Constance in 1926, Geoffrey in 1928, and then, after a decade-long gap, me in 1938.

I do not know why I arrived so late; it can't have been continence; I assume that a condom, forbidden to Catholics under the Church's draconic anticontraception teachings, sprung a leak one balmy early-summer night in November 1937, as randy flying foxes gamboled in the Sydney air. Or perhaps they were too anxious to get at one another and forgot to put the rubber on. I suspect that, despite their piety, they used these awkward devices. Why do I think so? Because decades later, well after Dad's death, my mother (in the course of one of her unscheduled searches of my room) found an unused French letter under some papers in a desk drawer, and shrieked imprecations at me for having this "filthy thing." But how, I wondered at the time and occasionally wonder still, did she know it was filthy if she didn't already know what it was? A rolled-up tube of gossamer-thin rubber with a funny little teat on the end: it might have had something to do with a model aeroplane. (As a matter of fact, non-Catholic aeromodellers in the East Coast Flying Club, which I joined and whose meets in Centennial Park I would attend as often as possible, did use condoms to prevent leakage from their planes' tiny fuel tanks. We Catholics used regular balloons.) And how (since it would have been unthinkable to go to bed with another man either before or after Dad was dead) would she have known what it was unless they had actually used a condom now and then?

Even though the war was over, Dad's flying days were not. He helped start a club for civil aviation, the Royal Aero Club of Sydney, and served for a decade or more as its president. It wasn't military, but most of its members were ex-pilots from the war, men who had caught the flying bug and hoped never to be deprived of the joy and thrills of flight. It played a large role in the founding of Australia's renowned airline Qantas (whose name lacked a "u" after the "q" because it was actually an acronym commemorating its first uses as a pioneering mail outfit: the Queensland and Northern Territory Aerial Services). It also had an obvious use as a training ground for future military pilots, should they be needed (as indeed they were) in some future

conflict. Hitler did something similar, by having Reichsmarschall Hermann Göring set up gliding clubs for pilot training all over Germany in the late twenties and thirties.

His aeronaut friends flew all over Australia to publicize the novel idea of airmail, taking sacks of letters to places that previously had only received them by train or even by camel. This delivery system to remote and godforsaken places, all red dust and termite mounds, started with a couple of rachitic war-surplus DH4 biplanes. But they began to take on passengers, and then the idea grew. Most of the work was done by others, such as Sir Hudson Fysh, but Dad loved civil aviation. He did not live to see it grow to its present enormous size, and he had already lost interest in it by the time he died, partly because he was too busy with law and family. But his biggest gesture in that direction was to have had Jesus Christ, no ordinary Australian, as its passenger. It was the Eucharistic Flight, by which he managed to bring together the twin major themes of his life, religion and aviation.

It happened at the Twenty-ninth International Eucharistic Congress, which took place in Sydney in September 1928. Without the idea of Eucharist, that of Christianity has diminished meaning. The Eucharist is a symbolic representation, a restaging, of the last supper at which Jesus Christ ate and drank with his disciples before he was seized and crucified. This has always been perceived by Catholics as the very core of their belief and ceremony—in effect, the moment at which the Catholic Church was instituted through its sacraments, specifically the sacrament of Communion, in which Christ changed the bread and wine into his own body and blood and distributed both among his disciples for them to eat and drink. The Last Supper was also the first Mass, in which he blessed the bread, broke it, and shared it out. "Do this in memory of me," he instructed the apostles and all coming generations of priests, exhorting them to this rite of sacred cannibalism. "From the Church's earliest days," wrote the historian Diarmaid MacCulloch in his masterwork of church history, *The Reformation*, "it has been a way to break down the barrier between the physical and the spiritual, between earth and heaven, death and life." Although the offering of consecrated wine to the faithful went out of use in medieval times, it is important to remember that, for Catholics, this disc of unleavened bread was not merely a *symbol* of Christ's body; we were all required to believe that it was the body itself, and worthy of the same veneration.

A Eucharistic Congress was an enormous Catholic jamboree, only rarely held. Essentially its purpose was propaganda: the whole Catholic population of a country would come together, pray, march, and in general make dignified whoopee in honor of its common religious symbol, the Eucharist or Consecrated Host, which had been transformed (so Catholics were required to believe) into the holy body and blood of Jesus Christ. Christ having instituted the Catholic Church at his "eucharistic meal," low Masses, high Masses, solemn pontifical Masses, benedictions, processions, all converged on one single end. Theoretically, at least, a Eucharistic Congress—there had never been one in Australia before—was *the* big opportunity, especially in those far-gone days before TV, for Catholics to demonstrate their identity against all other creeds.

And this had special weight in early thirties Australia. A rivalry existed then between Catholic and Protestant that today, seventy-five years later, has softened to the merest shadow.

The ancient tension between rock-choppers (Catholics) and Anglos was fed by only barely subliminal memories of the convict system, with its Irish prisoners and English guards; such factors lent the very idea of a public Eucharistic Congress an inscription of rivalry and assertiveness that no longer exists.

But despite the Hughes family's relatively high social rank, we could be as partisan and intolerant about religion as any other colonial clan. Weren't we church-builders, after all? Hadn't Great-grandfather John, that pious Irishman, given his enormous waterfront house at Elizabeth Bay to the Church, and even imported the Sisters of the Sacred Heart to fill it? Hadn't he done the same with a giant slice of the foreshore of Rose Bay, and built St. Canice's below King's Cross with, more or less, the spare change? Dad was determined to give this partisanship wings, in a curiously literal way.

So he approached the archbishop. It seems that originally he explained his wish to create a memorable gesture in the *propaganda fidei*, the propagation of the faith, by assembling a Eucharistic Flight, made of several planes from the Royal Aero Club, flown by Catholic pilots. In one of these planes would be a priest, and in this priest's hands would be a consecrated Host, Christ's incarnate presence. The Flight would fly—in the formation of a cross, naturally—back and forth over Sydney Harbour and the city, fairly low so that it could be seen and heard distinctly. It would demonstrate the triumph

of Christ over the sea and land of our country. I imagine Dad warming to his theme: pointing out to His Eminence what an effect this could have among the earthbound Australians, since aviation was as yet a novelty in our country and very few of its citizens had gone up in an airplane. That Jesus Christ should do so could well form a fitting climax to the Eucharistic ceremonies, and no one on the ground, Catholic, Protestant, or even Jew, would soon forget it.

The archbishop was not, apparently, convinced. By theological definition, the altitude of God was infinite. Why show Him Sydney Harbour, which He had created and watched over since the beginning of time anyway, from a mere two thousand feet?

Aha, I imagine Dad replying, but it may be that Your Eminence has perhaps not quite fully grasped the entire point. The object of the Eucharistic Flight would not be to show Sydney Harbour to God, which even Blind Freddie (not that Dad would have used such a vulgarism in addressing a high figure of the Church) could indeed see was unnecessary, not to say supererogatory, but rather the reverse: to show God to Sydney Harbour. And to its inhabitants, which might at least tend to the conversion of at least some of the Prots among them, though of course that was hardly guaranteed.

Thus I imagine the argument going back and forth, in a genteel way, like a very slow game of theological badminton—lob, volley, lob, volley—heading toward an inevitable conclusion in which even my father's epic stubbornness had to lose to the needs of doctrine. Airplanes were imperfectly safe, whatever Dad might say. And suppose—only suppose—the plane he was piloting, with a priest in it and a consecrated Host in the priest's hands, were to crash on the land or have to do a forced landing on the harbor. What then? Would this not put a damper on the festivities of the sacred spectacle? Better, far better, to have the sacred Host carried across the harbor on board a boat, by no less exalted a figure than the papal legate, Cardinal Cerretti, who would have come out from Rome for this occasion.

And so it was done. The chosen boat was a ferry, the *Burra-Bra*. She was painted white from stem to stern, with a broad yellow band below her gunwale—yellow and white being the papal colors—and a tall white cross, which oscillated violently in the harbor chop, was secured to her funnel. She was crammed with church dignitaries, headed by the papal legate. It was the last day of the Eucharistic Congress, September 9, 1928. The consecrated

Host, enclosed in a large gold monstrance, was displayed on an improvised altar before the funnel. As she moved out from the ferry wharf at Manly there was a roar and a whirring in the sky and five biplanes—the modified Eucharistic Flight, led by my father—made their appearance. First they flew in formation as the Southern Cross. Then they shifted into a crucifix formation and flew up and down the harbor. The reporters of *The Catholic Press* (September 13, 1928) were already moved to ecstasy by the appearance of the *Burra-Bra* and the crowd of boats around her: the sight was "too terribly intimate, too next to one's heart, too vibrant with a million poignant pangs of passion and love: it was cosmic, inexpressible." But with the appearance of the Eucharistic Flight, all reserve was abandoned. "Brilliant, shining things they were, like stars wrested from the firmament. As they swung around into the east, they scintillated as the planets, all their configuration lost, embodied in a blaze of glory reflected from the evening sun slipping down into the west. Round and round they flew in graceful gyrations, as the procession proceeded, adding to it a touch that some at first thought was accident, but very soon saw was design."

Whether the Eucharistic Flight converted any unbelievers, I do not know. Probably not. But it certainly made headlines and at least the press didn't satirize it—as they would, and mercilessly, today. More curiously, it fulfilled a prophetic poem that my father, who had only a few words of French, had certainly never heard of, let alone read. This was "Zone," written some twenty years before by the great modernist poet Guillaume Apollinaire. Starting with an emblematic glimpse of two Blériot-period aircraft, one red and the other black, battling in the sky above Paris ("two airplanes struggled for my soul"), Apollinaire wove a magical central vision of Christ, in his resurrection, as the Original Aviator:

> *C'est Dieu qui meurt le vendredi et ressuscite le dimanche,*
>
> *C'est le Christ qui monte au ciel mieux que les aviateurs*
> *Il détient le record du monde pour la hauteur*
>
> *Pupille Christ de l'oeil,*
> *Vingtième pupille des siècles il sait y faire*
> *Et change en oiseau ce siècle comme Jésus monte dans l'air.*
>
> *It's God who dies on Friday and rises on Sunday,*

It's Christ who climbs into the sky better than the aviators
He breaks the world's altitude record,

Christ, pupil of the eye,
Twentieth pupil of the centuries he knows how it's done
And turns into a bird this century like Jesus rises in the air.

To me these lines, which I would not encounter until after Dad's death, when a Jesuit at boarding school lent me a copy of Roger Shattuck's parallel translation of Apollinaire's poems, are still exquisitely beautiful and mysterious: they seem to contain all the millenarian promise and the magical freshness, later sullied and betrayed, of early modernism. More important, they connect that promise and freshness to my lost father, though he would likely have disapproved of the poem, as he apparently did of most kinds of cultural modernism. You might say that Dad, in his ambiguous love of war and his passion for new technology, was a Futurist without the more obnoxious fantasies of Futurist culture: he didn't want to burn the museums, like Marinetti, because he would have regarded such an act as one of sacrilegious barbarism.

Dad was rewarded for this public exhibition of faith and, I suppose, for his general conspicuousness as a Catholic layman, with an honor from the Vatican of which he was extremely proud. One day a stout, gilt-edged engraved card, swathed in a vellum envelope of crackling thickness, was delivered to the house. What did this portentous missive say? That in light of his services to the One, Holy, Roman, Catholic and Apostolic Church, the Pope, Pius XI by now, was pleased to elevate G.E.F. Hughes of Sydney, Australia, to the dignity of a *Cameriere Segreto di Spada e Cappa*, or "Confidential Chamberlain of the Sword and Cape." He was required to have made for him (by a specified ecclesiastical tailor in Rome, who no doubt had good connections in the Vatican corridors) four elaborate uniforms, with capes, frogging, and swallowtail coats, each a different color and looking as though it had been designed by Oliver Messel for an opera buffa about Garibaldi and the Thousand. When the reigning Pope died, Dad was expected to come to Rome and take up a station in some corridor of papal power, looking reverent and military. But there were no other designated occasions on which Dad could wear his uniforms, which were very expensive as well as somewhat ridiculous in appearance. Unfortunately, World War II broke out before

February 1939, when Achille Ratti, who had been elected Pope Pius XI seventeen years before, died; and by then it was obviously not feasible for Dad to undertake his trip to Rome with all his finery. Eugenio Pacelli then took the papacy and unfortunately, as Pope Pius XII, lived on until October 1958, thus far outlasting my father, who died in 1951. Thus Dad never had a chance to wear his Risorgimento uniforms, which must have grieved him somewhat, elaborate as they were.

The combination of Dad's illnesses with my disappearance to boarding school in the last year of his life meant that I had far less contact with him than Australian boys were normally supposed to with their fathers. It had the unhappy result that I remember some of his admonitions and punishments, but none of our conversations. Did we have any, in private? I suppose so, but I have no idea what they were. Little boys were expected, when the talk was flowing at the dinner table, to wait their turn and not butt in, and I had two elder brothers as well to repress my interruptions.

But of course Dad and I spent time together. The medium through which we connected was airplanes.

Having been grounded in 1939 he had wanted to enlist again, but the RAAF wouldn't accept him for combat duty because of his age (forty-five) and ill health. But it would have been folly not to use the accumulated experience of such a man, and so he was posted in 1941 to run a flight-training center in a remote part of New South Wales called Narrandera.

This outback town was where my infancy was spent, and I have practically no memories of it. I do remember, as in a freeze-frame from a movie, a yellow Tiger Moth (the RAAF's biplane trainer then) looping the loop in a blue sky, glittering at the top of its arc. I remember a swimming pool filled by artesian water, and the *chunka-chunka-chakka* of sprinklers defending my mother's garden against the brutal dryness of summer heat.

Presently, in any case, we were back in Sydney where, to my near-hysterical excitement (I suppose I was four by then) we were at least notionally touched by World War II. A colossal hoo-ha was caused on the night of May 31, 1942, by a trio of Japanese midget submarines that sneaked into the harbor past its defensive boom and bravely (or, as one was required to think, "fanatically") attacked the Pacific fleet, some of which was at anchor. One of them aimed at an American warship, the cruiser *Chicago*, but its only torpedo missed entirely and blew up a depot ship, the *Kuttabul*, which was moored at

the naval base of Garden Island. It sank with twenty-one Australian naval officers and ratings onboard. The second sub may have been meant to head up-harbor and attack an oil tanker, but its skipper got his directions confused and was sunk. The third Japanese midget somehow escaped through the Heads into the open sea, where its fate was unrecorded. This was the only time Sydney ever came under enemy attack in World War II. Australians all agreed it was the most filthy, spiteful, and treacherous piece of Oriental cowardice since Pearl Harbor. Yellow in skin, yellow in battle, the stinking little bowlegged, seaweed-munching, blowfish-eating, pebble-lensed, hissing subservient rat bastards. Underneath this rhetoric ran an unpleasant current of pure shock—no one had expected that the Japanese could deliver a blow to Australia so far south. Since white Australians were already well and truly inoculated against tolerance of the Orient, the attack on Sydney, weak as it was, provoked an ill-concealed mood of panic. Multiculturalism, in Australia, started with quite a few strikes against it. As well it might, given what the Japanese did to Australian prisoners of war. It was a weird and unexpected turn of fortune that, in later years, I came to love the art and admire the traditional culture of Japan as much as I do. But "traditional culture" isn't all *sumi-e*, tea ceremonies, and calligraphy practice on the moonwatching platform. It isn't all Hokusai, Jakuchu, Sen no Rikyu and the temples at Horyuji. Places like the Changi P.O.W. camp, loath as one may be to admit it, were extensions of that culture (tea was at root a samurai thing, and the Japanese samurai ethic has never been inclined to regard the defeated as fully human), and I have not lost the feeling that in Hiroshima and Nagasaki the Japanese did in a sense get what they deserved, dreadful though it was and innocent as they individually were. Once the Manhattan Project had succeeded and Americans had the A-bomb, it was inconceivable that such a weapon would not be used to force the Japanese surrender. There can be little doubt that vastly more lives, Japanese but especially American, would have been destroyed if the Allies had had to invade and then fight their way, house to house, against desperate and suicidally obstinate resistance, along the island chain of Nippon. What would I have thought if my father, like Clive James's, had been in Changi and died there? It's easy for people who have not been in a war to preach, and I have never been in a war. But that was the beauty of Australia in, say, 1950. No invasion, or not since we whites invaded the Aborigines, which wasn't "invasion" but "discovery." No con-

flict, since we killed them off, beat them down and legislated them out of civil existence. No foreign domination, since we weren't foreigners but (proudly, all together now) Australians. A womb with a view, in Cyril Connolly's phrase—admittedly, a huge womb and a very, very limited view. We had taught ourselves to believe that our origins, as Australians, were entirely peaceful—a lie. We thought of Australia itself as an inviolate womb or haven; of war, as something that happened in other countries and to other peoples. This would deeply and crucially shape our sense of country, of society, and of self. It underwrote the deep conservatism in whose midst I, like all other Australian children of the middle class, would enter the task of growing up in the 1950s. And just as it ensured that most Australians, believing that their country was the blessed exception to the world's complicated and marred history, would prefer to stay within its borders, so it all but guaranteed that I would become an "expat."

A Sydney Childhood

I am unsure what my earliest recoverable memory is, but the one I keep coming up with isn't at all happy. I am rather ashamed of it and I wish I weren't stuck with it. It is not one of joy (the Blakean child dancing, as it were, in the light of innocence) but rather of jealousy and manipulation. Jealousy, moreover, directed against someone I do not know, had never seen before, and cannot remember now.

It is some time late in World War II. I know the time, roughly, because the seascape before me—the calm blue surface of Rose Bay, a lobe of Sydney Harbor—is punctuated by the silver and tan bodies of flying boats, the American-made, twin-engine, high-wing reconnaissance aircraft known as PBY Catalinas, which, along with the stubbier and less stylishly graceful British Sunderlands, were the chief avifauna of wartime coastal Australia. They all carry military insignia—RAF roundels, USAF stars. So there is still a war on. This must mean I am less than seven years old.

I am walking with my doting and reciprocally adored Aunt Mim (Mary Constance Sealey Vidal, once of Barnsley in England). I remember her at this moment as shapeless and ageless, although, since she had been born in 1895, she could only have been in her forties. We are on a chipped and eroded concrete promenade that followed—and still does follow—the curve of the bay, some ten feet above sea level. Aunt Mim and I often used to walk there. My mother and I never did. These small excursions along the Rose Bay waterfront had created a deep bond between Mim and myself. Sometimes I would deepen it by insisting that we go down one of the flights of steps that

led to the beach at the tide mark, where I would gingerly pick up some odd-looking marine growth—a clump of seaweed, a cloudily translucent jelly-fish—on a slat of driftwood, and waggle it at her, to her feigned horror.

The Australian light can be very intense. It throws great sharp images of blackness, surrounded by stark flat light. Things look like silhouettes of dark cardboard and loom up with a surprising intensity. So it was with a shape immediately in front of us on the promenade. It was the old-fashioned sort of baby carriage that one never sees anymore: high-sided, tall on its wheels, impossible to see into unless you got up close and peered over the side, and black as a bat, a blot on wheels, with a folding mackintosh top that could be spread out at the first premonitory *splat* of Australian rain. Aunt Mim, being tall, had no difficulty seeing inside it. And what she saw clearly delighted her. Did she let go of my hand? I seem to remember a gesture of abandonment. Or perhaps she was not holding it to begin with, which may be so, since I didn't really want to look like a little boy being led along by a grown-up. In any case, she broke off our conversation, sprang forward, and gazed down into the enormous pram with what I remember was a look of rapture. She began to talk, animatedly, with the nurse who was pushing it. How sweet, isn't he a darling, how old is he, and so on and so forth: the language of auto-matic love. I, too, stepped forward and peeped into the baby carriage. What did I see? A gorgon? A cyclops? Not at all. A perfectly ordinary Australian baby boy in a knitted cardigan, goo-gooing and blowing bubbles of saliva and clenching its adorable, dimpled little fists.

In that moment I was flooded, almost convulsed, with hatred and jealousy. I had never felt such hostility to any living human being—not to Adolf Hitler, whose caricatured image stared at me each day from a dozen cartoons and placards; not even to Tojo, the dreaded Japanese warlord, who (I was old enough to understand, without knowing the why of it) dreamed only of dis-embowelling me and my sister, Constance, with his long sharp Japanese sword. (I had often wondered what that would feel like; my father had a razor, which he would strop energetically each morning, and whose edge I once experimentally touched with the tip of my index finger, but although it hurt in a small nicking kind of way it was obviously not to be compared to what Tojo could make me feel if he rose, deadly sinister and bowlegged in his puttees, half-blind but all-seeing, from a cartoon in the morning *Tele-*

graph and whipped out his glittering *katana*.) In this fit of five-year-old mad-
ness I honestly believed that Aunt Mim was deserting me, her previous dar-
ling, the apple of her eye, for a totally unknown baby. My mother was
remote from me, my father away at the war, and my siblings started at ten
years older than I and went up from there, so we were not really in competi-
tion for anyone's love. A gulf now opened before my feet, right there in the
cracked concrete of the Rose Bay promenade, and I could see an illimitable
loneliness at the bottom of it. Or perhaps there was no bottom: all I was see-
ing was the surface of solitude, and God alone knew what depths lay beneath
it. For a few seconds I glimpsed the solipsism, the grotesque feeling of being
the only sentient being in the world, that makes some children into needy,
unfulfilled tyrants.

People who imagine that childhood is a state of prelapsarian innocence do
not know children well. At root, small children are burning balls of jealousy
and insecurity. Remove the thin veneer of "socialization" and you see a
monster, a little mass of pure id and unslaked desire.

Somehow I had to distract Aunt Mim from this threat of competition. So I
began to cry. Mere blubbering would not do. I bawled and shrieked, I impre-
cated the heavens; they could probably have heard me across the bay on the
flying boats. Mim looked at me with incomprehension; the baby's nanny,
with disgust. *Spoilt little bugger,* you could have heard her thinking. It was a
revolting performance, but it worked. My embarrassed aunt, apologizing to
the offended nanny, dragged me away. I went passively, sensing victory. Up
the hill we went, to Marsland.

I wish I could claim that "Marsland," the name assigned to the house Dad
built for his family at 26 Cranbrook Road, Rose Bay, was furnished through-
out with English antiques and hung with original works of art that fed the
imagination of the budding esthete, but this was not entirely true. My
mother, sailing from Portsmouth to meet her fiancé in Australia, had gone on
board with a quantity of old furniture and knickknacks crated and shipped
securely in the hold of a P&O liner. Some of these I inherited and still have:
a Chippendale-pattern mahogany highboy from about 1760, a handsome
banded walnut chest of drawers with all its William and Mary veneer intact,

several George III cabriole-leg dining-room chairs with scrolled and pierced splats. Others went to other siblings, including the object I desired most and still miss—a Georgian sofa with a humped back, like a camel upholstered in canary-yellow damask, on which at the age of five or so I would scramble and ride pretending to be the Sheikh of Araby on his Ship of the Desert. I was so ignorant about such things—what kid is not?—that I simply assumed that every solicitor's house in Australia was furnished with objects like these. Perhaps some were.

There were other and smaller things, reposing in a glass-topped cabinet lined with faded green watered silk. A couple of miniatures of eighteenth-century forebears whose names I did not know. A tortoiseshell patch-box, inlaid with a silver monogram. And a small, fascinating weapon—a *breloque*, or working pistol, no longer than an inch, its silver butt delicately engraved with twining lines, which fired the tiniest of balls from diminutive cartridges. It must have been made in the nineteenth century. Because it was a "pinfire"—a spring-loaded hammer snapped down on a pin that stuck from the top of the cartridge through a slot in the breech—one could not replace its long-obsolete ammunition, all of which I used up when there was no one around to hear its sharp, and surprisingly loud, *crack*. One of its balls is still lodged, nearly sixty years later, in my right thumb. I could not see a doctor about it because that would have provoked an enquiry—there were no secrets about me between the family MD and my elders, they heard about every rash, pimple, and nocturnal emission—but in years to come, when I heard or read about veterans carrying unremoveable pieces of shrapnel lodged in their bodies, I thought I had some idea what that meant.

The sole valuable object amid this small clutter, it eventually turned out—we discovered the fact some years after my mother died—was the ugliest: a teapot, made in rough salt glaze by some folk potter who wished to commemorate Bonnie Prince Charlie, the young pretender to what had once been the independent throne of Scotland. It was painted with a red plaid pattern—the Prince's tartan, I was told—and its side bore a crude portrait of him, looking like a generic teenager in a tam-o'-shanter. How this object became a family heirloom neither I nor anyone else in the Hughes family knew. We hadn't a drop of Scots blood in our collective veins. Squatting in the corner of a glass-doored wall cabinet, it was a complete enigma. But it

had a history one could connect with, after a fashion; I must have been about ten years old when the singing instructor at my school taught the class I was in to sing, or in my case screech, a patriotic Scots ditty that went:

> *Speed, bonny boat, like a bird on the wing:*
> *Onward! The sailors cry,*
> *Carry the lad that's born to be King*
> *Over the sea to Skye! . . .*
>
> *Burned are our homes, exile and death*
> *Scatter the loyal men;*
> *Yet ere the sword cool in the sheath,*
> *Charlie will come again. . . .*

We all believed that it was extremely rare and of great value, cracked and ill-mended though it was. It may well have been rare, for I have never seen a teapot like it since. And it proved to be quite valuable; long after our parents' deaths, some time in the late 1960s, we sent Bonnie Prince Charlie's teapot to auction in London where, it was optimistically hoped, the future King Charles III would buy it. He did not, but some other collector did, bidding it up to several thousand pounds, a sum duly shared out between three brothers and a sister. I do not remember what I did with my share of this modest windfall.

As for works of art, especially paintings, there were very few. Previous Hugheses had never tried to collect them. There was something foreign, boastful, about the idea of a "private collection." People in Australia tended not to buy old European paintings. It was assumed, no doubt correctly, that any scrap of canvas bearing an attribution to Guido Reni, still less Claude or Titian, that had made its way to Australia would be either wrongly attributed or an outright fake, sold to a gullible grandfather in distant London. In any case, there is little point in collecting things that, once on your walls and tables, won't impress your guests, and they won't be impressed by something they can't identify; it only makes them feel vaguely uncomfortable. Australia at the time had no experts on Anglo-European picture attribution whose word could possibly stand against the most casual opinion of one of those haughty boys at Sotheby's with their faces like silver teapots. It may have been, as a patriotic Irish–Australian historian once put it, that the dauntless

village Hampdens of Old England slept by the shores of Botany Bay, thanks to the iniquitous transportation laws that sent them there in chains, but it was quite certain that no budding English collectors did. So no local Old Families were likely to have real, or even fake, Old Masters in their attics or basements. (As a matter of sober architectural fact, there weren't many real attics by the shores of Botany Bay, either.)

Paintings served us, to the extent that they had any use at all, as emblems or weak totems of clan identity. Almost the only images on the walls of 26 Cranbrook Road, therefore, were portraits, usually childhood portraits hardly older than the 1880s. There were only four exceptions to this rule. Sometime in the late 1600s, an English artist, name unknown, had done a portrait of a remote ancestor of ours on the Vidal side. He looks Spanish, or possibly French (the name "Vidal" suggests, but does not prove, a Huguenot ancestry). This Mediterranean cast of features may only be dirty varnish. I do not know what he did. He looks prosperous, with that lace at his throat. The story in the family was that he had made money in brick kilns and then reinvested the profits in ships, some of which Cromwell had chartered from him for his invasion of Ireland. Being of Irish paternal descent, we were not particularly glad of this brief, and wholly undocumented, entry of our maternal-side forebear into history. It's true that there were some ships pitching and rolling on the dark-green sea behind this primitive ancestor in his patrician-looking clothes, but though one of them is flying a white British ensign, there is no further clue to its purpose.

The second exception was a painting everyone in the family called "the Cuyp," which hung over the fireplace in the library. We all supposed it was a work by the Dutch artist Albert Cuyp (1620–91), a disciple of Salomon van Ruysdael notable for his Italianate golden-glow landscapes of the countryside around Dordrecht. This was a "tradition in the family," with no evidence for it at all, although the golden glow (more discolored varnish than paint) gave it some plausibility if you only knew Cuyp's work in reproduction. I didn't like the picture very much; it was too mellow for my childish eye. I would have rather seen airplanes and jut-jawed Biggles in it than a dray and a peasant woman. In the sixties, "the Cuyp" was extracted from its mural frame and sent off to a London auction house for an expert opinion. The expert opinion said it was by some late seventeenth-century Dutch unknown but its condition was so bad that it wasn't worth auctioning. Then

the expert handlers managed to lose the picture anyway, and we never saw it again. So much for "the Cuyp."

In the hall was a bronze-painted plaster bust of Sir Thomas Hughes, moustache, chains of office, and all. It stood looking dark, immutable, and stern on a wooden column in the curve of the hall staircase. The real bronze is still in the Sydney Town Hall, commemorating his Lord Mayorality along with the effigies of other Edwardian and Victorian worthies.

The fourth exception was really worth having. At some point in his life, presumably in the 1880s, Grandfather Hughes had made the acquaintance of the best Australian painter of his generation, Arthur Streeton, who also lived in Sydney. How well the two men knew one another is uncertain. If any letters passed between them, none have survived in the family archives.

But Bappa had bought one picture from Streeton—a small thing the size of a sheet of quarto paper, done on the unprimed lid of a cedar box. Not a cigar box, as with other paintings by this father of Australian Impressionism, but another box, made in Germany rather than Havana, which bore, on its reverse, printed patterns. These offered themselves to be fret-sawed out into shapes which, with their tabs and slots, were meant to interlock as a *Ständer für Swedische Streicholzer*—a "holder for Swedish safety matches." With my growing mania for model-making of any and every kind, I wondered how the parts, once sawn out, would actually fit together and what kind of shape they would produce once they were assembled. But, thank Heaven, I did not put this to the test, because on the other side was Streeton's little painting. It was, although I did not know this at the time, a study for one of his best-known works, a painting of monumental size which was itself a landmark in the short history of Australian art, entitled *"Fire's On,"* *Lapstone Tunnel*. Lapstone Tunnel was a section of the railroad which, in the year Streeton was working on this big landscape, was being driven through and across the Blue Mountains, the range which since the first days of colonization had sealed off the inland plains of Australia from the coastal strip on which white settlement had begun. Streeton, who had gone to the Blue Mountains to find what he called the "immense effects" of Australian landscape and its high, chalky light, had witnessed the aftermath of a mining accident there: a charge of rock-splitting explosive had detonated prematurely, deep in the tunnel, killing one of the workers. "Fire's on!" was the warning cry for the lighting of a fuse—the equivalent of the American "Fire in

the hole!" In the final painting, we see the victim being carried out on an improvised litter, while a blue thread of smoke rises from the tunnel mouth: Death in Arcadia. In my little sketch, there is only Arcadia, no tunnel and no death.

So much for paintings. There was also a Chinese vase that I still have, blue and white, gracefully swollen, with chrysanthemum stems twining around it, which had belonged to Grandfather Vidal; a small Kodak exists of him holding it in his arms, like an adored infant, outside the rectory at Barnsley. Later, this infant would be viciously battered by my first wife.

But the real treasure of Marsland, to me, was its library, assembled by three paternal generations.

It contained scarcely any fiction at all, beyond some copies of Sir Walter Scott (which I never read, then or since) and a set of Dickens's novels, which likewise I did not touch. As the twig was bent, so apparently did the tree incline. I have never really had much appetite for fiction, beyond the whodunits by Agatha Christie, Ngaio Marsh, Ellery Queen, and others, which I devoured when I was ten or twelve. But candor forces me to admit that the very first book I wrote—in my spiky scrawl in a brown-bound, lined exercise book—was a murder novel, an imitation of Ellery Queen which, being in all ways a fiction, was set in a place I had certainly never been to: a nightclub in midtown New York. In it, sophisticates lounged about wearing tuxedoes (the very word seemed unbearably exotic: in Australia, these garments were called "dinner jackets," and seldom worn) and sipping at concoctions whose names I had cribbed from a cocktail tray in my mother's pantry: gin fizz, sidecar, Alexander.

The story featured a degenerate-minded gossip columnist, a warped and febrile sissy—a bit like Truman Capote, I now realize, though at this tender age I had never heard of the Tiny Terror—who would meet a satisfyingly grisly death in chapter 3; a rich girl from Long Island with tough airs and attitudes, who melted into vulnerability by chapter 5; and (incredibly, it now seems to me in retrospect) a society cocaine dealer, of whom the hero (a plainclothes cop) pronounced in the last line of the novella, "He'll live—for the chair." I had little idea what cocaine was, but I did know it was an addictive white powder that drove people cuckoo, women especially. In some ways, therefore, I could claim to have begun as a social realist, though not a *bien-pensant* Marxist one. The title of the work was *Cyanide Martini*, and I

am sure I stole it—from whom or where, I do not remember. Sometimes, years later, when I saw people hoovering late into the night in Max's Kansas City or Studio 54, I would have a powerful sense of déjà vu.

Nor do I remember any "modernist" literature in the library. I would not get to read T. S. Eliot, W. H. Auden, or even Gerard Manley Hopkins until I went to boarding school. On the other hand, it was quite rich in early books about Australia, by Australians and others, necessarily by Englishmen and even Europeans, dating back to the very earliest days of the eighteenth-century colony: first editions of Cook's *Voyages*, of John Hunter's *Historical Journal of the Transactions at Port Jackson*, of John White's *Journal of a Voyage to New South Wales*, and Watkin Tench's *Complete Account of the Settlement at Port Jackson*. These I read with fascination, and revisited later with a degree of resentment: nowhere in my secondary schooling was I taught anything about Australian history, except for some superficial and conventionalized *contes héroïques* about nineteenth-century explorers such as Burke and Wills. The peculiar mode of Australian exploration seemed to be to launch nobly into the unknown, find nothing of value or interest, go blind from sandy-blight, and then die of hunger, thirst, snakebite, native spears, or all four. Odd fragments of memorial poetry still cling to the more adhesive surfaces inside my head:

> *With the pistol clenched in his failing hand,*
> *Di-dumpty dumpety dumpty eyes,*
> *He saw the sun go down on the sand,*
> *And he slept, and never saw it rise . . .*

That explorer, I think, was Burke or possibly Wills. Or it could have been Warburton or Ludwig Leichardt (that weird prototype of Patrick White's *Voss*). But our realer social history beyond these obsessed loners, that strange and barbarously cruel world of the early convict colony, was veiled from me. It was too discreditable and best forgotten.

Ultimately, my attempts to penetrate and evoke it in *The Fatal Shore* would have their origins in this shelf of books. There were editions of early Australian novels (*For the Term of His Natural Life*, that profuse, creaking, and sentimental epic of convict misery); beautiful but, alas, badly kept ornithological albums; and collections of the works of colonial poets, including some popular figures, like the bush balladeer A. B. "Banjo" Pater-

son (who wrote "The Man from Snowy River" and "Waltzing Matilda," the most parodied but beyond comparison the most rapturously loved of all Australian folk poems) and C. J. Dennis's *The Sentimental Bloke,* with its illustrations of porky little larrikin cherubs, Ginger Mick, Doreen, and the rest, and others with next to no public following at all, such as the early lyricist Henry Kendall and that odd figure Barcroft Boake, whose ambitions for poetic fame were so cruelly frustrated by public indifference that he hanged himself from a tea tree with his stock whip—the most bizarre and yet most emblematically Australian of suicides, it still seems to me. Boake was clearly a doomed depressive from the start, but then it is hardly surprising that a lot of colonial Australian poets were: not only was Australia a hard land for rhymers to survive in, but the prevalent belief about Australian nature (nine times out of ten the subject of their verses in the 1860s, '70s, and '80s) was that its "soul" was ineluctably miserable, arid, and monotonous, populated by stringy blacks, bizarre mammals, and dead or dying explorers, its "mood" varying between near purgatory at best and, more normally, pure hell:

> *Out on the wastes of the Never Never—*
> *That's where the dead men lie!*
> *There where the heat-waves dance forever—*
> *There's where the dead men lie!*
> *That's where the Earth's loved sons are keeping*
> *Endless tryst; nor the west wind sweeping*
> *Feverish pinions can wake their sleeping—*
> *Out where the dead men lie!*

I used to take such anthologies of verse into the garden and read them, with satisfaction and more than a little schadenfreude, under one of my mother's flowering gardenia trees, whose glossy dark-green leaves half-hid a cool rainbow fan of mist from one of the ever-working sprinklers, thanking kindly fate that I didn't have to be raised in the bush.

After that, my library list contains a small but, for me, emotionally potent collection of books about the air struggle in the Great War, and early books on how to make and fly model airplanes. It included biographies of "aces" like the French pilots Georges-Marie Guynemer and René Fonck, whose exploits I would peruse with adoring fascination. Next to it, and greater in influence, were the bound volumes of periodicals. Some were Australian and

one of these was a nationalist oddity of the 1900s whose name, *The Lone Hand,* clearly stated its truculent if not yet republican view of Australia's "proper," isolationist place in the world. At my age, not yet twelve, I had no notions of world politics or Australia's place in them except the crude divisions that had been sketched for me by the Second World War. So when I looked at its illustrations, often by that execrable racist Norman Lindsay, of barrel-chested Australo-Aryan heroes protecting white womanhood from pigtailed Chinese hordes or canoes full of "the dreaded Sea Dayaks," krises dripping blood and incisors dripping saliva, I thought I understood perfectly.

We had long runs of *Punch,* a series dating back to the 1880s and forward to the late 1940s, and of *The Illustrated London News.* The antiquated humor of the Victorian cartoons didn't touch me particularly—those two- or even four-line slices of dialogue, with their clunking puns, like excerpts from bad plays, with golfers on the course or clergy at table:

BISHOP: I must insist that you try another slice of this ham, Vicar!
VICAR: Ah, no, your Grace, I fear it may disagree with me.
BISHOP: Nonsense, my boy, it is a genuine Westphalia!
VICAR : I—ah—perceived at once that it is a failure of some kind, your Grace. [*Collapse of elderly party.*]

The jokes were at the Christmas-cracker level, but the drawings themselves were a different matter. Because it was the highest-paying and most prestigious mass-circulation outlet for humorous black-and-white art in England in the late nineteenth century, *Punch* was able to draw on a very considerable range of talent. Not, it is true, the great Frenchmen like Toulouse-Lautrec and Steinlen, who at this time were changing the very nature of illustration and poster design on the Continent, and not the brilliant illustrators who filled the pages of *Simplizissimus,* but well-known if less acrid (and, by that token, very English) figures like John Tenniel—the illustrator of *Alice's Adventures in Wonderland, The Hunting of the Snark,* and other delights of my childhood—along with now forgotten but exceptionally gifted ones such as Reginald Cleaver, who drew Victorian dandies at Ascot and beauties in Mayfair ballrooms with a fizzy, knifing line. And then there was Phil May, the contemporary of Aubrey Beardsley and nearly as brilliant in his disposition of light and dark with no halftones and only the most vividly schematic cross-hatching, who could create (almost) the

illusion of color with pure black and white. Phil May, I mentally noted, was also Australian. Actually he was not: born in England in 1864 and educated there, he was lured to Australia for a brief three years to draw for *The Bulletin*, after which he returned to England. But his Australian fans, who were many, continued to think of him as a fellow-citizen, and they loved his sardonic humor, as exemplified in the title of one of his collections of drawings, *Things We See When We Go Out Without Our Gun*. He was the first "expat" I had heard of, other than Dame Nellie Melba, the world-famed soprano, who had been a distant friend of my grandmother's. Melba's real name was Helen Porter Mitchell, but her stage name was taken from the city where her career began, Melbourne. She was an extremely direct, not to say blunt, superstar; one of the many stories about her was that, on being asked what she thought of the great Enrico Caruso, with whom she had often sung, she rejoined, "Finest semen I ever gargled with."

Since I was a shameless little musical illiterate (there was a piano at Marsland, but nobody tinkled it or knew how to; in any case, most of its keys were stuck fast by many years of humidity), I was far more interested in Phil May than in the Melbourne Nightingale. So my introduction to the visual arts really began with *Punch* cartoons, to which were added the Art Nouveau, Arthur Rackham-esque illustrations of witches and warlocks, sylphs, water maidens, knights, dragons, beetling cliffs, castles, and wonderfully sinister, imbricated dark woods in the series of volumes known as the Andrew Lang Colored Fairy books, each bound in a different hue and stamped with gold leaf.

Interestingly, looking back on the magazine content of the library, there was almost nothing American in it: no copies of *Life, Time, Look, The Saturday Evening Post*, or even *Reader's Digest*. My father had visited America, but not my mother. Both, however, regarded its high culture as nonexistent and its popular arts as debased. Fortunately, my sister Constance did not agree, and she amassed a big collection of 78s in brown paper sleeves—Fats Waller especially, but also Louis Armstrong and other great figures of hot New Orleans jazz. We had a shortwave radio, vacuum tubes crowded in a brown cabinet of vaguely Sheraton-like appearance, but the reception was terrible and the only time my parents ever used it was for the royal Christmas broadcast from London, when the monarch's tinny voice interlarded with static sounded as though it were coming from the distant bottom of a well.

Innocent American classics like the Superman comics were discouraged, while it was okay for me to read English youth publications like *The Boy's Own Paper*, *The Gem*, or *The Magnet*, or the Australian Sunday comics (dimwitted *Boofhead*, always in profile, and *Ginger Meggs*, the backstreet adventures of a freckled Irish larrikin boy faced with the ever-lurking threat of a monster bully named Tiger Kelly). I was allowed, if not exactly encouraged, to listen to certain radio serials: *Dad & Dave*, that interminable comedy series about Australian bush life, and *The Search for the Golden Boomerang*, an equally interminable quest-saga (about what, I still have no idea) underwritten by the confectioners who made that indispensable tooth-rotter of Australian childhood, Hoadley's Violet Crumble bars. And there was no problem with Mandrake the Magician, forever dapper and untouched in his *frac*, cloak, and gleaming topper. Mandrake had a subservient girl assistant called Narda—Spanish, strangely enough, for "nothing," an unconscious gleam of sexual politics showing through the surface. In moments of crisis a panel would tell you that "Mandrake gestures hypnotically," turning a cow into a runaway bus or a puddle into a raging ocean. I pocketed a black enamel chopstick from a Chinese restaurant, covered the thick end with silver paper from a Hoadley's Violet Crumble bar, and kept gesturing hypnotically with it, but disappointingly little happened.

The more formal areas of the library were naturally more sober. Curled up in an armchair, I reveled in its obsolete reference books, particularly the 1903 edition of Arthur Mee's *Children's Encyclopedia*, which, under "Aviation," contained the prediction that within a decade man would achieve heavier-than-air flight. The world in the atlases was still largely pink, betokening the vast British Empire. I wasn't particularly interested in philosophy, but there was plenty if you wanted it—mainly English Victorian translations of Plato and Aristotle, and for theology the complete works of Cardinal Newman. There were also Victorian history books aplenty, and of course massive doses of Winston Churchill, in uniform editions. Poetry went up as far as Rupert Brooke, where it stopped—significantly, there was nothing by the rebels of Brooke's time, Wilfred Owen, Robert Graves, and Siegfried Sassoon, since these would have gone counter to my family's view of the Great War. I could browse promiscuously through Tennyson, Swinburne, Wordsworth, Keats, and Shelley, though not the skeptical and immoral Lord Byron. The complete plays of Shakespeare were there, each

pocket sized in a neat floppy morocco binding. One could also find some serious stuff about art, for Bappa, like every late Victorian, seems to have been a buyer if not necessarily a reader of the works of John Ruskin; and these were interspersed with a number of 1920s and 1930s issues of *Art in Australia*, which introduced me to Australian painting through its handsome, tipped-in color reproductions. Who had bought these? Probably my father.

There were also such oddities and then-obscure classics as a Victorian edition of Robert Burton's *Anatomy of Melancholy*, written in the seventeenth century as the first medical study of depression but, to me, an immense storehouse of miscellaneous learning and discursive opinion whose winding, ceremonious language I loved but did not fully grasp. Probably the strongest influence on me was a shelf of cloth-board editions of Rudyard Kipling, both the verse and the prose: I learned some of the former ("Danny Deever," "Mandalay," and "Gunga Din") by heart, although I doubt if I could recite more than snatches of them by now; and I reveled in the latter, his great novel *Kim* and especially his tales for children—*The Jungle Book, Just So Stories*. I still think, sometimes, how lucky I was to have read them in their authentic original forms as a child, rather than be exposed to the watered-down, politically correct trash that Disney made of *The Jungle Book*. *The Jungle Book* was written at a time when England and Europe were full of stories about lost, savage children: children who, abandoned by their natural parents, defied the odds by surviving without clothes, shelter, or fire in deep forests, growing up without language or any normal relations to human parents and siblings. Kipling brilliantly posited that such a child— "Mowgli," the man-cub, he christened him—fell into an entire animal society governed by such wise creatures as Bagheera, the black panther; Baloo, the benign and slightly comic bear; Kaa, the python; and a vicious proletariat of thieving, jabbering, cowardly, unproductive monkeys, the permanent inferior race of the jungle, known as the Bandar-Log. My father, a Kipling devotee, used sometimes to refer to the members of the Australian Labour Party as the Bandar-Log. And *Just-So Stories*, with Kipling's own peculiar and bizarre illustrations, utterly fascinated me; later I would come to realize that they were a halfway house on the road to Surrealism, betokening a weird savagery of imagination. Like Lewis Carroll, Kipling found writing for children a means of complete imaginative release. He helped ease chil-

...ulthood by taking them seriously as readers. Such images as the ...ee with his millstone of a currant cake, and the rhinoceros struggling with his own huge leathery skin, stay with me yet. And the fact that he had illustrated them himself, and done it with such weird clumsy brilliance, prepared me for doing my own illustrations and cartoons in years to come.

I was very lucky to have access to such a library. Luckier still that TV, that jabbering moronic babysitter that has wrecked so much potential literacy in kids (and from which, nevertheless, I would draw much of my income in years to come), had not even reached Australia yet, and would not until 1956. So I never saw a TV program until I was nearly twenty-one. I have never been happier in a library, never more conscious of being on a voyage of exploration when I shut the thick door behind me, than I was in the one put together by my grandfather and my father. I devoured everything readable that I could lay my hands on. Being the youngest by ten years, I was in some crucial respects an only child, and there is much to be said for a lonely childhood—particularly if it instills in you the taste for reflection and soliloquy, as well as self-amusement, the best of grounds for a writer's peculiar life. I used to constantly talk to myself, although it was horribly embarrassing if an adult overheard me and joked about it. But this, although I did not realize it then, was good background for my later forays into TV, because when you are talking to the camera you are not talking to anyone—just a machine and a disc of glass, on which you focus your whole attention. There is no one behind the machine.

To this day, I have no real idea what it might be like to grow up surrounded by playmates, although I did have one close friend, Christopher Flynn, an intellectual prig like myself, who lived with an elder brother in a far grander house up the hill on Ginagullah Road.

Our house was handsome, but it could hardly rival the Flynn house's splendors. It stood on less than an acre of ground: a substantial plot by Rose Bay standards, but hardly an "estate." It had been designed in the early thirties by a cousin, Gilbert Hughes. Its manner was white Georgian, whose effect was somewhat undercut by its material—concrete render over brick. To be authentically period it should have been sandstone or at least stucco, but Sydney was short of competent *stuccatori*, and its climate was hostile to their work. It had gritty cement quoins at the corners, up whose grooves, like

the rungs of a ladder, I longed to scramble, and a front porch decorated with concrete pillars and cast-cement Ionic capitals, exuberantly wreathed with blue-flowering wisteria, which to my delight I was given the job of pruning with a pair of Wilkinson Sword secateurs. You got out on the roof of this porch through my father's dressing room. It indisputably had class. Its name—all "serious" suburban houses big enough to symbolize a respectable income level had names—was "Marsland," alluding, I think, to a part of Devonshire near the rectory of my mother's childhood.

My mother doted on the garden, which she filled with plants that would have been unknown to her English girlhood. Camellia and gardenia bushes, a frangipani tree and enormous flax plants with their spiky leaves. There were lavender bushes and, along the side of the small main lawn, three peach trees, which produced hard, inedible fruit but exquisite flowers: a white one, a pink one, and a deep-scarlet one, whose petals when they fell covered the green grass with a graded watercolor wash that never failed to fill me with delight.

When I read Tennyson thereafter (he was in all the anthologies: "Now sleeps the crimson petal, now the white . . . / Now winks the gold fin in the porphyry font") I thought of Mum's garden, although the font was not porphyry but cast cement, rendered fuzzily slimy with waterweeds. It contained not a statue, but a lump of petrified wood, a shapeless fossil that for some reason had a powerful, almost talismanic fascination for me. We never had any luck with goldfish; they always died, because nobody quite grasped that the water had to be aerated. It was, however, a fertile breeding ground for mosquitoes, against whose larvae I would sometimes dribble kerosene on the water surface, creating exotic rainbow-colored oil slicks to smother them. If you opened a small, rusty iron hatch to the side of the pool, next to an overhanging frangipani tree, and scrabbled away at the dead vegetable matter in the bottom, you would find a bronze tap handle which, when turned with effort, would cause a nozzle in the middle of the upper basin of the pool to send up a jet of water, rusty at first and then clear. It would peak at about four feet and then, exhausted, fall back into the basin with a thick flumping and plopping noise. This was the first fountain I had ever known and it always comes to mind when I see grander and more sophisticated *giochi d'acqua*, such as those in the gardens of the Villa Lante or at Chats-

worth. And whenever I see or smell frangipani, those white waxy blossoms shading to yellow at the center, with their almost unbearably rich perfume, I am carried straight back to the garden at Marsland.

Like all childhood houses, I suppose, it looked big then and seemed small when I revisited it fifty years later. (I made the error of saying so on a TV program shortly afterward, and was bitterly attacked for "elitism" by some reviewers, of course.) It was surrounded by wildlife: the bush, mighty totem of Australian identity, was always intruding, even into the inner-city suburbs. The birds were starlings and red-assed bulbuls, which I would mercilessly shoot with a beautiful, walnut-stocked Edwardian .177 lever-cocking air gun lent to me by the next-door neighbor, Mr. Barnes. One also heard the sweet carolling of bush magpies in the trees, the loud cackling song of kookaburras on the telegraph wires, the mourning doves. But these one never shot at.

I loved guns, and loved the idea of firearms. Killing at a distance, unseen, held fascination for me, as I suppose it does for many ten-year-olds, even in the most herbivorous of families. Several guns were stored in cupboards in the house. Neither my father nor my elder brothers had the attachment to firearms as emblems of virtue, patriotism, and democratic identity that millions of Americans feel. Australia had never raised a citizen army to rebel against the hated British. We did not hate the British; on the contrary, we thought we *were* British, and the idea of rebellion would have been inconceivable, except to an Irish minority whose sentiments seemed ridiculous, even to most other Irishmen. Our constitution was a dully formal colonial document written for us by English bureaucrats in Whitehall, not by dissident idealists in Boston, and it certainly contained nothing remotely like America's much-debated and so profitably misinterpreted Second Amendment, which said that "a well regulated Militia, being necessary to the security of a free State, the right of the people to keep and bear Arms, shall not be infringed." (Any effort to point out the obvious truth that the phrase "a well-regulated militia being necessary" reflects the early republic's well-founded distrust of standing armies, but also means that in a later republic the presence of an enormous standing army, navy, and air force completely annuls the need for citizen militias and hence the automatic right of citizens to "bear arms," which may be anything from a *breloque* to one's very own tactical

nuke, earns you the ill fame of a terrorist-loving surrender monkey in America. But not, fortunately, in Australia, where our love of freedom is less paranoid.) So the Hughes family did keep and bear arms. We kept them in a cupboard and only bore them when out in the bush, looking for rabbits and similar edibles. If one of us had been seen wandering along the Rose Bay esplanade with a single-shot Lithgow .22 in his hands, or (even less imaginably) my father's ancient but perfectly oiled military-issue Colt .45 in its worn leather holster, the local cops would have been onto him like the proverbial duck on a June bug. The gun I liked best was an old-fashioned octagonal-barreled Winchester .22 magnum, made sometime in the 1890s. It had a tubular magazine under the barrel, which held eight long, soft-nosed cartridges. Its action worked like silk, and I delighted in running one cartridge after another through the breech, with its lever action that made me feel a little like Gary Cooper or Dan Duryea crouched behind the overturned Conestoga wagon, defending the womenfolk.

I knew where the guns were kept, for snoopy little ten-year-olds get to know everything about the house they live in. When there were no adults at home I would take these guns out, not to "play," but to familiarize myself with them. The difference was crucial and, quite literally, moral. You did not "play" with things that were made to kill. Dad put great emphasis on correct gun-handling. The rubric boiled down, in essence, to three commandments. Always assume a gun is loaded. Never point a gun at anything you don't intend to kill. Never shoot at any living thing you don't mean to eat. These I scrupulously obeyed and, what was more, I used to wipe down each weapon after handling it with a lightly oiled rag, in case—here the education of *The Boy's Own Paper*, the radio-detective programs, the forbidden pulp comics, and my collection of tattered Saint books by Leslie Charteris would show itself—someone saw my fingerprints on them. (I was so afraid of surveillance by my elder brothers, particularly Geoffrey, that I would not have put it past them to dust breech, barrel, and stock with a sable brush and talcum powder to reveal my fingerprints.)

From the garden at 26 Cranbrook Road you could see Rose Bay, everyone's playground, including mine. Rose Bay was an airport, too: the flying boats

that went to New Zealand and to the north, big fat-hulled Sunderlands (of the sort my brother Tom used to fly on anti-sub patrol in the North Atlantic in World War II) and graceful Art Deco Catalinas, used to come in right over our house to land on its water—an unceasing thrill to watch. They flew so low that you could see the rivets on their hulls. On the hill beyond, far in the distance, you could see the Vaucluse water tower, a big gray concrete drum on four legs. It marked the suburb, invisible from Rose Bay, where my aunt Mim lived.

So much of my childhood owed its pleasures to Mim that I can hardly disentangle her from its background: she loved me, and I her, almost as though she were not my aunt but a second mother—a role she was seemingly made to fulfill, since she had never had any children of her own, but lived and died a (presumably virgin) spinster. I was about to say that she "treated me like her own son," but that cannot be true, because she never rebuked me or spoke harshly to me. She was in no way a disciplinarian, but she did not need to be, because by her mere presence she dissolved all impulses toward ten-year-old delinquency I might have had.

I spent almost a whole year living with Mim, in 1949, because my parents took off on a long trip to Europe, taking my sister, Constance, with them. It's hardly possible, in these days of routinely subsonic long-haul flight by Boeing 747, to imagine what the sea voyage from Australia then meant. It was as different (almost) from today's traveling as that of 1949 was from the days of sail. The trip took a month. Along the way there would be stops, with absolutely standard glimpses of exotic "native" life: a brief rickshaw ride in Colombo, the port of Ceylon, as Sri Lanka then was named; the bumboats jostling around the liner's side at Aden, with their crews of gully-gully men and hawkers selling ivory elephants, brass pots, and, less respectably, little tins or slightly grubby white envelopes of Spanish fly; the distant sight of pyramids from the end of the Suez Canal. This was not a voyage you lightly contemplated. In fact, it was less a voyage than a full-scale transhumance— no simple matter. It is difficult to visualize, more than half a century later, in an age first of airmail and later of e-mail, what these separations, Victorian in their length and completeness and generating reams of mail describing everything from the penguin house at the London Zoo to the inclination of the Leaning Tower of Pisa, especially not forgetting the contents of Hamley's, the treasure-house of hobbyists' material in Regent Street.

The preparations for this voyage were detailed, involving (among other things) the preparation of dozens upon dozens of eggs. At the time, eggs were severely rationed in England and, my mother believed, all but unobtainable in Europe. She may or may not have been right about France and Italy, but about England she certainly was. So she bought several crates of farm-fresh eggs, together with jars of a substance named Ke-Peg, which, smeared on the eggs, was meant to preserve them almost indefinitely. Ke-Peg had the look, texture, and smell of earwax. I know, because it became my laborious duty to anoint every one of the eggs with it. In due course, these preserved eggs, which had traveled all the way to England in the hold of the P&O liner *Orion*, got handed out in lieu of tips. The doorman at the Savoy, the driver of the taxi that he summoned for the Hugheses, the porter at Euston station—all, having held out their palms for the customary tip, would find themselves holding an egg, or sometimes two eggs, which my mother drew from her handbag and daintily bestowed on them. No egg seems to have broken inside that reticule. Nor is there any record of a display of ingratitude from the staff, so perhaps fresh eggs really were as much a treasure in postwar Britain as Mother thought they would be.

The high point of their trip was Rome, and the Vatican, where my father had been granted an audience with Pope Pius XII.

What did they talk about? No idea. Dad did not say in his letters, which were full of otherwise fascinating stuff about St. Peter's and Bernini and the huge collection of relics—leg bones of St. Paul, the top of Mary Magdalen's skull. (Now, for the first time, a tiny nibble of heretical doubt began to worry me: what about other churches with other relics, the spare parts of saints with five arms or two heads distributed across Italy? What was all *that* about?) At any rate, Dad and the Pope certainly didn't talk about model airplanes, so their conversation might not have been of deep interest to me. Probably it was general and pious, like the way Cardinal Gilroy used to speak when he visited the school on Prize Day.

Perhaps the Pope lectured my father (or, in the subservient phrase of the time, "favored him with an allocution") on his favorite subject, other than the inroads of atheistic Communism, which was the "miraculous" apparition of the Virgin Mary to a pair of illiterate peasant children near Fátima in Portugal on July 13, 1917. On this wonderful, never-to-be-forgotten, ever-to-be-believed-in day, the sun was supposed to have spun dramati-

cally round like a pinwheel, while the Portuguese earth was deluged by a miraculous fall of rose petals. Nobody outside Fátima, and no one other than these children in it, is known to have witnessed these preposterous solar antics, which were accompanied by three "visions," all banal, which the Virgin had allegedly confided to them. Pius XII, however, let it be known that *he* had seen the sun spin round when he was walking in the Vatican gardens some years after the "miracle" in Portugal. This was one of the factors that led him to proclaim a "Marian Year" of mass devotion to the mother of Christ in 1954. The Pope's devotion to the "miracle" at Fátima was enthusiastically endorsed by two of the more odious dictators of Latin Europe, Franco of Spain and Salazar in Portugal, who believed and made clear to their millions of subjects that the Virgin was underwriting their regimes.

We felt the impact of this in Australia, as the output of recitations of the Rosary increased manyfold. There is absolutely no reason to suppose that these children saw anything at all, or that there was anything to see. The rankest superstition was still processed into the stuff of faith by the twentieth-century Church. (And it still is by the early twenty-first, as witness the late John Paul II's quasi-industrial production of saints.) Pius XII attached huge importance to the "events" at Fátima as a sign of God's interest in the human race. It would make fine propaganda for the Church, and serve as an antidote to atheistic Communism. It would officially draft the Virgin Mary into the Cold War. We schoolboys in remote Australia were accordingly obliged, on special occasions, to chant a Fátiman hymn of unknown authorship—put together, perhaps, by one of the pious authors of the devotional pamphlets we got in church:

> *The sun at Thy roy-hoyal word*
> *Spun round like a sple-hendid toy:*
> *The rose petals showering down*
> *Proclaimed Thee the cause of our joy.*
>
> *O Lady of Fátima, hail!*
> *Immaculate Mother of Grace!*
> *O pray for us, help us today,*
> *Thou hope of the human race.*

It seems clear from my surviving letters to my parents that my eye was not fixed on piety, only on model airplanes.

Dear Father,
I am glad you saw the Pope and he blessed the medal for me and I hope he is
well. The food in Italy must be weird. When you get back to England please
get the Mills 2.4 cc. Diesel the one with the long crankshaft to go with the
Black Mamba kit if you are going to get that it is easy to forget. If you see
the Pope again give him my love.

Kits, engines, rubber and dope, and special fuels: toward the end of 1949, Group-Captain Geoffrey Hughes came back on clouds of glory, with a big box of these treasures. This thrilling argosy wholly obsessed me. Although I didn't as yet have the smallest interest in the visual arts, I am inclined to suppose that this revelation of European treasure, of the existence overseas of things that gave such pleasure and gratification, was the first tiny seed of my eventual desire to leave Australia and seek the delights of Overseas. Here was stuff you couldn't possibly get in Australia. Later, the same would apply to Michelangelo, Rubens, and de Kooning.

Denied his outlet in flying, grounded now, my father poured his intense nervous energies into his law firm, his directorships, and what seems, looking back on it, to have been the sole point at which our imaginations really touched—our model aircraft, in whose construction he was the sorcerer and I the apprentice. Making them together transported him back into an idealized past and projected me forward into an imagined, thrilling future, where I could feel myself, if not the equal of my father, then at least the rival of Biggles or Ginger, those warrior knights of the air who, written into existence by W. E. Johns (aviation's equivalent of George Alfred Henty, the kids' novelist of the British Empire in its imagined prime), starred in a long series of war-adventure novels. ("Ha-ha, Graf von Kluck, your Blue Max is of little use to you here. You would be sadly deluded to suppose you could set this observation balloon ablaze. We no longer fill them with hydrogen." Frustrated snarl from Teutonic villain.)

I made lots of "solid models," their fuselages and wings carved from blocks and sheets of balsa wood, and their spinning propellers symbolized by discs of celluloid whose transparency poorly simulated the blur of the

blades' motion. But the challenge was to build large models that really flew, whipped through the air in a circle on sixty-foot control wires by single-cylinder Glo-Plug or diesel engines—tiny, screaming power plants that spun their ten-inch propellers at something like eighteen thousand revolutions per minute and could kick back and all but amputate an unwary finger when you were flipping the prop to start the motor. The airframes were made not of plastic but of thin balsa strips and sheets, cemented together over printed plans with cellulose glue (the acrid smell of whose acetone solvent remains one of the indelibly evocative memories of my childhood). They were then covered with fine Japanese paper, tightened and reinforced to the consistency of a drumhead with several coats of dope—the same kind of liquid that, in Father's youth, was used for tightening the fabric flight surfaces of the real biplanes he flew above the trenches of Flanders. Later the covering would be a fine, heat-shrinkable plastic called MonoKote, which one applied with a hot electric iron. But the Japanese paper was what I loved, and now, so many years later, when I see some exquisitely laid piece of calligraphy by a student of Ogata Korin in a museum, I think first not of the spiritualized handwork of Momoyama Japan, but of those long evenings in the family garage with Dad, smoothing and stretching the refined wing coverings of those planes.

In fact, though, rice paper was not the most refined covering available. The aeromodelling fraternity had a small offshoot dedicated to building models that flew indoors, within hangars or high-roofed, disused factory spaces where no winds blew, thus allowing—in fact, demanding—an implausible delicacy of construction. The weight of such insect-like machines was to be measured in tenths of an ounce. Their lifting surfaces were made not of paper, which would have been too heavy, but of a homemade plastic film, a micron or two thick. One made this dream stuff by fashioning a largish wire loop and submerging it in a tray of water. Mim's bath would do. A drop, no more, of cellulose dope fell on the water surface and instantly spread out into an almost impalpable iridescent film, like oil. It dried at once. Lifted out on its wire loop and laid gently over the wing or tail framework, it became a tight, weightless surface which shone in all the rainbow colors of its birth. Such dragonfly machines were powered by a single strand, no more, of rubber, which turned a huge weightless propeller, similarly made of grass-

stem-thin balsa frame and dope; it rotated lethargically, dragging the plane with a sort of pensive delicacy through the roofed-over and windless air.

This was not for Dad and me. We might have gone in for such flying because, though he was retired into mufti, his service rank and the high respect he had from the Australian Air Force could have given him easy access to disused hangars.

But what we did was macho modeling. My immersion in it—I can't think of a lesser word: "interest" is certainly too pallid—probably explains why, when I hear the word "model" even sixty years later, I think of fierce lacquered little airplanes and paternal bonds, of which I had had plenty of experience, rather than tall satiny blondes with legs like gazelles, of which I have had much less. I still see, in memory, those drum-taut red wings, and feel the coating of burned oil where they joined the fuselage, blown back from the diminutive exhaust stacks. I still mentally waggle the elevators up and down, and experience the heart-stopping anxiety when the little aircraft, screaming like a banshee, leapt up from the brown summer grass of Centennial Park. I can still feel my relief and gratification at Dad's approval when, after the engine abruptly cut out (you could never predict when it would, you just hoped it wouldn't happen in the middle of a wingover or a loop), I guided the model in without crashing it, to a perfect dead-stick, three-point landing, jouncing on its out-of-scale balloon tires, thus snatching hours and days of patient shared work from an ever-present threat of destruction. He must have trusted me, to let me fly a plane he had guided me in building, down to the last balsa rib and longeron. He made me feel worthy of trust. But that was what he had been for years: a flight instructor.

In the year I lived with Aunt Mim, we happily kept one another company while I attended Campion Hall, the Jesuit-run preparatory school for Riverview.

Whether she ever had any love life, even of the most platonic sort, I do not know and cannot guess. I assume that she had none, although she maintained an affectionate friendship with a slightly doddery war veteran, who had copped a "Blighty wound"—one which necessitated being sent back to a hospital in England, and thus saved his life—in France in 1915 or 1916. His

coarse white moustache was tinged with nicotine, and he tended his garden next door in burst sandshoes and a moth-eaten maroon cardigan which, if memory serves, Mim knitted for him years before. Sometimes he would come across into Mim's garden and they would sit companiably together on the lawn in two misshapen green wicker armchairs with a wobbly wicker table between them, in the weak sunlight, having their "elevenses"—a blue-and-white pot of dark Kinkara tea, with crumbly, sugar-dusted biscuits she had baked herself the previous day. *Tea revives you!* harshly insisted the radio commercial one heard everywhere. *Start the day well with Kinkara tea! And remember—Mother's Choice Flour in every home!* This vied for first place in my memory with a radio jingle that ran:

> *I like Aeroplane Jelly!*
> *Aeroplane jelly for me!*
> *I like it for dinner, I like it for tea,*
> *A little each day is a good recipe:*
> *The quality's high as the name will imply . . .*

This stuck in my mind because of its utter bizarreness: an aircraft, made not of aluminium and stressed wires, but of soft, wobbly aspic. Indeed, there was an Aeroplane Jelly airplane beside the road to the town of Bowral, outside Sydney, where Mim and I often used to go during school holidays: it was a near life-sized monoplane crudely made of wood and tin, mounted pointing downward as though it had just crashed, with the words AER PLANE J LLY defectively lettered along its wings.

But I digress. I have no idea what Mim and her elderly war veteran might have chatted about.

Mim lived alone. There was a story, which I did not presume to ask her about, that she had been in love with a young English officer who was killed in the first hour or so of the battle of the Somme, on whose opening day sixty thousand Allied troops were slaughtered by the German machine guns as they walked so bravely and so uselessly toward the enemy trenches. Once or twice while she was putting up the laundry to dry in the sun (in those days before electric tumble dryers, when cotton sheets acquired such fine-lineny, almost crackly texture from the heat and wind) I heard her humming, through a mouthful of wooden clothespins, a tune which belonged to one of

those tragically laconic, innocently tinkling army ditties of the First World War:

> *Where is Tommy Atkins?*
> *O 'ave you see-een him,*
> *O 'ave you seen him,*
> *Angin' on the wire,*
> *Angin' on the wire,*
> *I know where he is,*
> *I see-een him,*
> *I see-een him,*
> *Angin' on the old barbed wire.*

Black bitter stuff for an auntie to be humming, in 1949 Australia. This went straight into the memory slot, to join the shrapnel paperweights and the Hun in the Sun at Marsland. Whenever I think of the millions of English, French, and Australian women left behind with no matrimonial prospects in the wake of the Great War, they generally have Mim's friendly, wide-mouthed, slightly truculent face, with the smoke-yellowed teeth and the mole on her chin from which three dark hairs sprouted. Sometimes today, when I see one of those interwar Joan Mirós with the fine spidery black lines emanating from little painted nodes, I think of dear Mim's chin. I can't imagine that she would have appreciated that, since she did not have a trace of interest in art, especially not modern art.

On the other hand, which counted for much more, Mim could really cook. My mother was not an exceptional cook. She was competent in the English manner. If I want to recall what my middle-class forebears in Australia ate on both festive and normal occasions, all I need do is remember Mum's cooking. She had never been to Europe when she left for Australia to join Dad in 1919; never cooked a coq au vin (or indeed anything with wine in it: wine was special, not vernacular), never eaten Camembert or goat's cheese, had no loving acquaintance with pasta, which always emerged from her stove (on the rare occasions when she cooked it) as a schlumpy farinaceous Gordian knot, to be doused in canned tomatoes, sprinkled with Cheddar, and eaten with reluctant misgivings.

Oddly enough, for one who lived in Sydney, whose Pyrmont fish markets

are the Grand Central of Pacific underwater life, she did not particularly like doing fish. Later in her life she would as soon have defrosted and fried a pack of prebreaded, frozen fish fingers (for there was something magical about freezing, Technology's newest boon to the housewife) as filleted a gleaming fresh John Dory. In this, she was following—whether she knew it or not—a well-established Australian tradition. Since earliest colonial days, "good"—or English—food had been fresh meat (signifying one's ownership of flocks and herds, hence one's free status in an agrarian society) and salted fish, such as smoked salmon or kippered herring. Salt meat and fresh fish, on the other hand, were what convicts were given to eat and hence connoted low status. Australians in the forties and fifties were enormous consumers of "animal food"—butchers' meat. Vegetables, other than the Irish potato, were not a major item of diet, and salads were rare. (Enlightened colonial observers had been complaining and ironizing about these peculiarities of colonial cooking since the mid-nineteenth century.) As for fresh fish, it had no large place on most middle-class menus.

But with anything carnal, Mum was good. Her roasts, usually lamb embellished with mint sauce, were always the centerpiece of Sunday lunch, accompanied with the golden sagging domes of "Yorky pudding"; they were overcooked to grayness (Barnsley had never known about pink lamb) but delicious nonetheless. She made a formidable steak-and-kidney pie. But what I really loved was her offal: the kidneys and bacon, and especially the lambs' brains. She would blanch them in cold water, gently poach and cool them to firm them up, cut them in pieces the size of a walnut, dip them in beaten egg, roll them in bread crumbs, and fry them golden-brown in sweet Allowrie butter. To eat these morsels fresh from the pan, sprinkled with a little lemon juice, was like biting through crispness into a hot white cloud. The fried brain is still my madeleine.

The curious fact, however, was that Mum in the 1930s decided, in partnership with Mim, to start a restaurant. She had no training for this, but it was something to do—one of the various ways she would find to burn off her nervous energy, instead of being an unoccupied and passive Australian housewife. She found a marvelous site for it—a cliff overlooking the immense Pacific Ocean south of Sydney. Because it was next to Whale Beach, and you often had a view of those prodigious migrating mammals moving slowly in the deep blue from its terrace, she called it Jonah's—its

logo, a little stick figure balancing on a cetacean's back, holding an umbrella to keep away its waterspout, was drawn by my father and embroidered on the placemats by Mom. This patch of rocky land, this view, would be worth a great deal of money today, but Mum got it for close to nothing—at least I presume she did, since she and Dad had very little cash to spare.

Jonah's was not an immediate success—a roadhouse which not much traffic passed. But the Vidal sisters, and their mother—who had immigrated to Australia to join them after the death of her clergyman husband in Barnsley—put their hearts and souls into it, as did Constance, who was then a teenager. Mim was in charge of the cooking. They served fish, sparkling fresh from the sea beneath the terraces of Jonah's, and omelets for first courses. Then there would be roasts and vegetables, "probably overcooked," Constance recalls, "as was the style of the time." They took particular pride in their desserts, the chocolate and coffee-iced éclairs, the sinfully rich chocolate marquise (a mixture of crushed almond toffee and grated chocolate held together with whipped cream), and the rolled brandysnaps filled with cream. "There was always a big bowl of brandysnap mixture in the fridge, and many a Hughes finger was dipped in it, unknown to the patrons and to Aunt Mim."

Jonah's also served afternoon tea, very much in the English manner, with scones, clotted cream, homemade jams, and cakes—the squares of cake baked in advance but not iced until ordered, with a warm fondant icing. Constance remembers "the beautiful, finely cut sandwiches. Mim sliced the bread with a very sharp curved knife; I think I have it somewhere still. I have never liked thick machine-sliced bread." The fireplace in the sitting room of Jonah's was decorated with old blue-and-white Delft tiles, which were covered up by a later Italian owner and are possibly still there under the modern "improvements." The crockery was a family service, a double Blue Bird pattern which Granny Vidal had received as a wedding present in England decades before. "Oh, they were enterprising in their day." The water at Jonah's was rainwater from a collection tank; its electricity was generated on the site. At first the cooking was done on kerosene stoves, there being no gas service; after World War II, Aunt Mim restarted Jonah's and equipped it with a big wood-burning Aga stove.

The food Mum produced at home without any input from Mim usually tasted routine, and she had a way of overcooking anything and everything—

the English kitchen vice of the day. There was one dish of hers which I particularly feared, the more so because she thought it a great treat: a sort of soufflé omelet which, by arduous whipping and frothing, attained the consistency and neutral taste of foam rubber. My mother would beam with anticipation when one of these things—I always thought of them as things, rather than dishes—was set before me, and I would make insincere *yum-yum* noises while furtively looking out for a way, which I often found, of smuggling the hated object out of the dining room and into the bathroom at the far end of the back corridor. There, with a skilled flip of the wrist, I would scoot the thing off the plate and under an iron bath which, raised on four ball-and-claw feet, had plenty of room below it. One day the inevitable happened: there was a guttural Ukrainian shriek from the bathroom as our housekeeper Efrasiniya Federosowa, a stumpy "New Australian" (as postwar immigrants were required by courtesy to be known) with stainless-steel, Stalinist teeth, discovered the barely identifiable remains of a dozen *omelettes soufflés,* guarded by enormous "water beetles" or, in plain English, cockroaches.

But Mim did everything well and with feeling, from my favorite pudding—a sort of aromatic, baked cinnamon stodge—to the best roast mutton with peas, mint sauce, and Yorkshire pudding I have ever eaten. Her cooking was plain, and I only disliked it when it tried to get "Continental"—Mim's idea of a European dish being elbow macaroni in a slightly gummy béchamel. Nearly everything she cooked turned into comfort food and remains so in memory. Even her porridge, a dish I normally hate, tasted delicious, with the dark granular dollop of brown sugar melting into the rim of yellow cream. Her toast was real toast, not made in an electric toaster, but sawn slice by uneven slice from a country loaf and then, impaled on a brass fork that had come all the way out from Barnsley with her, browned and blackened in front of the fire. This required close concentration. Sometimes the slice would fall off into the coals, but it could be rescued and scraped without harm to its flavor. And then there were the pumpkin scones, a rich saffron-yellow in color, baked in her little gas oven at the Cottage (as her house in Vaucluse was always called) or in the big Aga that ruled the kitchen of the house in Bowral where we sometimes went in the winter: scones that were the very epitome of warmth and lightness, dripping with butter and sometimes with the strawberry preserves she had made herself in a wide

copper jam pan, also from Barnsley, put up in glass jars, and sealed with a layer of white paraffin wax. *Non si pasce di cibo mortale / Chi si pasce di cibo celeste*, sings the stone Commendatore to Mozart's Don Giovanni, in response to his defiant invitation to dinner: *He who lives on heavenly food does not eat earthly things.* I know he was thinking of Mary Sealey Vidal's pumpkin scones, as they were in the mouth of a ten-year-old in 1949.

The scraps—including the lamb-chop tails, which I would not eat, having a horror of congealed fat that persists to this day—were scraped into a china bowl for the dog. Processed dog food, bought from the supermarket, was unknown in Australia then; so, as a matter of fact, were supermarkets. You could still go to the local butcher and ask for a couple of pounds of dog meat, a request that would be greeted with a blank stare today. My mother did not tolerate dogs, and my father had no time for them at all, but Mim owned one. She had always loved dogs, and used to show me faded photographs of what I remember as a large wire-haired terrier, which had been her pet in Barnsley. Its name was Girlie, pronounced by Mim "gairlie." (At times her vocabulary and pronunciation, and to a lesser extent Mum's, were a small museum of late-nineteenth-century rural English. If I was sluggish and morose, Mum would laugh at me as an "old mouldiwarp"—Cotswold vernacular for "mole." Time and again in later years, reading the underrated agrestic poetry of John Clare (1793–1864), I would come across words that one or the other Vidal sister had used quite unconsciously: "hirpling" for "limping," for instance.

When I was living with her at the Cottage, her animal was a corgi. I think she had chosen that breed in the belief that it was distinguished, since the young Princess Elizabeth owned several. Because it went yipping and snarling after a harmless carpet snake the moment it arrived at the Cottage, we named it Rikki, short for the cobra-killing mongoose Rikki-Tikki-Tavi in Rudyard Kipling's *Jungle Book*.

Rikki was insufferably hyperactive and snappish. He yapped unstoppably at strangers and tried to bite the postman. Strangely enough, he was a poltroon when faced with larger dogs (most small terriers, in my experience, are fearlessly indifferent to size and will launch themselves at the throat of an Alsatian or a mastiff if given the chance). He had, I suppose, a bad personality; most corgis are said to, not that I cared. I loved him with an unreasoning passion, for he was my first dog and through him I discovered that I was

a dog person, not a cat person. Rikki slept on my bed at night. He would come on long rambles with me through the South Head cemetery, lifting his leg to piss on favored graves. When we ran, his four short legs would scuttle frenetically in a ginger blur with white socks. He looked like the animal in Giacomo Balla's *Dynamism of a Dog on a Leash,* as I would realize later; but when Rikki was alive I had never heard of Italian Futurism, and Balla's multiple-exposure dog was in any case a dachshund, not a corgi. Rikki only had one drawback: he shed, copiously and continually. Since Mim rarely bothered to brush out the inside of her car, it was thickly felted with his ginger fur, both floor and seats, and it stank of old corgi. I have never encountered such a dog-smelling car since. It was a small, pre-1940 Austin with a band of white "blackout paint" still daubed on its running boards and mudguards, applied during the war to make it more visible at night, presumably so that Mim did not need to switch on her lights and thereby accidentally alert a passing Japanese fleet or bomber squadron to the existence of Sydney. With the dog-fur interior, it was a farouche-looking vehicle, and it eventually had to be taken away from Mim, because advancing age was making her blind. One bright day, stopped at a traffic light, she peered through the Austin's smeary windshield and saw blazing green. Instantly she tramped on the accelerator and popped the clutch (Mim was not timid at the wheel: she was a stubborn old hellion, having driven a Crosley ambulance in 1916 as her contribution to the war effort). The Austin shot forward and crashed into a barrow laden with ripe melons, which a Greek fruiterer was wheeling across the intersection. They burst and splattered their flesh everywhere, and had to be paid for. Fruitily sticky outside and doggily hairy within, the Austin was quite a sight. After that the family had to confiscate it, which was easily done by hiding its ignition key. Mim would grope and mutter around the Cottage looking for it, tipping over bowls and poking through their freight of pencil stubs, keys to long-forgotten locks, unstrung rosary beads, halfpennies and crumpled tram tickets, but to no avail.

The form of transport I most liked, however, was the electric streetcar, known as a tram. Until the 1950s, the city and its suburbs were served by a network of these magnificent vehicles; they were scrapped, abandoned, their rails torn up and their overhead wires taken down, under pressure from the usual corrupt New South Wales politicians and their friends the lobbying gas company executives, who wanted all state-owned public transportation to

convert to internal-combustion double-decker buses instead. Apart from its environmental consequences, this was an esthetic blot: roaring unpleasantly and belching nasty clouds of carbon monoxide-laden exhaust, the buses were intolerably ugly and hard on the ears compared to the elegantly skeletal, slat-seated "toast-rack" trams, or even to their enclosed successors. You would ride the tram along New South Head Road, down past the old colonial lighthouse on South Head, to the end of the line at Watson's Bay. You wanted to lean out of the tram but the conductor usually stopped you. On its headlong descent it swayed deliciously around the tight curves in the sandstone cuttings, injecting a note of fairground mock peril into the trip. The day would be salty, blue, and blustering with the wind off the Pacific. The bogies rattled, the bell dinged, harmless sparks flew from the wires. The speed of these vehicles even contributed a saying to Sydney's argot: if someone ran away fast, or perhaps fled from an awkward social or sexual predicament, he "shot through like a Bondi tram." Trams, like the harbor ferries, were among the things that made Sydney a great place to be, especially if you were ten or eleven.

The trams took me west to Rose Bay Pier or east to Watson's Bay, where began, on a lower-tech level, my lifelong relationship with water and fishing, which combined to so powerfully affect my esthetic sense. I got my swimming lessons in a fenced and palisaded sea pool at Watson's Bay. It was owned by a leathery ancient named Alf Vockler and was favored by Sydney parents because it was surrounded by shark-proof metal netting. Somewhat later I got hold of a pair of rubber-framed underwater goggles and (thrilling novelty!) a snorkel, and was able to have a look at that shark-proof enclosure. The ancient netting had rusted badly, leaving holes that a small whale, let alone a shark, could easily have swum through. I never actually came face to face with a shark in Sydney Harbor, but there were often dead ones to be seen out of the water at Watson's Bay, dangling from the gibbet of the weigh yard on the pier. Did the fascination with crime and punishment that formed *The Fatal Shore* begin with watching those immense, line-caught malefactors hauled up before the fascinated hanging throng? I would not bet against it. I loved to gaze on their corpses (weight chalked on the flank) as I dug, with a little wooden spatula, into my wax-paper cup of Peter's Ice Cream. There was, I thought, something extra-spectacular about big-game fishing— especially since its most publicized practitioner was a raucous minor come-

dian from Tennessee named Bob Dyer, who with his bottle-blond wife Dolly
had immigrated to Australia, grown a spivvy, southern-colonel-style mous-
tache, and become the kingpin of radio entertainment with his vaudeville
show. Most Saturdays, Bob and Dolly Dyer would roar off into the Pacific in
his forty-five-foot big-game boat to subdue the blue marlin and white sharks,
and we kids envied him almost to the point of wishing him dead.

Watson's Bay in those days framed other adventures. There was the Gap,
a false harbor entrance south of South Head, where in 1857 a sailing ship
named *Dunbar,* mistaking its bearings one moonless night, ran onto the
rocks with enormous loss of life. Its ponderous, rusted anchor was salvaged,
and leans as a monument near the Gap's railings. Ever since, the Gap had
been the *locus classicus* of Sydney suicide: crawl through the railings, jump,
and four seconds later your business failures, your unwanted pregnancy, or
your oppressive sense of *taedium vitae* would be over, and with luck you
would make it onto page 3 of the *Daily Mirror* as well. On one of the head-
lands just inside the harbor stood a number of mute concrete fortifications,
gun emplacements and ammunition magazines built during World War II
against a Japanese attack that, apart from the solitary irrupton of midget
subs in 1942, never came. These had long ago been stripped of their guns,
but the concrete tunnels remained, dark and dripping with seepage water and
smelling of old, mustily dry excrement. They had been sealed up, but ten-
year-olds can find their way into anything. In one of the underground cham-
bers I saw a graffito chalked on the concrete:

> *When apples are ripe*
> *Theyre reddy to pluck*
> *When girls are fourteen*
> *Theyre reddy to fuck.*

I knew vaguely what this meant, but only vaguely; coming on it in this
subterranean concrete cave was like being confronted with a sibylline mys-
tery to which I did not have the key.

Anyway, whether or not the girls were ready (which I doubted), I was not
ready for girls. What I liked, with a passion, was the harbor and the fish that
swam in it. Of the pleasurable memories of my early school days (before I
was sent away to boarding school), by far the best had to do with fishing.
The Hughes family house was not far above the harbor, where a dock, Rose

Bay Pier, projected into the water. There I would catch small yellowtail jack, red bream, and now and then a sluggish triggerfish with sandpapery skin and an erectile spine, known as a "leatherjacket." Belying their ugly looks, the leatherjackets were good to eat; failing a human taker, cats went mad for them if you skinned them first. (If you did not, the cat would whip the dead fish off the marble counter slab in the kitchen and drag it off behind some large piece of furniture in order to deal with it at leisure, which meant that by next Tuesday the room would stink.)

The gear in fishing was very simple. It was the kind that every kid on the shores of Sydney Harbor had—a round or square piece of cork, with about seventy yards of thin translucent nylon line, breaking strength about fifteen pounds, wound around it. Rods and spinning reels were out of the question. They were too expensive if good and, if cheap, hopelessly unreliable. The easiest fish to catch was the voracious little yellowtail jack; they swarmed around every pier and all you needed to catch them was a hand line, a hook, and a pellet of bread dough; once you had your first jack you cut him up and used him as bait for others. If you were fishing for red bream, a bottom-feeding fish, you would add to the basic hand line a running sinker, a lead bean with a hole through which the line passed. It was important that it should run freely through the sinker, because if the bream felt the weight of the lead it would take fright and drop the bait at once. You had to wait after the first *peck-peck-peck* telegraphed itself up the line, and then strike. It was difficult to get the timing right, and usually the bream just stole the bait. The bait was expensive, too: the bream preferred raw prawns, which you could buy wrapped up in a twisted page of the *Daily Mirror* from old Charlie the Chinaman, who sold them (sixpence a time) along with spring rolls and lumpy "scollops," or potato pancakes, deliciously grease-frizzled, from his stall on Rose Bay Pier. Charlie never said anything much, at least not to me, but when I bought his prawns or a spring roll he would beam toothlessly and utter sounds that might have been "Good ruck." He was a benign Old Man of the Sea, though whether he had ever actually fished or not I had no idea.

Only once did I ever see Charlie express enthusiasm or wonder about a fish. This happened when, by an amazing fluke—for the melancholy truth about the water in Sydney Harbor's bays back then was that it was too filthy and polluted to sustain decent-sized inhabitants, let alone fast-swimming pelagic ones—a misguided bonito, which had somehow strayed far into the

harbor, grabbed my prawn just as it hit the water, and was hooked. The struggle was intense and anxious but, more by luck than by skill, I finally dragged the madly quivering scombroid, its striped silver flanks glistening, onto the rough weedy planks of the pier landing and grabbed it with both hands. Not until I had it safely on the upper level of the pier, under the wrinkled gaze of Charlie, and surrounded by gaping envious small boys in whose republic I was suddenly and briefly cock-of-the-walk, did I see that those hands were streaming with blood from cuts inflicted by the running nylon line, which in places had bitten down to the bones of my index fingers. I still have very faint white scars to show for it. The bonito weighed a shade under five pounds and was by far the biggest fish I had ever caught. Its azure, silver, and obsidian colors faded to lead. I thought of the soul's departure from the body. It lay dead in my smelly canvas fishing bag like a glorious, weighty torpedo. Its noble, fusiform little corpse (which didn't look so little to me) filled me with respect and with what I now realize was a first stirring of desire for the Ideal. Walking back home up Cranbrook Road, I accosted two old ladies whom I knew to be acquaintances of my mother and showed them my fish. "Oh, how wonderful," one of them said in a thin tone of ill-disguised disgust. I kept stopping and opening the bag to peer inside. It was there. A hundred yards later I looked again and it was still there. It always will be.

My mother, having used up the bathroom cabinet's supply of elastoplast dressings on my lacerated and iodine-stung hands ("There's bound to be some sort of poison in that thing's slime," she said, a little disparagingly, I thought, as she sponged the cuts and gently dabbed the antiseptic on), baked it for dinner, with chopped parsley from a pot in the garden pushed into slits she made across its flanks. She overcooked it, but I didn't care.

The best thing fishing taught me, I think, was how to be alone. Without this ability no writer can really survive or work, and there is a strong relationship between the activity of the fisherman, letting his line down into unknown depths in the hope of catching an unseen prey (which may be worth keeping, or may not) and that of a writer trolling his memory and reflections for unexpected jags and jerks of association. *O beata solitudo— o sola beatudo!* Enforced solitude, as in solitary confinement, is a terrible and disorienting punishment, but freely chosen solitude is an immense blessing. To be out of the rattle and clang of quotidian life, to be away from the

garbage of other people's amusements and the overflow of their unwanted subjectivities, is the essential escape. Solitude is, beyond question, one of the world's great gifts and an indispensable aid to creativity, no matter what level that creation may be hatched at. Our culture puts enormous emphasis on "socialization," on the supposedly supreme virtues of establishing close relations with others: the psychologically "successful" person is less an individual than a citizen, linked by a hundred cords and filaments to his or her fellow-humans and discovering fulfillment in relations with others. This belief becomes coercive, and in many cases tyrannous and even morbid, in a society like the United States, with its accursed, anodyne cults of togetherness. But perhaps as the psychiatrist Anthony Storr pointed out, solitude may be a greater and more benign motor of creativity in adult life than any number of family relations, love affairs, group identifications, or friendships. We are continually beleaguered by the promise of what is in fact a false life, based on unnecessary reactions to external stimuli. Inside every writer, to paraphrase the well-worn mot of Cyril Connolly, an only child is wildly signaling to be let out. "No man will ever unfold the capacities of his own intellect," wrote Thomas De Quincey, "who does not at least checker his life with solitude."

So fishing contributed to an important lesson of my life—how to be alone. I still think solitude is one of the world's great gifts. *"Se sei solo,"* wrote Leonardo da Vinci, *"sarai tutto tuo"*—if you are alone, you are entirely your own man. If this was a vital lesson for a writer, the harbor's visual character also educated me. One saw the huge flank of a dark ship moving slowly, slowly toward the sea through a deeper darkness, speckled with points of light. One watched the lucid dawns and the flushed evenings over little sandy bays. Even more interesting to me than the boats—the Hugheses didn't have a boat—were the heavy, eloquent maritime structures of a great working port: old rust-streaked hulls and pylons, buoys and bollards, splintery wooden docks. These demotic forms intrigued me in a way that the "good" furniture, porcelain, and silverware of our family home never did. Their strength went beyond questions of taste, and ever since, I have delighted in vernacular objects, things made straightforwardly for use in work. To me, the tools used to make a Fabergé egg are more interesting, perhaps even more beautiful, than the egg itself. "Objects gross and the unseen soul are one," wrote Walt Whitman, and how right he was!

Sunday afternoons were given over to golf at Royal Sydney Golf Club—my brother Geoffrey, an expert golfer, became club champion at the age of twenty-two in 1951, and for a time held the course record with a 4-under-par 68. I wasn't a good enough golfer even to caddy for him, but I loved playing on my own on weekdays, when no other people were on the course. Then I would play two balls, one against the other, cheating flagrantly with both—a habit that both my brothers, when they found out about it, regarded as quite inexplicably bizarre. (Perhaps it was, but at least if you cheated when playing against yourself you couldn't lose and there was no one to accuse you of dishonesty.)

Sunday mornings, however, were dedicated to the fulfillment of our religious duties. The obligations of Sunday Mass, and of living up to Dad's and Mum's piety as "pillars of the faith," as the phrase went, were absolute. The parish priest of St. Mary Magdalen's in Rose Bay, our local church, was a singular, eccentric, and, to my childish eyes, almost archaeologically old man named Monsignor O'Regan. When you went to confession and recited the fairly pitiful catalog of the week's sins, which at my age had hardly even got as far as Having Impure Thoughts, Monsignor O'Regan would nod significantly behind the black gauze divider of the confessional, exhale a musty sigh and murmur, "Arrah, you're a lovely boy." He always said this, no matter what the sin was, and I sometimes wondered what he would say if you confessed to killing and eating the postman or stealing the contents of the church poor box. And if the penance for impure thoughts was kneeling down and reciting three Hail Marys, how many would it take to scrub your vagrant little soul clear of murder?

The Mons, as he was called, drove around Sydney in the biggest car I had ever seen, the gift of some pious and rich parishioner: a huge, gleaming black land yacht from the 1930s, a Cadillac limousine of the kind one remembered seeing in gangster films with George Raft or Edward G. Robinson ensconced in a fur-trimmed overcoat in the back. He drove it fast and, despite his age, skillfully, but with a sovereign disregard for the traffic rules. This never got him into trouble, since so many of the eastern suburbs' traffic cops were Irish Catholics. All other cars on New South Head Road, if driven by Catholics, gave it a wide berth; the price of scratching or denting the Monsignor's chariot was unknown, but it would have been more than three Hail Marys—probably more like a long sojourn in whichever circle of the

Inferno was reserved for impious vandals. I remember getting a questioning glare from him merely for photographing it with my box Brownie.

The main thing about Monsignor O'Regan, however, was his pulpit oratory. He was an Irish preacher very much of the old school, whose magnificently embellished and dramatic sermons would sometimes go on for forty and even fifty minutes, hopelessly disrupting the Sunday social pleasures of the congregation (a round at Royal Sydney, a family lunch). There was nothing to be done about this. To ask the Mons to shorten his sermons would have been an unthinkable insult. But you could not leave the church without sitting through the whole oration, because the consecration and elevation of the Host—which constituted the core of the Mass, the part you had to be in church for—did not take place until after the sermon, so that the old man had a helplessly captive audience none of whom could possibly dare to interrupt his flood of loquacity. To the further annoyance of some of its members, he gave the run of the church to an old and smelly red setter named Rex, which would come sniffing impertinently at the altar boys' asses while Mass was in progress. Monsignor O'Regan did much to form my conception of public speaking and what it could do.

I was at school when my father died. I had no idea that he was going to; I thought he would never die. We are apt to think that about our fathers. But he was extremely sick and none of my family told me so. In 1951, I had left the Jesuit preparatory school I was at, Campion Hall, and gone to board at the school all male Hugheses had always attended, St. Ignatius' College, familiarly known (from its situation on the upper harbor) as Riverview. One day in September of that year I was in class, as usual, when one of the Jesuits called me out. That was unusual; normally, nothing broke the monastic routine of silent study. Out I went, into the long colonnade of sandstone arches, and down at the end, near the vanishing point, I saw my twenty-three-year-old brother Geoffrey. As I looked at him his face, uncannily, came apart like tissue paper. He was weeping uncontrollably. Then I knew. Ever since, I have associated colonnades and their bars of shadow with memory and loss, and a miserable sort of shattered yearning: an image cluster that, long before I went to Italy, helped me to understand Giorgio de Chirico.

Out of some misplaced desire to protect me, my family did not allow me to see my father's corpse, with the result that for years (maybe, in my unconscious, even now) I had difficulty believing that he was really dead. It had

been the cigarettes, of course: one big round tin of fifty tipless, unfiltered Players every day, for at least thirty-five years. The cancer had eaten his lungs out. Nicotine had been his one weak point, and it got him in the end. Or rather, it did so with generous help from doctors. Radiology was in its infancy in Australia then; likewise, X-ray therapy. When Dad went into St. Vincent's Hospital for a lung checkup, and spots were detected, the doctors decreed that he should be given blasts of X-rays to kill the rogue cells. The cells were killed, but so was he, at the age of fifty-six. The treatment, so ignorantly and cavalierly inflicted on him by the doctors, filled his lungs with adhesions and scar tissue and he drowned from the inside out. Later I would find an unfinished tin of Players, very stale by then, in one of Dad's cupboards, and in an effort to seem like a real man to myself I clandestinely smoked them all, in less than a week, coughing and mourning.

Among the Cadets of Christ

I was a boarder at St. Ignatius' College. From afar, it was a minatory place. Nor did it look much cozier as you approached it. It was a blockish arcaded palazzo built of the yellow Sydney sandstone. It had been founded in 1895, and in those days, there being no bridge to the north shore of the harbor, most of its pupils were brought to it by a small, chuffing steam ferry. By the time I enrolled there, the school had been going for more than half a century, a long time by Australian standards—about a third of the colony's life. It was surrounded by playing fields for rugby and cricket, hard tennis courts and handball courts, and even its own nine-hole golf links. It also boasted a magnificent observatory, with rotatable dome and a powerful optical telescope, which was at the time the largest in the Southern Hemisphere. On very rare and irregular occasions, a senior science student or two would be admitted to wonder at its mysteries by the priest in charge, Father Daniel O'Connell. Having no scientific aptitude I was never invited in, but Father O'Connell, as it would turn out, changed my life in other ways. He made regular trips to Europe in order to advise the papal observatory at Castel Gandolfo, outside Rome. On these trips, being keen on art, he would collect postcard reproductions of paintings that struck his fancy. Though Riverview offered its pupils no art instruction of any kind, Father O'Connell would from time to time pin up some of these pictures, with brief comments that he would type himself, on one of the bulletin boards outside the school refectory. One of these postcards—I forget the year in which he pinned it up—was of a modern painting: de Chirico's famous image, completely new and unfamiliar to me then, of a girl bowling her hoop along an empty piazza, *Mystery and*

Melancholy of a Street, 1914. I was completely transfixed by it; I had never seen anything so strange and inexplicably moving. Hence, I owe my introduction to modern art to Father Daniel O'Connell, S.J., but remain almost wholly ignorant of astronomy.

You never had the feeling that Riverview was part of the great city of Sydney. It was monastic—an impression strengthened by those long colonnades, and by its physical isolation. It had several hundred acres of ground, most of which was raw, tangled bushland with liana thickets, through which narrow paths twisted. In the bush one encountered weathered statues of the Virgin Mary or other religious figures, which stood like sentinels in odd places. But they were rarely seen, simply because the bush was out of bounds and you were forbidden, on pain of punishment, to venture into it. The paths led down to the Lane Cove River, a smelly expanse of sluggish tidal water, fringed with mangroves and full of despised marine life—catfish, blowfish, discarded French letters, and the occasional shark. Other incursions from the animal kingdom, or from anything else outside school life except the ticks that infested the bush, were rare. Riverview straddled its hill in isolation, a self-contained and monosexual world of boarders and priests against whose limit the bungalows of Lane Cove pressed in a suburban tide.

When I was five, my parents dressed me in a tiny royal-blue-and-white football jersey (the colors of the Riverview team), which my mother had knitted with her own hands, and took me to football matches as a mascot. She ran the tuckshop committee, which sold all manner of sweets. There were the round hard balls of Jaffas—a core of chocolate, an outer skin like orange ceramic. You could load a Jaffa into a slingshot and break a window with it, not that I would have presumed to attempt such a violation of adult property at so tender an age. There were Minties, white mint-flavored taffies, which always bore on the box a drawing of some catastrophic situation— a workman on a ladder, say, with a bulldog ripping the seat out of his overalls—with the legend "It's moments like these you need Minties." For threepence you could buy one of the popular White Australias, unabashed propaganda for what were then Australia's racist immigration policies: plaques of white chocolate (itself a rarity), molded in the profile of a pure, undefiled continent, whose states melted sweetly on the tongue when you bit off a morsel. Was this a unique case, invented by some unknown antipodean genius, of propaganda by taste to corrupt the politics of the very young? I

don't remember ever reading or hearing about chocolates in faraway Europe being molded in the form of swastikas, cream-filled heads of Mussolini or raspberry Churchills.

I tried, without success, to swipe pink musk-sticks, floppy and cloying, from the tuckshop counter, but was always deterred by the vigilant eyes of the ladies' auxiliary. (They cost a penny each and once I spent a whole week's allowance, two shillings and sixpence, on thirty of them; the resulting fit of indigestion had me throwing up a sweet, disgusting pink slime for hours.) Otherwise this first contact with what was to be my school and, effectively, my home for a half decade is blurred into a montage of towering hairy knees, mud, the smells of wet tweed and tea from the parents' enclosure, the taste of fizzy orange drink from the plastic screw top of a thermos, and hordes of schoolboys (all, apparently, from the suburb of Brobdingnag, and twice my size) screaming the Riverview football war cry. Chanted on an accelerating tempo, like a Maori *haka*, it ran:

> *The emu, the kangaroo, the wallaby, the wombat,*
> *The emu, the kangaroo, the wallaby, the wombat,*
> *Ya, ya, ya, rinky ka ka ka*
> *Quork quork quork quork quork*
> *Quork quork quork quork quork*
> *V, I, E, W, View!*

If these aggressive syllables had ever meant anything once, it was certainly lost on me now. They, along with much else, formed a mysterious fragment of a mysterious semi-adult world which one did not question. Oddly enough, though I had no idea what it was about, I never doubted that I would fill it, like growing into an overcoat that was far too large for me. Long before I went to it, the school provided my childhood with obsessive images, mainly cupboards stacked with dozens of tarnished silver-plate trophies which my father, uncles, and brothers had won there for the 880-yard race, the 220-yard dash, the 100 yards, the mile and the high jump, the rifle shoot and the debating championship; the straw boaters with their biscuit-like brims, discolored by the sun to a light urine-yellow, never to be worn again; and the dog-eared copies of the thick annual school magazine, the *Alma Mater* ("Beloved mother"), beautifully produced on glossy coated paper, in each of whose issues hundreds of future lawyers, priests, soldiers,

and those with less distinguished futures before them, three-pea men and surreptitious Catholic gays, were caught in a blurred, perpetual adolescence, constellations of Irish freckles across their snub noses.

When I was sent to board at Riverview, I found at once that I had a handicap: an English accent, or what sounded to teenage Australians like one, inherited from my mother. Of course, it had never seemed to me that I had an accent of any kind; my voice was "normal," I thought. Not in their ears. I suppose I was lucky they weren't real proles, such as you would encounter at a state (i.e., genuinely public) school: they would have chewed me up. This was revealed to me by a mean, iron-muscled bully of a grazier's son named Proust—the "ou" pronounced as in "house." Unerringly, he zeroed in on me as, distracted with homesickness, I was wandering in the sandstone corridors that first night, amid the chaos of trunks and the other weeping new boys. "Cummover here," he cried in a breaking voice somewhere between a lion's roar and a mouse's. "Whatcha call yerself, shitface?" "Hughes," I said primly. "Cummagain?" "Hughes." "Shit," said Proust, clipping me over the ear, which was already burning with embarrassment and now began to throb with pain. "A bloody Pommy. Carntcher talk Australian?" "Hughes," I squeaked again, my sinuses vibrating in an effort to sound as if I, like he, came from the back of Bourke. All in vain: for the next five years, I was known as Pommy Bob, Cyril the Pom, or, after I won the debating championships, Fucking Churchill. "Pommy," meaning Englishman, was of old but obscure etymology. It is one of the commonest slang terms in the Australian language, but nobody really knows or agrees with anyone else where it came from. "Pomegranate," for the red, sunburnt cheeks of a newly arrived immigrant, branded by the relentless sun? Hardly likely. But wherever it came from, "bloody Pommy" carried a load of postcolonial resentment with it. It suggested pretension, false superiority. It reminded true-blue Australians of what most of them would rather have forgotten, their putative origin as transported convicts, and the lordly condescension with which the free English were reputed to view them (and often did). Calling someone a Pommy, a bloody Pom, or a Pommy bastard was, in those days, a form of preemptive condescension. It wasn't the deadliest of insults but it was certainly no compliment. Much depended on the timing and tone of voice. But Proust fairly spat it at me.

This traditional Australian dislike of Pommy accents was, by no small

irony, grafted onto an educational system which greatly resembled that of English public schools. There were big differences, of course: neither River-view nor any other school in Australia resorted to the odious practice of "fagging," by which junior boys were compelled to act as servants to senior ones. Seven schools in Sydney called themselves, without embarrassment or cavil, the Great Public Schools, or G.P.S. None of them, one need hardly add, were coeducational. The dangerous idea of mixing the sexes in a private school was unheard-of in Australia then.

Riverview was very strictly organized. It was split into three "divisions," junior, middle, and senior; they had separate dormitories, playing fields, and lavatories, and the boys of one division were forbidden, on pain of corporal punishment (always enforced, and never an idle threat) to speak to those of another. This was meant to curb bullying and homosexuality. It did reduce the former to manageable limits but it didn't do much to stop romantic ped-erasty. In these days of horror stories about libidinous priests having their way with powerless and helpless little boys, it probably sounds like either lying or willful ignorance to say that nothing like that went on at Riverview in the five years I was there—but as far as I know, nothing did, unless you count the practice of Father Gerald Jones, who was the coach of the rowing team, of making the "stroke," or lead oarsman, of the First Eight strip down to his BVDs and do rowing exercises on the desk in his study after lights-out. Since he never touched anyone, I think you would need to be Cotton Mather to bear him a grudge about this eccentric habit, though no doubt there are Americans today who would regard it as grounds for summary execution. At night the dormitories—large, totally lacking in privacy, and open through unglazed arches to the cold winds of winter—were patrolled by priests with powerful four-battery flashlights, alert to the creaking spring or the white patch of semen on the bedspread. (When two of those light beams con-verged on a source of suspicious noise, I imagined German searchlights stabbing the sky during a night raid on Hamburg.) Free time was closely regimented and, on the ancient but unsound theory that constant exercise represses the lusts of teenage flesh, they kept us constantly running round the rugger field or stamping up and down the drive in cadet uniforms, carry-ing ancient .303 Lee-Enfields at the slope. Many of the boys acquired some rudimentary homosexual experience before they left school. Due more to ignorance and timidity than anything else, I did not, and to this day I

have never had any kind of sex with another male. I am neither proud nor ashamed of this; it's just the way things were. Some ancient Greek or other, surveying the pile of intertwined Athenian corpses left by the fight against the Persians at Marathon, is said to have declared that "an army of such lovers could conquer the world." Clearly, I was not cut out for world conquest.

Riverview ran on bells. A bronze ship's bell signaled the time to get up, the change of classes, and bedtime. The refectory had a bell for grace and another for the end of the meal. (The memory of it fills me with gastrophobic images: the teeth-on-edge scrape and screech of 430 metal chairs on parquet, the din of serving dishes, the blunt spoon plunging into the sticky white tapioca pudding, known as "frog's come," which I hated so much, and the mutton chops so saturated with fat that, if left to congeal, they stuck to the cold china plates.) Each division prefect had a bell and the chapel was full of them, with assorted dingers and tinklers and a large mellow brass gong for the elevation of the Host. I always associated God with its lazy, outrolling *boinnngg* noise, something like the giant dimpled gong rung by the muscular actor in the pre-title logo for the old J. Arthur Rank movies.

Punishment took an invariable form: the Strap, on the hand, both hands, or the buttocks. The Strap was a flexible weapon about thirty inches long, an inch thick and an inch and a half wide, made of six laminations of cowhide sewn together with a raised welt. It was a heavy and formidable thing, and it hurt extremely, leaving marks that lasted (if you got it on the bare butt) as long as a week. Most of the priests disliked using it, but they had no choice about it and each one had an identifiable style, of which we boys were naturally connoisseurs. We knew which priest might, through nervousness, hit our wrists instead of our palms, thereby threatening to rupture the surface veins; which ones flicked instead of hitting squarely; which tended to use the edge of the Strap instead of the flat.

The most feared priest was also the one I liked best and learned most from. He was our Ancient History master, Father Gerald Jones, who doubled as the rowing coach. Nobody could have done more to bring the classics alive; he had a magical touch in evoking the life of the ancient Mediterranean, and he could transmit his gusto for Homer, Thucydides, and even dreary Xenophon with enthusiasm and utter directness, leaving you longing for more. His stories of Schliemann at Troy, or Arthur Evans simultane-

ously excavating and fabricating the remains of Knossos, left me gasping for more. Whatever abilities I have to evoke the past are owed, at least in part, to Father Jones's way of teaching. He put you there. He was a good—no, a *great*—raconteur, and in an effort to control the nervous energy that made him such a communicator he smoked until the fingers of his right hand were as brown as mahogany: sixty, seventy a day, to which, strangely, he seems to have been all but impervious; he had no smoker's cough and it was diabetes, not cancer, that killed him in the end.

He was an immensely well-read man, especially in the classics. At the same time, he was undeniably dangerous. A stocky muscular Jesuit who spoke with a lisp, possessed of great physical energy, with black hair cut *en brosse* and a seamed face, he would go for weeks without hitting anyone; then his desire for order would boil over. We feared these purges and nicknamed him Ogpu, after Stalin's secret police.

On one such occasion, a pupil in the study hall shot an overhanging light with a lead pellet from a catapult. A clang, a tinkle; silence. "Nobody," grated Ogpu in a small, level voice, "will leave this room." He strode up and down between the files of desks. "You," said Jones, "and you, and you, and . . ." He chose thirty victims, no less, told them to report to the Third Division shower rooms at ten o'clock that night, and stumped out. When they trooped fearfully upstairs after study (of course, nobody *could* study with this doom hanging over them), the chosen ones found Father Jones and a junior assistant, Father Drumm, waiting for them in shirtsleeves, Straps out and ready.

Ten prime suspects got six on the bum each; the other twenty, six on the hands. Two hundred and forty full-swing strokes with plenty of body weight behind them, no shirking on favorites, a considerable aerobic work-out for the two priests. By the end, Ogpu's shirt was wringing wet. The boy who actually fired the pellet escaped this hecatomb, and by the morning everyone (except the priests) knew who he was. But no revenge was taken on him by the boys who were thrashed. Punishment was, to us, a natural event, part of the order of the universe, like pimples or thunderstorms. We had no sense of persecution. Nor did we hate the priests for beating us, as modern schoolboys undoubtedly would. That night in the shower room would have made headlines all over the afternoon papers if it happened today; it would flood the Internet, and probably close the school down. But in 1953 it passed

without remark in the world outside, and even though all our parents immediately knew about it none of them protested.

But the unremitting environment of banging and strapping had ill effects on some pupils, including myself. You would have needed to be a bovine clod not to be affected by it. I can still remember the suspense of the queue outside the rector's tall, polished cedar door, the smell of disinfectant and floor wax, the desperate chafing of cold hands to warm them up so that the blows would not hurt so much, and the noise of the Strap within.

At such times I would have done anything to escape punishment—lied, cheated, run away, become an atheist.

And lie I did, hysterically and unconvincingly, and was punished the more for it.

It was a minor illustration of the fact that punishment creates crime. For many years after leaving school I couldn't open a letter from authority—bank, elder brother, tax department—without hesitation and a flicker of that desire to hide, and quite often I would not open the letter at all, but shove it under a pile of other stuff in the vain hope, I suppose, that it would disappear, or compost itself, rot away, and vanish. Of course it did not, and the result was that I would be embrangled in debt collectors' threats and sometimes actual lawsuits from exasperated creditors.

The only good result that came to me from corporal punishment at school (that I can think of) was a fringe benefit: years later, when I was writing *The Fatal Shore*, it enabled me to write with perhaps a bit more conviction and vividness about the Australian convicts' experiences when they were flogged. But of course there was no deep comparison between the appalling anguish of a hundred strokes of the cat-o'-nine-tails on a man's bare back, and the real but relatively slight pain of six blows of the Strap delivered by a halfhearted priest. And I think it is true to say that the Irish-Catholic system of corporal punishment could hang on longer in Australia (it is of course gone now, and unthinkable) because of the unconscious, socially assimilated convict legacy. The psychology of flogging is an interesting one, and not to be generalized about by those who have no experience of it. It did not, in case you were wondering, turn me into a masochist, as caning is said to have done to many an English public-school boy, notably Algernon Charles Swinburne, whose raptures over the birch fill many a page of his collected poems. Nor did it make me a sadist in revenge, although there was a period

in my late twenties and early thirties when I enjoyed tying girls up *(con su permiso, señorita)* and giving them a few strokes of a riding crop. This appetite, which must have had some element of revenge in it—could it be, dear Viennese Doctor, that I was punishing Mama for sending me to Riverview in the first place?—was released in me by Danne, my first wife, who had an intensely masochistic streak; it simply evaporated some twenty years ago, and I do not mourn its departure.

At Riverview, as at any Catholic boarding school fifty years ago, we lived in a steam bath of religion. Today's orthodoxies are mild as milk in comparison to it—weakened by debilitating options and tolerated doubts. However, if you want to know what Jesuit education felt like then—in its splendors as well as its miseries—read Joyce's *Portrait of the Artist*, in which every word of description rings true. Clongowes in 1900 was, in all essentials, Riverview in 1950. "Give me a boy before he's seven," the founder of the Jesuit order, St. Ignatius Loyola, is apocryphally supposed to have said, "and he's mine for life." They got us at twelve, but the intensity of their education went a long way to make up for those five missing years.

Every few weeks we would be issued "cards" stating our performance and attitudes in the various subjects on the curriculum. If you got a bad card for Religious Knowledge class, you were deprived of the one day each fortnight, a Sunday, on which you could go home to be with your parents and family. If you suffered at all from homesickness, as I constantly did, this was a devastating loss: the system made no allowance for the recent death of my father, and I will never forget my mother, with tears in her eyes, showing me an end-of-the-year report whose priestly author observed that "Robert is lacking in school spirit; it is as though he would rather be at home, under any circumstances," and suggesting a "prayerful reading" of some New Testament passage or other.

If you failed the Religious Knowledge exams at the end of the year, that was it: you had failed absolutely and had to repeat the year, no matter what marks you scored in other subjects. There were no exceptions to this draconic rule.

We attended Mass each morning; there were prayers before and after each class, Benediction in the evening, and night prayers in chapel.

From time to time, retreats were held. A retreat is a crash course in religious fervor, during which we were obliged to maintain monastic silence,

usually for eight days, neither speaking to one another nor whistling nor kicking footballs around. One walked the paths of the school like a policeman "proceeding" on the beat, eyes cast down. Our reading was restricted to devotional texts. Most of these were written by a prolific American Jesuit named Daniel Lord. They covered a large range of subjects from Devotion to the Virgin Mary (extreme) to The Truth About Atheistic Communism (almost unspeakable) and The Place of Science in God's Modern World (okay if you didn't make too much of it). Our biblical instruction was focused almost entirely on the New Testament. As far as I can remember, the Jesuits placed next to no emphasis on the Old Testament, except for Genesis. The Pentateuch seemed to be regarded merely as a symbolic prelude to the truths which would be fully expatiated in the "historical" life of Christ, as set forth in the gospels. This automatically put us, to a degree whose magnitude I would not truly grasp for decades—not, in fact, until I came to live in America—at an irreconcilable distance from the various Protestant versions of Christianity, especially the more charismatic ones. For this reason, the more extreme forms of the Baptist faith, for instance, seemed to me irrational and perverse. But we had our own irrationalities and were not short of hellfire. Not by any means.

At the retreats, a Jesuit with special oratorical powers would be brought in from "outside" the school to preach to us. I have forgotten his name but he was a powerful and indeed brilliant speaker and although (even then) I thought much of the content of his sermons overwrought to the point of craziness, I was lost in admiration of his technique. (I have always been a sucker for a good sermon, even the long lowbrow ones of gutbucket Baptists like Jimmy Swaggart; they act on me rather as great renditions of Delta blues do on others. This was the time of my life when I was learning by heart, along with much else, certain sermons of John Donne, which I would repeat word for word to myself out of pure love and envy. *The Almighty God himselfe onely knowes the waight of this affliction, and except hee put in that pondus gloriae, that exceeding waight of an eternall glory, with his own hand, into the other scale, we are waighed down, we are swallowed up, irreparably, irrevocably, irrecoverably, irremediably.*) Our retreat priest wasn't quite in that class of sublimity, but he was very good, at least as formidable in rhetoric as Monsignor O'Regan had been: small and old, like the future Spencer Tracy (the archetype of Irish movie priests), with very white hair, and a voice that

boomed and coiled around the chapel, shaking our guts with pity and terror. The terror was real, the pity largely fake. I couldn't bring myself to care about the sufferings of some Mexican priest staked to an anthill by unshaven Marxists in sombreros on the other side of the Pacific, but Hell itself!—the sermon in *Portrait of the Artist* is a masterpiece of eschatological scare tactics, but it was mere watercolor compared to the flaring fresco of the Four Last Things (Death, Judgment, Heaven, and, best of all, Hell) with which this priest confronted us in his cumulative, award-winning series of two-hour sermons. If I make this sound like public television, it's because in a sense it *was* like television—not that I realized it at the time. Lucky me, with my pre-electronic education.

Our religious education was, let us say, aggressive. Bellicose, in fact.

The Jesuits were not founded by pacific, contemplative monks in a cloister. There was no risk of ignoring, and even less of forgetting, the fact that before St. Ignatius Loyola founded the order of the Jesuits he had been a soldier. And I have no doubt that what I learned of Ignatius' military nature, as preserved in the order of priests he founded, meshed directly with what I already knew of my father's own warrior traits, thus providing a kind of lock between family and education.

Ignatius had begun his career as Iñigo, the thirteenth son of a minor provincial nobleman in the Basque country—an hidalgo, *hijo de algo,* the "son of somebody," not rich but utterly consumed with the desire to make his mark on the world and to stand out in it by virtue of his honor. His senior brothers, nearly all warriors (the exception was a priest, Pedro López de Loyola), provided him with a standard of valor against which to measure himself: the eldest of them, Juan Pérez de Loyola, contributed an escort vessel with eighty-five armed men to Columbus's second voyage (1493) and would die as a hero in a war with France over the kingdom of Naples. Other siblings also met heroic and chivalrous deaths. Their father, Beltrán de Loyola, on whom their lives all converged, was close to being a visible god in Iñigo's sight: powerful and manic in character, unquestioningly idealized by his son as warrior and adventurer. One could probably never live up to such a role model, or earn his unstinted respect, but one had no choice but to try: such was the fate of a Loyola and his tough, convoluted dictates of honor.

Beltrán died in 1507, when the son was sixteen, thus depriving young Iñigo of the opportunity ever to test his own valor and virtue as an adult

against that of the lost authority figure. Nothing could have done more to foster the authoritarianism of Iñigo himself, a trait which would have immense resonance for his later career and, indeed, for the history of the Counter-Reformation itself.

A different kind of idealization took place with Iñigo's mother, a woman of the minor Basque nobility named Marina Sánchez de Licona, who died soon after his birth, and whom he never knew. Remote and infinitely desirable, she became the psychological prototype of all the *señoras de valor* in the romances of chivalry, such as *Amadís of Gaul* and *Tirant lo Blanc*, that Iñigo would devour as a young man (and that would be satirized by Cervantes in the incomparable *Don Quixote*). The psychiatrist might say, and with every reason, that Iñigo's ferocious and obsessive devotion to the Virgin Mary was inextricably bound up, through the heroine figures of Romance literature, with his own lost mother. Next to the *Imitation of Christ, Amadís* was Iñigo's favorite book, representing the apotheosis of "quixotic" heroism. (This, incidentally, was not just a "masculine" taste. St. Teresa of Ávila wrote an imitation of *Amadís*, too.) We know from his own repeated account how deeply penetrated the future saint was by the chivalric ideal: it took, Ignatius would write in his *Confessions*, "such possession of his heart that he was buried in thought about it . . . imagining what he had to do in the service of a lady; the means he must use to go where she was, his motto, the words he would say to her, the deeds of arms he would do in her service."

But such matters aside (not that they can really be set aside), the biggest single formative influence on the future Ignatius Loyola was the time and place in which he lived. Nowhere else in Europe was the figure of the Christian warrior more esteemed and idealized than in northern Spain at the end of the fifteenth century. He represented the discovery and conquest of the world for Ferdinand and Isabella, and for Christ: Columbus's epochal voyage of 1492 took place in the same profoundly emblematic year that saw the destruction of Arabic power in Spain. The warrior, or Spanish samurai, perceived himself at the forefront of civilization, its exemplar and guarantor. But chivalry, as Iñigo came to realize, was an inferior state to holiness. "There is a fatal silliness at the heart of chivalry, a sentimentality which hides the true object of the ideal and . . . makes the discipline and ardor of the initiate a lie; the protestations of service were attempts at adultery, and the glorious deeds were the usual cruelties of warfare."

Iñigo de Loyola became "Ignatius" through a clerical error at the University of Paris. But his conceptions of chivalry and honor were entirely Spanish and he never, it seemed, contemplated any other life. There is much to suggest that he was a rake, devoted to his own sexual prowess—but this, too, was part of the Spanish samurai ethic, and it did not contradict his growing penchant for Christian mysticism. However, the great and radically transforming event of his life was military. It came in 1521, when he was leading a force of troops from his native Guipúzcoa against a French army twelve-thousand strong, at Pamplona, in Navarre. A French cannonball cut him down, smashing the bones of his right leg. The merciful French officers repatriated him home, and there his convalescent sufferings began in earnest.

They were atrocious and long. But characteristically, Iñigo insisted on them. He had the doctors break and reset his leg twice, so that he would not come out of war as a pitiable cripple. (It healed, after a fashion, and Ignatius demonstrated this by walking, or hobbling, the several thousand kilometers from Manresa to Rome and back again, a journey which I would hardly contemplate in a car.) There was very little for him to read at home during this interminable convalescence, so Ignatius had to make do with two texts—a pious but intellectually worthless fourteenth-century life of Christ, and an equally dull compilation called *The Golden Legend*. But out of this, and his own formidable inner resources, Ignatius was able to redirect his own knightly ambitions toward a spiritual end. The eventual product of this was his singular book the *Spiritual Exercises*, which since its first publication in 1548 has wielded an enormous influence over serious seekers of enlightenment within the Catholic Church.

It was on this ethic of sacrifice, confrontation, scholarship, and, above all, obedience that Ignatius founded his order dedicated to the promulgation of Jesus, the Jesuits, which in a hundred ways formed me and every other boy who came under its sometimes cruel, often bewitching, and always challenging spell.

The Jesuit order was a reform movement. It is not easily appreciated, in these days of (relative) religious tolerance between the various Christian sects and movements, how the Protestant Reformation threatened the Roman Church, or how menaced the Roman hierarchy felt by the emergence of Martin Luther. Ignatius Loyola was one of the first people to appreciate

that if the Catholic Church went into denial, and failed to grasp how its continued existence would depend on its capacity for self-reform, then it would certainly be gravely damaged and very possibly doomed by this unprecedented threat from the North: that Protestantism was not merely a revolt, not just a new heresy to deal with, but a potentially immense revolution.

To oppose the threat, Ignatius saw, the Church would need to purge itself of internal abuses, newly affirm and practice its disciplines, and admit that its weaknesses were of its own making. This would not just be a matter of the upper hierarchy—cardinals, archbishops, and monsignori—cleaning up its act. It would mean a far-reaching intellectual revision that started with the education of the young. Ignatius envisaged a cadre of priests, whom he called the Jesuits, dedicated to the original convictions of Jesus rather than to the power and swollen glory of sixteenth-century Rome, whose task would be to train other cadres—the young. There was not going to be any argument or debate about this. The Church must be remilitarized. Obedience had to be the paramount virtue of Catholics, both lay and clergy, as Ignatius stressed in letter after letter. And that obedience, as under military command, had to be blind. "What the superior enjoins is the command of God our Lord." One must "proceed blindly, without inquiry of any kind, to the carrying-out of the command, with the prompt impulse of the will to obey." If your superior tells you to walk on water, you must go in without even wondering if you will sink. A disciple of St. Benedict, on being told to bring back a lioness, "took hold of her and brought her to his superior." The Abbot John showed Ignatian obedience when, on command, "with great labor he watered a dry stick throughout a year." And even if you do what your superior orders, there must be no murmuring or doubt: "Though outwardly you fulfill what is commanded, this is not the true virtue of patience, but a cloak of your malice."

"Tough love" hardly summarizes the Ignatian code. Such prescriptions were, one may safely say, a long way from any known educational or social theory. They did not make for easy schooling. Ignatius, not to mince matters, was a scary genius as well as a scholarly one, and the Church could hardly have found a better spearhead—reluctant as it was, at first, to accept it—in its coming struggle against Luther and the Reformation, which became known as the Counter-Reformation. He thought of himself, and of others who joined his new order of Jesuits, as apostles rather than priests;

they had no dress code, did not even wear identifiable "habits," like the Franciscans or the Dominicans, and they did not go in for the splendors of High Mass. "We are not monks!" exclaimed the early Jesuit Jerónimo Nadal. "The world is our house!" What was more, instead of pursuing ideas of general education for rich and poor, Ignatius made sure that his cadre of teachers would concentrate on secondary education for the children of the well-off and the powerful. That education would not be highly theoretical, though of course it would be soundly underpinned by theological argument; but Ignatius did not care about metaphysical speculation. It was for others to bicker, if they wanted to waste their time that way, about how many angels could dance on the point of a pin. The Neoplatonist component in Renaissance philosophy hardly seems to have touched him at all. He was only interested in what was palpable and concrete, in representations that the body could recognize, in images of pain and victory. Hence the extraordinary power of his *Spiritual Exercises*, which are to meditative prose what Caravaggio's realizations of the body were to the art of painting or Bernini's would be to sculpture. If you didn't feel something, you couldn't know it. There was nothing dry or abstract about St. Ignatius.

He and the order he founded were emblems of a Christianity that was argumentative rather than contemplative, that didn't have truck with heretics and wouldn't take maybe for an answer, and that saw the world as a merciless theater of unceasing struggle, governed by Intellect and the Sword. Everything must be "offered up" to Christ, either as a gift of praise or as a sacrifice: Ignatius' motto was *Ad maioram Dei gloriam*, "To God's greater glory," and its abbreviation A.M.D.G., which one sees at the head of the page in which Ignatius is writing in one of his better-known portraits, was the invocation we schoolboys were expected to write on each page of our exercise books, sometimes with the less powerful J.M.J. ("Jesus, Mary, Joseph") at the end. Our school motto was taken from Ignatius' writings: *Quantum potes, tantum aude*, "Dare to do the utmost you can." We were taught inspiring, and entirely true, stories about the wide heroic spread of Jesuit missionary work; about the travels in Japan of his right-hand man, a resolute and brilliant Navarrese nobleman named Francisco Javier (known to us as St. Francis Xavier). Songs we chanted were somatic, dealing constantly in images of the body, the better to focus on delights and wounds. Some were taken directly from his *Meditations*, set to music: "Soul of our

savior, sanctify my breast / Body of Christ, be thou my saving guest. / Blood of my Savior, bathe me in thy tide, / Wash me with waters gushing from thy side." Such hyperbole was tremendously affecting: the only parallel I can think of in Christian usage was, perhaps, the extreme and ecstatic language of early Methodist hymns. One can glean a general idea of the state of mind to which Jesuit education sought to acclimatize us from the hymn that four-hundred-plus pupils used to sing in the Riverview chapel:

> *Faith of our Fathers, living still,*
> *In spite of dungeon, fire, and sword—*
> *O how our hearts beat high with joy,*
> *Whene'er we hear that glorious word—*
> *Faith of our fathers, holy Faith,*
> *We will be true to thee till death.*
>
> *Our fathers, chained in prisons dark,*
> *Were still in heart and conscience free!*
> *How sweet would be their children's fate,*
> *If we, like them, could die for thee . . .*

And so on. If you thought about it, the prospect that any of us good little upper-middle-class Catholics were ever likely to undergo dungeons (did we have any in Australia? Surely most of the existing prisons were at ground level, or on the second floor?) and the torments of martyrs (unless, of course, the Commies of North Korea came sweeping down in their junks and took Bondi, which could happen, you never knew) was fairly remote, but attitude was all. And it was not for us to get mixed up in the intricacies of geopolitics.

It is perhaps worth recalling that medical treatment at Riverview seemed to be based on the practices of St. Ignatius' doctors. You had to be tough to survive it. There was no resident doctor; instead we had a matron, Matron Meagher, an Irishwoman of almost incredible meanness and narrowness. She is said to have had a kind heart somewhere under that curved, icy bolster of starched linen, but I never saw it. Once I was accidentally (I think) bashed in the face with a cricket bat by some absentminded lout practicing on the sidelines. Streaming blood from a broken nose and half blind with pain, I collapsed and was carried down to the Infirmary, where the matron was

waiting at the door. "Don't bleed on the linoleum, Hughes," she snarled. "I've just waxed it." Despite the Ignatian stoicism the school encouraged, this did seem a little over the top.

Her idea of medicine was to treat the sufferer, no matter what was wrong with him, with large doses of purgative salts, and as a matter of fact this often worked, if only because most of the boys were so terrified of the explosive liquefaction of their bowels and the wretched stains of pale-brown shit on their pants that they would only join the sick line as an absolute last resort.

It was particularly awkward if you happened to get a tick, of which there were countless millions in the scrub around Riverview. For often the tick would fix its mandibles in some part of your penis. All Catholic Australian boys were circumcised—I never saw a foreskin until I left Riverview and, come to think of it, we would all have been in big trouble from the Germans if World War II had been lost—so at least the ticks were denied their natural refuge. Still, they were hard to dislodge, and often you had to go to the matron, who would glare with Medusan hostility at your willy and prod it disdainfully with a wooden tongue depressor. Sometimes, given the sensitivity of teenage libido, this would provoke an erection: looking back on it, it seems barely credible that any creature, even a sexually inflamed howler monkey, could get a hard-on within a mile of the supremely anaphrodisiac Matron Meagher, but it happened, and when it did she would focus her pale gray eyes on your face and exclaim, "You *filthy* little boy! Report to the Father Rector at *once!*" And off you would go, tick and all, only to be sent back by the puzzled priest. Then Matron would pull out the tick with her tweezers and drop it, with a hint of a flourish, on the Formica table, dab on some Mercurochrome (the purple stain a striking contrast to the quailing and pallid flesh of the rest of your inconsequential dick), and with triumph produce the flask of salts.

The Jesuits plied us with the mandatory claptrap about "just wars"— though they were not actually as far to the right as my brothers, especially Geoffrey, who in the extreme ideological heat generated by thermonuclear energy was sometimes given to opine that it would be better for the human race to perish than go Communist. (Better for whom, if there were no human race? The cockroaches that would inherit the denuded and radioactive earth?) We were taught that the state had every right to hang people,

and that birth control was a sin only a fraction less heinous than murder: if you practiced it, the unsophisticated version ran, you would be slaying countless millions of spermatozoa, which after all had their own right to life. The sophisticated version got rather abstract about the matter, claiming that sexual intercourse had both a primary purpose (propagation of the species) and a secondary one (pleasure). To frustrate the former in the interest of the latter was to invert the proper order of priority, a perversion of Nature so grave as to constitute a mortal sin. This was perhaps the most extreme form I ever heard of the casuistry for which Jesuits were held in bad repute.

But the big enemy was Vice, vice in its most accessible form, which was not murder or usury or card-sharping, but sex. This preoccupation played on our own horny confusions to such an extent that Riverview must have been one of the few places in Australia, or the world, where in 1953 it was still thought that masturbation (apart from being a mortal sin for which, if unshriven, one went to Hell) caused a loss of "vital fluid" from the spinal column and led to paralysis after sixty, assuming you got that far.

Since I had the utmost difficulty in keeping my sinful left hand off my cock, I was plagued by prophetic visions of myself with my spine bent into a quavering S in onanistic old age, driveling helplessly from the corner of my mouth and looking like a cross between the once handsome Dorian Gray and a spawned-out salmon. A rumor spread among the boys that it was mortally sinful even to have an erection, or to be seen with one; thus, before one scampered to the communal shower rooms first thing after getting out of bed in the morning, one often had to rush to the lavatory and, in the privacy of a cubicle, reduce one's willy to manageable size by pouring cold water over it from a tooth mug.

I was filled with guilt. Shame was the air I breathed. The unpredictability of this pink alien snake between my legs, which would rise up like some fakir's cobra in an Indian market when I was thinking about cricket or the turkey on St. Patrick's Day or even about God, suggested that half the world had been created by an evil principle and that I was, irrecoverably, damned. Looking back on my teenage self from the eyeline of a sixty-five-year-old man, I am of course intensely jealous of that disappeared sixteen-year-old boy who couldn't *not* have an erection. All dressed up on Saturday night and nowhere to go, except for the somewhat monotonous but reliable company of Mrs. Hand and her five ever-willing daughters. I would go to Con-

fession and confess to lust. But I knew quite well that I couldn't promise the priest in the confessional that I would stop having impure thoughts, and that, since absolution could not be received without the intention never to sin again, I couldn't fool myself, still less God, and nothing would be forgiven me. I was confused and shy, and my attendances at Confession dwindled.

This put me in a dilemma. Not to confess once a week, as everyone else did, implied either (a) that you thought you were sinless, and hence that you suffered from a bad case of spiritual pride, or (b) that you were deliberately rejecting the sacrament of Confession and the grace that it conferred.

But at the same time, I couldn't bear to enter the confessional, because I thought my sins were past redemption. I was like someone who had gone for a ride in a taxi without the money for the fare, watching the numbers clicking inexorably up on the meter. God swelled grotesquely, vengeful and all-seeing as a police inspector, angry as an insulted father.

And it got worse. Though you might stop going to Confession (it was a semiprivate act), you couldn't stay away from Communion, because other kids and the priests would certainly notice. To stay behind in the pew instead of queuing up to the communion rail amounted almost to public apostasy, since most of the boys were daily communicants (damn their virtuous hides); so I had to join them. Thus I found myself repeatedly shuffling to the rail and kneeling to receive the peculiarly flat and brittle taste of the unleavened Sacrament on my tongue: *Corpus domini nostri Iesu Christi custodiet animam tuam in vitam eternam, Amen.* Every time I did this I was drumming with a thousand devils, coldly aware that I was about to consume the body of Jesus Christ while in a state of mortal sin. *If the chapel roof falls down now, I will go straight to Hell, not passing Go.* What a dirty self-discolored little wanker I am. Polluting the sacred temple of my body like a country dunny.

I couldn't see how to go forward from this pickle, or claw my way backward out of it. In an effort to get myself into the state where I could go to Confession again (which I never actually did; that round certainly went to Old Scratch), I started taking a passionate and show-offy interest in Catholic history and apologetics. This was an appetite the Jesuits were abundantly qualified to satisfy, even though it was half fake. I pored over Aquinas, St. Augustine ("To Carthage then I came, where a cauldron of unholy loves sang all about mine ears"—yup, that sounded familiar, much as I would have preferred a real unholy love to a notional one), commentaries on the

Bible, Aristotle, and the lives of the Desert Fathers. I became obsessed with G. K. Chesterton—not such a bad training for a young writer, discounted and ignored though that great essayist may be today—and scribbled essays in his manner, full of paradoxes and stolen phrases like "the chariot of the Faith thundering down the centuries, the dull heresies sprawling and prostrate, the wild Truth reeling but erect." (Wild, Catholic, and erect: that's me, Father, under the acne. Ooo, yes.) I imitated Hilaire Belloc, coarse old stomper that he was—not the sentimental dogmatism and not the anti-Semitism, but rather the astonishing skill of his satirical verse, for nasty though it is in places I still think his attack on Cecil Rhodes and the African Imperialists in *The Modern Traveller* (embedded in which are the deservedly immortal lines 'Whatever happens, we have got / The Maxim gun, and they have not') was and still is one of the masterpieces of politically incorrect English satire.

I even wrote some verses of my own, on my way to discovering the deep, discouraging truth of Paul Valéry's dictum that "To be a poet at eighteen is to be eighteen. To be a poet at forty is to be a poet." It was fairly dreadful, pious verse, inspired by the report that Edmund Hillary had left a small plastic crucifix on the summit of Mount Everest in 1953 ("The ancient gods of Everest have fled," etc.)—but it won a schoolboys' poetry prize judged by the distinguished and sardonically conservative Catholic poet James McAuley, coauthor of the great literary forgery of the twentieth century, the Ern Malley hoax, who for some reason didn't see through, or chose to overlook, its pretensions. The habit of writing nakedly derivative poems, largely plagiarized, would stay with me till university, where it got me into trouble, and embroiled me in scandal; if there is any defense to be made, it is that we mainly learn by imitation and it taught me something about the construction of verse. But not enough. No poet died in me.

One or two of the Jesuits hoped otherwise. One of them suggested that, since Riverview had plenty of rousing hymns but no school song, I should write one. It was my first commission, or could have been; it piqued me for a moment, and then the feeble impulse, generated by adolescent vanity, died because I realized that I didn't have strong enough feelings about either the school or its sense of religious mission to carry it through. I can only think of this with relief, since the idea of two or five decades' worth of Australian Catholic schoolboys chanting an institutionally preserved song that celebrated the values I long ago abandoned, and perhaps never truly espoused,

repels me. There are some albatrosses no young neck deserves, and this was one of them. Instead, one of the priests—I have no idea which one he was, or how long his composition remained in use—produced a chant which ran:

> *O here's to Alma Mater,*
> *Our mother kind and strong.*
> *Come gather now around her,*
> *And lift your voice in song:*
> *View, view, view, view,*
> *Alma Mater, view,*
> *Riverview!*

The successful lyricist must not fear banality, and this one was indubitably brave. Whether his ditty is still sung on the banks of the Lane Cove River as it was half a century ago in 1954, I have no idea. I would prefer to doubt it.

Anyway, the Jesuits were somewhat appeased by my unlikely outbreak of teenage intellectual piety, but they were suspicious. "Robert's intellectual interest in the truths of Catholic doctrine is admirable but does not seem supported by simple Faith," one of them perceptively noted on my end-of-year report. "I suggest a prayerful reading of the *Imitation of Christ*." Father Jones, the scholarly flogger, was more sanguine. He made me captain of the school debating team, which changed my life incomparably for the better: up to then I had, unlikely as it seems looking back on it from my present volubility, a humiliating stutter. Sometimes I could hardly get the words out. By forcing me to get on my own two feet and speak in public, like teaching me to swim by throwing me in the deep end of the pool, Jonesy did me a colossal though draconian service for which I was, am, and always will be grateful. He plied me with tomes on Greek and Roman history, got me reading Gibbon (a delectable stylistic adventure), made me pick up some economic theory (for which I had no aptitude), and prodded me to read the first book on art I remember approaching, *Creative Intuition in Art and Poetry* by the French Thomist Jacques Maritain. I don't remember Maritain's arguments but I do vividly recall the (incomplete) pleasure of the snippets of modernist poetry, from Eliot and Apollinaire to Randall Jarrell's *Death of the Ball Turret Gunner,* that he used to illustrate them. They seemed to disclose edges, corners, and fragments of a whole world, buried from me and awaiting my ecstatic, unsystematic unearthing. There was no hint of these riches in my

father's library. Surrealist conjunctions seemed quite simply magical, though I couldn't decode them:

> *Les savons*
> *Les neiges*
> *Le rire d'un cheval sauvage*
> *Sortant nu du chez le barbier . . .*

"The soaps / The snows / The whinny of a wild horse / Issuing naked from the barber's shop"—who wrote it? René Char, maybe? I don't recall, but I had never heard of him anyway. What did such things mean? No idea. But I had already sensed their value from reading such totally disparate things as *The Hunting of the Snark* and Shelley's "Adonais"—the transformative value of word-magic.

Gerald Jones also put my feet on the next faltering step toward a serious interest in art. The year was 1954; the occasion, an exhibition at the Art Gallery of New South Wales, Sydney's museum. I don't remember its title but its subject was abstract painting in Europe. Very uncharacteristically, a small bunch of senior boys was rounded up by Father Jones and taken, dragging their feet, to see it. Everyone, including myself, thought it was some kind of a joke—all those dots and splots and swipes and squares by artists whose names none of us knew. One painting in particular stood out. It was a rough square of brown burlap, not even—which struck me as peculiarly offensive—covered in paint, just daubed with it in places. It had a spidery black star, like a tarantula's asshole (I cleverly thought), and some patches of red. Its main motif was the numeral 47, painted in black in a funny-looking cursive script. It was signed by someone called Miró. That, I thought, can't be art. "That can't *be* art," I said to Father Jones. "It just isn't art." "All right, Robert," he replied, "if that isn't art, then why don't you tell me what art *is*." For the first time in my life, I started thinking about that question; and so, in the end, I owe my career to Father Gerald Jones, S.J., and to Joan Miró.

Modern writing, modern art: I was fifteen going on sixteen, and I didn't know how it all went together, if indeed it did or could. But it was so exciting!—so much more so than school football, a game I hated, one which I still get an active pleasure and a feeling, almost, of illicit escape from not having to watch. Not only was I no good at team sports (except for cricket, in which I had a tiny sneaky talent as a left-hand spin bowler) but I had no

impulse to watch them or follow the teams. What did I most like to play? Ping-pong, and billiards, neither of which required cooperative masculinity.

Jonesy wasn't my only stimulus, though it was mainly through him that I came to see the pleasure a good teacher takes in the light in a pupil's eyes. There was also Father Fraser, who took us for Latin and Greek. I liked and admired this controlled, scholarly man immensely. He had an elegantly ironic sense of humor, and a dry way of praising your work if you did it well that left you, not self-satisfied, but keen to do more. His standards were exacting but they did not make you feel left out or threatened by exclusion.

Only once did I ever see Father Fraser blow his cool. This happened one morning in 1954 when, in the middle of steering his small Greek class through the paradigms of *luomai*, he glanced through the window and to his horror saw, three stories below, one of the school's cows serenely munching on the rosebushes he had cultivated and assiduously manured around the marble statue of Jesus clutching a burning white tomato, his Sacred Heart. Father Fraser froze. Galvanized, he rushed from the classroom. There was a .32 Colt automatic in a desk drawer of one of the administrative offices. None of us associated this weapon with Father Fraser and it probably hadn't been fired in years, until some minutes later, on the ground below, he appeared foreshortened, pointing it at the cow. His voice floated up to us. "Get away from my roses," he said. The cow kept munching. "If you don't leave my roses alone," Father Frazer enunciated, with pedantic exactness, "I will shoot you." No response from the cow. And then, unforgettably, a flat medium-caliber bang as the priest stuck the barrel close to the cow's ear and squeezed the trigger. The poor animal keeled over and kicked a few times, crushing most of the remaining rosebushes. Then it was dead, and Father Fraser marched victoriously back to the school building, jamming the pistol in his waistband.

Though Father Fraser was an excellent Latinist, he didn't have the long-term effect on me that his colleague Father Wallace did. Fr. Wallace was the headmaster of Riverview, and its English Honors teacher; I was his star pupil, and he favored me—outrageously, in the view of some other priests. Naturally, I took to this favoritism like a duck to water. Father Wallace gave me an extraordinary degree of liberty in reading. It didn't matter, for instance, that W. H. Auden and Christopher Isherwood were homosexuals and Communist sympathizers as well: he had me reading *The Ascent of F6*,

The Dog Beneath the Skin, and *Letter to Lord Byron* (as well, naturally, as much of Byron's own poetry, not just "Roll on, thou deep and dark blue Ocean, roll" but many of the more risqué passages as well. He encouraged me, without threats, to memorize poems, often quite long ones; years ago I could recite the whole of Shelley's "Adonais" without prompting from a book, and I may have been the only sixteen-year-old in Sydney who knew *The Waste Land* word-perfect and by heart—if anyone didn't believe it, moreover, I could and sometimes did punish him by beginning with "April is the cruelest month" and keeping on until the impious wretch begged for mercy. This usually happened when he had begun to recover from his surprise, somewhere around "What are the roots that clutch, what branches grow / Out of this stony rubbish?"—a line that brought to mind parts of the Australian bush.

I also memorized long stretches of Shakespeare and short ones of Marlowe: all of *Macbeth* and *Julius Caesar*—for in school play productions I had played the parts of both Brutus and the gloomy, guilt-ridden Scot—and even bits of *Doctor Faustus* and *Tamburlaine*, especially that sublime and terrifying soliloquy that precedes Faustus' descent into eternal Hell—"See, see, where Christ's blood streams in the firmament!" I am certain that none of this stuff would have stayed with me if television had existed in Australia then. There is no doubt in my mind that in cultural matters, at least among impressionable teenagers, bad money does indeed drive out good. Hang me for a filthy elitist, but it's true. Which is why I cannot feel much more than a regretful contempt for those goggling children with beards and with breasts who spend their evenings screeching at *American Idol*.

Father Wallace gave me further cause for gratitude. It consisted of letting me read, encouraging me to read, books that decidedly weren't on the menu for Catholic schoolboys; even books that were actively forbidden, and probably would have featured on the *Index Librorum Expurgatorium*, the Vatican's list of banned books—although, since Rome had only lately got round to banning Immanuel Kant, it would obviously be some time before it reached William Faulkner or that peculiarly mushy staple of wartime American art porn, *This Is My Beloved*. Neither, I hasten to add, was supplied to me by Father Wallace, but he did begin, as if inducting a postulant into the Eleusinian Mysteries, to lend me books. He lent me *For Whom the Bell Tolls;*

and what's more, when I asked him what that stuff about the earth moving meant (to me, it suggested a tractor), he painfully and scrupulously told me. Much later, when at last I got round to real girls, I tried calling some cute virgin from the Sacred Heart Convent my *conejita*, little rabbit, but this borrowed endearment got me nowhere: she was a grazier's daughter, and in rural Australia the rabbit is lower on the scale of being than a rat. Screw you, Ernest. Very daringly (he must have trusted me more than I deserved), Father Wallace also lent me an anthology of James Joyce which included much of *Portrait of the Artist as a Young Man* and the sublimely delicate, ravishingly sensuous "my breasts all perfume yes" monologue from *Ulysses*, which I read and reread as a music student might listen repeatedly to a favorite aria, carried away while worshipping control. It was from Father Wallace and the examples he showed me that I learned the great lesson that all postulant writers must learn: that no matter what the demands of "self-expression" may be, nothing is anything without fully articulate, conscious form. In my soul this would fight for years with the hostile, nervy freedom from parental and religious authority embodied by Surrealism, but it would win in the end, thereby setting me free to be a writer.

And then, like an idiot, I left James Joyce on a bench beside the ping-pong table in First Division.

When I came back for it, it had gone.

That night, there was a summons to the study hall. Father Drury, who had charge of the boys in First Division, a lean Savonarola with glittering pince-nez and glittering eyes behind them (my mental picture of Coleridge's Ancient Mariner is still inflected by Father Drury), a strength-through-joy enthusiast and a flogger, addressed us:

"Boys, today I have made a disgusting discovery. One of the boys in this Division is a reader of pornographic literature. Filth! Filth! I will not expose him to the humiliation of naming him in public, though he deserves it. I shall merely advise him to come to my study at ten this evening."

"Aha," I thought. Someone had been caught with a copy of *Man Junior* in his locker, one of Australia's rare and, by today's measure, mild masturbazines, featuring amateurish photographs of the sort of girls you saw in suburban milk bars. It happened all the time. That and cigarettes. I dismissed the matter from my mind and went to bed.

At 10:05, Father Drury stalked into the dormitory and stood at the foot of my bed. We looked at one another. Father Drury said nothing. "Goodnight, Father," I said.

"Is that all you have to say?"

I could think of nothing else.

"I have been waiting for you, son," said Father Drury, "for exactly five minutes."

"Oh?" I felt stupid.

"I am not disposed to this," Father Drury snapped. "Come to my study at once."

I scrambled into my dressing gown and shuffled after him.

Father Drury closed the door of his study, an ominous gesture, since closed doors often preceded a beating. He sat down, steepling his fingers. I remained standing.

"Presumably," he said silkily, "you are under the impression, Hughes, because of the powers of your intellect, which are greater than those of the Fathers at this school and, indeed, superior to the wisdom of the Church, that you have the right to defy authority and corrupt your fellow pupils." When Drury spoke, he spoke in *prose*.

But a fearsome thought occurred to me. *My God, he thinks it was me that stuffed young Darcy.* "I don't follow you, Father," I said shakily.

"Indeed? Have you nothing to say?"

"Well, if you'd tell me what this is about—"

"It is about literature, Robert. Literature. Your reading habits." He opened a drawer and produced Father Wallace's copy of the James Joyce anthology. "I take it that you recognize this?"

Relief flooded me. "Oh, yes, that's James Joyce, Father, that belongs to—"

"I am not concerned with its owner, Robert. The object of my enquiry is to determine how you could bring yourself to import this—*filth!*—into the school and then have the effrontery to leave it on a bench where anyone could pick it up. Before I punish you, I should like to *know*."

"Father Wallace lent it to me."

"You are a liar, Robert. You have frequently lied to me in the past. I now intend to teach you that nothing is gained by lying." The end of the Strap, blunt and black, peeked from the sleeve of his soutane, like a snake in a hol-

low log. That was where Jack Drury always carried his Strap, up his sleeve, ready to hand. Lightning-draw McGraw.

"Ask Father Wallace."

"Father Wallace is now in bed."

"Well, ring him or something, Father, I mean, honest—" I had begun to babble. Pornography, six on the bum, and it was a cold night.

A crinkle of doubt appeared in his forehead. "Wait outside." He reached for the telephone. I glued my ear to the door but could hear nothing. At last the door opened. "Get back to bed, Hughes," Father Drury snapped.

"Can I take the book, Father?"

"You may not. I will return it to Father Wallace myself. You are plainly irresponsible."

He did so. The next day, Father Wallace summoned me. "I think," he said, clearing his throat grumpily, "that you had best regard Father Drury's rebuke as proper under the circumstances. You haven't left that copy of *Sweeney Agonistes* lying around, have you? Thank heaven for small mercies. Just don't. You may go."

In my next-to-last year at Riverview, my life became immensely complicated by something I couldn't deal with at all, or talk to the priests about.

I began to lose my belief in the reality of God, the axis that held the whole system of Catholic cognition and discipline together.

What was worse, I didn't feel particularly guilty about it.

When I looked at a consecrated Host, I saw bread where others saw Jesus. When I looked at the altar of the chapel, which others perceived as the dwelling place of Christ in his Eucharistic form, I just saw an ornate brass tabernacle and some candlesticks. It wasn't as though He had fallen off the altar with a crash, nothing as dramatic and soul-piercing as that. He had just faded silently away, done a dissolve, like the Cheshire cat in *Alice*, leaving behind only the grin of churchly ritual hovering in the incense-laden air.

It was an awful feeling at first, but one got used to it and it didn't seem so bad after a while, just so long as no one knew about it. This blocked me from discussing my Doubts (as they were called, with a capital "D") with any of the priests. The result of this was that I began to find some aspects of Catholic doctrine and dogma absurd, not credible at all, and could not envisage any way of talking to my teachers about it. I felt very much alone, and although I have since become a great believer in the healing and focus-

ing powers of chosen solitude, there was nothing therapeutic about that loneliness—nothing whatever. At times it seemed designed to drive me crazy.

As near as I can fix it, the subject of my first experience of rupture with the Faith of My Fathers was a relatively new dogma: that of papal infallibility. Probably I would eventually have left the Church anyway, but the infallibility issue pushed me right out of it. Papal infallibility, a much misunderstood concept to which Protestants were understandably hostile, was "defined" as a dogma—that is to say, an "article of faith" that no Catholic could ignore or disagree with on pain of losing his or her immortal soul to the fires of Hell—in 1870. The reigning Pope was the notoriously conservative, anti-Semitic, and antidemocratic "Pio Nono," or Pius IX: not the worst pope in the history of the Church—a man would need to be a genius of misrule for that—but a very active and interfering one and very far from the best.

Infallibility, however, did not depend on the moral or theological capabilities of this or that Pontiff. It came, so to speak, with the job. Infallibility did not mean that Catholics had to believe that if the Pope said there was a mouse in the corner, it was there, or if he announced that the emperor of the Turks had horns concealed beneath his turban, then he had. But it did mean that when the Pope was pronouncing ex cathedra, "from the throne"—that is, from the highest level of papal authority—on an issue of faith and morals (not mere factuality), then God would intervene to protect the deposit of faith by safeguarding him, and the Church he led, from error.

In the nearly two millennia of the Church's existence, no previous Pope had felt the need to infallibly declare himself infallible, a most peculiar exercise in circular definition. The dogma of papal infallibility marks a special moment of anxiety within the Church, and in particular within the mind of Pius IX, who feared, hated, and wanted to suppress everything that could be construed as "modernism"—doubt, relativism, heresy, agnosticism: anything, in fact, that might have encouraged the faithful to argue back against a rigid authoritarian hierarchy. The penalty for doing so would henceforth be mortal sin, for which the punishment was an eternity in Hell.

This was to have quite implausible results when it came to questions of belief in Christ's mother, Mary, spouse of the Nazarene carpenter Joseph. Only two infallible "definitions" of any kind have ever been made, and both

were aimed to support her cult. Theologically, Mariolatry is pretty much an irrelevance. The Scriptures themselves have very little to say about her. None of the most heavily venerated aspects of Mary are either supported or contradicted by the gospels, in which she is the merest shadow; they are all later accretions, tacked on as the changing requirements, including political ones, of faith demanded. Certainly Christ did not make much of a point of his mother's sanctity: in Luke 11:28 we read of a woman crying to him, "Happy the womb that bore you," at which he shot back, "Happy, rather, are those who hear the word of God and act on it." There are indications in the gospels that Christ harbored a certain anger, or at any rate bitchiness, toward Mama. For all we know, Christ was a charismatic Jewish prophet—a type that swarmed in the Holy Land under Roman occupation—whom a Roman soldier sired on a girl in Judaea: this version of his descent was at one time believed by many people, and it can hardly be said to reduce the holiness of Christ. If he was a bastard, so what? Many saints and great men have been. If it is difficult to excavate more than a fraction of the historical Christ, it is flatly impossible to extract a historical Mary from the pious devotional overlays of two thousand years. When I was twelve or thirteen, an only moderately dirty-minded and not unusually skeptical preteen, the whole story about her hanging onto her virginity through all those years of matrimony with a Jewish carpenter seemed fairly unlikely, though this was not a thought one could have voiced in Religious Knowledge class. St. Joseph, whatever his woodworking skills, must have been an unimpressive wimp, a sexual retard. After all, as her husband he was entitled. Though Mary certainly existed, what can "she" have been? Nobody will ever know. She wrote nothing, said nothing and, in effect, was nothing—except a virtuous Jewish housewife who happened, against all the odds, to be and remain *virgo intacta*, even—a crowning absurdity—during and after childbirth. The cult of Mary remains one of the outstanding pieces of doctrinal flaccidity in the history of the Church, particularly since—to my generation, at least—it came wreathed and garnished in debased fairy tales like that of Fátima.

Pope Pius XII knew the answer or thought he knew it, and he was deeply interested in—not to say obsessed by—a minor part of the Marian legend, which he proceeded to inflate into one of the giant and pressing issues of faith: the fate of her body after death. It was, he believed, "assumed" in its entirety into Heaven, to save it the indignity of being left on earth to rot. It

was only "fitting" (but why, exactly?) that her virginity should be paralleled by immunity to fleshly corruption, and the dogma of her "Assumption" was devised to sustain this metaphor. What the dogma said was that, after she died, Mary's body as well as her soul was assumed, taken up, into Heaven, just as Christ's had been. It is a curious fact that this was, and still is, the only occasion on which the dogma of papal infallibility was used to support a statement by the Pope speaking from the Vatican, and make it binding on all Catholics everywhere. Henceforth, if you were told but didn't believe that the body of Mary went straight up to Heaven along with her soul, you were a heretic in a state of mortal sin, and could therefore go to Hell.

In the last half century neither Pius XII nor any of his successors made another solemnly infallible utterance about anything, although in recent years the coercively conservative Church has made much fuss over something called "virtual infallibility," a term invented by the present Pope Benedict XVI when he was Cardinal Joseph Ratzinger, ultraconservative advisor to the senile John Paul II, to denote practically any opinion on faith and morals uttered by a reigning Pope. But "virtual infallibility" means about as much as "virtual pregnancy." Either you are or you're not. Why the Assumption needed to be elevated into a dogma escaped me then and it mystifies me still. It was so unlikely, so parodical: this picture of a Jewish mother rising through the clouds to escape velocity, her blue robes fluttering madly in the airstream, and winding up as a physical body in a completely nonphysical space: the ultimate form of the Flying Nun.

> *Where did she go?*
> *Where the blessed Saints are, boy.*
> *And where had they gone?*
> *It's a mystery of faith.*

Surely this had more to do with parody than with belief, but the Australian Church did not think so. In the spurt of Marian devotion that followed the promulgation of the "mystery" of the Assumption, we were obliged to recite Hail Marys and utter Pious Ejaculations (not what you might think: a Pious Ejaculation consisted of uttering the name of a holy personage, like Jesus or Mary, in a spirit of reverence. This ruled out cursing if you banged your thumb with a hammer, which would have been an Impious Ejaculation). In the Marian name you were expected to say the Rosary as often as

possible, "offer up" your spasms of pain or inconvenience (like a sprained ankle or the bite of a redback spider, that diabolic arthropod of the Australian bush) to the Virgin to show her what a stoic cadet warrior of the Faith you were, and on public occasions march collectively around with a banner urging collective love of Mary. The Protestants must have thought we were superstitious nuts, but one didn't normally speak to Protestants anyway, so that didn't matter. In any case, as we were often reminded, mockery from Prots was a badge of honor, one which a soldier of Christ was expected to wear with equanimity.

What it is like for young Catholics today I have no idea. I think, or at least would hope, that many of them would have felt divided about that remarkable man the late John Paul II, on the one hand respecting his courageous stand against the disgusting orthodoxies of Russian Communism, but on the other being alienated by the dogmatic obstinacy of his refusal to admit women to the priesthood and his archaic objections to contraception, and puzzled by the vehemence of his saintmaking—even though his purpose in creating all these superfluous saints (more canonizations during his papacy than in the entire previous history of the Church) was so transparently aimed at gratifying the more superstitious areas of Catholicism in the Third World. The new papacy of his successor, Benedict XVI, who shows every sign of being a new *malleus maleficarum* in his suppression of thoughtful dissent within the Church, will only be a boon for its gauleiters like the members of Opus Dei. Perhaps if the Church continues to regard itself as superior to all other religions, closed to reform in its doctrine, it will pump up its charismatic appeal to the ignorant masses, whose increased supply is of course underwritten by, among other things, a ban on contraception. This was the subtext to John Paul II's policies and is one to which Benedict XVI is clearly committed.

Of course, as a teenager I didn't know and couldn't imagine any other kind of church. It was Rome or heresy. That great and humane Pontiff John XXIII was not yet elected; the second Vatican Council, with all its rationalizing and humanizing possibilities, had not yet been held—and it was to the repeal of this great event and the suppression of its reverberations that later papacies like John Paul II's were ruthlessly dedicated. Faced with so vast and authoritarian a structure of belief—and who was I, a teenager dragging his supposedly immortal soul around like an unwanted vermiform

appendix, to dissent from one quillet or codicil of this mighty mass?—I felt alienated and puzzled, cut off from what the Jesuits insisted on calling "the Living Body" of the faith. I had begun to realize what it was actually like to live among the devout, but with one's props kicked away. The fact that I was kicking them away with my own feet didn't make this any easier to bear. If my father had been alive he probably wouldn't have been any help. As far as I know, he had no particular critical or interpretative thoughts about Church dogma. Dogma was dogma, and different from mere doctrine, which was somewhat optional. Dogma was there to be believed. The authority of the Church, in which Dad believed entirely, reposed its mighty weight on it.

My elder brothers had no objections to offer, and in any case I didn't know them well enough—the gap between a fifteen-year-old and a twenty-five-year-old can be as wide as the Strait of Dover, particularly when they rarely see one another because of boarding school. They had been placed in loco parentis over me but it was a hopeless appointment: no brother can substitute for a lost father, and the effort to do so only destroys what should be a loving fraternal alliance and sets up in its place a distorted authoritarian one. (Years went by before I realized that, though elder brother Geoffrey was a pillar of piety and ancestor-worship whose faith never wavered for an instant, eldest brother Tom's attachment to religion was more formal than emotional.)

My dilemmas would only be seen as the self-inflicted ones of what Tom habitually called "a damn arrogant little prick," the term he tended to reserve for anyone his junior who disagreed with him. He was probably right about me, in a sense, but it wasn't much help.

I tried to compensate for my leakage of faith by preaching—a stratagem of virtue-on-parade which, I am sure, many Bible-thumpers and radical-right politicians in the grotesque theocracy of today's America have also resorted to. I could not, of course, get up in a church, but I used the oratorical and debating skills so patiently instilled in me by Gerald Jones, S.J., to join a lay Catholic Action group and preach in public in Sydney. The forum for this was the Domain, a large patch of grass between the Art Gallery of New South Wales and the Botanical Gardens. There, every Sunday, the "spruikers" (how did this Dutch term for "speakers" ever get embedded in Australian slang?) would appear, set up their soapboxes just like the traditional orators at Hyde Park Corner in London, and set off on their favorite

themes. It was a competition for the long-winded, the relentless, and the leather-lunged. Particularly the last, since in those days, the technology of microphones and portable amps was not available, or not in Sydney. You had to rely on the carrying power of your own voice, and mine, assisted with a few tricks learned from the Riverview elocution teacher, could and did carry, once it had fully broken and was in no danger of going squeaky. It could not compare with the booming and bellowing of a non-party Fascist named Webster, who could and did outshout anyone else in the Domain, but I was not in competition with him. I could drown out most of the Stalinists, Trotskyites, vegetarians, anarchists, and other loquacious weirdos who turned up in the Domain, but the especial target of my teenage animus was the radical Protestant women, who were (of course) mostly Northern Irish by descent and far to the right of the Rev. Ian Paisley. They sponsored a truly bizarre scandal sheet called *The Rock*, whose obsessive subject was the evildoing of the Roman Catholic Church. There was no convent or church or boys' boarding school in Sydney, or within fifteen thousand miles of it, that the Rock Ladies (as they were known) did not know for what it was, a den of vices unrivaled by Sodom or Lesbos. This gave rise to some splendid headlines: BEASTLY BROTHER IN BED WITH BOYS is the one I remember, which inspired a quatrain from one of my school friends:

> *Hail to these unhallowed joys!*
> *Beastly Bro in bed with boys!*
> *Ev'ry holy Roman knows,*
> *Boys are all in bed with Bros!*

There was nothing I could do to refute the wizened maenads who staffed the Sunday witness meetings of the Rock Ladies, and they had the advantage of hating us, truly and deeply. If one of Sydney's giant tropical storms had burst on us in the Domain, not one of them would have shared my umbrella. Their faith was pure and unwavering, as some forms of madness are. Mine, on the other hand, continued to crumble despite my ultimately futile attempts to bear public witness to it.

Help, of a quite nondoctrinal kind, came from a source just outside the family. This was the first sybarite and, as it was said in those days, "confirmed bachelor" I had ever met, a QC or "Queen's Counsel," meaning a senior and high-paid attorney who had "taken silk"—applied for and

received the professional honor whose symbol was a particular kind of black gown and, for wearing in court, a full-bottom wig. Anthony Larkins, QC, or, as we all knew him, Larko, was somewhat older than Tom (whose affectionate mentor he had been) and twenty-five years older than me.

Larko was in certain respects a character straight out of Wodehouse. He was a dandy, favoring striped trousers in court, an oyster-colored waistcoat, and perfectly polished, narrow shoes. He was the only man I have ever known who actually possessed a pearl-gray topper, which he had no hesitation in wearing on ceremonial occasions. He sported a gold-rimmed monocle and had mastered the art, more difficult than it seems, of letting it fall from his eye on its black baize ribbon at a precisely chosen moment of feigned incredulity or at the climax of an anecdote. Larko had the knack, possessed by very few then and probably no one in Australia now—it looked distinctly old-fashioned even in the early fifties—of making the deployment of the monocle seem as natural as putting on a pair of spectacles. There was almost as much art to it as to the management of the fan in the eighteenth century.

On one level, the first you saw, Larko had imperturbably good manners and was never at a loss in any social encounter. On the next level down, he was extremely shrewd and astute about human motives, and a skilled cross-examiner in court: less aggressive than Tom, with a silken and underplayed forensic manner. Sometimes, during school holidays, I would attend court and carefully note Larko's technique. He was very much a snob, given to bore on about meeting this duchess or that countess on his various trips to England. Nobody minded this mildly ridiculous habit; it was just Larko being Larko. He spoke a little French, but used it mainly on waiters who, to everyone's mutual confusion, turned out to be Spanish or Polish; he liked fancy terms, so that in a restaurant, instead of asking about starters or hors d'oeuvres, he would enquire about *amuse-gueules*. He loved silly, weak puns. He was the kind of person for whom those Edwardian editions of *Punch* in my father's library might have been created. Although he wasn't rich, he lived rich, with his own tailor, his buttoned leather armchairs, a Daimler convertible and a live-in manservant, a stolid Lithuanian named Pranis, who was known behind his back as Penis. Larko never married, had no girlfriends, and liked to hang out with elderly matrons and widows—he was, in short, a quintessential walker, with an enormous fund of gossip which, how-

ever, he would only reveal circumspectly. He was vehemently loyal to his friends, even when they were people one found unendurably brutal, officious, or tedious, like the coarse, vindictive Packers.

But loyalty, with Larko, was a matter of paramount principle; in this, he was extremely Irish. He might be loyal to some people I feared or loathed, but no matter: he was also loyal to me. All kids crave the approval of their elders, and though my father was dead and I was unlikely to win it from my brothers, I got it in full measure from Larko. This was one of the elements in my nervous boyhood and hot youth that did most to form me. To have someone who *approves* of you, in contrast to the it's-for-your-own-good censoriousness emanating from the male elders of your tribe—that was no small thing. His performances in court, added to Father Jones's debate coaching in school, awoke and encouraged in me a sense of rhetoric and measure. When I was fifteen and he forty, he was the only adult I knew to whom I could talk on level terms, who laughed at my jokes (even the smutty ones) as I did at his, and who was actually prepared to let me drink a glass or two of wine with him. I could never have done that with my blood relatives, and if my mother had known about it she would have gone bats with anxiety, but I still think these innocuous glasses of Tío Pepe, Veuve Clicquot, or '53 Château Tahbilk (spirits, never) inoculated me against alcoholism rather than fostered it. I loved to play golf with him, whereas the idea of playing with either Tom or Geoffrey was unthinkable: they were too good at it, and were martinets about the strict rules. Larko, on the other hand, though not wholly inept, was as poor a golfer as I and didn't give a dried fig for the rules. He would improve his lie or even kick his ball out of the rough without the slightest hesitation, and encourage me to do the same. This made our days together at Royal Sydney or the Elanora Country Club wholly enjoyable.

We went to restaurants together. It was in his company as an early teenager that I first ate steak Diane (an overrated dish, prepared by the maître d'hôtel in a chafing dish and flamed with brandy beside the table: more theater than food), oysters Rockefeller, and chicken in aspic. This was certainly a change from the fatty chops and rubbery blancmange of the Riverview kitchen, or the only somewhat more palatable cooking of my mother. I cooked for Larko at home, and he showered my clumsy dishes with praises they did not deserve, interleaved with discreet suggestions about their improvement.

We talked a lot. He had been raised a Catholic, and, like me, educated at Riverview. He was decidedly not a practicing Catholic, but he made no fuss about apostasy. He seemed remarkably relaxed about this, as he was about most things, and his gentle agnosticism showed me a way past the knots and inner sorrows of my own continuing loss of faith. He provided me with an escape hatch from the demons of youth, the inculcated guilt. For that especially, I will always be grateful to him. Larko died long after I left Australia. "You saw," I wrote to him in 1992, as he was failing,

> *that there would never be a shortage of people with reasons to rebuke me, and instead forgave me my follies and stupidities, which were many; and in general you helped me become what I now am. I don't believe a harsh word passed between us in all those years. You are a fine example of pigheaded Irish loyalty. How could I not think of you with love, now and in time to come?*

And I reminded him of a haiku by Basho:

> *Though it will die soon*
> *The voice of the cicada*
> *Shows no sign of this.*

At the end of 1955, I left Riverview and I would not visit it again for a quarter of a century. I felt no old-school nostalgia and made no effort to contact those I had been at school with, not even my best friend, Christopher Flynn, whose company I had not been able to do without. I was threatened with expulsion for disobedience and impertinence, but I lasted the course. The Leaving Certificate results showed that Chris Flynn had come first in the state in aggregate marks and first in Latin honors, while I had come fifth in aggregate and first in English honors. I had won two scholarships to Sydney University. I don't know how many Chris was awarded, but he didn't need them anyway—his parents were very rich, whereas my mother lived, in effect, on a fixed-income pension. So she needed me to have those scholarships, and I lost them. Overcome, on enrollment in the Faculty of Arts at Sydney University in 1956, with the sudden delicious absence of discipline

and the Strap, girls and beer everywhere, nobody to tell you when to work or punish you for not working, I hardly worked at all. I managed to fail Arts I, a course that a moderately intelligent amoeba could have passed without special coaching. I lost both scholarships at once. The roof fell in. When the recriminations were over, my brothers generously helped to take up the slack, and pay for my lost education fees—a pittance by American standards today, but not a trivial sum then.

There was no mystery about failing Arts I. Anyone can flunk anything if they do no work, and that was what I did. I cut lectures. I stayed away from seminars. I spent the minimum possible time in the Fisher Library and, when I handed my essays in at all, they were late and bore few signs of committed reading. I was even bored with studying English, though mainly what I wanted to do was write.

My whole relation to the Faculty of Arts was so absurdly tangential that I need not have gone to the university at all, except for one thing: it offered a whole lot of extracurricular societies and groups in whose activities I gratefully immersed myself at the expense of my actual studies, such as SUDS (the Sydney University Drama Society), the annual University Revue (for which I acted, wrote skits, and painted sets), and, especially, the university newspaper, *Honi Soit*, whose offices, consisting of a few tables with ill-maintained typewriters and an electric water jug for making Nescafé, I haunted. I wrote articles and satirical verses for *Honi Soit*, contributed wretchedly plagiarized poems (each one a pastiche of Dylan Thomas, Cavafy, Leopardi, and others whose names I have, in my embarrassment at this adolescent theft, forgotten) to campus literary journals, wrote plays (one of which, a dystopic three-acter with a noble prisoner and a devious interrogator, inspired by Auden and Orwell and entitled *Dead Men Walking*, actually won a prize and was performed, though—I hope—no script or written trace of it now survives), and discovered a facility for drawing cartoons.

Later, various Australian journalists would find occasion to rebuke and even to attack me for these late-adolescent attempts at learning by imitation. There was even a double-page spread in a Sydney newspaper reporting on a campaign written up by a young law student named Geoffrey Lehmann, himself later to become one of Australia's finest younger poets, fairly excoriating me for plagiarism. It didn't and still doesn't take much to make it into

the Australian papers—so little happened there then, or, for that matter, does today, that the most trivial events, like an undergrad lifting metaphors from the poems of George Seferis or heads from the drawings of Leonard Baskin and publishing in some student magazine, could get reported on if they contained some possibility of scandal. I wanted to reply, saying that I ought to get a teeny bronze medal for stealing from exotic Greek and American modernists rather than from Pope or Banjo Paterson; that the young can only learn by imitation, since nobody is born original; and that imitation can easily shade or even collapse into outright plagiarism; but then, alas, I thought the better of it, shut up and did not attempt to write any more poetry, except for satirical verse, which I have always found a marvelous release for cultural spleen and would never quite abandon.

With this extracurricular workload, my entry into Arts I was a fiasco. It had been meant as the opening phase of a double course: first two years of Arts (to give the rude student a little polish) and then four years of Law.

My idea had not been to become a solicitor, like my father and my brother Geoffrey. The old firm of Hughes & Hughes, now Hughes, Hughes & Garvin, at 16 Barrack Street, held out absolutely no promise to me; try as I might (not that I tried very hard) I could not see myself drafting wills and preparing briefs for others. Having been head of the school debating team had not prepared me for the behind-the-scenes life of a Sydney solicitor.

But perhaps I could be a barrister, a court advocate, like my brother Tom, who had just "taken silk," becoming the youngest Queen's Counsel in Australia at the precocious age of thirty-seven—histrionic and formidable, a genuine star of the Bar in his tightly curled, grayish-white wig and elegant striped pants, crushing recalcitrant witnesses with irony (as he had so often crushed me), building defenses and prosecutions with irrefutable logic and magnificent aplomb, like Hartley Shawcross and Garfield Barwick, the great English and Australian silks I had read about. There seemed no doubt where Tom was heading. (Actually, there was, because those who foretold a glittering future for him culminating in a seat on the High Court bench were wrong: Tom was destined to make so much money as an advocate, and spend it so unthriftily, that he couldn't afford to lapse into the relatively meager salary of a judge, however eminent.) But there was every doubt about me.

To have failed Arts I was a serious blot. I had read in the literature of the thirties about supposedly brilliant idlers who failed their way through Cambridge or Oxford, leaving a trail of glittering aphorisms and not much else behind them, like the shiny track of a slug. Unfortunately, all of them seemed to have some kind of private income, some family endowment, at their back, and I had none. Such creatures were not going to find a natural habitat on the forest floor of Sydney's academic groves.

What was I to do? It could no longer be law. And anyhow (I realized) the idea of setting myself up in the same field as the brilliant, intolerant Tom as a junior barrister could never work. I would always be "the younger brother," a status I yearned to escape: an impotent and slightly ridiculous figure, to whom solicitors would toss occasional briefs like bones of pity.

Well, having spent so much of my first university year in amateur theatricals, perhaps I could go into the theater in a serious, professional way, starting of course at the bottom, backstage.

Scanning the classified ads one morning, I saw a small want ad for "stage hands"; applicants to report to an address in Macquarie Street. That, I thought, must be for the Macquarie Street Theater. Off I went, and it was not. I found myself in a room with twenty or so large, sunburned, thongy men in Chesty Bond singlets who looked like, and in fact were, builders' laborers. They were being quizzed by a foreman, who soon turned to me. "You sure you're in the right place, mate?" he enquired amiably. Well, I dunno. "Let me ask you something, mate: do you know how to tie off a stage?" I was asking for a job as a scaffolding hand on tall buildings. Ears burning, I slunk out.

No courtroom, no theater. Only one avenue presented itself: I was being taken down to my inmost, scarcely admitted desires. Basically, I wanted to be an artist. That had been a secret hope of my freshman year in *Honi Soit*. Now I aspired to be, not an unpaid cartoonist, but a real (if still unpaid) artist. This necessarily meant, in my imagination, moving to Paris, which was where real artists went—no rented room in Paddington for me!—and finding myself an attic in whichever arrondissement real artists hung out in. Its smeary skylight, not cleaned since the last tenant (Bernard Buffet, perhaps), would admit a cloudy, *ville lumière* radiance. On a broken-springed couch draped in worn Turkistan rugs, something like the photos I had seen of Henri Matisse's studio in Nice in the 1920s, my imagination would install a

veritable harem of naked women, eager to be drawn. One of them, probably more, would get lucky. I would be the Pasha of rue de Seine.

That had become the secret hope of my freshman year, in which I spent so little time studying but so much doing student journalism, cartoons, and illustrations. I would sport a black beret, smoke Balkan Sobranies (the black ones with gold tips, which in real life I used to buy from a tobacconist in King's Cross and flaunt to some effect in the coffee shop of the Student Union), and wear a black duffel coat over a black turtleneck sweater, which would render me indistinguishable, I thought, from leading existentialists like Albert Camus. My role model was a friend at the university, a first-year medical student from Caen called Roger Gauthier, who, apart from his brother Bernard, was the only genuine Frenchman I knew. Roger, if one may be permitted the vulgarism, had the existentialist shtick down and played it to the hilt. He was supercool, with close-cropped black hair, eyes like burning coal, and a pronounced lisp, and his success with girls had to be seen to be believed: it left me paralyzed with envy, when I saw him putting the word on some adoring finch in a King's Cross coffee shop—"It ith nethethary, *n'etht-ce-pas,* to leeve *intenthely?*" Roger Gauthier and his brother Bernard were known as the Phallic Gallics. As my future girlfriend the actress Noeline Brown remarked, with no malice at all, they changed their women faster than they changed their sheets. Roger chain-smoked Gauloises Disque Bleu. He lent me his copies of Camus's *L'Étranger,* Sartre's *La Nausée,* and Baudelaire's *Les Fleurs du Mal,* which (despite my wretched French) I devoured as best I could, even memorizing short bits to impress the girls with:

> *C'est L'Ennui! L'oeil chargé d'un pleure involontaire,*
> *Il rêve d'échafauds en fumant son houka:*
> *Tu le connais, lecteur, ce monstre délicat,*
> *—Hypocrite lecteur,—mon semblable—mon frère!*

He had a room in the then rundown suburb of Glebe, just across from the university, which he generously let me use for my *cinq à sept* assignations. It was hung with dyed burlap—deep aubergine and rose madder, and I contributed a few of my pictures, which while not particularly erotic in tone lent the place a brooding and, I hoped, seductive air. He also had a number of

33 r.p.m. Juliette Gréco discs, which we played over and over again until the grooves nearly wore out. Gréco was, and remains, the only pop singer that I have ever been crazy about. She wasn't, in fact, much of a singer, but there was something irresistible about her slightly rasping, croaky, amateurish voice. When she sang her waifish songs about betrayed love and post-Resistance Paris, some actually written for her by Jean-Paul Sartre ("Dans La Rue des Blancs-Manteaux") and by Raymond Queneau (who ever heard of an Australian philosopher and an Australian poet writing songs for an Australian singer?), it gave me the late-adolescent shivers. I could really fancy being in the sack with Juliette Gréco. Straight, slightly dirty black hair. Gauloises and garlic. No bra. Two black sweaters rubbing hotly together. Her breath, sex, and armpits would smell slightly overripe. It would be the smell of Europe, as eucalyptus and talcum powder were of Australia. It would contain suggestions of Jeanne Duval and Emma Bovary. Aiee!

Such a lifestyle could be achieved, as I pointed out to my family (with certain essential details suppressed), by quite modest underwriting. In fact, the existentialist vogue—for existentialism was never a philosophy, more a matter of lifestyle and lots of attitude—passed fairly quickly in Paris, and was gone by 1957 (except from the eyes of American tourists hoping to spot Sartre at the Café Flore). That in itself didn't matter in Australia, which in cultural matters was still the land of late arrivals and discarded fashions.

But amazingly, the family didn't bite. In fact they thought it was the most foolish, la-di-da, self-indulgent fancy they had ever heard of, and went around making crude jests in grossly phony French accents about Monsewer Rob-air ze Bludgair. ("Bludger" is a rude Australian term for a sponger.) Thus ended my first attempt to become an expatriate.

My sister had graduated in Architecture. She was now a practicing architect—this, in a city which was by no means hospitable to professional women. Women, in late fifties Australia, were meant to be nurses, not doctors; secretaries, not lawyers (could you imagine, barristers joked, a woman in a wig, pleading a case in court?); and never architects. A few were artists, but they were not taken very seriously. Myself, I wanted to draw and be creative, a "feminine" ambition, and the Family wanted me to have the standing of a professional, an essentially "masculine" one. The division between "professions" and "businesses" or "trades" was of vastly greater conse-

quence then than it is today. So we would compromise. I would follow Constance. Architecture certainly was a profession, and I would enter it. Juliette Gréco, or perhaps her younger sister, would have to wait, if she could.

My Architecture studies began the next year, 1957.

I took to them. The Architecture course at Sydney University in the late 1950s was a distinctly old-fashioned one. It was modeled closely on the French degree course at the École des Beaux-Arts in the nineteenth century, and was presided over by a self-declared conservative, Professor H. Ingham Ashworth, who had scarcely heard of Bucky Fuller and regarded Le Corbusier (this being decades after the erection of the Villa Savoye) as rather an upstart, and of uncertain value.

You started by learning the rudiments of presentation rendering. The basis of this was to cast conventional shades and shadows—the geometrical setups for depicting, say, a cone sitting on a plinth with a ball on top, the whole placed inside a niche. The conventions for this were strict and absolute, because there had to be no room whatever left for "interpretation" or "expression." The object was always in planar elevation, and the light always fell upon it at 45 degrees from above and left. This would be "rendered" in numerous overlapping washes of Chinese ink. A sable brush was the proper tool, and you had to acquire the knack—not, in fact, a very difficult one, despite the mystique that attached to it—of keeping the wash wet all the way down the sloping page and then smoothly gathering it up at the end, to obviate blobs and overruns. Any sign of a brush mark or a streak was a fault. To do any supplementary shading or outlining with pencil, crayon, charcoal, or pen cross-hatching was a grave solecism. So in first year we did our cubes and cones and niches, and in second year our elevation of the west front of the Parthenon, with every flute in every Doric column crisply in place. The climax of this training was the "Classical Composition" in third year, involving, as may be, a pastiche made up of Myron's *Discobolus* (which nobody had the foggiest idea how to draw, so that it usually came out like a shaved gibbon clutching a dinner plate), a column from the Parthenon, an Ionic volute capital from somewhere, all rather shakily or woodenly drawn, the shades and shadows achieved with one hundred or so graded washes of extremely dilute Pelikan ink.

You'd think such projects would bore and alienate the students perma-

nently, but they did not. Generally, though, the students who did them best were the very ones who, when it came to designing their own buildings, did worst. I am slightly embarrassed to admit that I loved doing them and was not too bad at them. They also enabled me to impress friends, while visiting such ruins as Paestum, Agrigento, or some of the temples of the Turkish coast in later years, by naming their parts correctly: most people don't know an Ionic from a Corinthian capital, let alone a triglyph from a dentil, or entasis (the slight swelling of the shaft of a column) from a hole in the ground. Such things are no longer part of the living language of architecture, though whether this is the cultural catastrophe my teachers thought it was forty years ago I can't now say.

But how can I possibly ironize about these complex classical systems, some of which preserve such rich and peculiar mythic origins, when they are and were an essential clue to "reading" so much architecture from the sixteenth to the nineteenth century, as well as that of Greece and Rome themselves? A column is not merely a round stick of stone: it is part of an entire symbolic system, which one cannot intuit simply by looking at it in isolation. The basic reason for studying such things is not merely technical or archivally historical but humanistic; it is to seek out the answer to what someone like Vitruvius meant by his (to us) mysterious comment that "a building should have the proportions of a man," or what the hero of Paul Claudel's *Partage de Midi* believed he was saying when, in the act of embracing his beloved for the first time, he exclaimed, *"O colonne!"*

"In the back of every dying civilization sticks a bloody Doric column," wrote Herbert Read, in a transport of disappointed modernist aggression, but though the phrase was splendid he was utterly wrong. My main regret, of course, was that one couldn't actually see these wondrous buildings, for they were twelve thousand miles away in Europe. Alan Moorehead, the Australian writer who became my mentor, claimed that you (meaning he) could grow up in Australia without ever seeing a first-rate building. I don't think this was true. It depends what you mean by "first-rate"; there were, for instance, great industrial and vernacular agricultural buildings in Australia, some very fine Victorian Gothic Revival ones, and a few superb examples of Art Deco, the best (a masterpiece of the style by any imaginable standards) being the War Memorial in Sydney, designed by the brilliant but

too-soon-dead Australian architect Bruce Dellit, with its emblematic carvings by Rayner Hoff, the only major decorative sculptor Australia has ever produced.

Certainly Australia in its short history produced nothing to rival (say) the great Gothic churches of France or England, or the splendors of Roman baroque. But at the end of the 1950s, though it was largely arid, it was by no means an architectural wasteland. At the same time, the fear of provinciality, the thought that whatever had been done there had been done ten times better overseas, held enough truth to make an architecture student uncomfortable and self-doubting.

So I wasn't much good at architectural design, partly through lack of real talent, but partly also because there were so few good examples to copy and learn from. Besides, the problems we were set tended to be remote from the world in which we actually lived, and rarely described in terms of use. It was one thing to design, in first year, a gazebo in a garden: the functions of a gazebo are simple. But when, as we were in third year, you are presented with the task of designing a monastery on a mountaintop, without any indications of whether the thing is to be a cave or a cathedral, for Catholics or Buddhists or, if for Catholics, whether the order that will use it is contemplative or active, or what the monks' daily routines and ritual requirements may be, the task of design becomes somewhat generic and pointless. (One thing was guaranteed: nearly everyone's design had, somewhere in it, some sort of airfoil roof awkwardly adapted from Corbusier's chapel at Ronchamp, because that was the one sacred modernist building that had been featured in all the architectural magazines we were likely to see in Australia.)

On the other hand, I greatly enjoyed the structural engineering course, which taught you about strength of materials, prestressed and posttensioned beams, and so on—perhaps the reverse of what one might have expected, since I was never a hotshot at math. But I had some kind of instinct for materials, which must have been of use to me decades later when I took up carpentry.

Best of all was the Art course. We were—certainly, I was—extremely lucky in having, for a teacher, Lloyd Rees, one of the pioneers of twentieth-century Australian painting. A gently encouraging old man with a magnificent leonine head, the mane turned wispy white, Rees had been around seemingly forever—some of his best works, which rank among the finer

drawings of the twentieth century (and not just in Australia, either) were the grandly structural and highly realistic landscapes of rocks and cliffs done, with a hard pencil, before the Second World War. He was not a programmatic modernist, but his tolerance was wide and loving, and I feel I owe him a part of my life. One day we were talking about Italy and he spoke, with rapture in his voice, about his sojourns there in the twenties, cycling around Lazio and Tuscany; and how, looking down one day on the spur of rock on which the town of Pitigliano is built in a ravine, he saw how the town was joined to the land by "a bridge—a bridge as fine as a drawn line in the air." Suddenly every fiber in me yearned to see that bridge, and years later I did. Perhaps it was there that my expatriation from Australia truly began, with Lloyd, on that imagined bridge.

Uni and After

I have never been much of a joiner, and although there were plenty of opportunities to join this or that society at Sydney University, in the end I affiliated myself with none of them. The late 1950s were supposed to be the high years of what was called the Push, but I never had much to do with it, though I liked to drink in its designated pubs. The Push (an Australian slang term meaning something between "mob" and "group") loosely encompassed those who floated around the edge of the Libertarian Society, a skeptical, anarchist, freethinking, free-loving bunch of students (some already in their forties, and students no longer) who owed their basic allegiances to the memory of a former professor of Philosophy at Sydney University, a famous skeptic much demonized by Church and Press, John Anderson. Its home pub was the Royal George, in whose back room I did a mural, now (to my relief) long effaced. In those days, students of a generally bohemian kidney had only three places to go: two of them pubs, the Newcastle and the Royal George, and the third a wine bar named Lorenzini's, where one could get small glasses of rough red wine and eat that exotic dish, ravioli, which came *alla Bolognese* in a soupy meat sauce and cost two shillings and sixpence. There was no drug culture worthy of the name; nobody smoked marijuana. The only stimulant we used was speed—Benzedrine, and occasionally methedrine. One could buy these amphetamines openly across any druggist's counter, without a prescription—amazingly, they were not yet restricted—merely by invoking some necessity of studying for exams. There was a small edge of competitiveness in our use of it. How long could you keep going without crashing? In my case, the limit was around forty-

eight hours, at the end of which, with grinding teeth, sandpaper eyelids, and a hacking cough from my enormous consumption of cigarettes, I would take to my bed. I don't think I ever fancied there was any vision, hallucination, or actual pleasure to be derived from amphetamine excess. I just used the stuff, and irregularly at that, to keep going.

I longed to have something, anything, to do with the art world—whatever the "art world" was, and I was by no means sure of what or where it might be. It certainly did not extend into Sydney University. There was, at the time, no faculty of Art History in the whole place, and the actual making of art was taught miles away at East Sydney Technical College, a school located in an ancient convict prison in King's Cross. I had no idea what thrilling bohemian activities prevailed there. There was, however, a sort of soi-disant Dadaist society at the university presided over by a fiercely rebellious mathematician named, if I remember right, Don Levy. It held a couple of exhibitions in the fifties, chiefly memorable for the contributions of an as-yet little-known comedian and actor from Melbourne named Barry Humphries, who in later years became one of the great and minatory personages of the Anglo-Australo-American theater in the late twentieth and early twenty-first century, Dame Edna Everage. She had not quite been invented yet, but Barry's most striking early effort, exhibited in 1957, was a pair of rubber Wellingtons, or "gum boots," as they are called in Australia, filled to the brim with yellow custard and exhibited on a plinth under the title "Pus in Boots."

It was through *Honi Soit* that I fell in with new friends at the university: a groupuscule of wits, whose mannerisms had to be imitated because they would serve to cover my insecurities, I hoped, as effectively as they covered theirs. The principal ones were John Cummings, then a mild librarian, later as Katherine Cummings to become Sydney's most flaming transsexual; a poet named Philip Graham, a.k.a. "Chester"—nobody knew the origin or meaning of his nickname—who was one of those semilegendary figures universities sometimes harbor, not a student, locally renowned as a poet but one who published practically nothing and ended up, if rumor spoke truth, working in exile for, of all things, the Chilean telephone company. And then there was Clive James, a brilliant and omnivorous apprentice writer, the only one of the bunch apart from myself who went on to be a professional at this craft. (This did not begin until he hit London in the 1960s, at about the same

time as I did.) We all skated and skipped about between the university coffee shop, the *Honi Soit* offices, and the annual University Revues, whose sketches we wrote and acted in, devoting ourselves to being repugnantly clever young things.

Student journalism changed to more or less real journalism in 1958, when Sir Frank Packer, the gross and meat-fisted capitalist who owned Australian Consolidated Press, decided to launch a fortnightly journal of political and cultural opinion modeled on the English *Spectator*. Its name was the *Observer*. I am still not certain why Frank Packer wanted such a magazine. He must have known that there was some risk in owning an intelligent periodical, since in Australia in the late fifties, intelligent people tended to be closet Lefties, of however mild a sort. But then, I never really understood the Packers as such, even though our family paths kept crossing. The *ur*-Packer, Sir Frank, had something genuinely fearsome about him. I always loved the persistent story, which of course nobody had any means of verifying, of how he took a newly hired secretary in his big black car to a site overlooking the moonlit Pacific near South Head Cemetery. Having satisfied his lusts and possibly hers, he headed for home when the girl timidly raised the thought that she might get pregnant from their encounter. Packer groped in his pocket and produced a black aniseed jelly bean. "You must have heard," he announced, "those stories about the new oral contraceptive the doctors have come up with. You just take it afterwards and you're right as rain. Here yer are."

It was Packer who persuaded my elder brother Tom, who had done a lot of legal work for Consolidated Press, to run for election as a member of the Liberal Party and accept an appointment as attorney general. It was also Packer who financed the design and construction of *Gretel*, the first America's Cup challenger, and thus began the process that was to remove that yachting trophy from its guaranteed niche in the New York Yacht Club. The boat was named after his wife, by whom he had two sons, Clyde and Kerry (1937–2005). Kerry is said to have been the richest man not only in Australia, but in Australian history; a bully whose life seems to have been devoted to making Genghis Khan look like a twittering esthete. Clyde, on the other hand, despite his elephantine bulk, was an extremely sweet man, almost hippie-like in his unaggressiveness, with ambitions (never entirely fulfilled) to be an art collector and even a writer. Disowned by his sire, and

having no corporate ambitions, he ended up in Santa Barbara as the owner of several surfing magazines; alas, by then he was too monstrously fat to go near the water himself. He died, through complications of this obesity, at the age of sixty-five, in 2001. Sir Frank should perhaps have given the *Observer* to Clyde, but he did not.

Its first editor was a gentle, somewhat obese dandy named George Baker. Noticing that the first few issues of the *Observer* had few illustrations, I gathered together a small sheaf of the cartoons I had been drawing for *Honi Soit* and submitted them to him as samples. To my great surprise, George rose to the fly. He didn't put me on salary (I could hardly have expected that), but he kept asking me for work and, what seemed truly extraordinary, paying me for it—though not very much. Dinkuses (one-column space-fillers) earned two guineas each, and so on up to six guineas for a full-page drawing and ten guineas for a cover. This was not only my first paid work; at a time when a rented room in a terrace house in Glebe, just across from the university, cost two pounds ten shillings a week, it was wealth beyond avarice.

After Baker left the *Observer*—he lasted about a year, and later committed suicide for unknown reasons, perhaps the fear of scandal, since he was deep-in-the-closet gay and devoted to his unaware mother—he was replaced by one of the people who would change the face of Australian social commentary in the late sixties and early seventies, Donald Horne, the future author of *The Lucky Country*, which was published in 1964. This was the first serious critique of Australian society to emerge from the 1960s, a pioneering work in all respects. Horne's perception of the Australia of his time as a place with a derivative social culture, run mainly by second-rate people and incurious provincials who share its largely accidental fortunes, bit deep, but was, like so many criticisms of Australia, immediately converted into its near-opposite by the Australians themselves; within a few short years, the term "lucky country" had come in their ears and mouths to mean a place uniquely blessed, God's own country without the Lord, which was not what Horne had meant at all.

When he was editing the *Observer*, Horne rather skeptically supported Australia's reigning Liberal (i.e., right-wing Tory) Party, and even gave lip-service to its ponderous and cunning monarchist leader Robert Gordon Menzies, "the God of Sleep," who led Australia as prime minister through an uninterrupted span of seventeen years, from 1949 to 1966.

But Horne's natural skepticism was increasingly fueled by his nascent republicanism, and by the time I was contributing to the *Observer* it was by no means a passive instrument of Liberal Party views, still less a mere mouthpiece for the extreme conservatism of its owner, Packer. Horne was capable of an irreverence which few other Australian editors, if any, could muster.

At the time he took the editor's chair of the *Observer*, Donald was editing a Packer tit-and-bum sheet called *Weekend* and, understandably, fretting against its intellectual constraints, one of which was apparently never to print any words of more than two syllables. He therefore leapt at the chance to run the *Observer*, and for the next few years, like some trick circus rider with one foot on the bay and the other on the palomino, edited both. Since Donald and I got on quite well, I continued to draw for him and branched out into occasional book reviews.

Then something totally unexpected happened.

The *Observer* had an art critic, an elderly immigrant Yorkshireman named Bernard Hesling, an artist who made his basic living painting garish enamel tea trays. I have no idea what Hesling's qualifications as a critic may have been (in fact, you didn't need any to write art criticism in Australia then, as my own early career would amply show), but what led to his downfall was his loathing of William Blake. Normally it wouldn't have mattered much in Australia whether you liked Blake or not—very little of his work was there to be seen—but fate decreed that there was, in the summer of 1958, an exhibition of Blake drawings on loan from England at the National Gallery of Queensland in Brisbane, where Hesling was having a holiday. Thinking to earn a quick eight guineas, which was what the *Observer* paid for a short review, Hesling weighed in with a ferocious diatribe against Blake, whose figures he compared to skinned rabbits. (Actually, great as my enthusiasm for the Visionary of Felpham is, I still think—having skinned my own share of rabbits in Yaouk and elsewhere—that Hesling had a point there, but it was a small one at best.) Hesling did not deign to visit the show but he tore into it with the utmost savagery.

Unfortunately, the director of the museum, a dedicated and knowledgeable esthete whose name was Robert Haines, somehow knew and, worse, could prove that Hesling had not actually seen the show. Moreover, he was on easy social terms with Sir Frank Packer, and was a friend of his wife,

Lady Gretel, to whom in the past he had steered a number of important antiques. So he complained loudly and bitterly to the Packers, who in turn complained to Donald Horne. And one morning shortly afterward, Donald Horne burst into the *Observer*'s small staff room.

"I've just fired the art critic," he announced. "Anyone here know anything about art?" Nobody spoke up. Horne's gaze settled on me. "You're the cartoonist," he snapped. "You ought to know something about art. Good. Well, now you're the fucking art critic." He strode out the door, leaving me to contemplate my fate.

So that was how it happened, how my life's vocation was decided, how It All Began. *Iacta alea fuit*. In my undefiled cloud of unknowing, I had to learn on the job and probably I wouldn't have lasted two issues in a country whose readership or editors knew more about art than Australia's. It is inconceivable that any English-language magazine with serious journalistic ambitions, outside Australia, nearly fifty years ago, would have hired anyone, even in the moderately despised slot as art critic, on such terms. You'd think I'd have to show I knew *something* about art, but since no one else at Consolidated Press did, I was not put to the test. I was absurdly lucky, an innocent tyro (or, if you didn't like me, a naïve provincial brat). The only art I knew, and poorly, was painted in Australia by whites, and fairly recent whites at that. I had seen practically no European and no American art at all, except in reproduction. Of Chinese, Japanese, or "primitive" art I was ignorant. Aboriginal art, now so reflexively esteemed—though not all of it is as good as many people, doubtless wishing to expiate the racist sins of their forefathers, like to profess—hardly showed on the horizon. And, of course, I didn't have any academic preparation. In Sydney, no art history courses were available at the university. The only place that offered them was 550 miles away, where Australia's leading and only significant art historian, Bernard Smith, presided over his own department in the University of Melbourne. In general, as a place to see anything other than Australian art, Sydney in 1958 was a backwater. Exhibitions of historical art rarely came there (or to any other Australian city) from overseas. It offered no market for the work of any living non-Australian painters, so that 99 percent of the commercial gallery shows were Australian; no foreigner had any incentive to show there.

In sum, I was pitiably out of touch with my subject, but no one was there

to pity me, since nearly all Australians beyond a tiny, nearly invisible minority of scholars, collectors, and artists were in much the same boat fifty years ago. The whole environment of scholarship and argument concerning art was almost unimaginably different from today's. All this worked, I am slightly ashamed to say, to my complete advantage. Knowing little about non-Australian art history, and less about contemporary art overseas, was not the crippling disability that it would have been in New York, London, or even San Francisco. You could be an art critic in Sydney without seeing a Picasso (though it was a good idea, of course, to know how to spell his name and to have set eyes on a few reproductions). Australia *had* no Picassos, except for a few prints and one Rose Period portrait of a pudgy Dutch girl, *La Belle Hollandaise,* which a legendarily eccentric collector named Major Harold de Vahl Rubin had bought when he was an art dealer in London and later presented to the National Gallery of Queensland.

Yet for all my own lack of knowledge and experience, and for all the shortcomings of Australia's museums and the narrowness of its private collections, the late 1950s and early 1960s were still a good time to start cutting one's teeth on art in Australia, simply because its visual culture was waking up after decades of what has justly been called a "cultural quarantine." It had taken Australian culture that long to pay for the conservatism and xenophobia of the men who installed themselves as its cultural directors after 1910. The museums contained the most obvious and eloquent record of their narrow-mindedness, which even extended to "traditional" European art: the list of medieval, Renaissance, Baroque, rococo, Romantic, and nineteenth-century realist artists in its public collections was, with the episodic exception of Melbourne's, extremely short. Australia had not just missed the boat; it hadn't even bestirred itself to buy a ticket. One could hardly have expected the various state museums to buy things that were the equal of the paintings being snaffled, between 1880 and 1910, by the great American collectors (Frick, Mellon, Carnegie, and so on), whose private collections, facilitated for them by Bernard Berenson, had formed the basis of the astounding public collections of the U.S. But Australia bought almost nothing; its nerves were as feeble as its endowments and public funds.

And if its museums had largely missed out on old art, they were almost parodically hostile to the new. They could tolerate Impressionism, but only just, and they had ignored the opportunity to buy Monet, Manet, Degas, or

even Renoir. Everything from Fauvism on was dismissed as the vulgar effusion of incompetent and presumably Jewish madmen.

Since World War I, they had been run by implacably conservative and often quite nastily anti-Semitic men, such as J. S. MacDonald, the long-time director of the National Gallery of Victoria, and Lionel Lindsay (1874–1961). Lionel Lindsay, infuriated by the contents of an exhibition of recent European painting sponsored by the *Melbourne Herald* that had been brought to Australia in 1939, had published a book called *Addled Art,* a tirade against modernism in general which blamed it all on a collusion of the stunts of cynical artists with the greed of Jewish dealers (Picasso being "a Jew from Malaga"). This disgracefully racist text, written at the very moment that the Jews of Europe were being herded to the ovens, was regarded by most of the Australians who read it as quite normal, though perhaps a bit over the top in a few places here and there.

It was based on Lindsay's vehement reaction against what was in effect Australia's Armory Show—an exhibition of European modernist painting, chosen by Basil Burdett, the art critic of the *Melbourne Herald,* and underwritten by the paper's proprietor, Sir Keith Murdoch, father of the eponymous Rupert. It had opened in 1939 in the Melbourne Town Hall (the National Gallery of Victoria, being run by J. S. MacDonald, wouldn't touch it) and forty thousand people lined up to see it. It included works by van Gogh, Cézanne, Picasso, Braque, Derain, Matisse, and, most controversial of all, Salvador Dalí. Somehow it confirmed Lindsay's belief that all modernist art was a Jewish plot. World War II broke out, and it was too risky to send the paintings back to Europe. Instead of profiting from this by exhibiting the works for the duration of the war, the museums of Melbourne and Sydney kept them crated in their basements until 1946, so that they would not corrupt the general public. Thus we were protected from those Parisian-Mediterranean Jews. What the museum-going public of Sydney got to see, as always, were the same blue-and-gold products of Australian pastoral Impressionism, along with a number of (admittedly first-class) Pre-Raphaelite canvases and an enormous narrative set piece by the Victorian academician Sir Edward Poynter, depicting, on Cinemascopic scale and with many coal-black Nubian extras, the visit of King Solomon to the Queen of Sheba. This immense canvas had a devoted following because the Art Gallery of New South Wales stood on a rise overlooking the Woolloomooloo docks, where

the cargo ships came in. And at least until the 1950s, the engines of those vessels were mainly stoked and tended by Lascars, among whom the Queen of Sheba had the status of a deity, rather as the emperor Haile Selassie of Ethiopia does among Rastafarians today. Consequently, when one visited the gallery, one occasionally saw Lascars in their white paper hats prostrating themselves in reverence before Poynter's gigantic canvas, which they seemed to believe had been placed there for their religious satisfaction.

Lascar stokers were one thing, but Jewish painters like Picasso were quite another. Of course, one would not wish to be too anti-Jewish. It might be all right to exclude those blokes from golf clubs—none of my own family, for instance, seemed to have qualms about belonging to Royal Sydney, which had an unwritten no-Jews policy—but putting them in concentration camps, not that we really knew about such things at the time, seemed a bit rough. If you raised the subject of *Addled Art* with anyone else who had read it, you were as likely as not to be told what a good bloke old Lionel had been, that his bark was worse than his bite, that he didn't have a drop of anti-Semitic blood in his veins, and so forth. Anyway, how could you hate Jews if you'd never met any?

The wide world was a very dirty world, and how lucky we Australians were to have no part in it! Especially since we should count our blessings that the Japanese had not forcibly inducted us into what Tojo's warlords called "the Greater East Asian Co-Prosperity Sphere." The horror of having very different and probably hostile cultures "on our very doorstep," as the phrase went, contributed to a wide fear of assimilation by Asia—our thousands would be lost like a drop in the genetic bucket of their hundreds of millions. "We are not only a nation but a race," wrote J. S. MacDonald in the 1930s, in a panegyric on the landscape paintings of Arthur Streeton, "and both occupy a particular territory and spring from a specific soil. The racial expression of others will not be ours, nor the methods of interpreting their own country and folk. We will be mainly contented with our own imagery expressed in our own independent-minded sons . . . If we so choose we can be the elect of the world, the last of the pastoralists, the thoroughbred Aryans in all their nobility." Essentially the same sentiments were being expressed at the time by the Regionalists in America, led by Thomas Hart Benton, in their loathing of the "international left"; by the Stalinist "social realists" in the U.S.S.R., with their hatred of "rootless cosmopolitanism";

and of course by the Nazi cultural officials in Germany, trumpeting their message of *Blut und Boden* and their detestation of "internationalist Jewry." The language was much the same everywhere. In the twenties and early thirties, all countries that had been violently scarred by their losses in World War I experienced this recoil into half-stagnant, half-militant nationalism, and Australia was no exception. Its infamous "White Australia" policy was still in force, and would remain so until 1966. Its clarion call had been uttered by Arthur Caldwell, the Minister for Immigration who, in the course of refusing to allow a Chinese businessman named Mr. Wong to join his legally married and resident spouse in Australia, wittily declared that "Two Wongs don't make a white." Its conservatives (and, in cultural as in political terms, Australia was run by conservatives) were determined to keep the dangerous and divisive world out of their country, away from its sacred shores. They imagined Australia as a rural paradise untouched by, vehemently protected from, racial difference and industrialization. The only art such a place ought to want and encourage was Arcadian, pastoral landscape. The very notion that the Australian economy would ever shift from wool and wheat to industrial production was abhorrent to them, especially since industry meant unions, strikes, and class torment.

This had been a recipe for cultural stasis—freeze-up as the "cure" for breakdown. Which was essentially what the Old Guard wanted, though they would not say so. By 1958, when I sidled onto the little stage afforded by the *Observer*, most of them were dead anyway, and the only one of them I actually met was Norman Lindsay, Lionel's younger brother. This Lindsay exerted an enormous, almost hypnotic effect on some of the best of Australian writers—poets from Hugh McCrae to Douglas Stewart and even Kenneth Slessor. Painter, etcher, illustrator, cartoonist, art critic, would-be philosopher, novelist, and nostalgist, he had claimed a place—which turned out to be completely illusory—as the *uomo universale* whose mission was to lead an Australian Renaissance, the final answer to the pessimistic horrors of modernism, the incarnation of Joy, Sex, and Tradition. Nobody outside Australia has ever taken Lindsay seriously, or ever will. But in the late 1950s he was still considered rather an oracle, or at least a force to be reckoned with, by some Australians, probably because back in the old days he was one of the few citizens of Australia who regarded art as possessing real, transformative importance, as though it actually mattered as much as cricket or party

politics. His conviction had been inspiring, even though his ideas were mostly romantic rubbish and were vehemently hostile to the modern world. Moreover, he had stood out against the censors, both church and state, and had taken his licks and lumps for it. And so I was dispatched to his home at Springwood in the Blue Mountains to do a birthday interview with the old man, who was just turning eighty. His pale, piercing eyes blinked at me from the depths of his armchair, under a white skullcap of wispy hair. "So," he said, "you're the latest little bugger trying to brain me with his feeding bottle." The interview was not a success.

The xenophobic influence of the Old Guard, amounting to a form of cultural quarantine, had persisted during the forties and even into the fifties. But such countervailing pressures had been built up against it by artists in Sydney and Melbourne, and even a few writers, that it could not possibly have lasted. Finally the cork came bursting from the bottle, and by my good luck it happened just at the time I started writing about Australian art. In Australia in the late fifties and early sixties you felt a terrific *jouissance*, a sense— near-orgasmic at times—of celebration and enjoyment, even though the art was often dark. Nobody thought the world was his oyster—we were too provincial for that—but at least the fresh-oyster feeling, the sense of possibility, pervaded Sydney and Melbourne, though (due to their differing art backgrounds back in the 1940s) in quite different and sometimes opposite ways. Given the meager endowments of Australian museums, and the almost total absence of private cultural philanthropy, it was too late for any museum to form a great collection of "overseas modern." But at least the ukase against *local* modern, current Australian art, could be lifted; and it was.

The Old Guard of Australian painting didn't agree—they wanted local art to have an Old Masterly authority, which, in a country without Old Masters to learn from, was hardly an option.

Yet by now it was obvious to anyone except a few nostalgic cronies and suburban pub-keepers (hearty types who liked those heartily callipygous tits and bums) that Lindsay and the recycled Nietzschean vitalism he stood for had had its day, and so had the stereotyped pastoral landscapists who were still doing their coarsened blue-and-gold canvases far, far back in the wake of Streeton and Roberts (who themselves remained immensely respected originals but had died, respectively, in 1943 and 1931). These were the artists whose work, in the words of the painter Sali Herman, a European émigré,

consisted either of "a gum-tree with a sheep on either side, or a sheep with two gum-trees likewise." But Australia was ceasing to be a pastoral country. By 1960, only a minority of its citizens knew how to shear a sheep, skin a rabbit, or even ride a horse. Comparatively few had been to the bush, and there was even some dispute about where, given the encroachment of suburban sprawl, the bush actually began. But everyone had been to the beach, and all their kids were learning to surf. For those with any kind of historical memory, this was an almost incredible mutation—only a few decades before, and well within some living memories, surfing in Sydney had been banned on the grounds of indecency, and I recall how at Bondi in the late fifties the sand was policed by lantern-jawed old farts in toweling hats, their once muscular bodies now wobbly ziggurats of dark-mahogany flab and gray chest hair, rudely banishing harmless and pretty girls from the beach for wearing the indecent bikini.

The direction of view was shifting through 180 degrees. Such wealth as Australia had no longer came chiefly from pastoral work, but from mining, industry, and real-estate speculation. Most Australians lived in cities on the coast, the dominant two being Sydney and Melbourne. We had become a nation of rim-dwellers, staring out at the immense wet blue, with the dry bush behind us: a presence certainly, and part of the myth, too, but no longer as powerful. The beach had replaced the billabong as the focus of imagery.

But I must now confess a deep dysfunction in my Australian nature. I didn't feel altogether at home either in the bush or on the beach. In the bush I felt out of place and unskilled (even now, for instance, I do not know how to saddle a horse) and too far from Sydney. I did like walking around, watching the pink-and-gray clouds of galahs in the evening, and hearing the cockatoos screech in the morning, but that only showed what a citified bugger I was. On the beach I felt hot and uncomfortable, skinny (which I was in those days), unathletic, and, worst of all, bored. I have never been a basker. I did not like to read on the beach, but I also disliked just staring vacantly at the horizon. Attempts at the passive acquisition of a suntan were no good either: first I went pink, then an angry red, then sheets of skin peeled off, and then I reverted to my natural pallor, more or less that of a peeled parsnip. Only on a boat or inside a house—preferably a café—did I feel at home.

It was inevitable that the *Observer* would not have sole occupancy of the small, but distinct and useful, niche of fortnightly journalism. The old *Bul-*

letin might have filled it—it was still limping along after eighty years and selling some thirty thousand copies a week. But it had no fresh blood, and as a vehicle of either cultural criticism or astute political commentary it was exhausted, despite Donald Horne's energetic efforts to revive it when he was transferred to its editorship.

A more promising rival, however, started with *Nation*, founded on the merest shoestring by that superb editor Tom Fitzgerald in 1959. Its offices were two small, dilapidated upstairs rooms at 777B George Street. A friendly abortionist had his practice one floor below. Fitzgerald was a true liberal in the largely cynical and conservative milieu of the Australian press, a milieu which has never given independents much of a chance. He ran nothing but nonfiction articles; the only exception to this rule was his remarkable feat of persuading Vladimir Nabokov to let him print a chapter from *Lolita*, immediately after the Minister for Customs had banned that novel's entry into Australia. Nabokov sportingly let him have the rights for a hundred U.S. dollars. *Nation* ran it over two issues. After the first appeared, a squad of federal cops raided *Nation*'s offices but failed to discover the typescript of the second installment, which the resourceful associate editor George Munster had hidden in the tank of the office lavatory. It was an honor to be published by such men, and after Tom Fitzgerald rang me up in 1959 and offered me a slot (not a job: there were no jobs, there being so little money to go around), I moved sideways from the *Observer*. I would write *Nation*'s art criticism, and draw most of its cartoons, for the next five years. I also wrote occasional criticism for the tabloid *Mirror,* and did its political cartoons—rather a stretch for me, since I was politically extremely naïve and rather bored by affairs in Canberra. But the *Mirror*'s editor, Zell Rabin, paid me fifteen guineas a shot; this translated into more than sixty pounds a week, a fortune. Unfortunately, the *Mirror* was bought by the then budding tycoon of world media, Rupert Murdoch. It was the first of his many papers and he was determined to economize. One afternoon, as I was inking away at the next day's cartoon, I was summoned to his office. What, Murdoch enquired, did I get per cartoon? I told him. "That's sixty guineas a week," he said reflectively. "Tell you what, I'll make you an offer. Eight quid a drawing." "That's an outrage," I spluttered. "Yeah, but it's the offer, too," said Murdoch. "Tell you what, you can always take it up with the journalists' union. Of which, wouldn't you know it, you're not a member." Thus my brief amphibious tenure as News Lim-

ited's cartoonist and art critic came to an end. I sometimes think of this when I open a copy of Murdoch's *New York Post* and scan its miserably ill-drawn cartoons by Sean Delonas, with their clumsy hatching and Neanderthal wit. True, I wasn't Herblock or Ronald Searle or David Low; but at least I wasn't *that* bad—for an art critic.

Traditionally, Sydney writers and journalists tended to congregate in pubs that became their own. So did the bohemians and anarchists: hence the loyal clientele of the Royal George, the Push. But in the early sixties, the drinking center of Sydney writers—at least, of the ones whose company I enjoyed, since you could get crabs just by looking at some of the folk in the Push—was a King's Cross café without a liquor license, run by a White Russian émigré from Harbin, in China, named Vadim Kerr. Originally the place had been called the Corroboree Coffee Lounge (this being a name for an Aboriginal tribal dance ceremony) and it was decorated with wavy lines copied from churinga-sticks and, of course, with boomerangs, in those days the bane of Australian decoration. Vadim, or "Steve," as he was more often known, had been born Vadim Kargopouloff but wisely dropped the last three syllables of his surname. His renamed café had an espresso machine, and served food. Basically, though, it was an upscale sly-grog joint. Vadim had an under-the-counter stock of red wine (Cawarra Claret, nothing fancy, just your reliable red infuriator), vodka, passable brandy, and drinkable Scotch. These he would serve in china demitasses, and you could blot them up with fried and breadcrumbed oysters, beef Stroganoff, and chicken *à la Kiev*, a flattened half breast rolled around in cold butter and garlic which, after frying, became deliciously golden and squirty. The kitchen closed at midnight, but people often went on drinking until four in the morning: it was the only late-night place in Sydney, where the pubs had by law to shut tight at ten. The décor wasn't much, since few artists drank at Vadim's and so he didn't get free pictures for his walls. The conversation was the décor. Insofar as Sydney had a café culture in the traditional European sense, it consisted, however briefly, of Vadim's.

This was largely because Vadim's was also, in effect, the second office of *Nation*, presided over by the rubicund, eagerly disputatious figure of Tom Fitzgerald, and everyone who contributed to the magazine ended up there. Its drama critic, Harry Kippax, would eat there every night, and hold forth—often brilliantly, but with an irksome right-wing bias—deep into

the night. Visiting luminaries would end up there, especially Russians: when they were in Sydney (not often enough), it was the hangout preferred by Rudolph Nureyev, whom I never met, and Yevgeny Yevtushenko, whom I did. Vadim's was where I met William Walton, the composer, who had written the music for Edith Sitwell's *Façade* and kept a house on Ischia, which struck me as the height of enviable exoticism. I also remember various visiting actors, notably the still exquisitely beautiful but distinctly crazy, manic-depressive Vivien Leigh. Sometimes Vadim, needing his sleep, would leave the keys with a trusted client—usually Fitzgerald—and leave him to lock up. On very late nights, Tom and George Munster would walk across King's Cross, after Vadim's had been closed, take up a laminate table at a hamburger joint named the Hasty Tasty at the head of William Street, and finish their editing there.

Fitzgerald was almost unique in Australian journalism, a principled and entirely uncorrupt liberal, a fighter for causes and a fearless critic, and so, despite the smallness of *Nation*'s circulation—it rarely went much beyond ten thousand—the magazine acquired a wide reach: it was required reading, both for those who agreed with its politics and those who did not. You always knew, if you picked up a copy of *Nation*, that you were reading the views of a writer backed by a sympathetic editor, not the imposed opinions of management. This independence was rare in Australia, and it was unheard-of within the Packer empire, of which *Nation* was conspicuously not a part: Sir Frank could, would, and sometimes did have a whole issue of the *Bulletin* pulped if it contained views he disagreed with. But with the one notable exception of Donald Horne, just about everyone who worked for Packer ended up as a mere hack with no worthwhile books to his or her credit. The people who fared best as Packer staff were blimpish yes-men like David McNicoll. That was not the case with Tom Fitzgerald. Practically no one ever made enough to feed and house a fieldmouse by writing for *Nation*. But then, Fitzgerald didn't either. Somehow he managed to keep the magazine going, and with distinction, at the same time as he held down a "main" job as the financial editor of the *Sydney Morning Herald*. This was his bread and butter, but *Nation* was his pride and joy, an inspired labor of love and mischief.

To younger writers, he was prodigally generous with his time and care. He saved me from numerous gaffes. And in the early 1960s I was doubly

lucky in having, not only a fine editor, but a beautiful, realistic, and gifted girlfriend. In 1959, I had gone off to England rather briefly in pursuit of Brenda, a ravishingly pretty dancer with the Royal Ballet with whom I had fallen in love. The affair fizzled when I reached England and I was too distraught with frustration and self-pity to do any serious looking at art before I ran out of money and had to come "home" to Australia. (What I found especially galling was that her new swain drove a convertible sports car, an Austin-Healey, whereas I had never owned a car of any kind, not even a humble Holden, and had to get around on the tube in my damp black duffel coat.) But when I got back to Sydney I at least had the sense not to make my trip sound like the disappointment it was. Besides, it can be amazing how quickly the young recover. The person who made me do so was a twenty-two-year-old fledgling actress, presently to be the outstanding comedienne of the Australian stage—and later, through a revue-like program called the *Mavis Bramston Show*, of local TV as well—named Noeline Brown.

Noeline and I met in 1960, soon after I got back from my brief trip to London. She was there at Vadim's one night, and he introduced us. It was, for me, a *coup de foudre*. In years to come I would meet a number of hoarse, once-spectacular beauties of a certain age, such as Humphrey Bogart's costar Lauren Bacall, but in Noeline I saw that kind of beauty when it was young and it knocked me flat. She was a splendidly contoured blonde, with plenty of muscle tone: not insipidly pretty—a slightly hawkish nose lent character and strength to her face—but sexy and handsome. With those cheekbones and a hoarse, purring voice, she was a long way from the more or less identical billion-dollar bimbos and Botoxed models with spackled skin that now, so boringly, fill the screens of America. She looked and sounded rather like the young Marlene Dietrich but to me she was better looking (Dietrich's looks appealed mainly to masochists, lesbians, and inwardly timid Hollywood Jews), and her penchant for full-blooded Australian vulgarisms wasn't in the least Dietrich-like. Moreover, unlike Dietrich, she was a very good actress and her career changed the terms of Australian television comedy rather as Lucille Ball's had changed the form in America. In the days when I suffered occasionally from sexual nostalgia, which returned intermittently until my third marriage, it was Noeline that I thought of: bawdy, sweet, a great mimic, explosive in her occasional anger but without a mean streak anywhere. Moreover, she never turned her back on her family or on her working-class

roots, a loyalty which is not as common a virtue in Australia as you might suppose. In the 1990s she went into politics as a member of the Australian Labor Party. She, like many other Australians (but not enough, alas), was thoroughly fed up with the spiritual aridity and intellectual mediocrity of the Australian Right, as incarnated in John Howard, Australia's long-running Liberal Party prime minister. Noeline's political ambitions did not succeed as her thespian ones had. I have long thought that was a pity, since although she might not have made the most astute Labor P.M. in Australian history she would certainly never have become the subservient poodle of Washington; she would also have been a most humane, decent, and patriotic P.M., as well as the first natural blonde one, a virtue that our national windbag Robert Gordon Menzies, let alone his wannabe imitator John Howard, could not have claimed.

We might have married, but we both knew we were too young to do so. The sense of career ran very strong in Noeline, and neither of us could imagine being surrounded by ankle-biters (Australian for small children) in a flat in some Sydney suburb.

Writing art criticism is never easy, and should not be, but in Australia at the beginning of the sixties it was particularly difficult, because the culture presented you with so few viable or even honorable models to follow. Certainly there were no critics of distinction writing for Australian papers or magazines. English journalistic art criticism was hard to come by, and you couldn't see the shows it referred to.

But what about America and its formidable figures of the fifties and early sixties, notably Clement Greenberg and Harold Rosenberg? Same problem, because in Australia you could never see the works of art they were writing about in New York. The museums hadn't bought any and the galleries didn't show any. And what could be learned from the external prose forms of art criticism when the work to which they referred could not be known? In any case, simply as writers, I didn't feel much enthusiasm for either of them. Greenberg was too dry and dogmatic for my taste—and I didn't even know yet what an obnoxious and arrogant bully he was in relation to the art world as a social and commercial system; Rosenberg was better, but he still didn't seem to be very distinguished as a writer. Both of them, moreover, had the

singular limitation of not seeming to know, let alone care, about art made before Cézanne. They just wrote about modernism, and that was that. And it seemed to me that an art critic who had nothing of interest, nothing vivid or penetrating, to say about Velázquez or Turner was no more likely to be worth taking lessons from than a literary critic who had no response to Cervantes or Dickens.

The critics I admired, read incessantly and wanted to be like—monkey see, monkey do—were all concerned with arts other than painting and sculpture. There was Kenneth Tynan, with his ferocious wit, his genius in dismissal. And his obvious commitment to the work he admired: his sense of the moral necessity, not just the entertainment power, of theater. He was fiercely involved with the contemporary—witness his championing of Brecht, or of John Osborne's "Look Back in Anger"—but he was also equipped, and willing, to show what burning and direct messages a sixteenth-century play could bear, like a fire-arrow loosed into the present day. No art critic in the early sixties was writing in this way about old art, and I found it thrilling, even though I had no more seen the productions than I had seen the exhibitions at the Tate, the Met, or the Museum of Modern Art.

When I was sixteen or so, I had come across a book in my brother Tom's library. It belonged to his then wife, Joanna Fitzgerald, a part-time journalist. It was entitled *The Unquiet Grave,* and its author, Cyril Connolly (1903–74), had edited one of the great (if relatively short-lived) literary magazines of the twentieth century, *Horizon,* which survived from 1939 to 1949. It was a collection of finely honed reflections on art and life, written under the spell of such French aphorists as Chamfort, pessimistic and elegiac in tone, lamenting what Connolly feared was the wartime disappearance and perhaps the destruction of Europe. It had been published under the pseudonym Palinurus, the name of Aeneas' helmsman in Virgil, who is swept overboard from the flagship on its way from Troy to the future site of Rome and whose corpse is washed up on the future Côte d'Azur. Connolly was an unabashed hedonist whose longing for expatriation from gray England was frustrated by war. His evocation of life in Paris and beside the Mediterranean in those palmy years of the 1930s struck deep into me, as did my admiration of the scope of his reading and his apparently total recall of what he had read. His melancholy and self-pity resonated with my own adolescence. His polish was superfine, and his lapidary style—which managed to be vernacular and

high, both at once—almost beyond envying. I didn't want to write like Connolly: I wanted to *be* Connolly. Reading and rereading *The Unquiet Grave*, I felt myself drawing close to him—a complete illusion. In 1966, living in London now and contributing pieces to the *Sunday Times*, I would occasionally see the portly and irritable figure of my hero bustling along the corridor in his chalk-stripe suit. I did not dare approach him. This turned out to be a sound instinct.

I greatly admired Kenneth Clark. *Civilization* lay far in the future, but *The Nude* and his studies of Piero della Francesca and Leonardo were essential texts for me. I read them often, especially the former, and I saw nothing wrong or snobbish about the slightly mandarin character of Clark's style; it was natural, without affectation, and entirely the unforced product of character. Best of all, it was clear and completely free of any kind of jargon. Clark was not, and never could have been, one of those writers to whom one looked for explications of what had gone on in twentieth-century art; he was temperamentally ill-fitted to the emotional reach and intensity of Expressionism, for instance, let alone the Surrealists' sexuality. But when in later years I heard people dissing Clark for his social standing and vast institutional success, his precocious directorship of the National Gallery and the near-worship of *Civilization* when it hit American TV screens after 1969, I could see why he annoyed his critics—I certainly had my own reservations about *Civilization*—but could not share their irrational class bias against him. Certainly the TV Clark was easy to parody—"I am standing in front of the medieval façade of San Vietato da Sosta, which you cannot see because I am standing in front of it"—but he practically never fell into habits of condescension: the one example of it I remember, vivid because of its uniqueness, was right at the end of program 13 of *Civilization*, when he expressed some mildly turned apprehensions about the continuity of civilization itself and then toddled off into the garden at Saltwood, having given a Henry Moore maquette an avuncular and (I suppose) reassuring pat on the head, as though it were a beloved pet.

For good or ill (the former, I still think), Clark was the only living writer on art who influenced me when I was in Australia in the early sixties. (John Berger would do so somewhat more deeply later, in England.) But the most beneficial influence on my slowly forming approach to criticism was, undoubtedly, that of George Orwell. Orwell had never written a word of

what one could call art criticism; it's true that he once produced a piece, which became quite celebrated, on Salvador Dalí, denouncing him as a fraud and a decadent—the peg being the English publication of the painter's highly fictionalized autobiography, *The Secret Life of Salvador Dalí*. But it was not one of Orwell's better efforts, and to the extent that it revealed anything it only made it clear that the writer didn't have much sense of the visual and couldn't stand Dalí's often hilarious, narcissistic fantasies.

Rather, what influenced me in Orwell was his direct use of the English language, in exposition and in argument. This was a most uncommon attribute of art criticism. Probably it has always been. Every period finds its own peculiar modes of obfuscation and intolerable bullshit when art is under discussion. Today, at least in American academe, the prevalent mode is an abstract, colonial parody of French post-structuralist jargon, thickened with gobbets of decayed Marxism. But in the early sixties, one had to contend with an airy-fairy, metaphor-ridden kind of pseudo-poetry, which infested the art magazines and made reading about art a bore and a trial. Orwell's prose, in all its plain straightforwardness, its no-nonsense attachment to verifiable meaning, was a wonderful counter to this. His essay on the use of the English language, advising the neophyte writer never to use a Latinate word where an Anglo-Saxon one would do, to prefer the short word to the polysyllable, to employ the active rather than the passive voice, and so on, should be mandatory reading for all young cultural critics, and it became so for me. *Politics and the English Language* is one of the great instruments of truthseeking in English or any other tongue. In this, as elsewhere, Orwell rose to the level of his unsurpassable model, Jonathan Swift.

I was not particularly concerned with Orwell's politics, although he was obviously a man of the Left who vehemently opposed the deadly reigning orthodoxies of Stalinism while advocating a humane form of Labour Party socialism; the efforts of neoconservatives in the 1970s and '80s, such as the American Norman Podhoretz, to draft Orwell posthumously into the ranks of the right-wing Reaganites would strike me not only as flatly wrong but as a wretched example of bad faith—a serious betrayal of the values Orwell stood for.

But it was his instinct for the politics of culture—his belief that every use of language must pay its dues to clarity and force of expression, and that to misuse it is a crime against the integrity of one's craft—that stuck with me,

and seemed necessary to apply to the discussion of visual art. Maybe that would leave you with less to say, fewer ruffles and flourishes. But perhaps what might have been said would not have been worth saying anyway. And there is never any good reason to fear that an embarrassing silence will fall if you stick, as far as possible, to what is concrete. Art is mostly concrete stuff, appealing to and through the senses (another reason not to take conceptual art seriously). In any case, I am not a philosopher and have never had the least talent or desire for metaphysical discussion.

The people I learned most about art from were, perhaps inevitably, the artists themselves. Many of them felt suspicious of me, as well they might, since I was so young (a mere twenty-one in 1959) and cockily inexperienced. Some welcomed me, others rather watchfully made room for me, and still others despised me from the start and continued to after I left Australia. The politics of the Australian art world were not merely inflected but determined by the bitter rivalries that built up inside it—no doubt because, as Henry Kissinger once remarked of the hatreds born of academic jealousy, "the stakes were so small." Most of these rivalries had their ultimate origin in the market, rather than in this or that ideology of painting. The prices of art were extremely low. Almost all the painters and sculptors I knew were either apolitical or only marginally interested in party politics. There was no "political" art of any consequence; Australia had a few Old Lefties of the social-realist persuasion like Noel Counihan, painting slums and their down-trodden inhabitants, but that was all. This faithfully mirrored the general lack of confrontation in Australian intellectual life. It is almost, if not quite wholly, true to say that in the 1950s there were no "public intellectuals," in the modern sense, in Australia. Dissenters there certainly were, but they didn't have a forum of any kind outside the little magazines. One could not imagine a politician in Canberra giving the time of day to a nonelected political analyst, or to anyone who attempted to set forth, much less criticize, a political philosophy. Ideology was for Commos. Indeed, the word "intellectual" had little concrete existence. We could hardly imagine what such creatures might be for. All we had, the media and the politicians insisted, were "pseudo-intellectuals"—useless, effete, academic marginals who theorized impotently in corners, could not have any effect on public policy, and should not be allowed to try. And if intellectuals were powerless, how much more so was the little, underpaid art world! Even our bohemianism was of a private

and nonconfrontational sort. Absurd rivalries existed between the "abstract" painters in Sydney and the "figurative" ones in Melbourne, the two main culture centers—absurd because most "abstraction" wasn't abstract at all, being permeated with references to landscape and the natural world. Australia has never been hospitable to purist abstraction of the Mondrian sort—and, in fact, Mondrian himself was not as purely abstract as was once conventionally supposed.

Not that there were any Mondrians to be seen in Australia. Their invisibility had been taken care of by the generations of semi-educated, blokey reactionaries who directed, and served as trustees in, its museums. (In America, nobody has ever been appointed to the trusteeship of a great museum solely on the basis of his or her knowledge of art; what gets you on the board is a combination of your wealth and your privately committed willingness to leave a good slice of it to the museum. In Australia in those days it was the same, but not as good: as a general rule, you didn't have to make any promises of future bequests, you just had to be "eminent"—in other words, one of the Good Blokes but not encumbered with connoisseurship or promises. It was a weak system that insured a concentration of ignorance just where some degree of knowledge and openness was needed: in the boardroom, where decisions overrode those of curators. And nowhere did it provide regular funds or an efficient arrangement for buying "overseas" art. Consequently, Australian museums did not and could not inform their public about what had been going on for the last half century in Europe and America in terms of abstract art, and the result was the lame controversy that surrounded the so-called Antipodean Manifesto in 1959.

Since Australian artists have never tended to seek group identity in clubs or "movements," the very existence of this document had a certain significance, but its meaning mostly lay in its misunderstandings. Drafted by Bernard Smith, the not yet quite ex-Marxist professor of art history at Melbourne, with some prodding by the painter and potter David Boyd, it set forth a scenario of threatening trivialization. "Today we believe," it ran,

> that the existence of painting as an independent art is in danger. Today tachists, action painters, geometric abstractionists, abstract expressionists and their innumerable band of camp-followers threaten to benumb the intellect and wit of art with their bland and preten-

tious mysteries . . . we are witnessing yet another attempt by puritan and iconoclast to reduce the living speech of art to the silence of decoration.

Sure, and of course all these simply awful things happening to painting in New York, Paris, and London were going to be rolled back by a resistance movement starting in Melbourne, Victoria, weren't they? Perhaps a modest reality check was in order. The fact was that abstraction had never been very pure in Australia, and when it was pure, as in the work of figures like Ralph Balson, never at all popular. Far from threatening to reduce art to "the silence of decoration"—and since when was decoration so silent, anyway?—it led an entirely marginal life as far as the public and the market were concerned. Behind most "abstract" paintings made in Australia there was usually a landscape, earth at the bottom, sky at the top. The work of the best-known and most esteemed "abstract" artists in Australia in the early 1960s, such as John Olsen and Ian Fairweather, was permeated and enriched by images of figures, landscapes, and animals, to the point where it could not have been called abstract at all, even though abstraction and stylization played large parts in its making. Besides, none of the signatories of the Antipodean Manifesto, not even Dr. Bernard Smith, had seen much (or in most cases, any) Abstract Expressionism, or had more than the foggiest and most general ideas of what that inadequate label might mean, because they traveled very little (especially not to New York), while none of the paintings in question ever came to Australia. It seems to me that their noble-sounding warnings about the meaning and fate of art in Australia really came down to banal turf squabbles over who, the Abs or the Figs, got the larger share of a very small art market. And these soon ceased to mean anything, because with the growth of Australia's business prosperity and the increasing fashion for art on the wall—whether as décor or investment—there turned out to be plenty of room for everyone.

This was brought sharply home to me one evening in 1962, at a party thrown by Melbourne painters for a group of Sydney "abstractionists"—John Olsen, Leonard Hessing, Stanislaus Rapotec, Bill Rose, and others—who were having a show at a gallery in Melbourne, calling themselves the Sydney Nine. No question, this was meant as a polemical gesture (a symbolic invasion from the north); the catalog introduction I wrote tried to make this

fairly harmless point in an offhand and humorous way. But it was not taken offhandedly by the Melbourne artists themselves. Nor did they think it funny. The evening, whose venue was a cavernous, sawdust-floored restaurant furnished with massive tables and cedar logs to sit on, the sort of place so ruggedly lumberjackish in tone that its owners probably thought pâté was intrinsically effeminate—though I forget what we actually ate—rapidly devolved into childish, drunken squabbles. The Melbourne painter John Perceval, a cripple with a big bad drinking habit, drew a line in the sawdust with the rubber tip of his crutch and challenged any "fuckin' Sydney poofter" to step across it, which John Olsen did, without result. Arthur Boyd's brother David, in whose dark, glutinous, and ill-drawn pictures of genocidally oppressed Tasmanian Aborigines the family talent for painting had not appeared—though he was a gifted potter—seized me by the shirt-front, burst into racking sobs, and declared that I and the members of the Sydney Nine had come down to Melbourne to snatch the bread from antipodean babies, of whom several fat and rosy examples were crawling between the restaurant benches and peeing in the sawdust, seemingly unconcerned with their impending starvation. These scenes of Australian cultural life, so distant from the cooler and more stylish realities of the present day, called for a Rowlandson to do them justice.

The best-known Australian figurative painter was not in this mêlée, or even in Melbourne. He could not be persuaded to sign the Antipodean Manifesto. He was in London, enjoying his life as our most famous expatriate, along with Sir Robert Helpmann and Peter Finch: Sidney Nolan, later (as from 1981) Sir Sidney (1917–92). To me, Nolan has always been a controversial figure, but the controversy has often been within myself. I have known artists whose work was uneven (indeed, whose is not?) but I have seldom known one whose output spanned such highs and lows as Nolan's, such extremes of crap and lyrical near-genius, and I sometimes wonder if my dislike of his lesser work is not due to some blind spot of mine. (For the record, I don't think so.)

I am quite sure, though, about the near-genius. The series of paintings Nolan devoted in 1947 to Australia's bushranger hero Ned Kelly is one of the few exceptional narrative cycles in twentieth-century art. But it was in the context of his earlier work that I came to know Nolan himself. In the early years of World War II, he had been stationed as an army private in

the flat, hot, wheat-growing country of the Wimmera, in northern Victoria. His base was a military camp in a town, hardly more than a railroad siding, named Dimboola. There, in the intervals between work and work, he had painted; these pictures were mostly undocumented, and lost; and now, in 1962, there were plans for a short book on them, which Nolan hoped I would write. But they had to be recovered first, if they could be. So off to the Wimmera the two of us went.

Nolan had realized quite early that the military life was not for him. In Dimboola in 1942 he was swinging hundredweight wheat bags into a railroad truck when the yob private who was the other half of his team slammed the massive iron tailgate door on his hand, cutting off a finger. Bending down, the boy picked up the roughly amputated digit from the track and held it out to Nolan. "Get over to the medical officer, Sid; if he sews it back on you'll be as right as rain."

Overcome with horror, Nolan (as he told me) decided at that moment to desert. He got his hand roughly sewn up. The penalty for desertion was the firing squad, but Nolan did not care. He would rather die than stay in the Australian Army; it was that simple. Anyway, the bastards would have to catch him first.

He gathered up all the paintings he had done in the Wimmera—scores of them, all on cheap hardboard, which were worth nothing in 1942 but twenty years later would have been very valuable by Australian standards—and stashed them under the houses and sheds of sympathetic wheat workers. The buildings were raised on ironbark posts with tin ant caps to protect them from termites; alas, the paintings had no such protection.

Nolan tossed his rifle in a creek and hopped a freight train to Melbourne, four hundred miles away, where he found shelter outside the city with his patron John Reed and Reed's wife Sunday Baillieu, on their property, "Heide," in Heidelberg. John Reed's patronage is always cited as the principal reason that Nolan was able to get his start as a painter, but the love of Sunday Reed was at least as important. She was so convinced of Nolan's talent, so enamoured of it and him (like Thomas Butts with William Blake, only more so) that she would even make the punitively long, clanking rail journey from Melbourne to Dimboola in order to bring him paint, brushes, and magazines. She was more than his lover; she helped create Nolan as an artist, probably more than even her husband did, and their letters in the early

1940s—which, alas, are unprintable, due to Nolan's widow, Mary Boyd, who controls their copyright—are all but unique in the annals of modern art: to find anything parallel to them, one must go back to the correspondence that passed between Oskar Kokoschka and Alma Mahler.

Protected and supported by both John and Sunday Reed in their ménage à trois, which was an open secret in the little Melbourne art world but quite unknown outside it, he concealed himself at Heide for six years, until well after the war. His Kelly paintings were mostly done on a table in the sunroom there—a perfect place for one fugitive to paint and meditate about another. When the military police came to Heide looking for him, as they did from time to time, Nolan would even copy a trick from the Kelly gang, one of whose members, Steve Hart, used to don his sister's dress as a disguise when the troopers rode by looking for him. One of the Kelly paintings is titled *Steve Hart Dressed as a Girl,* and this bucolic transvestism was copied by Nolan when the MPs appeared at Heide—he would struggle into one of Sunday Reed's dresses and wander about in the pasture by the creek with a staff, muttering to himself, the candid Irish blue eyes staring. "It's just me crazy kid sister," Reed would explain. "She likes to look after the geese." What the military police would have thought if they had been granted a vision of this cracked dame in a goose-stained cotton shift being dubbed a knight at Buckingham Palace four decades later cannot be guessed. When not in drag Nolan used the name of "Robin"—for Robin Hood, presumably, a further embellishment on his and Ned Kelly's fugitive status.

Meanwhile, the Wimmera paintings were all eaten by mold and termites. Every last one of them was gone, and when Nolan and I went crawling beneath the stump foundations of the few surviving farm buildings whose locations he could remember we found nothing at all, beyond a few nibbled fragments of hardboard. They bore traces of colored enamel which may (or possibly may not) have been the Ripolin that Nolan, hearing that Picasso used this brand of house paint, had employed in his early paintings. "Ripolin is healthy paint," Picasso is said to have said, whatever that meant. It was not healthy enough to be proof against the ravages of Australian insects—but then, few things are. Nolan had half-expected this outcome, but he had nourished the hope that something would turn up. He had few of his own early paintings—all the 1947 Kelly series, except for one, had passed into the hands of John and Sunday Reed. On some none-too-subliminal level, I

think, he associated the idea of saving some of his early paintings from their corrosive Australian environment with the thought that he himself might have been spared some of the obloquy that fell on him because he was an expatriate. The press was always nasty to him about this; it was their standard performance to give him stick because he no longer lived in Australia and could therefore, with impunity, be derided as something of a traitor—and a snobbish traitor at that, some thought, because he had accepted a knighthood from Elizabeth II. Over schooners of beer in various pubs, Nolan waxed bitter to me about the merciless double standard he felt (correctly enough) that the Australian Meejah had applied to him: half proud of his achievements as an Australian, half jealous of them. "They'll kill you," he said morosely. "They'll kill you if you give them half a chance." At the time I thought he was exaggerating. He was not.

Actually, only one of the three Melbourne artists who stick most vividly in my mind signed the Antipodean Manifesto, and that was Arthur Boyd, the most saintly and unpretentious of them all, who more or less had to out of family loyalty because his brother David had helped dream it up. Nolan, ever complicated, wouldn't touch it. And the nastiest, most paranoid painter in Australia wouldn't sign it either, though he was asked to.

This was a veteran of Melbourne's forties, the painter Albert Tucker. Tucker, a heavy-handed Expressionist with an ego like a pit bull, had done some paintings of merit in the early 1940s, mostly on the theme of the semi-prostitutes known as the "Victory Girls," who hung around the pubs and pinball parlors of Melbourne, picking up American G.I.s. But he was never able to turn a living from his paintings in Australia, and he left for Europe in 1947, declaring that "I am a refugee from Australian culture"—the word "refugee" having a far heavier and more pathetic political loading then than now, suggesting not mere displacement but active persecution, as of Jews by Nazis or kulaks by Stalinists. He lived for a time in Paris, where he picked up the influence of Dubuffet's intentionally crude drawing and thick pastes. These became the basis of his style, with its fissures and *art brut* mannerisms. He settled in Italy for a few years. Then, via New York, he gradually worked his way back to Australia, where he arrived in 1960, declaring (in an interview with me in Melbourne that year) that "I've come back to pick up my back pay."

Exactly why Australia should owe Tucker anything for the unsold paint-

ings he had done in Melbourne twenty years before, or in France and Italy during his expatriate years, was left unexplained. But he was messianically determined that Australia should pay, and pay more for him than it did for Nolan, whom Tucker regarded not as a fellow veteran but rather as a loathed rival. (In Tucker's inflamed world everyone was a rival, even the taxi drivers.)

He therefore invented, as part of his strategy, the myth that he had become an admired and sought-after artist both in Europe and, more important, in New York; he created the impression that the curators of American museums, headed by James Johnson Sweeney of the Guggenheim and Alfred Barr of the Museum of Modern Art, were elbowing one another aside to get his cratered profile heads. Sid Nolan might have the inside track in London but he, Bert Tucker, was the Australian watched in America. Since there was no way this could readily be checked from Australia, it became fact, part of the *legenda aurea* of international stardom which Tucker spun about himself. It was, however, a complete lie. Practically no one in a position of power in the art world outside Australia, and certainly no one in New York, had ever heard of him.

As time went by, Tucker's paintings became increasingly repetitious. His "Antipodean Head," that rugged and expressionless profile that looked rather like a map of Australia turned on its side, devolved into a mere trademark. Sometimes its owner carried a gun, sometimes not. Sometimes it had birds clambering and pecking on it, and was entitled *Explorer Attacked by Parrots*. (As a matter of ornithological fact, parrots never have attacked explorers: they are too shy and they eat nuts, insects, and seeds, not human flesh.) But whatever Tucker did to it, it was still the same image with trivial variations. This did not prevent him from issuing blasts of invective against anyone who failed to detect in his latest show some significant reinvention or new departure. He was, in sum, a bore with an ego the size of Uluru, that huge red rock in the middle of the continent, and one dreaded bumping into him within the small confines of Australia's art world. I am not generally a coward, but I was so frightened of Bert Tucker that when the Sydney painter Bill Rose told me that, having read a less-than-enthusiastic review by me of his last show of parrots and explorers (or perhaps it was explorers and parrots), Bert had come to Sydney looking for me with a pistol, I hired a Halvorsen cruiser at Coal and Candle Creek and disappeared for a week up

the Hawkesbury River, taking with me my trusty shotgun just in case. When the story got around it caused much merriment, since it turned out that Tucker had not even read the review, let alone left Melbourne in pursuit of vengeance.

There were antidotes to the likes of Tucker, and fortunately there were not many like him. Some of them became my friends and influenced me very much for the better; they opened up for me vistas and purposes within art whose existence I had only dimly perceived. John Olsen (b. 1928) had gone to Europe on a private scholarship and settled first in Paris and then, for most of his three-year sojourn, in Majorca. He took in and digested, with great acumen and élan, whatever seemed most vigorous in European painting at the time—not the tardy imitators of fifties Picasso, not the tired reruns of geometric abstraction, but rather the work of the Cobra group, of Jean Dubuffet and the young Spanish artists who were beginning to make a stir in the late 1950s, Antoni Tapies, with his sullen, beautiful "walls" of incised pigment, and Antonio Saura. He talked about Barcelona and Antoni Gaudí— thus lighting the long, slow-burning fuse that would cause me to write my own book about both thirty years later. He spoke of Pierre Alechinsky and Joan Miró with their swarming canvases of weird little animal-insect-astronomical-human images. He couldn't have been less interested in "pure" abstraction, whatever that was, and with paintings like *The People Who Live in Victoria Street* (1960) and *Entrance to the Siren City of the Rat Race* (1963) (what a title!), he tried to draw portraits of the swarming life of Sydney, completely at the opposite pole of experience from the "bland and pretentious mysteries" that the antipodeans, down in Melbourne, fancied that Sydney painters were encouraging. Did Olsen mind vulgarity? Not at all:

> I rejoice in it. It has enormous vitality. Sometimes I put in a loutish kind of head, sneering and snarling. One has to be prepared to be a bit corny; I don't like international painting—the slick sort of abstraction one sees a surfeit of in Europe. If one is really to get down to the problem here one has to be banal even. The power of Australian society is this vulgarity . . .

At a time when many, perhaps most people, thought of Paul Klee as a sort of marginal esthete—a painter of "little paradises," suitable for liberal nurseries—Olsen had divined how profound Klee's influence on his con-

temporaries, from Kandinsky to Picasso, and on his heirs, especially Pollock, had actually been. Klee's famous phrase "taking a line for a walk" became Olsen's talisman, and the approach to imagery it proposed, as epitomized for Australians by the series of paintings generically entitled *Journey into the You Beaut Country*, was wonderfully congenial, full of sly humor and pictorial jokes. ("You beaut" is an Australianism, archaic by now, expressing enthusiastic, over-the-top approval.)

I thought then, and still do, that Olsen was to his time in Australia what Arthur Streeton had been to the late Victorian years in Australia: the landscapist who, with unrivaled grace and energy, gave his country a face which had not been perceived before but, once seen, was almost axiomatically truthful. Some Australian artists, as they enter the badlands of late middle age, tend to stiffen into routine imagery and typical gestures—the theatrics of self-parody. John, who is nearly eighty now, has avoided this, and only his energy and visual curiosity has let him keep drawing with such abandon and gusto on a fund of common images.

I remember an evening when Olsen's work came especially alive for me. It was shortly before I left Australia and I had gone up to visit him in the bush at Yarramalong, near Wyong. He had been lent a house on a country hillside by the Australian writer Frank Clune (1893–1971), a cawing and self-infatuated old hack. A well-to-do accountant who lived in the "silvertail" suburb of Vaucluse in Sydney, Clune was only a writer by courtesy: most of the work published under his name—and there were at least sixty books, mostly about travel, which made him the second most popular author in Australia after the bush storyteller Ion Idriess—were actually written by a resentful ghost by the name of Percy "Inky" Stephenson (1901–65), a curious and second-class Anglo-Australian soldier of literary fortune. Educated at Oxford, Stephenson had been a friend of "the wickedest man on earth," the diabolist Aleister Crowley, and of D. H. Lawrence. Back in Australia, having passed through early attachments to the Lindsay family and then the Communist Party, Inky helped between the wars to found a quasi-Fascist organization called Australia First, for which he was interned for the duration of World War II. Along the way, he managed to write most of Clune's books for him, although, as he wrote in some anguish, "For two pins I'd chuck up this distasteful literary hackwork altogether . . . It ruins my nerves and eyesight, and wastes my talent." To be shackled to Clune, who kept pro-

ducing books with such titles as *Flight to Formosa, Prowling Through Papua, Rolling Down the Lachlan,* and *High-Ho to London,* must indeed have been a disagreeable fate.

Clune's carrot-haired wife, Thelma (who, luckily for their marriage, was as deaf as a post, and so could tolerate his monologues), ran the Clune Gallery in King's Cross, where John occasionally showed. A goodhearted soul, sometimes she would lend "her" artists the farm cottage at Yarramalong as a studio, and John had been painting there for weeks. It was an idyllic place, with a broad veranda that looked past a grove of trees, across the hills that rolled eastward down to the gray-blue sheet of the Pacific, glimmering in the fading light. Mercifully its owner was not there. But John was, and so were a couple of carloads of friends. I had brought some fish (flathead and prawns, a bag of mussels and another of pippies, those succulent little sand clams that, in those days, most Australians refused to eat themselves but employed only as fish bait) and a case of wine. Someone else produced fresh baguettes. John pulled out his blackened paella pan. An hour later, in a darkness lit only by kerosene hurricane lamps, eight of us settled down at a table outside to feed. And suddenly chaos broke loose. Amid breaking plates and toppling wine-bottles, several opossums swung down from the roof, raced across the table, grabbed the loaves and, clutching them like pirates making a dash for the rigging, scooted up into the trees. Startled, splashed with wine, and half hysterical with laughter, we could only watch helplessly as the possums chomped and chewed, scattering the leaves with crumbs. This total surprise in the half dark, this irruption of innocent greed from the animal creation, this combination of rudeness, gourmandise, mystery, and humor, was totally in the spirit of John's art.

Colin Lanceley (b. 1938) was the founder of the Sydney collage group called the Annandale Imitation Realists.

The Imitation Realists took their name from the working-class, and as yet wholly ungentrified, suburb in which they lived and made their bizarre assemblages at the start of the 1960s. There were three of them, Michael Brown, Ross Crothall, and Lanceley, all in their early twenties, living in a rambly four-story Victorian house: rusting iron-lace balconies, goose-turd green paint, a smell of turps and baked beans in the narrow rooms. Nobody who saw the place three decades ago has forgotten it, but perhaps only twenty people, all artists and writers, actually did see it. It was the East Vil-

lage a quarter of a century before its time, but much stronger, fifteen thousand miles west, and endowed with a degree of mystery that cannot be revived. Hardly a square foot of wall was visible. The house had been turned into a palace of incrustation, jammed with icons and effigies made from junk, as though the accumulated contents of lower-middle-class Australian life in all its kitsch, pathos, and grinding insistent force had been flung against the walls and stuck there, provisionally held together with splots and gouts of paint. At the time of their first joint exhibition in Sydney, at the Rudy Komon Gallery, they and Lanceley created the kind of scandal that hadn't been felt in Sydney for years. Imitation Realism was all about Culture, and scarcely about Nature at all. "She's synthetic, vulgar and bawdy," wrote Michael Brown of his *Mary Lou*, a scandalous trash Madonna whose breasts and vulva were two plastic toy ducks and a squashed paint can, "but at the same time, if you can bear to look at her long enough, there is a weird kind of beauty that does come through." It didn't come through to everyone, by any means. Punk had not yet been named, and would not be for a couple of decades, but quite a few of its elements were there in Annandale. No Australian artists, as I noted in *Nation* at the time, had ever done so much with the *urban* vulgarity of Australian society at the expense of the pastoral dreams of its "high" culture, still fixated on landscape in the unconscious hope of denying its city-bound nature: the bush towns were dying; 90 percent of Australians now lived in coastal cities.

Looking back on it, I think of this bizarre, fun-fair art house as a distant equivalent to the *Palais Idéal* slowly put together, out of stones, oddities, and little bits of junk assembled on his rounds, by the postman Fernand Cheval in the late nineteenth century, at Hauterives in the Drome, a temple to the naïve imagination worshipped by the Surrealists; but there was nothing so very "naïve" about the three young men who made it, for they had all at least been to art school. Lanceley had certainly heard of Kurt Schwitters and of his *Merzbau*, the house of glued-up and nailed-together junk he had created in Hanover—but that was long destroyed, and no photos existed that gave any idea of it. He had also heard of Joan Miró's Surrealist constructions, and Arthur Dove's object-poems, and Robert Rauschenberg's marvelous street-scavenging "combines" of the late 1950s. But you do not hear art. You see it. In Australia, none of these things could be seen, or ever had been. Lanceley was suffering from exactly the same image deprivation

as the rest of us. But he was able to transcend it by going to Australian sources, to Australian idioms, and to a vernacular of Australian objects, and refracting them through what he knew about the high European modernist tradition. In this, knowing Olsen and his paintings was a great help. For, as he put it, it amounted to

> trying to recreate an experience by putting together impressions of its piecemeal nature . . . A lot of Olsen's paintings at the time were walks down the street, an elaboration of Paul Klee's doodling, in which various calligraphic happenings and images got noted down and annotated in a freewheeling spirit. Its appeal for me was that it seemed a very inventive approach to painting; it looked as though there could be an enormous vocabulary, a great fund of imagery to be discovered.

Other things fed into Lanceley's work. There was, for example, the influence of New Guinea art, particularly the masks and carvings from the Sepik River, those glowering and confrontational faces of heroes or gods into which—a particular delight—the Melanesian artists often incorporated salvaged fragments of white culture, like a worn leather boot-sole curling downward to form a tongue.

I was lucky to count both Olsen and Lanceley among my friends—and still am. The third artist friend, alas, is no longer alive. His name was Donald Friend, and he died of emphysema at the age of seventy-three in 1988. Donald was of an older generation than Olsen's or Lanceley's. As often seems to be the case with people who have been really important to me, I cannot remember where or when I first met him. But despite our differences of age and sexual orientation, we hit it off right from the start. It must have been in Sydney, and when I was writing for *Nation*—say 1960. He already seemed a fairly senior figure in Australian art; a long-time expatriate, who had for more than five years been living on a tea plantation in Ceylon, and for years before that in places remote from Sydney, such as Italy and the islands of the Torres Strait archipelago. His cock, in effect, had led him around the world like a divining rod. Donald was, as he once put it to me, a "negrophile"—it was typical of him that, while admitting his celebratory preference for blacks, he should have used this peculiar and outdated mock-clinical term, which I had never heard before, as though his likings belonged in Krafft-

Ebing's *Psychopathia Sexualis.* In the obdurately, dully racist white Australia of his youth, it was not the kind of sexual preference one would necessarily want to be born with. The White Australia policy was in force. By and large, the only blacks within range of a reasonably lustful young man who lived in Australia were Australian Aborigines, and Donald—like most whites of his class background, which was of grazier stock and therefore elevated— found those Aborigines coarse, spindly, and unattractive.

But Donald was not cut out to stay in Australia. One reason I liked him so was that he had an expatriate's nature. In the thirties he had gone to London, where as a young art student at the Westminster School he had haunted the jazz clubs and *mauvaises lieux* of Soho, hooking up with their floating popu- lation of African migrants and undocumented passers-through. And there he got to know a number of West Africans: tall, lithe, elegant of carriage, by turns languid and bursting with energy, great to draw, and black as Pelikan ink. It occurred to him: why not go to the source, to the mother lode of these semidivine young beings? And so, having saved up what little money he had—some income coming in from sales of drawings to English collectors, three or five pounds apiece—he took ship to Lagos, the capital of Nigeria, and ended up living in the capital of the ancient kingdom of Ikerre, still (this was 1937) presided over by its Ogoga or paramount native chief- tain, Alowolodu II, Lord of the Palms and Protector of the Secrets of the Forest. Alowolodu's ancestors had been tremendous and bloodthirsty Yoruba warriors, whose slaves would turn your and your friends' skulls into a matched set of palm-wine goblets in a moment. Their ferocity is commem- orated in a fine set of carved wooden doors from the Palace of Ikerre, now in the British Museum, showing rows of enemies' heads impaled on stakes, like so many bonbons, with elegantly formalized crows pecking out their eyes. Fortunately for young Donald, this severe atmosphere had softened over the previous half century, and the present Ogoga, an amiable lad of twenty, was content to rule from his large grass palace, reclining on a pile of handsome cushions and paliasses upholstered in brightly colored cloths, while his many arm, leg, and neck bangles were greased by subservient women. He was not predominantly homosexual but he certainly showed a liking for Donald, whom he appointed his chief tax collector. Donald's first, and indeed only, job in Africa was to make intermittent trips into Lagos, driving a rachitic Austin along the bush trails, to extort tax money from the dissident nobles of

Ikerre who, distressed by the decline of the Spartan virtues in their kingdom, had decamped one by one for the big city. Strangely enough—especially for someone who would spend much of his later life dodging Australian tax collectors—Donald proved to be good at this, and his skills made a lifelong friend of young Alowolodu II. Reading Evelyn Waugh's classic and darkly hilarious account of life in a thinly disguised Ethiopia under Haile Selassie, *Black Mischief*, will give one an idea not only of Alowolodu II in Seth the emperor, but also of Donald Friend as an Australian version of Basil Seal.

This idyll did not last. You might say that Donald's life was a whole sequence of idylls that, by their nature, could not last, real but fragile semi-Arcadias whose integrity was constantly being ruptured, interrupted, or threatened by obligatory returns to white Anglo-Australian civilization. When World War II broke out, he returned to Australia and enlisted. When hostilities were over he moved north, to the Torres Strait, where he lived in various Thursday Island communities. Later he would live in some state in a bungalow in Ceylon, now Sri Lanka, on a tea-planting estate named Brief, owned by a Sinhalese friend Bewis Bawa. There followed periods in Australia, and in Bali, where he created around himself a truly seigneurial environment near Kuta Beach—now, alas, a condominium development, since the property was in effect stolen from him by a Balinese co-owner who managed to get Donald thrown off the island for his homosexual practices. Depending on the reigning moral atmosphere among the Balinese authorities, who were not above using eminent gays to promote their "island of culture" one moment and expelling them in fits of moral sanctimony to impress the electorate the next, the life of the aging gay—the "Norman Douglas of the Spice Islands"—was by no means as secure as it might have been.

Because Donald and I got on so well, when the idea of a book on him was mooted by an Australian publisher in 1963, he insisted that I should do it. I was overjoyed at the thought. I forget what the proposal was: certainly it did not include royalties, although I did receive a lump sum (one of the smaller lumps in the history of Australian publishing, alas), and although I suggested to Donald that the gift of a couple of his drawings would not go amiss I never, in the end, received them. (Donald had a parsimonious streak which accorded strangely, sometimes, with his capacity for ostentatious generosity.) But I was fortunate in that the book was not meant to be long, that its subject was still very much alive and could answer questions as frankly or, on

occasion, as misleadingly as could be—and, best of all, that he had kept a journal most of his life, a mighty project that by 1963 ran to more than thirty handwritten volumes, all done on beautiful sheets of tinted, watermarked Arches paper and embellished with thousands of drawings—an irreplaceable and, in some areas, unprintable record of the life of a highly observant, upper-class but socially omnivorous Australian homosexual through the 1940s, 1950s, and 1960s. Australia never had an equivalent to the *Mémoires* of Saint-Simon, because it never had an aristocracy or a court. But it did find its near-equivalent to the writings of James Boswell in these extraordinary journals of Donald Friend, which, fortunately, have now found safe haven in the National Library of Australia in Canberra, and since his death are methodically being edited for publication by Paul Hetherington, two volumes being already out. Donald not only gave me complete access to the journals but, slightly to my amazement, allowed me to take them out of his house in twos and threes in my battered briefcase so that I could work on them at home. To my intense relief, I never left that briefcase on a bus, and when I see one of the precious volumes opened to a given page in its glass case in Canberra I thank my stars for saving me from my habitual carelessness.

Donald Friend was both my first book and my last project before leaving Australia. I knew, as Donald and the publisher also did, that if I left the country before the book was done I would never get it finished. This would have been a catastrophe of broken faith for me, and a terrible disappointment for Donald. So I did push the last of the text through, staying under a form of benign surveillance on a sheep station near Canberra owned by one of his oldest friends, the painter Mitty Lee Brown. Not until the manuscript was wrapped up and delivered was I really free to go.

One of Donald's closest friends within the circle of living Australian artists was Russell Drysdale, known to his friends as Tass. He was, you might say, the demigod of semiconservative Australian painting, its pictorial laureate of bush experience. He was a gentle, modest, solidly built man, blind in one eye, with a singularly disagreeable shrew of a wife, Bonnie, and a son, Tim, neurotic to the point of complete craziness, who showed no sign of inheriting his father's talent and would presently kill himself in a fit of depression. Drysdale, who was of Anglo-Scots birth—the family immigrated to Australia in 1924—had come to know the bush very well, and had

evolved the first genuinely popular "modernist" schema for depicting it, more stylistically "advanced" than the gum-trees-and-sheep formulae of pastoral landscape. His version was shot through with an alienation and even pessimism that matched both modernist feeling and the Australians' actual doubts about the land they lived on: the sense that those dry distances and the ever-lurking threat of bushfire and other disasters contradicted the kindly-womb imagery of Australian nationalism, and that this ought to be given pictorial form. The form Drysdale developed was, inevitably, somewhat imitative: cliffs, rocks, and twisted trees out of Graham Sutherland and Henry Moore, theatrical and processional landscapes by courtesy of Claude Lorrain, with, on occasion, an infusion of Giorgio de Chirico. But it had a powerful impact in the 1940s (inevitably, less so by the end of his life, by which time it had turned into rather more of a theatrical cliché), although it never quite acquired the sheer poetic strangeness of Nolan's rendering of the Australian bush.

Donald Friend was bothered by the thought that he was a superficial artist compared with Drysdale. In one of his characteristic moments of self-pity he saw, or thought he saw, in Tass's paint "a wonderful abyss, a chasm filled with a great soul . . . but not in my pictures. In mine there is no chasm, but a sort of rabbit hole from which issues a calm amused voice saying, 'Nice weather, isn't it?' ". Donald was exaggerating his friend's virtues and being less than fair to himself. There was no chasm and no rabbit hole either: just different temperaments. Donald felt things deeply, but he tended to metabolize his feelings in irony, the sort of mocking distance one associates with his adored exemplar, John Wilmot, the Earl of Rochester, poet and sublimely dirty wit. He hated not to be clever but when he was least clever, he was at his best. Australian painting has, for some reason, always been poor in images of the nude, especially the male nude—probably because of the widely spread Australian male fear of being thought homosexual, which did not relax until well into the 1970s. Donald was the only artist to consistently ignore or defy it, and his naked men and boys have a straightforward sensuality about them that could hardly be found elsewhere in his country's art. (Since then, Australia has produced a lot of "gay art," but Donald was its pioneer.) It was largely through Donald and his work that I learned how ridiculous and hypocritical Australia's national phobia about gay sensuality was. It is almost wholly dissipated now, of course. Many years later, when

working on a TV series about Australia, I did a sequence about the huge Gay Day processions and high jinks in Sydney, the largest fiesta of its kind in the world, and remarked in passing how the sight of such public tolerance, unheard-of and unimaginable thirty years before, was a cause for patriotism. When it was broadcast I received a letter from my brother Geoffrey, then nearly seventy-five, expressing his outrage and disappointment that I, as the son of a war hero, should go telling a television audience that such a seething mass of vile perverts could inspire any love of country. I felt like writing back and reminding him of the ancient relationship between homosexual love and military valor, as exemplified by such famous couples as Harmodius and Aristogiton, the Greek tyrannicides. But then, what would have been the point? Donald, I know, was no Harmodius and he had no Aristogiton: he was more fitted for the role of Cherubino when rumors of war were in the offing: *"Non più andrai, farfallone amoroso, / Notte e giorno d' intorno girando, / Delle belle turbando il riposo, / Narcisetto, Adoncino d'amor."* ("You'll go no more, amorous butterfly, / Fluttering around night and day, / Disturbing the pretty girls' rest / Little Narcissus, little Adonis of love.")

I hardly knew the man who was, in my eyes, the most important Australian painter of the time. I did meet him—once, and once only. This was Ian Fairweather (1891–1974).

To call Fairweather a rolling stone would be the most extreme of understatements. He had been a wanderer most of his life. He was born in Scotland and abandoned as a baby by his parents, who left for India and entrusted his care and education to a succession of aunts. Growing up, he studied forestry in Edinburgh and then, on the outbreak of World War I, enlisted in the Scots Greys. Posted to France, he was almost immediately captured by the Germans at Mons and spent the rest of the war in a prison camp, where, to relieve the stultifying boredom of captive life, he began to study first Japanese and then Mandarin. Chinese calligraphy would be the slender but continuous thread of his life from then on. After the war he studied art in London for four years and then headed west, via Canada, to Shanghai. He remained in China until 1936, mostly in Beijing. Nearly all his early work is lost. He then headed south to Indonesia, settling for a time in Bali. At the time, Bali was just beginning to become the "enchanted island" of slow-motion Oriental tourism (it was getting about one hundred tourists per

month, as against some thirty-five thousand by 1990). It was the Capri of the tropics, with a foreign community of rich, cultivated homosexuals, but with ancient and living art traditions that Capri wholly lacked. Nothing could have been more congenial to a struggling homosexual artist like Ian Fairweather, and in fact nothing was—but the Dutch authorities hustled him off the island after a few months, and he kept wandering disjointedly about, first to Australia, then to Ceylon, then to Shanghai again, and Beijing again, and Australia again. He painted all the time, apparently, but with such wretched materials—cardboard and newspaper, low-grade tempera, cheap housepaint—that the work perished if it wasn't merely lost. Fairweather's meager surviving output has been a nightmare for curators ever since.

The dividing line in his life came in 1952, when he was living like the old bum he was beneath an overturned boat on the beach in Darwin, capital of the Northern Territory. He was seized with the desire to get back to Bali. He had been reading Thor Heyerdahl's *Kon-Tiki* in the Darwin Public Library. He scrounged three aircraft wing tanks from the city dump and collected some driftwood, rope, and nails. From this junk he cobbled together a triangular raft, about ten feet on a side. It was the most crank, hopeless parody of a raft imaginable, but Fairweather believed that, with a cheap compass (though he had no idea of navigation), a few gallons of water, and some tins of bully-beef, it would take him away from Australia to Bali. But the sail ripped to shreds in the wind, the rudder failed, he could not steer at all, monsoonal storms battered him, and after sixteen hellish days at sea, Fairweather and his raft were swept ashore on an island off Portuguese Timor (very luckily, as it happened, since beyond the island lay nothing but thousands of miles of open Indian Ocean), where he was imprisoned by the newly independent Timorese as an English spy working for the hated Dutch. Then, as if that weren't enough, he was repatriated to England, and he had to raise the money to get back to Australia by manual labor—digging ditches, at the age of sixty-two. He finally did make it back, and fetched up on Bribie Island off the Queensland coast, where he spent the remainder of his life in a ramshackle hut he built for himself in a native pine forest. And it was there, after about 1960, that he finally achieved his "great late style," the fusion of abstraction, landscape, figure, and calligraphy beside which, he believed, nothing he had painted before was better than falsely picturesque tourist art.

I had been able to buy, from an exhibition at the Macquarie Galleries in

Sydney, one of the best of these paintings, and the one which directly commemorated his nightmarish, life-changing voyage—*Monsoon* (1961–2). It cost all of three hundred pounds, and I secured it by queuing all night, accompanied by Noeline and ahead of eight or ten other impassioned fans, on the steps of the gallery, with a thermos of rum-laced coffee, blankets, and a sleeping bag, in order to get first pick on the show's opening day—you could not reserve things in advance, not even if you represented a museum. It was a large abstraction, predominantly black, brown, and gray, traversed by a violent yet exquisitely harmonious net of swiftly daubed, creamy lines. It gave a sense of lightning flashes piercing tropical darkness, along with vague intimations of a beleaguered figure—Fairweather himself, I suppose, who had had to lash his own ankles to the rickety mast to escape being swept overboard. It was one of those works which represented exactly why many Australian artists, especially in Sydney, regarded Fairweather as a sage and his work as a talisman of cultural openness: for there we were with all Asia to the north of us, and no other Australian artist had ever immersed himself in or even made use of its traditions. Probably Fairweather's best late painting was *Monastery* (1961), then owned by another local art critic (Wallace Thornton, of the *Sydney Morning Herald*), now in the collection of the Art Gallery of New South Wales. With its images of softly curved figures in compartments, rather like bees curled up in the waxen cells of their hive, it was a highly distilled memory of a night spent in a Chinese monastery whose monks saved his life and gave him shelter after he was caught in a raging blizzard on the road. Admiration for it ran so high when it was exhibited in Sydney in 1961, that John Olsen proposed that a posse of artists should bear it through the streets of Sydney in a small procession, as Cimabue's Madonna had been carried in triumph and homage through Florence by its pious citizenry. It was a charming idea of homage, but it wasn't done—fortunately, because if it had been, *Monastery* would probably have fallen to bits.

Word reached me in 1962 that Jon Molvig, an Expressionist painter who lived in Brisbane—another of those hairy Australian artists with a tiresome reputation as a wild man—was going to visit the Sage of Bribie Island and wanted me to come along. Since Fairweather had always been inaccessible—you didn't just turn up and knock—I jumped at the chance and flew to Brisbane. After a long and nerve-racking coastal drive (Molvig drank a lot, and

believed that Australian art critics were in cahoots against him), we made it to Bribie and, eventually, to Fairweather's leaky den in a grove of pine trees, back from the beach. His paintings were always being rained on, much to their detriment; at one point his dealer in Sydney, worried by the bad materials he painted with, had sent her aging star a two-meter-wide roll of the finest Belgian flax canvas, a commodity so expensive in Australia that few artists could afford it. Fairweather had written to thank her, used the canvas to fix his roof, and gone right on painting with tempera and acrylic house paint on soggy cardboard.

His huts were built in the Balinese manner, with thatched roofs. Over the entrance to the living hut was nailed a wooden board with the Chinese characters for the Tantric text *Om mani padme hum* painted on it. Fairweather appeared, a slight figure with a gray scrubby beard, and offered us Nescafé in tin mugs, lightened with condensed milk. He had lost most of his front teeth, and was limping badly. His right foot was swathed in rags, which gave off a faint but repulsive odor. It turned out to be suppurating from the bite of a goanna, one of the big scavenging lizards that lurked and scuttled around the outskirts of Fairweather's camp and served him, after a fashion, as trash collectors. He had got into the habit, every morning at breakfast, of placing chunks of cheese—processed Velveeta, I think—between his toes and offering it to the goanna in the hope of taming it, "for company, you know." Now the foot had swollen up and the toes had turned black. It was obvious (though not, apparently, to Fairweather) that our greatest painter was in risk of dying of gangrene, from a lizard bite. And clear, too, that the hoped-for conversation about spirituality in art was not going to take place. Over Fairweather's somewhat peevish protests, he was bundled into the backseat of Molvig's Holden and driven to a hospital on the mainland; his survival, the doctors said, was a near-run thing. Alas, I never saw Fairweather again; and a few years later, badly short of money, I had to sell *Monsoon*. I regretted this, but not too much. It bought me time to see and learn in the country I had most come to love by then, Italy.

My decision to go there was, if not decided, at least crucially influenced by my own painting. I don't think I had a real vocation as a painter, any more than I did as a cartoonist—in the sense that I couldn't imagine not doing anything else for the rest of my life. Of course I always knew that I was going to be a writer, that this was my ineluctable direction and grain—

indeed, that I had burned the boat in which I might have floated back to be a failure at the family profession of law. Nevertheless, I loved learning to draw from the motif and even, when I could, from the model; I loved caricature; I loved the smell and feel of oil paint, and there was no one around to warn me not to get mixed up in the difficult, enormous technical and expressive field it opened before me. Many writers have also been painters, some rather good ones. One has only to think of Victor Hugo in the nineteenth century, whose brilliant free-associative drawings based on blots and stains were one of the benchmarks of Surrealist sensibility; or, on a lesser scale of achievement, of Günter Grass today. When I left Australia in 1964, I left all my paintings and drawings behind. Some were sold, others lost, one or two stolen, and quite a few thrown out. I now possess only one example of my "early" work, a large landscape which is now in ruinous condition, flaking and spalling, because a relative with whom I left it hung it over her bath, in maximum humidity, for nearly twenty-five years. I do not particularly regret the loss of all these pictures, since it is the experience of making them that stays with me and was of real benefit. You do not have to be a painter to be a critic. You do not have to be a good painter to be a good art critic: nothing could have been more stupid than the notion, prevalent in the Australian art world of my youth and quite often trotted out against me, that a critic who paints is only a failed artist, morosely plotting to take out his frustrations on more genuinely creative people by assailing them with bad reviews. But there is, to me, something a little suspect about an art critic who has never painted and who cannot claim to grasp even the rudiments of intelligent drawing. Even Clement Greenberg could draw—not so very well, admittedly, but at least he drew. The great merit of one's own painting, for a critic, is that it teaches a somewhat negative but important lesson. It shows you how incredibly difficult certain effects that one sees in the work of real masters can be to achieve. It demonstrates that nothing, not even facility itself, is easy. Without knowing about such matters, one cannot write usefully about art. *Ars celat artem,* ran the Latin tag: art conceals the art. One of the critic's tasks is to unmask, in some degree, the fact of that concealment. Which is one of the reasons that so much of the best twentieth-century writing on art in English was done by people who were chiefly known as practicing artists: by Patrick Heron, for instance, in *The Changing Forms of Art;* by Walter Sickert, whose marvelous essays were collected in a book now long

out of print, *A Free House!;* by the painter and sculptor Michael Ayrton; and by the American artist Fairfield Porter.

The only time I produced any paintings that I would call worth looking at (without too much expectation, though) was just before my departure for Europe, in 1963 and 1964. They were memory pictures: landscapes of the Australian alps, where I used often to go in the summer, sometimes helping out on the construction of ski huts in which my brother Geoffrey was involved. The mountains were extraordinarily beautiful at that time of the year. Most of the snow would have melted, leaving large residual patches in valleys and sheltered depressions, like albino skin lying in curves and scoops against the gray weathered granite boulders and the snow daisies' drifts of silvery foliage. It was an intensely sexual landscape, reminiscent of thighs, breasts, bellies, all gleaming under the sun, and that was what I tried to convey.

But while gazing at the Snowy Mountains I kept thinking about Europe, so demanding and so difficult of access. And the fact that I was able to go there at all was due to my one and only patron, Major Harold de Vahl Rubin, whom I first met on December 8, 1960, a deceptively bright summer's day. He was not well known as a collector then. There were rumors of a Queens-land millionaire grazier who came down occasionally from the north and secretly bought paintings; but nobody I knew had actually seen him except the dealer Rudy Komon, who (as usual) was saying nothing.

I had a painting called *Bull* in a Christmas show at Komon's. Major Rubin walked in and bought the picture. This started a dispute with a young Amer-ican woman who also wanted it. In the end, Major Rubin, in an extravagant parody of Southern courtesy, bowed to her and gave her the picture. Then he told Komon that he wanted to see me in my studio the next morning.

And so, at ten o'clock, I was pacing about in that semi-fever of anticipa-tion known only by young lovers and by young artists who know a rich John is coming. I had prepared the mise-en-scène with the care of a virgin lad set-ting up his first seduction: some pictures stacked face-in to the wall ("Yes, well, Major, I do happen to have a couple of others"), the others hidden ("Now these are ones I keep for myself"), the Big Bomb hung in the most flattering light. Ten struck; then half-past. The cold bottles of beer were leaving condensation rings on the table. Komon phoned. "Do not vurry, you vill see that the Myjor vill soon be there." Eleven. Half-past. Twelve. The

telephone again: "Naturally, you vill see that he is vith his solicitor, and ve cannot get him away," said Rudy, my umbilicus to riches. "It vill be all right! It vill be all right!"

At one-fifteen, there was a flurry in the street. A taxi pulled up, and out stepped Rudy Komon, with a quiet lady and, between them, wearing carpet slippers, a stained gray suit and a small black skullcap, Major Harold de Vahl Rubin. "Bring 'em out, bring 'em out."

"What, Major?"

"The pictures you were keeping till later."

Somewhat demoralized, I produced them. The Major pulled out a note-book and scribbled in it, hobbling from picture to picture. Rudy, like a mallee fowl guarding its eggs, paced to and fro on the veranda. Time stretched out while the Major jotted down titles, sizes, and prices. The taxi kept ticking over in the street outside. (Later, I was to find that the Major sometimes kept taxis waiting ten hours or more.) At length, he said, "I gather that those are gallery prices." Yes, I gulped. "Then that will be subject to 25 percent off for me. I will take it." "Which one?" I asked. "The lot," replied the Major, with a gesture that included all the pictures and, it seemed, me. "Let us go to lunch."

We went to a restaurant in nearby Double Bay, where the Major sat down and immediately fell asleep. He snored. His head lolled sideways. The waiter began to look skeptically at the ancient suit, the egg-stained tie. "Major," I said nervously. "Major?" The Major woke up. "Are you in love?" he asked. I said, truthfully, that I was, with an actress named Noeline Brown. "So am I," he replied. "But I am in the autumn of my years." He peered opaquely at me, and coughed. "Not, mind you, the winter. Not bloody yet."

Eventually the lunch was done and Rubin had put down his cards. He wanted to turn his mansion in Brisbane, Toorak House, into an art gallery. He would retire to the beach resort of Surfers' Paradise, a parody of Miami but even more horrible and without the history, where he was building a house. I would live in Toorak House and paint. The Major would buy all my work and send me on regular overseas jaunts. He wanted Noeline to give up the stage and run the gallery. She looked askance at this, and firmly said so. Nevertheless, Rubin wanted us both to join him at his Sydney apartment that evening, for dinner.

So Noeline and I went there, to be greeted by an affable Major, grinning,

twinkling and—so far as his gout would allow—capering. He was so capti-vated by his new scheme that he couldn't see we had not yet agreed to it.

His flat was full of birds, stuffed and live: parrots, cockatiels, lorikeets, budgerigars, finches, and a huge, lugubrious-looking black palm cockatoo that shifted uneasily on its perch and clattered its menacing beak at us. The floor was covered with neatly piled bundles of old newspapers. These we had to sit on because the armchairs were stacked with cartons and sacks of birdseed.

After several whiskies but no dinner, the Major suddenly announced that he had a plane to catch. Off we went, in caravan. I had to carry a cage of rosellas. Noeline bore a stack of defunct copies of the *Sydney Morning Her-ald*. The Major brought up the rear with an armful of Birdy-Tweet boxes, two of which burst. Leaving a trail of seed behind us, we heaved ourselves into the taxi (it had been ticking there since six o'clock) and sped to the airport. I kept wondering what I'd got into: the old loony hadn't written a check yet.

I soon found out. A few days later, a one-way ticket to Brisbane arrived with a peremptory summons from the Major. "Well," said Noeline when I showed it to her, "no harm in a free ride, is there?" But when I arrived at Brisbane Airport, nobody was there to meet me. Eventually I found my way to Toorak House, a sandstone pile with gloomy halls, carved lions flanking the entrance, and crenellated battlements, built by some haberdasher in the 1860s. The Major wasn't there either—he had gone north to one of his cat-tle stations—but his PR man was, a former TV cameraman named Ramsay Bryce who had been charged with the not entirely easy task of presenting his hitherto evasive boss to the world and, in the process, publicizing me as his art find, the future painter-in-residence. "You can't!" I wailed. "I haven't signed anything!" "Tough tit," said Ramsay. "Major's orders." I looked across the wide sun-browned lawns and rosebeds of Toorak House with apprehension: somewhere out there was a grotto or gazebo waiting for its prisoner, the estate's Decorative Hermit, me. The Queensland Meejah were due in half an hour.

We sent out for beer and sat drinking it in the Major's sitting room. It was not easy to move about the place, since its floor was covered with paintings, all face-down. The grand piano was also full of them, stacked face to face. If you wanted to see one of them you had to fish it out, turn it round, turn it

again and put it back. This was the Major's way of protecting the pigment from light. The reporters came, finished the case of beer, listened unsympathetically to my denials (without believing a word, as the next day's stories proved), took some photos, and left.

Then the telephone rang. It was Sir Arthur Fadden, the Treasurer of Australia, in Canberra. Yes, said Ramsay, he would pass the message on. Yes, he would certainly ask the Major to ring him in Canberra. The phone rang again and again; it seemed that half the Australian government, and much of the Queensland bench, too, needed to talk to the Major urgently.

It took half an hour of crossed lines, outback switchboards, and static to run Major Rubin to earth. He came furious to the phone; you could hear him across the room. "He wants to know why I'm disturbing him at dinner, the old shit," hissed Ramsay, hand over mouthpiece. "Major," he said soothingly, "Major, I wouldn't have troubled you except that Sir Arthur Fadden rang, and—"

"Sir who?"

"The Treasurer. He wants you to ring him in Canberra tonight."

"Well, ring him, Bryce, you damned idiot."

"What'm I supposed to say?"

"Ask him if he's had his dinner. Tell him to get stuffed," snapped the Major. "How dare he disturb me at dinner? How would you like to be disturbed at dinner?"

"I've had dinner," said Ramsay.

"There you are. You've had dinner. What about me? No," the Major said, with a note of steely finality. "Tell Sir bloody Arthur to go and stuff himself."

"There were other messages," said Ramsay, and read them out.

"Tell them all to get fucked," said the Major. "Goodbye."

"That go for me too?"

"Yairs, indeed it does."

"I will deliver your messages, Major," said Ramsay. "I resign. And stuff you too." He hung up, rang each of the dignitaries in turn and recited the Major's message, verbatim. "Sorry sir, but that's what he said. Yes, Sir Charles. With an F. Bye." Then he shook hands with me, wiped his brow, got in his car, and drove away to Surfers' Paradise. I never saw him again.

My taste for being the Decorative Hermit was waning, and it wholly van-

ished as the night drew on. I lay huddled in bed, alone in a house which creaked like a concertina. To my haggard relief, Noeline responded to my phone calls by flying in the next morning. In the veranda aviary, she noticed a small bird, a sort of yellow warbler with a red behind, lying stiff on the floor of its cage.

Perhaps it had died of fright. I buried it in a corner of the rose garden.

The following day, the Major got back from the deep North. He stepped out of a helicopter onto the lawn. He was in a foul mood. Apparently some of the recipients of Bryce's message had rung him at his cattle station. "Damn idiot Bryce, can't take a simple reprimand, disturbing me at dinner like that, must have been drunk. Were you drunk?" No, I said, how could I have been, you didn't leave any grog in the house. The Major stumped off to his bedroom and changed. When he came back, I told him about the bird.

A nasty look crept into the Major's eyes. "Birds don't just go and die like that." He went to the veranda and inspected the cage. "Where is my warbler? Where is it? What have you done with it?"

"I buried it in the garden."

"Produce it," said the Major. "Go and get my bird!"

"Dig your own bloody bird up," I said crossly. The three of us set out to the bottom of the garden where, with hoe and trowel, we exhumed the corpse. Ants were crawling in and out of its eyes. Major Rubin's eyes, by contrast, were emanating a look of black hostility. He snatched the warbler away and went back to the house, where, with a knitting needle on the kitchen countertop, he began a rudimentary autopsy. Noeline and I retreated to the smoking room. Soon the Major burst in. He pointed a bony finger at me.

"You accept my hospitality," he croaked, "and repay it by killing my birds! You and Ramsay Bryce birded that merd, I mean murdered that bird! You strangled it in a drunken frenzy! It cost twenty-five guineas! Do you think valuable birds like that just grow on trees?" Well, yes, I almost said, actually in a manner of speaking they do, but I bit my tongue. "How many other birds of mine have you killed?" "I didn't kill your goddamn bird," I yelled, seeing the sale of my pictures vanishing down the drain. "Crippen!" the Major cried, referring to the noted American wife-poisoner of the early 1900s. He started trying to count his birds.

Terrified by the racket, the parakeets, lorikeets, finches, budgerigars,

cockatoos and corellas, and even the Indian warbler's bereaved cage-mate were flying hysterically around. "Keep still, blast you!" the Major cried. He opened the door of the biggest part of the aviary, which was the full height of the veranda, and clambered in. Surrounded by screaming and cowering parrots he stood there with arms extended, like St. Francis in a trecento altar-piece, cooing and whistling in an effort to calm the birds. After several minutes he climbed out again, spotted like a statue. "You killed one of them and let two others free," he said. *"They will be eaten by hawks!"* In vain I protested my innocence. The Major disappeared to the kitchen, and Noeline followed him.

"I know," he said to her cunningly, "why your boyfriend let those birds go." Suddenly he raised both arms above his head and flapped his hands. Then he repeated the gesture. "Don't you recognize that?"

"No."

"Man Releasing a Bird?" the Major cried, as though in triumph at his own insight. "That picture I bought from him? It's all there. That's how I *knew,* my dear. That young man of yours needs treatment."

Noeline's temper, normally equable, exploded. She flew at the Major, chased him around the kitchen and threatened to beat him up unless, within ten minutes, he had written a check for my paintings and our return airfares to Sydney. The Major, who liked being bullied by strong women, caved in at once. He wrote the check. Wreathed in smiles, he came back into the room where I was biting my nails and cursing the day I had met him. "Never mind about the birds," he said magnanimously. "Now I am going to buy you and your lady the most luxurious dinner Queensland can offer."

The most luxurious meal in Queensland proved to be some grayish pâté, a steak, and several bottles of claret at a funereal Brisbane hotel, which the Major owned. He ate and drank with gusto. He was back on the twinkle again. "Cézanne found it necessary to go to Aix-en-Provence," he said, "and you should get away from Sydney and come to Brisbane." "I'm not Cézanne," I said firmly. The Major gave me a stern look. "That is for me to decide," he pronounced. He asked Noeline to rhumba. We parted at the airport next day with effusive, if on my side feigned, bonhomie. Once home, I banked his check and as soon as it cleared began drafting a letter to Major Rubin saying that we were desolated, etcetera, but due to other commitments I would not be able to move to Queensland.

There were no hard feelings, but I saw nothing of the Major for some time. Every now and then he would appear in the headlines, a reward for making some record-breaking, if now small-looking, bid for an Australian painting at auction; he was particularly fond of the artist William Dobell, whom he thought greater than Picasso, though in fact he owned a couple of Picassos and was the only Australian who did. Then in the autumn of 1963 I ran into him again, outside the Hungry Horse Gallery in Paddington, where a show of my own work had just been hung by its director, Betty O'Neill. "Go and have a look upstairs," he said. I did so and found Betty in a state of near-trance: the Major had bought the whole show and, what was more, paid cash on the nail for it, without his usual haggling, from a thick "softy"—a roll of notes in his pocket.

I never again saw the Major. The last I heard of him was later in 1963, when he had just created a new auction record. There he was, in a photo in one of the afternoon tabloids, propped on the hospital pillows, holding up the picture. On his head was a sort of Beatle wig. It appeared to be made of parrot feathers.

The first overseas survey show of Australian art that meant anything, within the frame of my own life, was held in 1961. It was organized by the curator Bryan Robertson, director of the Whitechapel Gallery in London. Robertson was a figure of the kind that has almost vanished from the art world today: a man of great idealism and complete probity, with no dependence on and therefore no obligations to the art market, who loved painting and sculpture with an immense and disinterested enthusiasm. He went back a long way—as a seventeen-year-old boy he had actually known Constantin Brancusi, and hung out in his Paris studio—and although unflinching in his judgments on the qualities of an artist's work, he was as completely without petty malice as anyone I have ever met in that scorpions' nest known as the art world. Running the Whitechapel Gallery on a shoestring since his appointment as director, he had mounted a series of pioneering exhibitions. Now, it seemed, it was Australia's turn. Bryan was a fan of Sidney Nolan's work, to which he had given a retrospective. Realizing that there had to be more where Nolan came from, he came out to Australia on a research trip in 1960 and started sniffing out the field, picking candidates for a survey of contemporary Australian art.

As soon as the news of Bryan's presence got around (which took rather

less than five seconds) there was great competition for his time and attention. He handled it with aplomb. It is not easy when a whole lot of Australian artists, not the most diplomatic or light-handed bunch in the world, see you as a possible route to fame and glory. There was no network, made up of either curators or dealers, connecting Australia to England at the time. Australian artists were completely in the dark about the English art world, and vice versa. Consequently, many of them imagined that being in a survey show at the Whitechapel Gallery would make their fortunes, an illusion if ever there was one. In particular, people were worried about balance. Would he emphasize the Abs over the Figs, or vice versa? In the end, nobody need have worried. He did a remarkably fair-minded job, and the show was a success with both critics and the London art public. And I was lucky, too, because Bryan had commissioned me to write its catalog introduction, which was the first long, serious piece I had ever published outside Australia. Rereading it, I cannot say that I am very proud of it—only that it was okay for a twenty-three-year-old. In it I made the error of trying to turn Australia's inadequate contact with the currents of contemporary art, and the poverty of collections that nominally represented European traditions, into some kind of a virtue or even an advantage, as though they had forced an inventiveness from Australian artists that they might not otherwise have had. This, I came to realize—partly because it was sternly pointed out to me by Bernard Smith and other critics—was nonsense. Ignorance is never a spur to creativity (only the desire to overcome it is), and an inadequate grasp of traditions is not necessarily a step toward transcending them. If this was the road to some special kind of "vitality," it was an easy and unprofitable path. Without thinking it through, I had given as a cause of "cultural vitality" the very reason that I myself was itching to leave Australia.

However, this introduction had one big result for me. A few people in England did read it, and one of them was Sir Allen Lane, the founder and chairman of Penguin Books. Lane was the young nephew of that legendary figure in British publishing John Lane, founder of the Bodley Head, who had brought out the *Yellow Book* and the works of Oscar Wilde.

In the 1930s, books were expensive. A cloth-bound novel cost an ordinary working man about a week's wages. Nothing did more to impede the spread of general literacy than the price of quality books. Allen Lane had been struck by the thought, which possessed him and would not go away, that

somehow it *must* be possible to publish books that could be marketed, at a modest profit, for the price of a packet of Woodbines. (The Woodbine was the English working-class cigarette par excellence, the no-frills, no-tip, no-filter gasper, thinner than a Players or a Senior Service, which sold for sixpence a packet of twenty in thousands of tobacconists and news-agents throughout England.) In this way, serious and educational books—translated French and German authors as well as English ones—could be offered to a working-class readership, something that had hardly been con-templated before. But how could the price be kept down, given the cost of hardback binding? The very notion of "paperback rights" did not yet exist. But Lane, as he later told me, had spent time in Paris and he had observed that French publishers were in the habit of selling their books bound in plain blue, soft paper, on the assumption that later the owners would have them rebound, in cloth or even leather, to suit their tastes. Lane decided to imitate this, binding his texts in more reasonably durable paper than the French used: title and author's name on the front, and on the back a brief bio and a small, usually blurry, photograph of the author. The contents were color-coded: dark green for crime, blue for the historically or scientifically inform-ative Pelican series, and so on. This kept the price low—a mere sixpence per copy, in fact; it became the classic format of Penguins and remained so for two decades and more. Like many other aspiring writers, my dream of glory—which I saw no prospect of fulfilling—was to see that grainy lit-tle black-and-white picture of myself on the back of a Penguin book, like André Malraux, like George Orwell, like practically everyone else you had ever wanted to be. The little shelf of dog-eared Penguins soon became an essential part of the furniture of the young English-speaking mind—and the Pelicans, without exaggeration, became the working person's university library, constantly added to. All of a sudden it was possible for a postman or a coal-miner to own and read Malraux's *Man's Hope* or Tawney's *Religion and the Rise of Capitalism* or E. P. Thompson's *The Making of the English Working Class,* and pass it on to his kids. It's hard to imagine a world without paperback books; but there was one, not so long ago, and the man who did most to change it was Allen Lane.

I met the great man in Sydney in 1962. What Lane had seen at Bryan Robertson's Australian art show at the Whitechapel Gallery had confirmed an enthusiasm he already felt for some living Australian painters, and he

had read my catalog introduction. It was necessary, he believed, to have a "proper book" on Australian art, for none existed at the time. And since he wanted Penguin to publish books on Australia by Australian writers for the Australian market, instead of merely distributing English books there, he saw a book on Australian art as part of his strategy. (At the time, Australians bought more books per capita than any other society in the English-reading world; perhaps this was due, in part, to the fact that relatively few of them had TV sets.)

In this he was eagerly supported and encouraged by the three people who were in charge of the new publishing arm of Penguin Australia. These were an accountant, Brian Stonier, and two writer-editors, each with a long track record in Australian publishing, Max Harris and Geoffrey Dutton. In years to come I would fall out with Max, who tended to distrust "expats" on principle and regard them, with some bitterness, as cultural quislings; but we were friends then, and there had always been the warmest comradeship between me and Geoff, who was sixteen years my senior but had never been afflicted by that occupational hazard of many writers, dislike and suspicion of the young. So they both vigorously proposed to Lane that I, a twenty-three-year-old rookie, should be given the Pelican history of Australian art to write, and that Geoff Dutton should edit it. Lane said yes, but he wanted to meet me first. And as luck had it, we got on very well. Though Lane was a knight, he was not a snob; he could afford not to be, whereas in Australia he found himself surrounded by royalist sycophants who were always deferring and sucking up to him. The notion prevalent in the early 1960s that Australians were sturdy egalitarians when faced with an English toff was a self-congratulatory myth. Australians would slit one another's throats for royal honors. From our prime minister, Robert Menzies, down to the last sheep-shit alderman, we antipodeans tugged the forelock hard and often. The very thought of a shoulder tapped by Elizabeth II's sword—"Rise, Sir Wombat"—made us, as a nation, go weak at the knees; we were all, as Menzies put it in a famously pompous and subservient address, "the Queen's men."

Lane, however, far from being the grand and suave creature that the Australian social imagination supposed titleholders to be, thought of himself as the bullet-headed buccaneer that he actually was. He liked to tell how, being escorted around Hobart, the old convict capital of Tasmania, he noticed a

street sign somewhere in the bowels of its dockland: Cutthroat Lane. "Why," he exclaimed to his guide, "that's what they call me in the trade." He also took pride in his newly acquired reputation in conservative circles as a pornographer. He had earned it by republishing D. H. Lawrence's *Lady Chatterley's Lover* as a Penguin, which provoked a sensational and fiercely contested obscenity prosecution from which Lane, Penguin, and the long-defunct Lawrence emerged triumphant: the *Chatterley* case, whose verdict of acquittal was reached in November, 1960, was the major turning point in English ideas of publishing morality, and Lane, who had risked prison with it, was rightly viewed as a hero by many, myself included. It may be only fair to add that, as brave jousts of chivalric consequence were sometimes fought over rather plain ladies, so the *Chatterley* verdict never made me feel that Lawrence's descants on sex were at all stimulating or that his lumbering, preachy epic of upper-with-lower-class fornication was one of his better novels; but that didn't matter.

Sir Allen was a drinking man and he had a taste for Australian wines. I did too, and our business relationship was annealed by a number of bibulous lunches in Sydney during which we would tell each other mildly dirty jokes, he would enlighten me about English publishing, and I would lay forth my ideas for an account of Australian art—ideas that were not always more than notions, since beyond the requirements of weekly reviewing I had done little serious research on the remoter stretches of the eighteenth and nineteenth century, prior to about 1870. But Lane didn't seem to mind. Our encounters were crowned by a lunch given by his sister Nora, who had married a somewhat conservative Australian company director named Bird and lived in a handsome house above the blue waters of Newport, a suburb some miles north of Sydney near Palm Beach. Lane and I were driven down there by Geoff Dutton. The preprandial white wine flowed. Just as we were all getting ready to sit down, it occurred to me that I could use a glass of red, of which an open bottle was standing invitingly on the sideboard. I made my way to it, turned, and with a hideous lack of aplomb tripped on the long-haired white flokati rug the Birds had recently brought back from Greece. (In those distant days flokati rugs were the height of decorator chic, at least in Australia.) I fell flat on my face and the wine came glugging copiously out onto the white pile. "Fuck!" I exclaimed. The outraged Mr. Bird, our host, rose to his feet and demanded that we should all leave at once. He would not

have such filthy language used in his own house, in front of his own wife. His brother-in-law, Allen Lane, saved the day by declaring, "I made a fortune off that word. You can't throw us out because of *Lady Chatterley*." We then settled down to a surprisingly convivial lunch.

The Art of Australia was not a difficult book to write. In fact, it almost wrote itself, because I wrote it journalistically, unencumbered by theory—which would have been impossible if I had embarked on it ten years later—and picking up the research, ad hoc, as it moved along. Today I would certainly not recommend it as a model to young art writers (not that I ever felt tempted to), but at least it made up to some degree in verve and directness of feeling for what it lacked in depth of theoretical understanding. At the time it was written, between 1961 and 1963, the only general historical study of Australian art that had any serious merits at all—but which, like all the rest, was out of print—was Bernard Smith's *Place, Taste and Tradition*, published almost my whole lifetime before (in 1945) and tattooed throughout with the pious disfigurements of Australian Marxism. Did I believe that art could contribute to the advancement of proletarian interests, or be rebuked for not doing so? Did I think that art—smearing colored muds on cloth or paper—was, when you came down to it, likely to stay the murderer's hand or the tank treads of the oppressor? Emphatically not. I thought all beliefs in the socially reformatory powers of the plastic arts were pious hogwash, to put it stridently, and my book reflected this. I am still mildly proud of thinking so at the time, and it does something to console me for the otherwise slightly embarrassing fact that a text so obsolete and juvenile in so many respects should still be in print in Australia forty years later. Apart from Lane himself, the men at Penguin who shepherded *The Art of Australia* into print were Tony Godwin and his precociously gifted young lieutenant, Tony Richardson. Godwin took the project over from Penguin Australia when the book literally fell apart: due to some remarkable defect in the binding glue, the volume cracked when opened flat and all the pages fell out. It therefore had to be completely reprinted, which gave me a little breathing space to correct some of the errors of fact, judgment, and taste, which kept surfacing in its text like adolescent acne. Godwin insisted on pressing ahead with this project. It was a part—a very minor part—of his larger intent, which was to move Penguin leftward and youthward. He was publishing Penguin Specials against capital punishment and the nuclear arms race. He

had contracted to bring out names that Allen Lane, who despite *Chatterley* was basically a conservative, would probably never have touched: Jean-Paul Sartre, Italo Svevo, Bertolt Brecht, and even—very daringly for England in the early sixties—Jean Genet. Some of the people he backed, such as the cult therapist R. D. Laing *(The Divided Self)*, have since fallen into oblivion or disrepute, but Tony Godwin was a wonderful publisher for a young man to have; he might make you no money, but he would bet on you, throw his heart over the fence, and then jump after it.

And yet, and yet. By the early 1960s I could no longer conceal my worst inadequacies from myself. I was running out of rope, eating my patch bare. You can lead a complete and totally articulate life as a literary critic in Australia, because books go everywhere and anyone can afford them: hence, there is no necessary and inbuilt difference of cultural range between the English, the French, the Russian, the American, and the Australian writer. Not so with paintings and sculpture. They do not go everywhere. This is *the* besetting problem for the "provincial" whose concern is the visual arts. Public collections are spotty, private ones (of anything but local art) hardly exist. Try acquiring a working knowledge of fifteenth-century Italian painting, or Baroque sculpture, while staying in Australia—it's flatly impossible. The same, but even more so, with contemporary art. I knew I had to up pegs and leave.

At least I had to try. In this my mind was made up for me by Alan Moorehead, my beau ideal of a popular historian. Today, not all that many people under fifty seem to recognize his name. Back in the early sixties it was otherwise, and there can hardly have been a literate Australian who had not heard of him and even read one or two of his books: *The Blue Nile, The White Nile, Gallipoli, Cooper's Creek, The Fatal Impact,* and so on. With his frequent appearances in *The New Yorker,* he was a best-selling author on a worldwide market and he brought dignity and distinction to the term "popular history." He had been born in 1910, so he was just past fifty when we met, and I was twenty-four.

In biology there is a phenomenon called "imprinting"—the baby duck struggles out of its shell, and the first thing it sees is its mother's backside. Thus it knows it is a duck, and discovers how to waddle and quack. So it was

with me and Alan. I had known other Australian writers, of course, but none had so aroused in me the instinct for emulation. I found in Alan, though without his overt permission, the kind of father I had never had. And I think he put up with my sometimes clingy and presumptuous gestures of would-be filiation because, although his daughter Caroline Moorehead turned out to be a first-rate writer, neither of his sons showed much leaning in that direction.

Alan had begun in Australia as a journalist, but in the late thirties he had lit out for Europe. He had done some reporting on the Spanish Civil War, and then turned himself into one of the three or four best war correspondents reporting in English from the front in World War II. After 1945, he tried and completely failed to write fiction. In those days, difficult as they now are to remember, successful fiction was considered the ultimate proof of a writer's prowess, and young American writers still dreamed of producing the "great American novel" to rival *Moby-Dick* and *The Great Gatsby*— a vanished period in cultural history, but one which, somewhat to Alan's irritation, had not vanished yet in his own youth. No Great Australian Novel came out of Alan, or ever seemed likely to. Only fact stirred him. His great achievement was his account of the explorations that penetrated Africa in search of the source of its greatest river, *The Blue Nile* and *The White Nile*. But he also wrote admirably on Australian history, its explorations (*Cooper's Creek*, the disaster saga of the Burke and Wills expedition of 1860) and the tragedy of the Australian Army's campaign at Gallipoli during World War I. Then—less recognized at the time—there came his early and absolutely correct perception that in the realm of journalism, the great issue of the future would be ecology, the fate of our earth and its nonhuman life at the hands of its delinquent and murderous offspring, *Homo sapiens*. The book he was gestating when I met him, *The Fatal Impact*, was about this issue: it was much more than a narrative of European exploration in the Pacific, though it began as that.

I knew he was in Sydney; he had come to Australia to make an appearance at a biennial cultural celebration, the 1962 Adelaide Festival. I would not have dreamed of intruding on this august stranger. Instead, to my amazement, he rang me up: he had read some pieces of mine in *Nation* and the Sydney *Daily Mirror*, to which I was also contributing, and he had liked the writing. Almost speechless with nerves, I invited him round to dinner. To my further surprise, he accepted. I forget what I cooked that night for the

two of us, but we drank several bottles of Gewürztraminer, an expensive German wine, which can only mean that I was trying to impress him—we would both have preferred something Australian. In the middle of our increasingly loud and bibulous conversation, Sidney Nolan turned up looking for Alan. My cup ran over. So did the glasses, with the result that around midnight both Alan and I were quite drunk, while Nolan, who rarely touched liquor, had fallen in the ornamental fish pond under the frangipani tree, to the detriment of his beautifully cut, pale linen suit.

By then Alan and I had arrived at a compact. I would have to leave Australia, just as he had done, if my work was ever to go anywhere. "If you stay here another ten years," Alan pronounced, looking at me rather owlishly, "Australia will still be a very interesting place. But *you* will have become a bore, a village explainer." Luckily, I had the sense to realize that he was right. But then, it was what I had been waiting to hear.

Alan laid it out for me. He would give me letters to his literary agent (there were none in Australia in 1962, and the very idea of having one seemed exotic); to his publisher, Hamish "Jamie" Hamilton; and to several other people who might matter in the life of a budding writer. If I hit the wall or otherwise got into trouble in London, I could treat his house in Italy as a bolt-hole, a refuge from debt collectors or wronged women. Though not, he added firmly, indefinitely. All I had to do was raise enough money to leave, and to survive on for a while. He and Nolan then rose and made their way out of the garden, one tipsy and the other dripping, leaving me to contemplate an altered future.

Dad's death had been terribly hard on Mum. How could it not have been? His loss did not leave her financially destitute, but emotionally she was fragmented. She adored him, and he her. They had not been apart since they married, and that had been in 1923—close to three decades before. She depended on him so entirely that she had never cultivated any friendships that might have compensated, even a little, for his sudden absence. They had been absolutely faithful to one another since they met; her entire emotional life, her compass, her gyroscope, all were centered on him. No matter what efforts at support she got from her children and in-laws (apart from Mim, she had no blood relatives left alive), no matter what comforting words the

priests might offer her, whatever tight-lipped expressions of sympathy might come from the wives and widows over the sliced rolled ham and prawn-and-celery mayonnaise at Royal Sydney Golf Club, she was doomed to solitude for the rest of her life and she knew it; in 1951, a widow in her early fifties in Rose Bay was essentially unmarriageable, and in any case her own widow's devotion would never have permitted her to look at another man. She also had intervals of intense clinical depression, a state of mind which was not recognized by the well-meaning family doctors of the day as being pathological—merely a "natural consequence" of her loss. It was not natural; it was a disease whose crushing weight she could not control. Her grieving went on a long time, and now and then she would awkwardly stand below the middle peach tree on the Marsland lawn and vent her misery in sharp hiccupping wails. There was little I could do to comfort her; most of the time, I was immured in boarding school. But things got better with time. For Mum began to transfer her considerable energies to the Australian mountains, which gave her something to do in her widowed middle age: building and running a ski lodge in the as yet totally undeveloped alpine valley of Thredbo.

There was no skiing-holiday industry in Australia. Skiing wasn't chic: it was considered a rather wild and marginal hobby, even an eccentric one. There was, however, a mountain lodge, the Hotel Kosciuszko, up on the main range of the Snowy Mountains, three hundred miles or so south of Sydney. (Why its name? Because the highest mountain in Australia—which actually was the merest stump, seven thousand feet—was called Mount Kosciuszko. And why on earth would anyone want to name the highest peak, or for that matter any peak, in Australia after a barely pronounceable nineteenth-century Polish nationalist patriot? Because one of the members of the survey team that first conquered the mountain—actually it was quite an easy walk up there, as I know, having done it myself several times—happened to be a wholly unpronounceable Polish naturalist, Paul Strzelecki. Probably the Sherpas and other denizens of the ineffably sacred Chomolungma, footstool of the gods, never got a chance to complain about Mr. Everest, whoever *he* may have been.)

In the mid-1930s, before I was born, the Hughes clan got into the habit of taking summer holidays at the Hotel Kosciuszko, driving up there—which took ten to twelve hours on those awful roads—in its Hudson Six. The hotel

was built on a lake and near one of the most beautiful trout streams in the whole Snowy River system, Spencer's Creek. There was, I presume, next to no one there. Certainly there was no one around in the late 1940s, when I used to wade and fish Spencer's Creek myself, hooking deep-bodied, two- to three-pound rainbows in its lucid brown pools. In the 1930s, the whole area must have been paradisical, benignly wild; the kids and Dad would fish, and Mum (who was something of a tomboy, loved riding, and was good at it) would join them for long horseback rambles over the Snowy Mountains.

Then my family started going there in winter. I have no memory of going to the snowfields as a small child, but they did take me—first in a basket, later in toddlers' boots. They skied everywhere, with increasing confidence, on heavy wooden Norwegian planks, steam-bent but not laminated, lashed on with leather straps—the days of safety bindings, which came off at a heavy twist and saved your ankles and tibias from breaking, lay far in the future—and wielding ski poles with bamboo shafts and leather baskets. The skis were extremely long by modern standards—a six-foot man would use seven-foot planks. This kind of gear had scarcely changed since the days of Amundsen and Scott. There were, however, no chairlifts, rope tows, T-bar lifts or, indeed, any means of getting to the top of a run except by laboriously climbing it yourself on your own two skis, either herringboning or sidestepping. For main-range touring in those days, people used "skins," narrow strips of hairy calf hide along the sole of each ski, attached front and rear, with the lay of the hair facing backward. These provided friction against the snow when going uphill, and made the task somewhat easier. But only somewhat. If there wasn't much concentration on après-ski pleasures in the Australian Alps in those early days, if people weren't posing around in the hut like models in a Swiss magazine drinking hot chocolate and playing backgammon in those yeti boots of white hair, it was because most of them were so fatigued by the exertions of herringboning up the slopes in order to zip down them that the first scotch of the evening would knock them flat on their backs.

My mother, although she couldn't ski, entered this new world with alacrity. First she had waterproof parkas made, designed by my sister, Constance, with a big marsupial zip pocket across the chest into which the owner could put everything: goggles, mittens, map, sandwiches. These came in three sizes and whatever they may have lacked in elegance of line they more

than made up for in capacity. When they began slowly to sell, she daringly secured a lease on a plot of land at the head of the Thredbo valley and got Constance to design a small ski lodge to build on it. This was pioneering work for a woman in her fifties, but once Mum got her teeth into a project she did not let go of it. Gradually, the Snowman Ski Lodge took shape; it was to turn into the first room-rentable ski hut in what would eventually become the first fashionable ski resort with its own rope tow in the Australian Alps. Mum took her role as its chatelaine very seriously. She kept the accounts, in her sprawling eccentric hand, in a scuffed leather-bound stamp album that she had appropriated from me when I lost interest in philately; and almost every week, up she would get into her tiny car, a blue, beetle-like Morris Minor, and embark on the harrowing ten-hour drive from Sydney, up through Canberra and Cooma, and on to Thredbo. This was a perfect arrangement for me, since it left me all alone in the house at Cranbrook Road, where Noeline and I were able to pursue our affair—which would have infuriated Mum had she known about its hot, obsessive character— without interruption from her or any other oldies.

But Snowman Ski Lodge not only gave Mum a new lease on life; it brought her death. In 1963, she contracted hepatitis B, a deadly viral disease for which, at the time, there was no cure. She thought she had got it from, of all sources, a traveling salesman, who had booked in for a couple of nights in the lodge at Thredbo and left his calling card of viruses on the insufficiently sterilized tableware. By the time she realized that something out of the ordinary was wrong, and a doctor had seen her, it was too late to do anything about the disease. It was galloping through her. She turned a nasty shade of yellow, all over. She began, with appalling suddenness, to waste away. She was moved, first to a hospital in Canberra, and then as fast as possible to St. Vincent's in Sydney. Once again, as with my father, I did not witness her dying, and as far as I can remember, no one else in the family did: the doctors were too afraid of some rampant infection to let us go near her. So I had lost both my parents without seeing them go, or saying goodbye.

Conscious of an Inferiority

When the moment came to leave Sydney, I hardly felt a twinge of misgiving. I might miss some of my friends, but the chances were that we might see each other again on the Other Side, in Europe. My mother's death had freed me from the emotional ties I felt to her; I would miss her whether I was in Australia or in Europe, but not as much as I would miss Mother Europe if I stayed in Australia. Mim was entering the grip of Alzheimer's and gave little sign of recognition when we saw one another. My brothers understandably wanted me out of the Cranbrook Road house, so that it could be more profitably let or sold, and in fact I spent the last few days of my time in Australia in a funereal rented room in King's Cross, Sydney, whose blood-red curtains and puce carpet, like a stage set from some play by Jean Genet, stay with me yet. All I wanted was to be off, out, away.

On my way from Australia, not much befell me in the way of art. I stopped off in Los Angeles, the home of the only West Coast Americans I knew: Louis Licht, a show-business lawyer, and his wife Miriam, who had for a time rented the upper floor of our house in Sydney. Lou and Miriam had seen and been mightily impressed by the movie *On the Beach,* in which Gregory Peck, Fred Astaire, Anthony Perkins, and that infinitely desirable woman of my young dreams, Ava Gardner, were stranded in Australia, the last living country of a post-nuclear world. (Stories circulated in Sydney that, during the making of the film, largely shot in Melbourne, the beautiful Ms. Gardner, bored to tears by the city and its inhabitants, had been heard to say that "They wanted to make a movie about the end of the world, and they sure chose the right fucking place for it.")

The Lichts had never been to Australia before, and had decided that it would be the best place to get away from the atomic apocalypse which, they had convinced themselves, was likely at any moment to engulf America and Europe. So they came looking for a rental in Sydney, and found 26 Cranbrook Road. Since Mum was perennially short of money and the Lichts had plenty of it, this was an ideal arrangement. But eventually our dream tenants found their apprehensions of nuclear devastation fading. Month after month went by, and no mushroom clouds appeared over London, Rome, or Malibu. The Cold War was not hotting up. Sydney was a great place, but not, perhaps, so great for an elderly Jewish couple who could not surf. And in those days before faxes and e-mail, when trans-Pacific phone calls cost a small fortune and were not a medium through which one could economically schmooze, Lou Licht was beginning to feel distinctly out of the loop: his legal practice in Beverly Hills had begun to suffer by his absence and he did not feel ready to retire, not yet. Accordingly, the Lichts made ready to depart, with many (and I am sure, quite sincere) expressions of sorrow. They said they could not imagine why I should want to quit such a paradise as Sydney, but that if I came through Los Angeles I should look them up.

So I did. And they generously threw a party for me. I knew nobody there, and it did not (contrary to my unadmitted hopes) feature either Ava Gardner or any film actors I had ever heard of. There was, however, a young and pretty actress. We monopolized one another, and by the end of the evening I had asked her to dinner the next night.

So to dinner we went (a heavy steak house decorated in the plush style of the day, with brocade curtains, a lot of buttoned red-leather banquettes, and Etna-like eruptions of flame from table-side chafing dishes: it was the kind of restaurant that, given the chance, would have flambéed a potato), and we got on so well that by the end of the meal I felt bold enough to ask her where she would like to go now. She answered, "Vegas." Of course I had heard of Las Vegas: it was the place owned by the Mafia and by Howard Hughes, where Frank Sinatra went to sing and the rest of America to gamble, and I had always been curious about it, especially the neon signs. Knowing nothing of the topography of the American West, I assumed that it must be some kind of suburb of Los Angeles. I found out otherwise once we were in a cab, when the young lady told the driver to go to the airport. "You've never been to Vegas?" she asked me, a little incredulously, shaking her beehive. "Boy,

you really don't know America." Quicker than you could say "Lewis and Clark" we were at LAX, and into a Vickers Viscount—the old turboprop with the elliptical windows—with some weird name like the Golden Cannonball Vegas Jet Express. Compared to this, the names of Australian airlines (TAA, ANA, Qantas) seemed, in retrospect, boringly understated. Nobody asked us to empty our pockets or handbags, or for ID; there were no metal detectors; we just walked on board—a lost world.

As soon as we were airborne, the stewardess, who wore a perky lilac Jackie Kennedy pillbox hat, a faux-modest high-necked blouse, and a chartreuse miniskirt, handed me an enormous glass—a crystal bucket—of bourbon and ice. I swigged it down. Shortly after, I headed for the aircraft lavatory. And there, unbelievably, was the first slot machine of the night. You were supposed to put your spare change in it when you sat down on the loo. There was just room to pull the handle. In theory, if the right combo came up, it would disgorge a silver shower of quarters. It would shit on you, right there, even as you shat in the toilet. Its symbolism would have made Uncle Sigmund and Dr. Krafft-Ebing writhe and squeal in delight. Alas, I won nothing. When I returned to my seat I told the girl about this extraordinary lavatory. She uttered silvery peals of laughter, not at the weirdness of the idea, but at my own provincial and strange naïveté: as though every airliner west of the Rockies had a one-armed bandit on board.

Things got odder. Once off the plane at the Las Vegas airport, one was expected to buy chips, valid gambling currency at all casinos. I felt I was crossing a frontier out of America, into a yet deeper America, through the *bureau de change*. One paid for everything in Vegas with chips: for cigarettes, for drinks, for burgers, and for the airport taxi. I had gone from a place where gambling was utterly illegal, Australia, to one where it seemed mandatory. The girl gave the driver the name of a casino, I forget which one. As we sped toward it, through the warm desert night, under the immense radiance of neon signs that looked as tall as skyscrapers and blotted out all traces of real architecture behind them, I felt myself mutating. I was turning into James Bond; my rather ordinary mohair suit was becoming a white tuxedo, and I felt the irresistible comma of hair falling over my brow. I was going to double my money at the roulette wheel—the entire grubstake, which was supposed to take me all the way through to Europe and keep me there for a while, hung heavy in my inner coat pocket. As I won, from time to time I

would slip Ms. Thing a little stack of fifty-dollar chips and she would pop them *en plein* on 27 (my age), red, and sure enough the little white ball, its orbit decayed, would rattle into the right slot, paying her thirty-six to one. Later, with sardonic and mysterious ease, I would cash in my chips and take Ms. Thing upstairs to a suite and fuck her until her grateful shell-pink ears fell off. Then we would down a bottle of whatever vintage of Mumm *blanc de blancs* 007 normally drank under these circumstances, and go at it again. Thus the night would pass.

It did not. As a sophisticated gambler, I was a miserable failure. My luck wasn't helped by the fact that American wheels have two zeros, not just one, which gives the house a much bigger edge. My grubstake kept shrinking and as it shrank I began to panic. I couldn't pay attention to anything or anyone beyond the roulette table and after a couple of hours Ms. Thing, offended at being ignored, had simply vanished, never to be seen again. Before long, I realized to my sweaty horror, I would indeed get the definitive screwing of my life, but not from Ms. Thing: penniless in Las Vegas, condemned to wash dishes or swab floors for the Mafia (if I didn't end up in a shallow grave in the Nevada desert) for the next five years or so before, at last, slinking back to Australia with my tail between my legs. I was not 007. I was a twit, an object of contumely, mirth, and self-loathing.

In desperation, at about three in the morning, I switched games and began to play blackjack. I had never done so before, and I was the only player at the table, but inexplicably I began to win, thanks—I believe—to the ancient and bored dealer, who looked like some wrinkled reptile of the desert but began giving me good cards, while reminiscing with a curt, gloating intimacy about his wartime sexual adventures in Australia. He must have taken pity on this foreign idiot, washed up on the green baize. I won back my entire stake of traveling money, plus five hundred dollars' pure profit. Near dizzy with fatigue and disbelief, I tipped him handsomely, cashed in my chips, and wandered out into the desert night, away from the fug of cigar smoke, stale bourbon, and acrid fear. The desert night had turned into the desert dawn and what I had supposed were tall buildings covered in neon graffiti were revealed as mere iron frameworks, towering above what appeared to be Quonset huts. So much for the capital of chance. Clutching the roll of notes in my pocket—I must have looked as though I were furtively masturbating, which in a sense I was—I swore a silent oath never to go near a roulette table

again; and I more or less kept it, except for one night in London a year or two later. Then I hailed a taxi and scooted for the airport. Since that horrible night I have only been back to Las Vegas twice, both in connection with documentaries about art that I was filming, and each time I was taken ill, and had to spend most of the day in bed breathing the cold-steel air-conditioning of the vilely pretentious hotel. "Hell is a city much like London," wrote Shelley in "Peter Bell the Third." He was wrong. It is, of course, a city very much like Las Vegas.

Back in Los Angeles, I visited the cemetery of Forest Lawn, because I had read Evelyn Waugh's *The Loved One*, then went on to New York, where the editor of *The Nation*—not the Australian magazine, but its American prototype—asked me to do a piece on the 1964 World's Fair, that enormous combination of boondoggle and Pompeii-of-the-Future whose ruins and relics still, amazingly enough, confront the overseas visitor coming in from Kennedy Airport with their sad, crumbling remains, such as the stainless-steel Unisphere with the continents still clinging, like charred pork chops, to its framework. They were too expensive to tear down when there was no more use for them. The place still sticks in my memory not just because of its utopian bullshit of technological wonderlands in the future, but because of one pavilion and, in it, one exhibit.

This was the Vatican pavilion, to which Michelangelo's *Pietà* had been sent from Rome. This act of propaganda was conceived as a riposte to France's weirdly irresponsible consignment of Leonardo's *Mona Lisa* from the Louvre to America as a grandiose gesture from André Malraux, then France's minister of culture, to the Kennedy dynasts in Washington. If the picture commonly thought of as the World's Greatest Painting could be sent off to America as a sort of greeting card, so could the World's Greatest Sculpture. Thus the Pope's staff must have reasoned, with the result that the *Pietà* was uprooted from its niche in St. Peter's Basilica, elaborately packed, and flown to New York, where it was installed in the Vatican pavilion in Flushing Meadows. Those in charge were well briefed on the technical difficulties that had beset the exhibition of the *Mona Lisa* a couple of years before. It had been difficult, and in the end impossible, to get enough people to move past it at their own walking speed, because spectators tended to tarry and thus slow the whole line up. During the month it spent at the Met (February 7 to March 5, 1963), the *Mona Lisa* was seen, or viewed, or glimpsed,

or passed in front of, by 1,077,521 people, not counting the museum's own staff. This was twice the attendance in Washington (518,535), and it gave an average "exposure time" of 0.79 seconds per person, which must be multiplied by ten, since the queue moved toward the picture ten abreast. Obviously, there is not much use in showing anyone a painting for eight seconds. And yet this was a singular experiment in museological crowd control—the first time a museum in America (or anywhere else) had tried to treat a "traditional" image, meant for long and steady looking, as though it were a reproduction of itself—like a photo in a magazine or a newspaper, to be quickly scanned and discarded. When Andy Warhol, who in 1963 was just at the outset of his career but had already done several silk-screen repeat images of the *Mona Lisa*, heard that the painting was coming to New York, he asked, "Why don't they just have someone copy it and send the copy? Nobody would know the difference."

This clumsy process had to be refined for the Michelangelo *Pietà*, and the only way of doing this was to deprive its audience of the ability to choose its own contemplation speed. It was therefore necessary to make the crowd flow past it on a moving walkway. Coming in from the harsh light of day, you were streamed into a sort of twilit antechamber and then found yourself on a conveyor belt, not unlike the belts used to carry animals into slaughterhouses. No need to move: indeed, with someone right in front of you and someone else right behind you, to move or to delay was impossible. And there, in front of your eyes, was the *Pietà*, displayed within a proscenium arch (designed, in fact, by the famed "Broadway" Jo Mielziner, who had done the sets for many productions, including the first one of Arthur Miller's *Death of a Salesman*). The sculpture was bathed in a pinkish light that made it look unfortunately like an enormous chunk of Ivory soap, and rising behind it—lest you didn't get the point of Michelangelo's *concetto*—was a large black cross, draped in a purple penitential cloth. On either side of the mourning Virgin and dead Christ stood a security guard, in plain view, all brown leather and gleaming badges, each with a pistol holstered on his hip, just in case you had notions of hopping over the rail and stealing or damaging the statue. It was too far away to be seen in detail. Actually, it may have been no worse off than it was, and still is, in its setting in St. Peter's, where its baroque environment of gaudily colored and figured marble overwhelms it, and its elevation on a high plinth entirely disobeys Michelangelo's intention,

rendering Christ's beautiful face invisible. Be that as it may, by the time the moving footpath had carried me past the stage and out the other side I thought I knew what I had seen, and I hurriedly ran back outside the pavilion to rejoin the line at the other end. The second time through, I was sure. I had been granted a prophetic vision of the future of American ideas about the museum: the as yet undeveloped blockbuster, with its swarms of passive art-imbibers lining up to be processed with brief but therapeutic culture shots. Struck as by a revelation, I wrote an article about this ghastly project for the American *Nation,* and when Carey McWilliams, its editor, published it, there came a spate of angry readers' letters denouncing me as an ingrate, an elitist, and a pessimist. But as future exhibitions ten or so years down the line, like The Treasures of Tutankhamen, amply showed, my little peek into the future saw something real.

I wish I could claim that I arrived in London full of good ideas and well-formed resolutions, but I did not. Apart from the small sheaf of letters of introduction from Alan, I knew nobody and I felt lost—a provincial Australian in a place that still, in 1964, tended to look down on Australians.

Whatever credibility as a writer I might have accumulated in Sydney counted for very little here. I traipsed around the museums, and each time I crossed the august portals of the National Gallery, the Tate, the British Museum, the Wallace Collection, or the Courtauld, the same message hammered on me: I was a provincial, I knew so little, I was not qualified to speak or write about anything here, it had all been done before (and so much better!) by others who were better versed in it than I, and who unlike me had something of actual value and originality to say. I passed my days oscillating miserably between a sense of inferiority, which I did my best to conceal, and periodic flashes of exaltation induced by the wonderful things I was at last getting a serious look at.

But I was inhibited by my own snobbishness, which took the form of a preference for the rare, the obscure, the less visited, the un-touristy. The fact that I *was* a tourist, and should therefore have felt no embarrassment about acting like one, did not really register on me. Thus I am embarrassed to confess that I semi-deliberately missed out on certain great masterpieces: not once, during this stay in London, did I visit the Elgin Marbles in the British Museum.

On the other hand, I took some pride in looking for, and finding, such

minor curiosities as the "Magical Mirror of Dr. Dee," a round Incan mirror of black volcanic glass that Queen Elizabeth I's favorite magus and astrologer, John Dee, used in divination, and that was referred to by John Donne as "the specular stone." I was fascinated by (then) out-of-the-way collections like the Soane Museum, which in those days—before the invention of postmodernism, and Sir John Soane's installation as its architectural god—you could have entirely to yourself any day of the week, from its Turners to its immense sarcophagus, and not forgetting the exquisite tomb of his pet bitch, whose funerary inscription I resolved to purloin if ever I owned a dog and that dog died: "Alas! Poor Fanny."

I marveled at the sheer impaction of national art and imperial loot. And I was cowed by it. It was wholly outside my experience, because in Australia one had only been able to see the distant tail end of it. But would I, could I have anything of the smallest interest or originality to say about these mighty deposits of British culture, after all that the English, Irish, and Scots themselves had written and uttered? The best way to find out was not to wait, and perhaps to write about something intrinsically foreign to the Brits.

I had begun to meet artists almost as soon as I arrived in Europe, but none of them made the same intense impression on me as Robert Rauschenberg. Of all the visual artists I have met, none has ever given me a stronger feeling of continually sprouting genius than this wide-open, colloquial Texan, for whom 1964 was an almost dementedly busy year: not only was he touring with his friend and collaborator Merce Cunningham's dance company in thirty cities in Europe and Asia, from London to Osaka, not only did his big silk-screened painting *Skyway* occupy a place of honor on the outside of Philip Johnson's New York State Pavilion at the World's Fair, but he brought off the extraordinary coup of being awarded the International Grand Prize in Painting at the thirty-second Venice Biennale, even though his works were displayed, not in the official U.S. Pavilion in the *Giardini Pubblici*, where the other national pavilions stand, but off-campus, as it were, in the building which had once served as the American Consulate. Today, the Venice Biennale is hardly more than one vulgar trade fair among many. But in far-off 1964 it still had enormous prestige, an importance that survived from the days when there was little publication of contemporary

art, when the circuit of information on current painting and sculpture was still only embryonic, having ceased entirely to exist during the 1939 to '45 war; the Biennale was not just the best but virtually the only institutional place where you could get a fix on what was new in art. Nor had it fallen entirely into the hands of open and covert art dealers, shamelessly corrupt critics, investment-minded collectors, and dishonest curators, as would happen during the 1970s. The International Grand Prize in Painting carried an award of two million lire, $3,200 at prevailing rates of exchange, which would hardly buy two rounds of drinks for Damien Hirst's hangers-on at Harry's Bar today, but was considered a big deal then. Its importance, however, was mainly symbolic. The award of the International Grand Prize had long been considered a lockup for Europeans. The only Americans to win it before had been James McNeill Whistler in 1895 and Mark Tobey in 1958. Alexander Calder had won the prize for sculpture a few years before, in 1952. The idea of giving it to a talent as prancing, fecund and—above all—*un-European* as Rauschenberg seemed, to many critics and museum people, not to mention European collectors, positively offensive, and to some almost sacrilegious. Particularly in the eyes of the French, whose critics—led by Pierre Restany—believed that *their* mass-media and junk-inspired artists, the European *Nouveaux Realistes*, such as Arman, Daniel Spoerri, and Mimmo Rotella, were the truer innovators, much of the talk about the superior strength and startling originality of American art as exemplified by Rauschenberg was hooey. Some (though not Restany) declared that Rauschenberg himself was little more than an imitator, even a plagiarist (albeit on a large scale) of the late, great German Dadaist Kurt Schwitters. Their hostility to Rauschenberg, and to the slowly coalescing profile of American Pop Art, was of course able to present itself as a radical position because anti-Americanism *was* radical: to be against America was to oppose the Coca-Colonization of Europe, to speak out for "genuine" democracy as against the gross and manipulated capitalist populism that Uncle Sam was exporting to all points of the globe.

But you couldn't—or, at least, I couldn't—maintain this kind of political nonsense in the face of Rauschenberg's paintings, when they went on display in Venice.

Some critics like to claim credit for having "got the point" of a great artist's work before his greatness was generally recognized. I can't claim this

about Rauschenberg, of course: he was already well known in America, and to a limited extent in Europe too, before the éclat with which he burst out in the 1964 Biennale. But I will always be grateful to him, and feel rather humble before him, for having *shown* me the point so that I could get it. Two things in particular stand out in memory. The first was, of course, the exhibition of his screen-print paintings at that Biennale. Their range was so big, and it seemed to embrace so much of possible human experience, replicated from photographs and enlarged as silk screens: politics (who can forget the blue image of the freshly assassinated JFK, pointing an accusing finger like an angry God, in *Retroactive I* [1964]?), space technology, the sweetness and otherness of nature, the work of other artists from Rubens to Duchamp, and so on. Those who denigrated him (at first) as a mere imitator of Kurt Schwitters were on a wholly wrong track; it was Rauschenberg's use of silk screen, which enabled him to enlarge tiny images to giant size, that freed him from being restricted to the original objects, as one is in collage; through silk screen he could unveil and release a further level of dreaming, even more potent than what lay in the original objects. All found objects could share the freedom and malleability of images. Of course, Schwitters had been an inspiration to Rauschenberg. Nobody, least of all he, either denied that or wanted to. So had a host of other artists, including some Americans— Arthur Dove, Willem de Kooning. The issue was not what he took from others (so much art comes from other art anyway; total "originality" is a total fiction), but the respect with which he took it, and the uses he put it to. Silk screen enormously increased Rauschenberg's image bank because just about everything in the world, from beetles to mountains, from spermatozoa to Thor rockets, has been photographed. Besides, Rauschenberg loved opening doors and holding them open for others to walk through. If the Pop artists could confidently allow themselves to be fixated on media subjects, it was Rauschenberg who showed them the way. If Andy Warhol could base his entire career with its messages of repetition and image glut on a single media device, the photographic silk screen, he got that from Rauschenberg. Rauschenberg was like some crazy millionaire in an American comic strip, the laughing sugar daddy of American modernism, who loved changing lives by handing it all out and giving it all away.

The second thing I remember so vividly was also in 1964. It occurred at a theater in London; the occasion, the first night of the dance piece created by

Rauschenberg and Merce Cunningham, *Winterbranch*. I knew a little bit about classical ballet—the lessons of the Royal Ballet performances I had attended during my relationship with Brenda, the dancer, had not been entirely in vain. But her tastes, which were fairly categorical, ran to Ravel, Stravinsky, Tchaikovsky, rather than to John Cage. Of modern dance in general, and of the work of Cunningham and John Cage in particular, I knew nothing. So Bryan Robertson and I settled into our seats with great anticipation. The house lights went down. *Winterbranch* unfolded as a wonderfully moody, stark piece. The movements of the bodies and the patterns of light and darkness were pared down to what seemed an absolute minimum. It presented a choreography that seemed as new, in its way, as the movements of *The Rite of Spring* must have seemed fifty years before, to a Paris audience accustomed to the arrangements of Petipa. It wasn't "shocking," but mysterious and beautiful. One felt no resentment, only a different kind of joy, and a curiosity that was new to me.

And then, extraordinarily, a chair appeared, up in the flies, just visible on the right of the stage. It began to travel slowly through the air, toward the left. It was an ordinary Thonet-type bentwood café chair. Its sinuous curves, hit by a strong directional light, cast weird shadows on the curtain behind, seeming to writhe like the tentacles of a squid. As it crossed the stage, in unbroken silence and without any kind of context from other events, I felt— there is no other word for it—ravished. For the first time in my life I felt swept away by something inexplicably powerful, self-sufficient and yet mysterious. Just a chair in the air! Later I would realize that this apparition must have been a gloss on Marcel Duchamp's *Tu m'* (1918), in which a chair fixed to the surface of the painting casts its elongated fictional shadow, done in pencil, on the canvas. But when I eventually saw the Duchamp (at the Tate's retrospective in 1966), it did not affect me with even a fraction of the power that Rauschenberg's chair in *Winterbranch* possessed. It symbolized nothing. It told no story. The dancers did not react to it, or even notice it. It was just there, magical in its banality, reminding us—in the thirty seconds or so of its passage through the proscenium—of how amazing the simplest things in the world can be. An artist who could do that with a chair and some string, I felt, was an artist who could do anything. And so it proved to be. Rauschenberg would remain, for me, the greatest of American artists. I care little for anything Jasper Johns, with whom he was always bracketed, has made in the

last quarter-century; to me, Johns—who made some very fine pictures in the 1950s—has been since at least the mid-sixties an increasingly leaden and overvalued bore, whose multimillion-dollar prices ridicule the very nature of artistic participation. But Rauschenberg has always been open and welcoming. The two are night and day, chalk and cheese, breathing in and breathing out.

I took one of Alan Moorehead's letters to Hamish Hamilton, his publisher, and before long, thanks to a kindly testimonial from Sir Herbert Read, one of his advisory board (whom I had met in Melbourne the previous year), I was signed up to write a book on irrational imagery in Western art. This, though I did not realize it at the time, was an impossibly large subject; but because it was centered around the twentieth century, around Dada, Surrealism, and their aftermath, I thought I could handle it and continued to believe so for the next couple of years, until my researches—and my gradual discovery of my own severe limitations—showed me otherwise. The book would never be finished. I was too unfocused, too distracted by the great city in which I could not find my bearings. I felt like an insecure, intellectual fop. In the meantime, I could put bread on the table, and even some butter on the bread (for it is amazing, in retrospect, how little it cost to live in London in the early sixties) by writing reviews for the "quality Sundays," whose editors, thanks again to Moorehead's recommendation, took me a little under their wings. But I was painfully aware that doing this kind of journalism only served to put the book on hold, and that I didn't really have the kind of equipment or experience that would enable me to confront its minatory subject. The list of the people whose work was fundamental to Dada and to Surrealism, and who were still alive and even active in 1964, was promisingly but intimidatingly long. It included, in France, André Breton, Pablo Picasso, André Thirion, and a host of others; in New York, Hans Richter, Richard Hulbeck, Marcel Duchamp; in Germany, Max Ernst and Hannah Hoch; in Spain, Salvador Dalí and Joan Miró—and so on. I had no worked-out means of getting to such people and no real plan for dealing with all this potential material—or with the humiliation of being turned away from their doors. I was a boy who had dispatched himself to do a man's job. I was no better than a dilettante and I began to despair at my lack of a formal context of life and

of research. And as I was mulling over what seemed like the opening paragraph of a catalog of future failures, I thought of Alan Moorehead's suggestion: that if I ran out of rope, but not otherwise, I should come and stay with him and his wife Lucy in Italy.

So I went. I gathered together every cent I had, about a hundred pounds after the airfare was paid, and flew to Rome. From there, a train misleadingly called an *accelerato* (the slowest category of Italian passenger train, which stopped at every station) at last deposited me at the station of Orbetello, just 143 kilometers north of Rome. I knew four words of Italian: *"Casa Moorehead, per favore."* Luckily, the person I tried them on was Bruno, the Mooreheads' gardener and general factotum, who had been sent down to meet me. He drove very slowly, almost meditatively, through the tiny town of Orbetello (not an old building in the place, it seemed; everything had been flattened by Allied bombs twenty years before) and along the causeway that joined Monte Argentario to the mainland.

The Mooreheads' house was approached by a winding uphill road that branched off the main route into Porto Ercole, next to a walled cemetery marked, to my delight, by dark vertical stands of the *invisos cipressos,* the funereal cypresses of Latin poetry. Having no car at first, I walked that track so often that it seems the loud hum and chirruping of insects in the *macchia,* the aromatic bushes (mostly thyme and rosemary) that stretched away to the olive groves on either side, still enter my ears when I shut my eyes. Yellow butterflies flirted among yellow stalks of asphodel. The house was cool, comfortable, and not grand. It stood about a kilometer back from the sea and had a spreading view of farmland, two massive sixteenth-century castles in the headlands that embraced the port, and drift after drift of scarlet, ephemeral poppies.

Below the terrace and its framing cypresses, Alan and Lucy had planted vineyards: perhaps an acre under vines in all, not a large *vigna* but enough to keep the household supplied with its own ordinary white most of the year. Nineteen sixty-four had produced an abundant crop of grapes and now, in September, they were ready for the *vendemmia,* the gathering. I was looking forward to this. It was the kind of archetypally Mediterranean activity that I had heard of but never seen. Bruno was in charge of the grapes; I was to tag

along picking and doing as much of the heavy lifting as he needed me to. Alan had rented a big oaken vat some two meters in diameter, which had, lain across it, a perforated pressing-lid with raised edges. The baskets of grapes, which we carried uphill on our backs, were emptied onto this lid.

And then came the Mediterranean moment: barefoot, one scrambled up onto the pressing board and started treading out the grapes, pushing down with movements similar to doing the twist. The grapes popped slimily underfoot, they squidged between your toes, the juice trickled into the vat, the crushed grapes were pressed again with wooden tools and at last the exhausted pulp of grape skins, pips, and twigs was scraped and shoveled out to be replaced with fresh bunches, while swarms of aggressive yellow-jacket wasps buzzed around. Then the greenish juice was filtered and drained off into straw-encased, twenty-liter glass demijohns. These were corked and carried down to the stone basement, a two-man job.

Two or three nights later the action began. You could hear what had been mere fruit juice fermenting, turning into wine: the rumble of the demijohns vibrating on the stone floor. It was an ancient, satisfying sound, and it permeated the whole house. To me it was deeply exciting, and it didn't matter that the wine that resulted wasn't great; it was drinkable, and I had helped to make it, and that was enough. *O for a beaker full of the warm South!* I was in Italy, and that was what counted.

Looking back, Porto Ercole seems an eccentric place for a young man anxious to know art to have chosen. There were no significant works of art on the Argentario Peninsula. Porto Ercole had one church, which had only a newish iron crucifix and some plaster madonnas and saints, indistinguishable from the pious Pellegrini rubbish I had left behind me in Sydney.

Its only association with great Italian art of the past was buried, invisible. In 1610, the painter Caravaggio died there. He was on the run from vengeful thugs working for a grandee whom he had offended, the Grand Master of the Knights Hospitallers of Malta, Alof de Wignacourt, into whose order Caravaggio had been received as a Knight of Obedience in 1608. He had quarreled with another senior knight, been imprisoned on Malta, escaped, and then, for the next two years, he had lived an increasingly desperate, peripatetic life, only a jump ahead of de Wignacourt's vengeance. In the summer

of 1610, the boat on which he was traveling put into Porto Ercole, where Caravaggio was mistaken for some other miscreant and imprisoned. He was let go after only two days, but that had been enough; he contracted "jail fever"—the malignant typhus that killed so many of Europe's convicts in those days—and died within a week. There is no indication of where he was buried. But the street I had my flat on, which ran uphill from the port, was called the Viale Caravaggio. This in itself struck me as remarkable, since practically no Australian artist or writer at the time had a street, even a miserable blind alley, named after him. The very idea would have been inconceivable. It still pretty much is. Go to Madrid, for instance, and you will find streets, squares, and passages named after Velázquez, Zurbarán, Goya, Ribera, Murillo, and, indeed, most of Spain's great national artists of the *Siglo d'Oro* and the eighteenth and nineteenth centuries. Likewise the writers and musicians. Little of the kind has happened in Australia, and probably it never will, since the descendants of some otherwise forgotten politician or merchant would probably raise a stink if their ancestor's name had to be scrubbed in favor of one more evocative of cultural achievement. I suppose Dorothea Mackellar and Banjo Patterson are commemorated somewhere, but will there ever be an Ian Fairweather Street, or Kenneth Slessor Place, or a Patrick White Square? I wouldn't bet on it.

Yet for all the thinness of its cultural connections, Porto Ercole had its own fascination. In fact, it became magic to me. Its transformation into a tourist "destination" had scarcely begun, and the waves of developers that would descend on it over the next forty years had not yet destroyed it with their multistory apartment blocks and artificial yacht basins. It was still basically a fishing village, and at one end of the port was a *cantiere*, a boatyard, where the big wooden fishing boats were constructed with their oak frames and hammered-in trenails. Some nights, leaning over my tiny iron balcony on Viale Caravaggio, I would watch the smaller sardine boats heading out of the harbor, on their way to the waters north of Elba: they still carried hooded carbide lamps on gooseneck stanchions mounted on their sterns, and when the lamps were lit the sardines would come swarming to the light, to be gathered up in nets. If the fishing had been good, small fires would be lit on the shore early in the morning as the boats came back, and fresh (almost live) sardines, anointed with oil and clamped into a twin-leaved wire grill between sprigs of rosemary, would be cooked over them for breakfast, washed down

with milky coffee from the Bar Centrale and tumblers of the harsh wine of the Argentario.

The port basin was narrow, and framed between two high headlands. Along the waterfront, known as the Lungomare Andrea Doria after the sixteenth-century Genoese admiral, there were modest apartments, a restaurant or two, and a hotel called the Gambero Rosso ("Red Prawn"), which had a passable dining room and bedrooms rendered frigid by their polished terrazzo floors. There was a ships' chandler that served the boatyard and, propped on its outside wall, an extraordinary pair of objects recently entangled in fishermen's nets and raised from the sea floor. One was ancient Roman, an unglazed terra-cotta amphora, about four feet high and almost intact, dating from the second or third century A.D. It was thickly encrusted with marine growths. The other, similarly encrusted, was the rotor shaft of a jet turbine, which had evidently come from one of the engines of a De Haviland Comet, an early jetliner that had crashed, with great loss of life, into the sea off Elba a decade or so before. (Among the passengers was Moorehead's close friend and onetime fellow war correspondent, Chester Wilmot.) Two similar forms with a couple of thousand years of technology between them: the sea is a great equalizer.

Just offshore, in fact, there were many more amphorae, some real but most fake. The sea around the Argentario was speckled with islands, the nearest of which was called Giannutri. On Giannutri were the beautiful ruins of a Roman villa, supposedly built by the dissolute late emperor Elagabalus. Three columns with Corinthian capitals still rose from a plinth at the top of a crumbling flight of steps, and framed a blue view over the Tyrrhenian. It was a romantic spot; nobody lived there—in those days there was no need for *guardiani*—and you could go diving among the rocks for sea urchins, which grew there in clumps and spreading black meadows of slowly waving spines; their orange roe, extracted with scissors and a teaspoon, was good eaten raw but made an exquisite pasta sauce if you collected enough. A little further out from the rocks, in about twenty feet of water, lay row upon row of brand-new ancient Roman amphorae, which had been made and fired in a pottery kiln on the mainland and laid down to "mature," acquiring incrustations of marine growth and fan corals, until they were ready to bring up and transport to the Porta Portese flea market in Rome for unwitting American and German tourists.

In the seventeenth century, during the Bourbon reign over Naples, Spain had recognized the possible strategic importance of the Argentario peninsula by planting half a dozen forts along its seaward flanks, and one of these was built on each side of Porto Ercole harbor: Forte Filippo to the south, Forte la Rocca to the north. These huge structures had been abandoned for years, except that Forte la Rocca had a guardian and his family living in shacks within its girdling walls. On its high gates, clad in rusty iron, which were always chained shut, were various sloppily painted, fading, but still quite legible slogans from the Fascist years, including IL DUCE HA SEMPRE RAGIONE, "The Leader is always right." This invocation of the infallible Mussolini, who had ended his days a couple of decades earlier hanging by the heels with his mistress, the movie starlet Clara Petacci, from the roof of a Milanese garage, struck me as an Italian equivalent to Ozymandias' injunction: Look on my Works, ye Mighty, and despair.

It was more difficult to get into Forte Filippo: the bridge across its twenty-foot-deep outer moat had collapsed decades before, but a couple of rusty iron beams were left, and with luck and determination you could crawl on them across the chasm, scaring the lizards and snakes that nested in chinks of the stone of the inner wall.

One of the corridors in the seaward-facing flank of Forte Filippo gave onto a row of prison cells, each of which, far from being a dismal dungeon, enjoyed through its rusting bars a million-dollar view of anfractuous rocks plunging down to the Tyrrhenian, whose calm blue plane stretched away to Civitavecchia and thence to Rome. Several of these were accessible. Their inmates—prisoners, apparently, of some forgotten conflict between the Italians and the Turks—had left indecipherable graffiti in Turkish all over the now crumbling plaster walls, along with touchingly elaborate drawings: the pornography of sad fantasy, with every stiff nipple and curly little hair meticulously in place, and each spiral of the lace on the corset rendered in.

The only peril involved in my rambles over Monte Argentario came in the autumn, and was posed by the excessively trigger-happy local shooters. I had loved hunting in Australia in the past, but not as much as these Port'Ercolesi. I had hunted rabbits and duck (never a kangaroo, though these innocuous creatures were regarded quite unfairly as pests by sheep farmers); I enjoyed

shooting trap and skeet with a 12-bore, and when in practice could average a fair twenty-two clays broken out of twenty-five. But on the whole, shooting, unlike fishing, was something I could take or leave.

La caccia, however, was an obsession with every red-blooded Italian male, and at the autumnal opening of the hunting season the forested slopes of Monte Argentario would be fairly pullulating with hunters. Each was magnificently kitted-out in leather breeches, cartridge belts crossed bandit-wise on his chest, game pouches, and a coat of woodland green. It was not uncommon for a hunter to spend more on his gun (preferably a fully engraved, Circassian walnut-stocked, over-and-under Beretta) than on his car. One had to cut a *bella figura* on the field of honor. One season I read on the first page of the *Cronaca di Grosseto* the instructive story of how, in a forest clearing near Manciano, a solitary pheasant—a bird nearly extinct, by then, in central Italy—was scratching around, unaware that four hunters were converging on it from different sides, each also unaware of the others' presence. The resulting fusillade from the 12-bore Berettas blew the poor bird to rags and feathers, and in the heated quarrel over whose prize it actually was three of the *bravi cacciatori* were shot, one fatally. One morning I saw Alan Moorehead's factotum in full hunting dress sitting a few yards from a bush, tossing pebbles into it. At last a tiny wren-like creature flew out, and was mercilessly gunned down. *Eccolo!* cried the hunter, as though he had just shot a grouse.

One Christmas I made my way to my regular trattoria, Da Umberto Fusini on the Lungomare Andrea Doria, hoping to get a somewhat more festive solitary meal than usual. The proprietress was wreathed in smiles. *"Oggi, Roberto, oggi c'abbiamo la haccia"*—we've got game today. And indeed, delicious smells of roasting were wafting out of Signora Fusini's tiny kitchen. I sat down and contemplated the plastic holly and the gray frigid waves beyond it, beating monotonously on the stones of the breakwater. My mind's eye was filled with the prospect of *la caccia,* like one of those seventeenth-century Dutch still lifes—pheasant, quail, a furry bunny or two, a limp roebuck draped over the bench. I swallowed several glasses of the rough Argentario red. Out came Signora Fusini, beaming, with a thick white china plate. On it was a thicker slab, a socle, of steaming polenta, crisscrossed black from the grill. And on the polenta were four tiny carbonized corpses, arranged north, south, east, and west. Their heads were still on, and

their wiry charred feet were sticking up in the air: a grotesque miniature. Not wanting to be rude, I picked halfheartedly at the tiny breasts, but that was all I could manage. Signora Fusini was disappointed that I hadn't eaten the heads; when it was clear that I wasn't about to, she took one of the little corpses and bit the top of its head off, sucking out the half teaspoon of brains it held. And what, I asked, had I been eating? *Petti rossi,* said Signora Fusini. *Petto:* that meant breast. And *rosso,* red. Oh sweet scavenging Jesus: I had just been feeding on roasted robin redbreasts for my Christmas dinner. Would Signora Fusini mind, would she be mortally offended, if I asked her to fix me some *spaghetti alla carbonara* instead?

I think of Alan as my mentor. But he only taught me by example, not by telling me what to do. To say that he showed me the necessity of work, and how to do it, sounds banal: who doesn't know that a writer has to work, and needs to have a special kind of persistence to write every day without anyone at his shoulder telling him to get on with the job? Yet it is one thing to know this, and quite another to do it. Having dropped into a new life in a new world, I was almost pathetically distractable and could rationalize every minute spent away from my typewriter as a foray into potentially useful new experience, when it was rarely more than goofing off. Back in Australia, I had finished both my history of Australian art and my little monograph on Donald Friend because I knew that if I didn't deliver them, I would never get unstuck from the runway: I would never make it to Europe. But no such stringent incentive existed now. I was in Europe; I had a little money, enough to coast on, coming from the sale of my Australian collection. I could live, if not like a prince, at least like a remittance man. But Alan did not live like either. He worked. He lived like a successful worker. He was a complete professional. One of his traits, as I saw when I was staying at Casa Moorehead, was his invisibility in the morning. He got up at seven o'clock on the dot, in fair weather or foul, when no one else (and certainly not I) was stirring; he made himself a battered filter pot full of inky black coffee, drank most of it, downed a slice or two of yesterday's bread with apricot jam, and trudged up the hill to his writing shed at the back of the house. It was a simple stone cube with a terra-cotta roof, and although it should have enjoyed a splendid view over Forte Filippo and the sea beyond, I do not remember it having anything

like a picture window, because that would have been a distraction from the task at hand. That task, for Alan, was to shut the door, sit in front of his type-writer until he had shamed himself into writing a thousand words, and not let himself out until he had. Sometimes the words came easily. Sometimes, as he put it, the effort was "like straining shit through a sock." But he never failed to write something merely because he didn't feel inspired to do so, and that was one of the essential differences between the two of us. For I would do almost anything to avoid writing. I would go for long walks along the sea-side or through the *macchia*. I would have prolonged, solitary lunches with a book, go back to the flat half drunk, and take two- or even three-hour siestas.

I was not the only unformed or failed writer in Porto Ercole. Apart from a gloomy and unsuccessful Italian novelist, whose name I have forgotten and the cruel world never learned, who would spend some evenings drinking on a tubular-frame plastic chair in the Bar Centrale until he fell off with a thump and had to be driven home, there was Alwyn Lee and his wife Essie.

A particularly strong friendship existed between the Mooreheads and the Lees, who had renovated a small farmhouse, hardly even a *casa colonica*, just a cottage, across the valley from Casa Moorehead. The Lees only used it during the spring and summer. Alwyn was an expatriate Australian writer in his early fifties, who had joined *Time* magazine decades before, and was now its head book reviewer. Essie had a somewhat more demanding job, as the head of researchers for *Time;* this invested her with enormous authority within the magazine, or so I was told.

Alwyn was a cadaverous man with a saintly, aquiline look, like a spawned-out John of the Cross. Alan and he had been friends since their early days at Melbourne University, in the 1930s. Unlike Alan, who was essentially apolitical, Lee had been a vehement socialist, and he eventually joined the Communist Party. It was he who introduced Moorehead to the "advanced" writing of the day: to Eliot, Pound, and Joyce, and to the early poetry of Auden. He had never, as far as I could discover, published a book of his own, though his magnum opus, from which he was prone to quote indistinct frag-ments when drunk, was an epic poem in iambic couplets about a sheep shearer who has a vision of God and breaks out in the stigmata, later becom-ing the hero of a cult. (It should go without saying that Alwyn Lee was a

lapsed Catholic with an implacable Irish prejudice against all efforts at Church liberalization; having rejected the Church, he could not stand the thought of improving it.) He never finished this poem, and I doubt if it really existed. Henry Grunwald, who was his editor at *Time* and later mine, recalled as a fairly typical fragment of his early journalism a report he had done for the Melbourne *Herald* on a leprosarium in Victoria. " 'Conditions at Coode Island are disgraceful,' a leading leper said today," it ran in part. In 1939, Alwyn and Essie had left Australia, permanently, as it turned out, and headed for the United States. On the way they stopped in Mexico, where Alwyn paid a call on Leon Trotsky, who was living in exile (and under continuous threat of assassination by Mexican Stalinists) in Diego Rivera's house in Coyoacán, outside Mexico City. Without ceremony, he was shown into the modest room where the former organizer of the Red Army was working. At the sight of his hero, Alwyn was suddenly bereft of speech. "Well, Mister Trotsky, you're a long way from home, aren't you?" he finally managed to blurt out. Trotsky looked at him benignly. "And so, by the sound of your accent," he rejoined, "are you."

But Alwyn had an excellent arrangement with *Time;* he was not required to be in its New York offices, so that he could live undisturbed for quite long periods in Porto Ercole. Parcels of books would be sent to him care of the offices of Time-Life (pronounced "Teemay-Leefay") in Rome; now and then he would get the village taxi driver to take him the 140 kilometers down to Rome, where he would choose some of these new publications as candidates for review; then he would bring them back to Porto Ercole, and work his way through them, pattering out his prose on an elegant blue Olivetti Lettera 32, beneath a rustic grape arbor with a view down the hill and across to Forte Filippo. Neither he nor Moorehead had a telephone, and of course the fax machine had not been invented in 1966, so when his copy was ready Porto Ercole's taxi driver would be summoned again for another trip to the Rome office of Teemay-Leefay, whence it would be telexed to New York.

It was in some respects an ideal arrangement for a writer: a guaranteed income, a place in the sun, and only light, undemanding deadlines to satisfy. Alwyn unerringly made the worst of it, because he was an irreclaimable drunk: not just a bit fond of the bottle, as anyone might be, but a lush so dedicated that, the first time he came down the hill to the port to have breakfast at my flat, he insisted on moistening his cornflakes with a mixture of half

milk and half vodka. When sloshed, he would produce hideously elaborate puns: I remember him goggling into an empty Chianti flask late one evening and declaiming, from *Macbeth*, "The wine of life is drawn, and the mere lees / Are left this vault to brag of." When relatively sober, he was a wonderful conversationalist, full of anecdotes (music to my hungry and culturally inexperienced ears) about writers he had known, about the vagaries and peculiarities of the literary world as seen from his long-occupied perch at *Time*. Yet through them ran an unmistakable vein of melancholy, the sadness of a man who had spent so much of his adult life judging the books of others, writing about them but never producing one himself—and, worse still for the writer's ego, being condemned to anonymity while doing so, for by imperial fiat, issuing from Henry Luce's office on high, *Time* had no bylines and whatever you read in it was the voice of the corporation, not acknowledged as that of any individual writer. Although he never complained about this fate—or not to me—I cannot imagine that it caused him no pain.

To be the anonymous author of essays that were read by millions must have been even more galling than to write namelessly for the much smaller readership of the *Times Literary Supplement*, which in those days had the same policy of anonymity. The *TLS* fancied that not giving the names of its contributors encouraged "objectivity" among them, whatever that was supposed to mean, and led to fairness in reviewing. This was hokum. If anything, anonymous reviewing served as the gauziest of cloaks for uninhibited malice. It encouraged dagger work of every sort. This was not true, or not *as* true, at *Time* in the mid-sixties, though there was never a shortage of writers who felt that a bad review in the magazine was the result of Henry or Clare Booth Luce's personal vendetta against them for their left-wing views.

Being friends with Alan, I sometimes saw this feeling in action. Every spring and through the summer, writers would forsake their nooks in London and their aeries in Manhattan or Los Angeles, and go roving in Europe. With increasing frequency they would stop off in Porto Ercole, where they would visit the Mooreheads. Conspicuous among them, in the warm months of 1965, were the novelist Irwin Shaw—then at the height of his fame and wealth—and an Italian writer, the former journalist Luigi Barzini, whose book *The Italians* had just become a runaway best seller in five or six languages. The three of them had been friends twenty years before, at the end

of World War II. They had all been war correspondents, and all in the same theater of war, attached to the Allied forces moving north through Italy after the reconquest of Naples. One evening in the early days of the liberation of Rome, Barzini, Moorehead, and Shaw were happily tucking into a black-market meal in some Roman trattoria when the question arose of what, since the Allies were plainly winning the war, their own peacetime plans would be. By then Alan had made up his mind to stay in Italy, and he thought he knew where he would get himself a cheap, pretty *pezzo di terreno*, in a ruinous and bombed-out little place on a peninsula north of Rome, Porto Ercole. And there, he said, he would have a farmhouse and a boat. And I, said Barzini, who at the time was a not very well-paid correspondent for an Italian daily, will have a bigger boat than you. And I, chimed in Shaw, who had not yet written, let alone sold the film rights to, his World War II best seller, *The Young Lions*, will have a bigger boat than either of you bastards. As the evening went on, the three musketeers resolved on a plan. Twenty years from then, which was to say in the summer of far-away 1965, the three of them would converge in their boats on the little one-horse port where Alan was talking about getting a place—Porto Ercole. And there they would, so to speak, compare lengths.

It was a contest Alan did not expect to win, and lose it he did. He owned a boat, or rather a half share in one, the other half being owned by his friend the socialist TV magnate Sidney Bernstein, the founder of Granada television in England: a pretty thirty-two-foot sloop that they kept moored in Porto Ercole harbor and had named the *Lucandra*, a fusion of their wives' names, Lucy and Sandra. (It seems barely credible, in the early twenty-first century, that the man who founded and largely owned the first commercial TV station in the United Kingdom would have been content with half a puny cockleshell like this as his pleasure boat, but Sidney Bernstein was one of a vanished species.)

Lucandra was a modest enough craft alongside Luigi Barzini's boat, a black toothpick some eighty feet from bowsprit to rudder that had once been owned by Mussolini's son-in-law Count Ciano, and which Barzini had managed to pick up at a fire-sale price amid the general collapse of the fortunes of eminent Fascists after the war. But even this corsair's yacht shriveled when Shaw turned up. Flush with the proceeds of movie rights and best sellers, Shaw had directed a yard in Genoa, then the world center of nouveau-riche

yacht-building, to build him a dream boat. I do not remember the dimensions of this gin palace, but it had five or six cabins and was so long that it practically needed a hinge amidships to get into the cramped harbor of Porto Ercole. Maybe it wouldn't look all that impressive today alongside the Leviathans that are now routine among software billionaires, but this was 1965, and the sight of all its glittering mahogany, chrome, and classily rotating electronic doodads, not to mention its crew's white uniforms, was extraordinary, especially if you reflected that a writer had actually brought it all into existence with words, that he had framed and planked and triple-varnished it all with adverbs, nouns, prepositions, the things that were flitting unpaid around my writing room on Viale Caravaggio.

I liked Shaw, and he seemed to like me, so I proposed dinner in my little flat, whose dining room could (with a squeeze and a couple of borrowed chairs) accommodate Shaw, the Mooreheads, Alwyn, me and my current girl-friend, Adele, and an English painter. My kitchen wasn't commodious, but at least it could handle a big *spaghettata*, with fruit and mascarpone to follow. The table was narrow and the guests had to talk into one another's faces, but no matter. All was conviviality until dessert, when everyone was agreeably tipsy and Shaw began to hold forth on the subject of reviewers. It was a delicate matter, because he had been taking heat for a long time. All had been well between him and other writers until the fairy godmother of Hollywood touched him. He had been the bright boy, and in some people's eyes his *New Yorker* stories, like "The Girls in Their Summer Dresses" and the anti-Fascist "Sailor off the Bremen," marked him out as a likely heir to the mantle of the late Ernest Hemingway, who, despite the Pulitzer he won in 1953 with *The Old Man and the Sea*, and the Nobel Prize in 1954, had clearly descended into a vortex of booze and self-caricature—and had been doing so at an accelerating rate ever since his worst novel, *Across the River and into the Trees*, was published in 1950. But now the knives were out for Shaw as well. In the eyes of the New York literary crowd, of whom Shaw spoke with impassioned generalization, the success of *The Young Lions* and of the 1958 film based on it, starring Marlon Brando, Montgomery Clift, and Dean Martin, was simply intolerable.

But if his old pals on the left had turned against him, if success brings mainly enemies, then there were other people who wanted to bring him down as well. Paramount among them, a monster of right-wingery, was

Henry Luce, owner and dictator of Time Incorporated. Shaw launched into a description of Luce, making him sound like Machiavelli's description of Cesare Borgia, a personification of evil: *come il basilisco soavamente fischiando nella sua caverna,* like the basilisk softly whistling in its cave. And his wife, too, let us not forget Clare Booth Luce, that ball-cutting bitch with her bad plays and her Roman Catholic anti-Semitism. Both of them were bound to hate a left-wing Jew with affiliations to noble causes, like Shaw. So what did they do? asked Shaw, rising to his peroration. They ordered their flunkies, those anonymous creeps who shelter behind *Time*'s no-byline policy, to attack me every chance they get, any way they can. They want to destroy my sales and me along with them. They will not rest until I, Irwin Shaw, am a little mound of gefilte fish. But if I ever meet one of those Luce hacks, God help him. I will do *this* to him, and *that* to him, and . . .

There was a piercing shriek of metal on terrazzo: Alwyn Lee, who weighed perhaps 130 pounds to Shaw's 220, had pushed back his chair and now unfolded himself from it, rapidly and, it seemed, in jerky sections, like a galvanized stork.

"Well I'll tell yer, Irwin," he said in his best residual Australian drawl, hanging over the narrow table, "if yer going to do that yer better start now. Because I wrote the last review of you in *Time,* and the one before that. And Luce didn't have anything to do with them. I disliked yer books all on me own, and I still do. So if yer wanta come outside, come on."

He then turned and lurched magnificently out of the dining room and down the hall. We heard the front door slam. There was a pause, and then Shaw began to chortle. "I didn't think goddam Luce hired tough cocks like that," he said, and went in pursuit of Alwyn. Minutes passed; then there was a knocking at the door. I opened it and in came Irwin and Alwyn, their arms around one another's shoulders. "Ah, fuck it is what I say," said Shaw nobly, and they settled down to finish the small amount of whiskey I had left.

By way of recompense for dinner, he invited me and Adele out for lunch on his boat soon after. It was a heavenly day, one of the days that made Porto Ercole unforgettable, like a huge living postcard. After some fiddling around reversing out of dock without crushing any fishing wherries, we went steaming majestically out of Porto Ercole, past the breakwater, and headed for the Cala Grande, a spectacular high-cliffed inlet on the other side of the Argentario. Here, the captain anchored up and we were served beautifully

golden-fried chicken, salad, and Frascati in spiral-striped Venini decanters by white-gloved stewards, with the twisted volcanic rocks as a red background. "This is all a writer needs," Shaw declared expansively. "A bit of chicken, a glass of wine." He smiled, in a suspiciously overreaching manner, I thought, at Adele. I wanted to kill him. Worse, a week later, Adele disappeared on the boat with him on a voyage to Crete, with the transparent excuse of working as the ship's cook.

From a letter in November 1964 to my old buddy the Australian artist Donald Friend, who had just sold every drawing and painting in a show in Sydney, and on whom my little book was about to appear: "Now that you're so rich, why don't you come back to Italy? You are mad not to. To remain in Australia is a joke. Think of the Sydney suburbs. Then think of those Tuscan and Latian hill-towns, San Gimignano, Pitigliano, Viterbo, Manciano, and the rest. The conclusion is inescapable. I have hired a Fiat 600 and am making slowly widening excursions into the countryside . . ."

Gradually I was discovering the pleasures and esthetic delights of provincial Italy, of places that forty years ago were somewhat off the tourist map, or even completely so; of what was local and agrestic, as distinct from metropolitan and central. It was, for instance, one thing to admire the baldachino by Bernini in St. Peter's in Rome. Any package-tourist off a bus could do that. But it was (so I thought at the time) entirely another thing to visit the little church of Sts. Cornelius and Cyprian in the town of Calcata in the district of Orte e Gallese forty kilometers north of Rome, where one of the three rival foreskins of Jesus Christ was preserved in a reliquary. (Jesus was assumed bodily into Heaven after his glorious Resurrection, and the only part of his body to stay on earth, except presumably for the locks of his hair which from time to time had been shorn, was the tiny and ineffably sacred Holy Prepuce, snipped off by the High Priest of the Temple many years before when he was a baby.) I paid the priest ten thousand lire, the going price then, for a look at it. It resembled a small fingernail paring, and reposed under a glass dome on a tiny cushion of pink silk.

Roving the secondary roads in my sluggish and temperamental Fiat I came to love the country inland of the Argentario, that swath back of the coast known as the "moorland," the Maremma. Before the twentieth century,

not many people did like it. It was the wildest, the most primitive area of Italy north of Rome. Dante refers to it in the Inferno, though not flatteringly— *"Siena mi fè, disfecemi Maremma":* "Siena made me, Maremma undid me." For centuries, much of the coast had been malarial, and therefore half-abandoned, left to revert to low forest and scrubland: agriculturally poor, but rich in game, particularly in the wild goats and *cinghiali*, the giant wild boar with their impressive recurved tusks, that hid out in the scrub and sometimes emerged from it to devastate a vineyard in late summer, chomping up the grapes just as they were ripe enough for the *vendemmia*, or harvest. Enormous tracts of the Maremma were still uninhabited in the early 1960s, though of course this was beginning to change; today, there is not much of the "old" Maremma left. But in 1964 there was. It was strange, bony country, the predominant stone from which everything was made—sheds, houses, churches, retaining walls, cattle troughs—being a porous volcanic rock called *tufo*, which when newly out of the ground was soft and ocher-yellow but soon hardened and became a funereal black with blooms of dark red. In the spring, the tufa hills would light up for miles with *ginestra*, yellow broom. Sheep were grazed here, and from their milk pecorino, the local cheese, was made. They were managed by large, fluffy white Maremma sheepdogs, something like Pyreneans, fast and heavy-set and bred that way to keep away wolves. (The Mooreheads had a fine example of that breed, gentle as a lamb but surly if offended, which answered to the name of Nubia—cloud.) And when the plowing was not done by tractors (still a relative innovation which only the cooperatives could afford), the machinery was hauled by the white Maremma cattle, powerful and graceful beasts, bulky but at the same time ghostly, with wide-spreading horns. These noble creatures suited the archaic landscape and looked like the phantoms of a vanished way of farming, as indeed they were.

This had been Etruria, the country of the Etruscans, who inhabited and ruled this part of Italy from the eighth to the fourth century B.C. but were inexorably wiped out by the conquering Romans. Practically all the towns of central Italy had Etruscan foundations: not only Siena and Florence, but the smaller ones, too: Viterbo, Orvieto, Arezzo, Cortona, Grosseto, Volterra, all maintained a continuous history from Etruscan times forward. Others were simply frozen in time, becoming necropolises—tomb cities of the dead that might have a later village affixed to them, but were little more than archaeo-

logical sites. These included most of the cities of the once powerful Etruscan league—Vulci, Veii, Cerveteri, Tarquinia, Chiusi. Nearly all lay within a morning's drive of Porto Ercole.

It has often been noted that modern people are inclined to like the Etruscans in a way that they do not like either the ancient Romans or the ancient Greeks. The cultural and political achievements of ancient Hellas are, well, too Olympian, too grand and fundamental and irrefutable, and their exemplars still tower over us in a way that inspires more admiration than real fondness. Homer, Plato, Aristotle, Anaxagoras, Sophocles, Aeschylus, Ictinus . . . they were, in Bernard Knox's imperishable phrase, the oldest dead white European males. How could they possibly not seem remote, especially now that the once fundamental role of classical literature and philosophy as the basis of education survives only as orts and fragments? The paragons of Hellas had fallen from the temple frieze, and when you should consult them, as Louis MacNeice so movingly and wryly wrote in *Autumn Journal*, you thought instead

> *Of the crooks, the adventurers, the opportunists,*
> *The careless athletes and the fancy boys,*
> *The hair-splitters, the pedants, the hardboiled skeptics,*
> *And the Agora and the noise*
> *Of the demagogues and the quacks; and the women pouring*
> *Libations over graves,*
> *And the trimmers at Delphi and the dummies at Sparta and lastly*
> *I think of the slaves.*
> *And how one can imagine oneself among them,*
> *I do not know;*
> *It was all so unimaginably different,*
> *And all so long ago.*

The same was true of the ancient Romans, with the further disadvantage that they were imperialist bullies who loved pushing people around and, when the people didn't want to be pushed, putting them to the sword. *Tu, regere imperio populos, Romane, memento . . .*

But the Etruscans? Certainly you could have a soft spot for the Etruscans. One's Victorian forebears had made them out to be, if not villains, at least undesirables: think of Macauley's *Lays of Ancient Rome*, with brave Hora-

tius and his companions holding the bridge over the Tiber against the
oncoming hordes of Etruria:

> *Lars Porsena of Clusium*
> *By the Nine Gods he swore*
> *That the great house of Tarquin*
> *Would suffer wrong no more . . .*

But that was all that English schoolboys knew about the Etruscans, or
their general from Clusium (Chiusi), or their king Tarquinius Superbus. The
Etruscans had left behind no real literature, no poetry, no histories, no
tragedies, no comedies, only thousands of stereotyped inscriptions, mostly
funerary, scratched in black bucchero clay or cut in coarse rock. There was
no Etruscan Rosetta Stone, but from this fact arose the belief—prevalent
forty years ago, and still around today—that Etruscan, with its odd,
chicken-scratchy alphabet, was a "mystery language," a riddle. This gave it
glamour, a cachet with tourists and the public, but it is quite untrue. Actually,
as the archaeologist Massimo Pallottino observed a half century ago, in his
introduction to the 1957 edition of D. H. Lawrence's *Etruscan Places* (1927),
"We can . . . read with almost perfect understanding the overwhelming
majority of Etruscan inscriptions . . . I don't think there is any other field of
human knowledge in which there is such a daft cleavage between what has
been scientifically ascertained and the unshakeable beliefs of the public."
The main trouble with Etruscan writing is not that it can't be read, but that it
has little of interest to say. Unlike Greek or Latin, it therefore presents no
cultural challenge, which may be a reason for many people to like Etruscans:
they seem warm, innocent, and semiliterate. Best of all, they are (or at least
were) victims. It is politically correct to prefer the Etruscans, whom we see
harmlessly dancing, feasting, and wrestling on the walls of their tombs, to
all those trampling ranks of Roman clones. That was the decided opinion of
D. H. Lawrence, who wrote in *Etruscan Places* about how the Etruscan
Lucumo or High Priest would enter his village, "very noble in his chariot . . .
he was divine, sitting on the chair of his chariot in the stillness of power. The
people drew strength even from looking at him," and before long "the whole
place is eating, feasting, and as far as possible having a gay time. It is differ-
ent now. The drab peasants, muffled in ugly clothing . . . trail home, songless

and meaningless. We have lost the art of living . . . we are complete ignora-muses." Of course, Lawrence had no more idea of how Etrurians lived than you or I do, and his condescension to real peasants was limitless. But he had a fixed idea, as so many educated tourists did and still do: these were the Noble Savages of the Mediterranean, they were full of the Life Force that we have lost, they were Nietzscheans before Nietzsche was ever born. A fantasy, of course: but a durable one, whose continuation is largely due to a now seldom-read book.

Of all the Etruscan places I went to, one of the most evocative, strangely enough, had the fewest ancient artifacts in it: the Ponte dell'Abbadia, near the necropolis of Vulci in the region of Montalto di Castro. It is a narrow, single-span arch that crosses a deep gorge of the river Fiora, which was once part of the border between Tuscany and the Papal States of Latium. The bridge is barely wide enough to push a handcart across, and though very old (probably dating from the thirteenth century), it was certainly not made by the Etruscans. It is a romantic place. The Fiora, constricted into a narrow channel, boils over its rocks a hundred feet below. A strange pleated curtain of water-deposited limestone, a stalactite known as the *Fazzoletto del Diavolo* (the "Devil's Handkerchief"), hangs down the north side of the bridge, like a huge tumor. The far side of the bridge abuts a medieval fort, which for a long time served as a customshouse. Some decades ago it was made into a local museum, and it does contain some Etruscan pots and bronzes, none of them very fine; perhaps the most intriguing things in it, when I was there, were several dozen tools hung around the walls that had been confiscated from the *tombaroli* or grave robbers. These were long pointed iron spikes, with wooden T-handles. You pushed them into the ground and if they struck emptiness, you had possibly gone through the roof of a tomb below.

It may be that tombs and artifacts are still occasionally found around Vulci, but if they are it would seem a miracle: the place has been dug and dug again, sifted and combed over and over since the early 1800s, when Lucien Bonaparte, brother of Napoleon, took refuge in the Papal States and was given the title of Prince of Canino. Vulci was part of his land, and in 1828 huge finds of Etruscan material began to be made there. Greedily deter-mined to keep the market for antiquities high, Prince Lucien ordered his peasants and farm managers to keep and piece together every shard of

painted pottery that came out of the ground, which might be and sometimes was "Greek," with resale value, while destroying all the unpainted black-clay bucchero ware, which was Etruscan.

The quintessential Etruscan spot was Tarquinia, of course: the *paese* that used to be called Corneto, but was renamed in Mussolinian times to remind Italians of Rome's legendary Etruscan enemy King Tarquin the Proud. It lay a few miles back from the ancient Via Aurelia, the main road north from Rome to Grosseto and thus to Orbetello, the nearest mainland town to my crib in Porto Ercole. The painted Etruscan tombs which undermine the long hills behind the city of Tarquinia are justly famous. They only make up a small minority of the actual tombs behind Tarquinia; so far, about 5,700 of these underground chambers have been found and mapped, but only sixty-two of them have painted interiors—hardly more than one percent. Today they are almost completely inaccessible, for reasons of security and conservation; I am told that, even with the necessary *permessi* from the *Istituto delle Belle Arti*, you can't see more than three or four in a visit, and such permissions are not frequently given. I applaud this, but all the same I cannot find it in me to regret that in 1965 I got in with such ease. Some of the tombs didn't even have gates on them then; there was just a guard, a local boy whose job (slight as that was) consisted of keeping tourists, vandals, and otherwise unauthorized strangers from going undergound in a necropolis several square kilometers in extent. Having too much to do, he had nothing to do. So if you could find him and bribe him, there was nothing you could not see.

The painted tombs of Tarquinia, quite apart from those of other Etruscan sites in Italy, make up the biggest collection that exists of paintings from the ancient Mediterranean world. It's a curious paradox that we don't know the name of a single Etruscan painter, though their work exists in such profusion, whereas, though the names of various Greek painters—Zeuxis, Parrhasius, Polygnotus of Thasos—have come down to us, not one actual work by any of them has survived. The tomb paintings all have something in common: they were very quickly and sketchily done, in a primitive kind of fresco, the pigment brushed onto a layer of wet plaster laid over the smoothed tufa of the excavated space. The work had to go quickly because Etruscan funerary rites did not include mummification. Tombs would seem to have been commissioned after, not before, the death of their occupants; and so the designs emblematic of the dead person had to be applied, and the

chamber sealed, before his body rotted and made the air in the tomb unbreathable.

So the paintings are what you might expect: vigorous, often crude, sketchy, and full of emblems of life that counteract the fact of death. There are wrestlers and horsemen, high priests and foot-pounding dancers; women—courtesans, perhaps—stretched out on couches at a feast, and bacchantes whacking their drums. There are charming scenes of divers and fisherfolk, of startled ducks bursting into the air, and friezes of heraldic dolphins. One may see a few representations of demons and monsters, as in the Orcus tomb (c. 375 B.C.), but these are late, and the early tombs from the sixth century B.C. almost all depict an afterlife without dread or punishment, where the dead man can continue to enjoy himself after death much as he did before. There is even sex after death in the Tomb of the Bulls (c. 550 B.C.), in which one man, looking rather apprehensively over his shoulder, is seen with a large erection, about to sodomize another.

But you did not need to constantly visit the tombs in order to be aware of the presence of the Etruscans in "their" landscape. You couldn't drive down a country road without seeing caves in the cutting walls in its sides, the remains of long-abandoned tombs converted into toolsheds or chicken coops. Sarcophagi hewn from tufa were strewn everywhere in the fields, turned into cattle troughs. And sometimes the remains of Etruscan architecture were put to nobler uses. Thus a Romanesque church on a hill overlooking the village of Tuscania had a round rose window in the façade whose "spokes" were actually small columns of different-colored marbles with different designs of capital, all late Etruscan or very early Roman work, which had been dug up and recycled. I found this natural continuity enchanting, and loved to pass time in its nave, drinking in the silent, reverent, powdery light and admiring the Cosmatesque patterns of the floor mosaics, whose pinks, ochers, blacks, and gray-blues had all been dulled to a near-uniform putty color under years of ingrained dust but would spring to contrasting life if you spilt water on them.

Over time, in my tours around Etruria, in local restaurants and bars (invariably called the Bar Centrale, and furnished with one of those football games with little forwards and backs on axles, spinning to kick a dented white ball toward the opponent's goal), I got to know a small network of peasants and small-town dealers—fences and crooks in the official view.

These people had come to regard what lay buried in the earth as being as much their property as the land itself. The laws on buried antiquities were a joke to them. They knew that if they observed the strict law on Etruscan objects the finds would never be seen by the public because they were of no interest either to that public or to the officials who, however nominally, served its interests. They would just pile up in basements as more mediocre-to-average *antichita*, the stuff that not even local museums had shelf space to display but that low-level collectors and antiquarians were only too happy to buy. So they earned a partial living as *tombaroli*, working under the cloak of darkness in their own familiar fields. To them, this was as morally neutral an act as picking wild mushrooms, and sometimes I would go with them at night and be rewarded with souvenirs—hare-eared drinking cups of the matte-surfaced black bucchero ware, fragments of Greek red-figure pottery, and once a heavy bronze buckle, which I still possess. The owner of a bar in Tuscania made fake bronze gods, warriors, and other "Etruscan" goodies that were sold in the Porta Portese market in Rome and from there made their way up the food chain to wealthy collectors; the new bronzes, cast and hammered in a local garage, were laid in a shallow trench behind the bar and covered with straw. This served as a urinal for clients; human urine gave the metal a superficially convincing patina.

These mildly illicit adventures were enriched by more licit ones. Naturally I spent as much time as I could in Florence and in Rome, but today I wonder if it was not the experience of provincial Italy and of its landscapes that made the deepest and longest-lasting impression on me. Nothing (I was beginning to discover) is more true than the adage that much great art tends to be local, and this was to a spectacular degree true of central Italy. (Its reverse, the notion that all local art is great and "pure" and that "internationalism" is dangerous, is of course not true and was one of the defensive Australian prejudices I rejected.)

To the north lay the "Piero Triangle" or, as John Pope-Hennessy christened it, the "Piero della Francesca Trail," far more frequented by tourists today than it was in the sixties—the trio of Arezzo, Sansepolcro, and Monterchi, all within a few miles of one another, all containing masterpieces by the fifteenth-century Umbrian painter Piero della Francesca. Piero's greatest fresco cycle, narrating the "Legend of the True Cross," is in Arezzo. Two of his most powerful paintings, the Misericordia altarpiece and the fresco of the

Resurrection, are in Sansepolcro. But the picture of his I most often went to was in a small cemetery below the otherwise insignificant town of Monterchi: the fresco of the *Madonna del Parto,* or Pregnant Madonna. It is not certain why it was there. It has since been moved to Monterchi itself. An attractive theory proposes that Piero's mother came from Monterchi, which would help explain his choice of the uncommon image of the Madonna in mid-pregnancy: perhaps the picture is a votive image for the local cemetery in which, otherwise uncommemorated, his mother lies buried. But one cannot know. In any case, this fresco is all that was saved from a church called Santa Maria della Momentana, when most of its structure was demolished in 1785 to gain extra burial space for the cemetery. Fortunately—for Piero della Francesca was by no means the household name, the formalist demigod, he is today, and his reputation declined sharply after his death—it was thought worth saving the part of the church the Madonna was in. This may have been due to the great loyalty it had generated among the women of Monterchi, who saw it then as they still did two hundred years later: as an essential talisman of their own identity as mothers and their awe at the principle of fertility it glorified.

Would that have happened if the Pregnant Madonna had come down to them, and us, with the conventional attributes of glory, the gold leaf and elaborate costuming? Somehow I doubt it. The gravity and plainness are what make Piero's image so convincing, and seem to tie it to the ordinary life outside the church.

The Madonna stands upright within a sort of tent, a cloth tabernacle. Its flaps are held open to reveal her, by two angels—angels of annunciation, in effect. The angels are identical but reversed, done by flipping the original cartoon over so as to produce a mirror duplicate. The outside of the tent is painted as though embroidered with a design of formalized pomegranates, traditional symbols of fecundity. (The pomegranate also held an ancient pagan association with Proserpine, goddess of the underworld, through whose agency crops rose in the spring: on all levels, then, a suitable emblem for a rustic chapel.) As the tabernacle opens to disclose the Virgin, so her blue-gray dress, a conventional quattrocento pregnancy garment without decoration or embroidery, opens in the front to reveal a white shift; and behind that, by implication, the mother's body; and within that body, the womb, which is already prefigured by the tabernacle. Such intimations of

ancient cycles, of processes of death, growth, and rebirth that wind back to pre-Christian days, are of course part of the magic of Piero's paintings; another is the great *Resurrection* in Sansepolcro, whose austere Christ, holding the triumphant banner of the Cross and rising irresistibly out of the sarcophagus above the sleep-stricken guards, could be as old as Mithras.

Piero's most sustained work, without a doubt, is the cycle of frescoes *The Legend of the True Cross* in the church of San Francesco in Arezzo. It is based not on the Bible, but on an accumulation of silly tall tales and legendary writings dear to the Franciscan Order, and I doubt if one visitor in a thousand today would have more than the vaguest notion of what the story that unfolds before him in such rock-solid, Apollonian form and singing but muted color actually says. Certainly, I had no idea when I first saw it.

Very briefly, it tells of man's redemption through the wood of a tree from the Garden of Eden, which became Christ's Cross. Adam is dying. He sends his son Seth to the Garden of Eden to beg for some drops of oil from the Tree of Mercy. The Archangel Michael, guardian of Paradise, refuses to allow him the oil, but instead gives him a branch from the apple tree—the same one that had borne the Forbidden Fruit. When the branch fruited again (that is, bore the body of Christ) mankind would be redeemed. Seth plants the cutting on his father's grave. The site of the grave, as it happens, is Golgotha, where Christ will eventually be crucified. We move forward a couple of millennia; it is the time of Solomon, who is looking for timber from which to construct his temple. He chooses the sacred apple tree but, Proteus-like, it keeps changing shape, so that nothing can be made from it. Despairing of finding any structural use for the wood, King Solomon's architects throw it across a stream. And so it becomes a bridge. Enter the Queen of Sheba, who has come to Jerusalem with her retinue to pay her respects to Solomon. In a vision, she foresees that the wood of the bridge she has just crossed will become the cross on which the world's Savior will hang. She and her women kneel down to adore the bridge. Solomon is alarmed by their devotion and causes the wood to be buried, out of sight, out of mind. But it is not so easily got rid of. A miraculous pond forms above the burial place and the wood floats up—just in time to be made into the True Cross on which Jesus is sacrificed. Then, after the Crucifixion is over, the Cross is hidden again. Very few people know its hiding place. One is a Jew named Judas (not the same Judas who betrayed Christ); he is tortured by being kept in a well until he

reveals the whereabouts of the Cross but then, having expiated both his sin and his Jewishness by doing so, he goes on to become the Bishop of Jerusalem. Meanwhile, the Cross has become the emblem of renewal of the Roman empire in its Christian form. The Emperor Constantine, while dreaming in his tent at night, has a vision of the Cross: *In hoc signo vinces, By this sign you will conquer.* He declares for Christianity and utterly defeats the barbarians at the Battle of the Milvian Bridge. Then a Persian king, Chosroes, steals the True Cross and his Christian opponent Heraclius goes to war to get it back. Chosroes is defeated and Heraclius beheads him.

It was this confusing, ill-connected stew of legends that Piero della Francesca was expected by his Franciscan patrons to put together in a visual narrative on the walls of San Francesco in Arezzo. It had no biblical authority and was, for the most part, downright silly. For a twenty-first-century visitor, the plausibility or otherwise of the Cross legends is no longer an issue—nobody believes them anyway. What remains plausible, commanding, beautiful, and *true* is the paintings themselves: those nobly ordered, coherent emanations of Piero's eye and hand. So perhaps the early twentieth-century formalist critics, from Roger Fry through to Clement Greenberg, were actually right? Perhaps the story told by the painting didn't matter, and all you were entitled to judge was the painting itself, considered as an esthetic arrangement of color, shape, and line? But that certainly wasn't the way either Piero or his employers, or presumably their audience, saw it. No question, Piero was one of the supreme formal artists of all time. No question, either, that the story was essential to him. So why follow along with the modernist distrust of narrative, as though half the loaf were as good as the whole? This is so obvious a point, perhaps, that it is almost embarrassing to make. Yet I am fairly sure, as near as I can fix it, that it was in Arezzo, in front of those Pieros with their sometimes foolish stories, that the potential sanctimony of "pure" formalism was lifted from me completely for the first time, and I was never again to feel any twinge of embarrassment at wondering what the narrative of a work of art might be.

There was abundant landscape in Piero, and it led naturally into the even more abundant landscape outside. I loved its elements: the scrolling and recurving lines of vine terraces, the distant dot-dot-dot of the vines themselves, the dark space-forming clumps of evergreens, the exclamation points of cypresses. All that sweet calligraphy of wood, earth, and leaves! The

unsystematic way in which I was looking at art, grazing from museum to museum and church to church, made up for having no academic "qualifications," as the Americans say, as an art historian. Perhaps I would have done better to learn about the fifteenth century by listening to a professor and looking at slides in a classroom. But instead I was looking at the originals: out of sequence, certainly, but an immeasurably richer experience, especially when fortified by the sense of place that no classroom can give you—put briefly, what it feels like when you come away from, say, the murals of *The Legend of the True Cross* in Arezzo and, driving out of town, see the same fields cultivated, pruned, and shaped into the same immemorial forms.

One of the strangest and, in its way, most beautiful spots near the Argentario was the village of Saturnia, inland from the coast, not too far from the necropolis of Tarquinia. Unlike the latter, it had only minor archaeological interest then; some Etruscan stonework, a tomb or two (long since rifled) and a few Roman remains. It was a tiny, rundown place, its houses and primitive-looking church built from the time-blackened tufa and roofed with mossy terra-cotta pantiles. In the middle of its piazza was a coarsely detailed octagonal fountain. A curious whiff of sulfur hung over the place. It came from the hot springs downhill from the town. Less than a kilometer below Saturnia, an extraordinary landscape began. Steaming water, of a yellowish tinge and smelling intensely of sulfur, came gushing inexhaustibly from clefts in the tufa. It formed pools, then cascades, then more pools. None of these were deep; they were more like hot sitz baths. The women of Saturnia—always the women, through some immemorial agreement; I never saw a man there—would come to this place to bathe, especially in the cold of late autumn and winter. Nobody was young and pretty, and none wore anything resembling a modern bathing suit; instead, attired in dark cotton and sometimes even woolen shifts that enveloped them from their necks to their calves, they would descend with a certain agrestic majesty from ancient Fiats and waddle commandingly to this rural Pool of Bethesda, advance into the hot water, and calmly sink into it until only the upper halves of their bodies could be seen, like massive dark cones wreathed in steam. There they would remain quite immobile, like statues, like hillocks, these emanations of the Etruscan earth, sometimes chatting to one another in the thick harsh Maremman dialect that turns every "c" into an "h"—*"harẓa"* for *"casa,"* and so forth—until it was time to go home. Did they remind me of

anything in art? Perhaps, though only a little, of the big dropsical mammas of Picasso's so-called classical period. But they were far more strangely suited to the landscape, whose smaller details—the twigs on long-smothered bushes, for instance, whose thin branchings had long ago been thickened by the continuous deposit of gray stony sulfur—confirmed the stoutness of their bodies. Later, when I visited the Etruscan ruins and museum of Volterra, further north (another volcanic spot, whose name literally records the presence of earthquakes: *"voltare,"* to jump, and *"terra,"* earth) the crude and thickly proportioned figures of Venuses on the Etruscan ash chests would recall these women more intensely than any Picasso.

Saturnia was a sheep-grazing center, renowned for its production of pecorino, or sheep's-milk cheese. And so, every year in autumn, the village would stage a big *festa* in honor of this delicacy, which in that region of Italy is less a delicacy than a staple. The piazza would fill with battered vans, all laden with cheese, hams, olives, and other goodies. There would be big demijohns, encased with brown greasy wicker and filled with thick, green olive oil. The centerpiece and, so to speak, the hero of the day would be the *porchetta*, or roast suckling pig, spitted on a pole as thick as your wrist and roasted, slowly turning, over a charcoal fire until its hide was the beautiful, shiny chestnut brown of a polished boot. Its flesh would be melting, almost buttery and redolent of thyme. But the real subject of the event was the cheese itself, or rather, the cheeses. When pecorino is young it is soft and unctuous, almost as much so as mozzarella. But as it matures it grows harder and acquires a more complicated, layered flavor. One is therefore confronted with a vast range of choice, whose basic divisions are measured month by month: the *pecorino di trenta giorni*, a mere virgin as cheeses go, then the sixty-day, the ninety-day, the one-hundred-and-twenty-day *pecorini*. Beyond four months it becomes a grating cheese, but not a "mere" grating cheese; scraped out into those thin ribbons that melt so finely over steaming, hand-cut fettucini fresh from the caldron, and perhaps (if you are lucky) heightened with a razor-sliced spoonful of those white truffles found in the Apennine woods, "old" pecorino can be a considerable treat. And in those days, the *tartufi bianchi* themselves were neither as expensive as they are today, nor as hard to find. Once, in the autumn of 1966, I was walking across the main piazza in San Gimignano, after filling my eyes with the horrendous tortures inflicted on moneylenders, sodomites, and other unworthy souls in Taddeo

di Bartolo's fresco of Hell in its church, when I was accosted by an old and wrinkled man. He smelt wonderful, both earthy and heavenly. This, it turned out, was because of the paper bag he was clutching. It was half full of newly dug white truffles—about a pound of them, for which he wanted the absurdly low sum of about twenty-five dollars. This, allowing for gas, was all the money I had on me, but I was not going to bargain or palter. I paid him, stuffed the bag in the tiny glove box of the Mooreheads' Fiat 500, locked it and went off for a coffee. Several hours later, back in Porto Ercole, I could not open the glove box; its lock had stuck. Alan and Lucy were away, so I could not get their permission to force the lock. By the time it was finally opened, the truffles had gone bad in the heat but the glove box was frustratingly perfumed with rotten truffle for weeks, indeed months, to come.

One of the keys to my early Italian experience was Bomarzo, whose gardens, when I first visited them in 1964, were not on any map of Italian tourism. They are now—alas. The place brings its buses and its guides, honking inanities through bullhorns at their passive flocks. Those who go there today will never experience what it was like forty years ago. This is the unvarying complaint of the culture snob, but unfortunately it's true. The toxic combination that has wrecked so much experience of the past in Europe—the impacting together of mass tourism, local greed, and grossly insensitive "restoration"—has ruined the ruins, expelled the magic of the genius loci and turned what was once a marvel into a Disney parody of its former self. Sculptures were moved around, tracts cleared, axes shifted and—in a particularly dumb act of vandalism—the inscriptions on the stone figures and buildings of Bomarzo were arbitrarily filled in with orange paint, sometimes so inaccurately that their meaning was distorted or lost. It is now a sterile tourist mess.

I first read a brief mention of Bomarzo in an architectural magazine belonging to my sister Constance. This must have been in the late fifties. The weird Italian place with the Hell Mouth—what could it be? There was no detail, but it stuck with me. I knew a few people who had been to Italy, but not one of them had heard of Bomarzo. Over the years it worked its way up to the top of my list of priorities, such as it was, for Italy, if I ever got to Italy. So I got hold of a car in Porto Ercole (Alan Moorehead's spare one, the red

Fiat 500) and set off. It was not far from Viterbo, about sixty kilometers north of Rome.

The entrance to the garden lay below the beetling cliff of tufa from whose crest rises the hill town of Bomarzo (originally the small Roman settlement of Polimartium, "City of Mars"). It was a small rusty gate, through whose iron whorls nothing was visible except some dark clumps of oak and a little stone temple with portico and dome. This structure announced a descent, past a stone statue of triple-headed Cerberus, the guardian hound of Hell, baying beside the broken flight of steps; along a terrace lined with what looked at first like randomly scattered bombs, but turned out to be stone acorns six feet high, toppled from their pedestals; and toward a colossal nymph, whose skirt held a pool of rainwater. One passed barely decipherable inscriptions on every rock and lintel. Then, down more broken steps, was the second terrace, and a life-sized elephant crushing a Roman soldier with its trunk, watched by a silently roaring mask cut into the rock of the hill; one could walk through this mask's stone mouth, beneath the inscription *Ogni pensiero vola* ("Every worry flies away") cut in its upper lip, and eat one's mortadella sandwich on its tongue, which was in fact a stone banqueting table. Outside, farther on, a dragon reared up, its wings spotted with Islamic crescents, battling against two mastiffs. There were fountains, long since dried, their pipes blocked; a nymphaeum; a leaning tower, but *built* leaning, with the fireplaces in its small rooms plumbed straight by whimsical masons—so the path downward into Bomarzo's *Sacro Bosco*, its Sacred Wood, continued along washed-out tracks, under retaining walls that bulged outward and threatened to collapse at the next rain, past two stone colossi locked in a rending embrace, and on to a twenty-foot tortoise and the monstrous mouth of a whale just emerging from the tufa and clay. Bomarzo in late autumn, when I first went there, was a peculiarly silent place. No streams, no people, only the drip of water punctuated by occasional birdcalls; it seemed haunted, but by what chilly afternoon ghost?

This was beyond comparison the strangest garden in the West; not even Gaudí's Parc Güell in Barcelona held a candle to it. Inevitably, though it was not much visited by outsiders back in 1964, it had become a subject of much local legend. At midnight on a certain day in March, if you had the courage to wait on the steps that ascend to the *Bocca d'Inferno*—as the Bomarzese called the mask—its lips would writhe and speak, revealing the time and

place of your death. (I have to confess, rather to my shame, that I did not put this silly superstition to the proof. Would you? No, I thought not.) Fairies and worse were reputed to infest the Sacred Wood. But such fantasies aside, what could actually be said about this place?

At first not a lot, except that Bomarzo was in absolute contrast to the general, more formal trend of late Renaissance garden design. One of the supreme examples of that genre was only a few miles away—the Villa Lante near Viterbo, laid out and built by the architect Giacomo Barozzi, known as Il Vignola, for the bishop of Viterbo, Gian Francesco Gambara. Usually when I went to Bomarzo I would also visit the Villa Lante, because the contrast between them was so sharp and revealing. Lante is exquisitely formal, designed with perfect symmetry, with two identical pavilions—small palaces, actually—flanking a central axis of water. Water issues from a spring at the top of the long slope, and descends through a series of transformations: down a purling water race, into pools and tanks, out of fountains. At one point it rises into a long narrow trough, which is the center of an outdoor banqueting table. You follow its course downhill, through terraces and flights of steps, all symmetrically arranged. At last, in the parterre garden that finishes the site, it bursts with ravishing élan from a bronze star supported by four bronze Moors, possibly the work of the sculptor Giambologna.

Bomarzo had none of this order and pairing. Its images have individual meaning but they are scattered around. You wander from one "marvel" to the next. They go by like allegorical figures on floats in some sixteenth-century court masque, except that you move and they do not. The stones were naturally occurring outcrops of tufa, carved where they stood. The landscaping, the downward path, the sudden apparition of a sculpture at a bend or from an odd angle—all this built up a level of surprise and expectation *(what's coming next?)*. It always must have done so, even when the carvings were new, the woods not so overgrown, the shrubbery less rank.

Very little was known back then in the early 1960s about the man who created Bomarzo, and not much more has been found since. His nickname, "Vicino," meaning "neighbor" or perhaps "country cousin," suggested peripherality, though he came directly from one of the most powerful and richly documented clans in the history of Renaissance Italy. Pierfrancesco Orsini, duke of Montenero, Collepiccolo, and Castelvecchio, was born

sometime between 1512 and 1520; he died in 1585. He sprang from a notably ruthless line of robber barons, traceable back to the tenth century, whose heraldic animal was the *orsa* or she-bear. Vicino's father, a condottiere named Gian Corrado Orsini, acquired the valley of Bomarzo in 1502 and, because it commanded a wide strategic view of the Tiber valley, converted an existing fortress into the four-hundred-room castle that stands today, jammed into the cliff like a yellow labyrinthine tooth in its petrified gum.

There is no record that Vicino ever took part in the rapacious political life of the Orsinis. Nor is there any trace of what he looked like: nothing like a portrait or a statue.

One of the inscriptions in the *Sacro Bosco* reads "Vicino Orsini Fec. MDLII," so the scheme must have been started at least by 1552. Its construction would ramble on for another thirty years, ending with the duke's death in January 1585. In a letter of 1580, Vicino, heading into his sixties, confessed that he was tiring of the whole project. After he died, no one wanted to maintain the place and it began immediately to decay, to revert to forest and scrub. In the end, the *maraviglie*, or marvels, of Vicino Orsini's fantasy went unnoticed for three centuries. Not even Goethe, who went into raptures during his Italian travels over the much less interesting parade of carved grotesques at the Villa Palagonia in Sicily, was told about Bomarzo.

The Surrealists rediscovered it, halfway through the twentieth century. Trailing a squad of journalists and paparazzi, Salvador Dalí went there in the late 1940s and tried, fortunately without success, to buy two of the sculptures for his house in Cadaques. Bomarzo thus sidled into the Surrealist canon of strange and diabolically marvelous sights, with the unfortunate result that, until lately, most of the meager writing on it was by critics steeped in Surrealist ideas of fantasy. Here, wrote the French novelist André Pieyre de Mandiargues in 1957, was "a mad beauty," "a calculated aberration."

But actually, it was more like a fun park. Whatever else he may have been, Vicino Orsini was not a melancholic madman. He thought of his garden as a place of rest and amusement. *Anima quiescens silentior fit* (The soul grows more silent as it is calmed): so runs a Latin cartouche on Vicino's leaning tower. *Sol per sfogar il cor* (Just to unburden the heart), says another. And the place is full of stone jokes—huge, labored ones. Here is a stone tortoise, five times the size of anything on the as yet undiscovered Galápagos, creeping

with a pedestal on its back, and a sphere on the pedestal, and a battered figure with wind-streaming drapery on the sphere, its arms raised to hold a long-vanished trumpet to its worn-away lips. The figure is a common one in Renaissance allegory: *Fama*, reputation, or *Fortuna*, Lady Luck. Normally she is depicted as almost too swift to catch, riding the winds. But here she is lumbering along at tortoise pace, blowing her own trumpet: Vicino is ironically pointing out that his own reputation as a poet has come far too slowly, in a place where his works are extant only as hand-cut inscriptions on the boulders of his ancestral valley—an extreme case of vanity publishing.

They were aimed, not at a general public, but at a small sophisticated minority—in Vicino's case, apparently, a minority of one. The voice of the duke whispers continually through his garden, promising and demanding stupefaction:

> *He who passes through here*
> *Without raised eyebrows*
> *And a mouth agape*
> *Will be even less astonished*
> *By the seven wonders of the world.*
>
> *Reflect on this, part by part,*
> *You who enter here:*
> *Then tell me if so many marvels*
> *Were made by deception*
> *Or by art.*

The point being, of course, that *inganno* ("deception") and *arte* were so close as to be indistinguishable. The recluse of Bomarzo had produced a literally incomparable work of art, "The Sacred Wood / which resembles only itself and nothing else." Others, inevitably, had had hands in it. Bartolommeo Ammannati, Pirro Ligorio, and Giacomo da Vignola are among the architects whose names have been guessed at; but there is no agreement about what is by whom. The sculptors' names are lost, and probably they were not "name" sculptors anyway. Even allowing that they were working in tufa, a stone not amenable to fine effects, the detail is too coarse, the forms too clunky.

The Mannerist patron marveled, not at the action of the unconscious (as in Surrealism) but at consciously deployed skill. Vicino was very much a dilettante, and in his time it would not have been possible to be one for long without coming across one of the most admired books of the sixteenth century, the *Hypnerotomachia Poliphili* or "Love, Dream, and Battle of Poliphilo," believed to have been written by a Venetian monk named Francesco Colonna and published in 1499. The *Hypnerotomachia,* a long, windy, and almost impenetrable allegory, was widely read—or at least, widely owned—by humanists and scholars in Italy, France, and England. It tells of a man who, in search of his ideal lover, Polia, begins in a trackless and frightening wood, emerges from it parched with thirst, falls asleep, passes through successive layers of dreaming, and awakens in an ideal garden landscape strewn with peculiar monuments and the ruins of antique temples. He has come to the fairy realm of Queen Euleuterilda, where Polia at last appears to him in the guise of a nymph, and they are blissfully united. In some ways the *Hypnerotomachia,* being an allegory of the descent, purification, and rebirth of consciousness, resembled other medieval and Renaissance literary monuments.

It was liberally sprinkled with woodcuts, plate after plate showing the ruins, statues, masques, inscriptions, and processions that Poliphilo is always running into. There are more than two hundred inscriptions, of stupefying length and prolixity, "recorded" from graves in a cemetery which he and Polia visit.

These plates in the *Hypnerotomachia* had an immense influence on the way people thought about gardens in the sixteenth and seventeenth centuries, and they inspired some real monuments of the time—Bernini's elephant in Piazza Colonna in Rome, for instance, derives from a woodcut in the *Hypnerotomachia.* Colonna's work is one source of the artificial ruin as garden architecture, which became a cult in eighteenth-century gardens. It seems likely that Vicino Orsini consulted this book while designing his valley at Bomarzo. The valley became a text, copiously inscribed with references to dreams, spirits, and initiation by amazement. And there are many similarities between the book's woodcuts and the duke's designs. The stone siren in the valley is the exact sister, except in size, of a picture in the *Hypnerotomachia.* Even the profusion of texts and mottoes carved on Bomarzo's rocks reminds one

of the inscriptions with which Poliphilo's dreamland is dotted. They mark points in the story just as Vicino's inscriptions stop you in the garden.

But it would narrow Vicino's fantasies to try to find them all in one book. Some Bomarzo sculptures could have come from a dozen written sources. Others are clearly historical: the elephant with its war howdah, crushing a Roman soldier, obviously refers to a victory won by Hannibal not far from this valley. The dragon with crescents on its wings may allude to the defeat of the Turks at Lepanto. But we will never entirely decipher this garden, not now, and perhaps—due to the abusive "restorations" it has suffered—not ever. Those who knew it in better days think so fondly of it; I particularly cherish the memory of a May day in 1967 when I went there with a newly acquired American girlfriend (who of course had seen nothing like it); we smoked some pot together, drank some of the local white wine, spread a rug on the banqueting table inside the *Bocca d'Inferno,* and unmolested by gardener or ticket-taker wriggled out of our jeans and made love in the thrush-punctuated silence of that warm spring morning. *Ogni pensiero vola;* and it really did, in a delicious, carefree haze surrounded by benign spirits of the wood.

Nobody could say that those who designed and carved the "monster-park" at Bomarzo were great artists. But it was at this stage of my life that I began to get some firsthand idea of what great sculpture could be. It may seem ridiculous that this awareness took so long to dawn. But it only comes about from discoveries you feel you have made for yourself. Sometimes a great work of art can be so monotonously praised that out of sheer obstinacy, not to say perversity, you resist it. It can even verge on the comic, as my sight of Michelangelo's *Pietà* at the World's Fair did. It doesn't matter how often, or insistently, you are told that an artist is great: unless you experience it for yourself the term will never mean anything to you, it will just be someone else's clanking superlative. Your only course is to come back later. And even then the promised experience may not arrive. The arch example, for me, would be the work of Paul Cézanne, whom everyone considers to be the absolute god of modern painting, the initiator and forefather. The fact that, apart from critics and art historians, so many artists whose work I admire have thought so makes me feel, with respect to Cézanne, rather an outsider. For, to be honest about it, Cézanne's work (except for some of his water-colors and certain landscapes and still lifes) has never awoken any real rap-

ture in me, and his big awkward figure compositions of nudes, which others consider the summit of his achievement and do not hesitate to compare to the work of Michelangelo, Poussin, and any number of other masters, leave me quite cold and unconvinced. Not all "masterpieces" are necessarily masterpieces for everyone, and if they were, taste would remain static down the centuries, which fortunately it does not.

I was unused to sculpture. Australia has never produced anything that, even with the most patriotic intentions, you could call "great" sculpture. Neither of its cultures, neither the black nor the white, created much in solid form that was even memorable, although a few artists of European descent, principally Rayner Hoff in the 1920s and Robert Klippel in the 1960s, did fine things.

Thus the possibilities of sculpture were essentially unknown to me until I reached Italy, and if there was one single artist who opened my eyes to them he was an earlier and much lesser-known figure than Michelangelo or Donatello. He was the thirteenth-century Pisan artist Giovanni Pisano (c. 1250–c. 1319), who had worked in several parts of Central Italy (Pistoia and Perugia, Pisa, Siena), and about whose life—beyond the fact that his father, Nicola Pisano (c. 1220–c. 1284), was also an exceptional sculptor, who sometimes, as was the custom, brought his gifted son in to work on family commissions—little is known. There are no letters from Giovanni Pisano; only a few unrevealing documents exist concerning him, and the partial records of an unpleasant lawsuit. But this is the common fate of medieval artists, and it is of course what gave rise to the pious but ridiculous legends of "holy anonymity" among them—the notion that painters and sculptors gave up their very names so as to submerge themselves in a God-fixated collectivity. Giovanni Pisano did not suffer from such false humility. *"Sculpsit Johannes,"* runs the inscription on one of his masterpieces, the pulpit for the church of St. Andrea, in Pistoia: "Giovanni carved it, who created no empty works. Born of Nicola, but blessed with greater knowledge, Pisa gave him birth and gave him knowledge of all things visible."

An empty boast? No, more like a statement of plain fact. The father, Nicola Pisano, has usually been credited with creating the emotional fullness and human intensity of Renaissance sculpture by integrating the roundness and apparent depth of classical Roman sarcophagus reliefs with the stiff, hieratic dignity of Byzantine figures, the *maniera greca,* as it was confusingly

called, of early Romanesque. Yet even at his most intense—and some of Nicola's works, like the dense, convulsed masses of bodies thrust down by angels and carried off by grimacing fiends in his pulpit relief of the Last Judgment in Siena Cathedral, have an intensity almost without precedent in carved sculpture—they do not have the awesome humanity of his son's best work.

This was brought home to me on early visits, during the winter of 1964 and '65, to the Cathedral Museum in Siena. In this building were (and still are) housed the carvings of prophets and sibyls that Giovanni Pisano had made for the façade of the cathedral in the decade after 1287. There is no way of recapturing their original arrangement, which treated the tall striped façade of the cathedral as a stage on which fourteen heroic figures, the inspired prophets of the Old Testament and the trance-seized women of classical antiquity, discourse to one another and to the world below, announcing their revelations—each confirmed by a biblical text on the scroll that he or she is grasping. In the Middle Ages it was believed that awareness of the coming birth of the Savior was prefigured not only by some Old Testament prophets (Isaiah, Habakkuk, Moses, Simeon, and others) but actually disclosed in pagan antiquity by the sibyls of Cumae, Erythrea, Delphi, and elsewhere. So what Giovanni Pisano proposed in this assembly of twisting, gesticulating figures was a kind of *sacra conversazione,* frozen in stone: a "holy conversation" about the arrival of the world's savior, through the agency of his mother, patroness of Siena and of all its citizens. And we are meant to know what the figures are saying. What Giovanni put on the façade of the cathedral, I came to realize, was one of the ancestors of the comic strip—an august, eloquent, and grand ancestor. Each of the figures holds a scroll, and on each scroll is incised a text which the figure is "uttering" as prophecy of the coming Savior. Thus Isaiah's scroll reads *Ecce Virgo concipiet et pariet filium,* "Behold a virgin will conceive and bring forth a son."

In terms of sheer effort, this was a project on the scale of Michelangelo's future (and never to be completed) papal tombs. Of course, one could not see them as they were meant to be seen, from far below; but the advantages of having them on one's own eyeline are very great, because one is in some ways better placed to appreciate the drama and subtlety of Giovanni's work.

Its marble was not from Carrara. It was the softer, more open-pored and

vulnerable stone from a quarry at San Giuliano, near Pisa, and over the centuries before the figures were taken down from the façade it had eroded and spalled from wind and weather. Henry Moore, who was greatly inspired by Giovanni Pisano's work and whom I was lucky enough to meet, with the English artist Michael Ayrton, when we were all in Siena at the same time in 1965, didn't even think this weathering was such a disadvantage. "I even think the weathering reveals the big, simple design of his forms more clearly," he wrote. "It probably reduces what we see to what it had been a stage before it was finished, simplifying it back again without the detail."

Whether this is true or not—and I think it is—this softness of the San Giuliano stone had a countervailing advantage. It made the blocks easier to cut, especially when the stone was "green"—newly quarried from the earth. With exposure to air, it would harden up. But the fresh blocks in the cathedral stoneyard enabled Giovanni to go deeper into them, and faster, with the tools available to him—the steel chisels of an age before carbide tips. The easier it becomes to remove stone, the quicker the figure within can be revealed—and the more dramatic its postures and gestures. Giovanni's prophets and sibyls are not content to stay on the face of the building: they lean out, twisting and pointing, shouting at one another in stony arguments that are now forever stilled. The animation of his prophets, one might say, is prophetic in itself: it predicts a kind of sculpture that did not yet exist, that had not been imagined.

And there was something else about the look of these figures, which could hardly have been seen from the ground but was very apparent close up. It was Giovanni Pisano's use of the drill. All stone-carvers had drills, including Giovanni's father, Nicola. But Giovanni used his drill—a pointed steel rod, twirled with a bow—in his own peculiar way. He liked to bore into the stone to create dots of shadow, or connect the dots to produce undercut lines. This gave the forms an especially crisp and vigorous "drawing," an emphasis that chisel strokes alone did not produce.

What all this achieved was an expressiveness beyond anything I had seen in sculpture before. The lazy adjective for this expressiveness might be "dazzling," but actually it was the very opposite of dazzle. It did not blur or seduce one's sight, did not call the factual truth of one's gaze into any kind of question. It seemed to make you see, and therefore feel, more vividly. Stone was stone; rough surfaces were rough surfaces; substance, substantial—and

gray heavy stuff at that. Almost any one of the figures from the Siena façade shows this quality. The most extreme of them is the prophet Balaam, whose ruinous mouth gapes in such tragic, eloquent grief. The most beautiful, to my mind, is the outward-leaning figure of a cowled woman which has been read variously as Mary or as Miriam, the mother of the prophet Moses, or as an unnamed sibyl. Her face is bony and taut; it expresses both gravity and fierce urgency, as though what she is saying *had* to be uttered.

If Giovanni Pisano's creations were the most beautiful and eloquent sculpture in Siena, there could be little doubt whose the greatest painting was; and it was in the very same building. It was the enormous double-sided altarpiece, some five meters square, commissioned for the cathedral from Duccio di Buoninsegna shortly after 1300, in praise of the Virgin Mary. It is known as the *Maestà*, which meant simply "majesty." It replaced an earlier altarpiece, the *Madonna del voto* ("Madonna of the Vow") by Guido da Siena, which in turn had displaced an effigy of the Virgin long considered almost miracle-working, the *Madonna degli Occhi Grossi* (the "Big-Eyed Madonna"). When it was finished, signed, and carried in state to the cathedral on June 9, 1311, the whole city (said a fourteenth-century Sienese chronicler) turned out for the event:

> The shops were locked up and the Bishop ordered a great and devout company of priests and brothers with a solemn procession, accompanied by the Signori of the Nine and all the officials of the Commune, and all the populace and all the most worthy were in order next to the said panel with lights lit in their hands, and then behind were women and children with much devotion, and they accompanied it right to the Duomo making procession around the Campo, as was the custom, sounding all the bells in glory out of devotion for such a noble panel as was this.

Giovanni Pisano was in the last decade of his life when Duccio was celebrated in this way, and it would be hard to find two more dissimilar talents. Giovanni, though earlier than Duccio, still looks more "modern" to us: craggy, tragic, and filled with extreme images of suffering. (As one example among many, think of the eyes of the anguished mothers in Giovanni's *Massacre of the Innocents* on the pulpit in St. Andrea in Pistoia: these drawn-in brows, squinching the whole eye socket into a triangular shape, may have

come out of Giotto's facial signs for unbearable grief but we also know them from Picasso's *Weeping Women,* six centuries later.) And every figure in his sculptural reliefs, true to their origins in the flat-paneled sides of ancient Roman sarcophagi, is pressed up against its neighbor—but one reacts to the other, the whole picture is a narrative of crowding and response, nobody has the option of detachment, of not-feeling. Whereas the groups and crowds in Duccio's panels on the *Maestà* are more erect, apart, and dignified, whatever their physical propinquity. It is one of those works without which the artist who made them can hardly be imagined, still less understood: the only signed and documented work by Duccio, his largest and most complex. MATER SCA DEI SIS CAUSA SENIS RELIQUIE SIS DUCIO VITA TE QUIA PINXIT ITA, runs the inscription on its base: "Holy Mother of God, be thou the cause of peace for Siena and of life to Duccio because he painted you thus."

The *Maestà* is a pictorial summing-up of the lives of Christ and his Mother, and it commemorates the gigantic role which the ritual honoring of the Virgin played in the life—political as well as religious—of Siena. The Sienese believed that they had particular privileges from Mary, the mother of Jesus. She safeguarded the city from its enemies, notably the detested Florentines, those "iniquitous and evil dogs," as a thirteenth-century chronicler called them. Her cult was linked to an intense civic ideology. You could almost say that, since the victory of the Sienese over their enemies in the battle of Montaperti in the thirteenth century, there was no such thing as an apolitical picture of the Virgin Mary. The politics, of course, have long since been lost to us; what remains is the residue, the thing itself, Duccio's majestic image of the Mother of God surrounded by the ranks of his saints, all focused in adoration of her. And something more than adoration: petition. They are all there for a purpose, to ask for her intercession. On whose behalf? Manifestly, on that of the citizens of Siena.

The result is a quite staggeringly complicated and ambitious painting, which sweeps together the Virgin and "her" saints and promoters on one side, and on the other a complete narrative of the doings, Passion, Crucifixion, and Resurrection of her son Jesus of Nazareth, into one sequential image. Duccio could not have painted every one of the events and figures in it, because he must have had assistants to get this enormous work finished in contract time. But he must have kept an iron hand over them, because the style is absolutely consistent throughout. Duccio maintained an unwavering

hierarchy of forms, starting with the immense, inlaid, architectural (and, one might think, stonily uncomfortable) throne on which Mary sits at the center. No extreme gesture, no vehement facial expression is allowed to disrupt the general narrative calm; even Mary in the Crucifixion scene on the back swoons with extraordinary grace at the sight of her tormented son, the wriggle and wave of the gold hem on her dark-blue robe suggesting the collapse of her suddenly limp musculature under gravity as she faints in sorrow. Duccio, with his reds and lilacs, blues, ochers, and pale greens, was not only a great colorist. He was an extraordinary linear painter—an ancestor of the much later, and culturally much removed, Florentine Botticelli. Byzantine mosaics, out of which the formal stylization of Sienese art is often said to have evolved, were also linear in their essence. And yet, face by face, gesture by gesture, Duccio's groups have none of the stereotyping and stiffness that comes with Byzantine art. All of them, from the Sienese patron saints Crescentius, Ansanus, Savinus, and Victor lined up by Mary on the front of the enormous altarpiece, down to the last donkey and hod carrier on the back, are given their share of individuality. The Queen of Heaven, we are shown, presides equally over all men, and all women too.

On visits to the Museo dell'Opere del Duomo—one must remember that, in the mid-sixties and out of high tourist season, one usually had the place to oneself—I would stand before the *Maestà* and inwardly recite the lines from W. B. Yeats's "Sailing to Byzantium":

> *O sages standing in God's holy fire*
> *As in the gold mosaic of a wall,*
> *Come from the holy fire, perne in a gyre,*
> *And be the singing-masters of my soul.*
> *Consume my heart away; sick with desire*
> *And fastened to a dying animal*
> *It knows not what it is; and gather me*
> *Into the artifice of eternity.*
>
> *Once out of nature I shall never take*
> *My bodily form from any natural thing,*
> *But such a form as Grecian goldsmiths make*
> *From hammered gold, and gold enamelling*
> *To keep a drowsy Emperor awake;*

Or set upon a golden bough to sing
To lords and ladies of Byzantium
Of what is past, or passing, or to come.

At such moments—and there were not a few of them—tears would roll down my face. It would have seemed like deception to hold them back. This had never happened to me in church, during a ritual or a sermon; it had not occurred in the theater, or even in the cinema. Art, I now realized, was the symbolic discourse that truly reached into me—though the art I had seen and come to know in Australia had only done this intermittently and weakly. It wasn't a question of confusing art with religion, or trying to make a religion out of art. As some people are tone-deaf, I was religion-deaf, and in fact I would have thought it a misuse, even a debasement, of a work of art to turn it into a mere ancillary, a signpost to some imagined, hoped-for, but illusory experience of God. But I was beginning, at last, to derive from art, from architecture, and even from the beauty of organized landscape a sense of transcendence that organized religion had offered me—but that I had never received.

The English Puritans, seeing Catholic shrines and cathedrals filled with devotional images—the rood screens with sculptures, the rich visual narrative of their stained glass—had tried to smash, deface, render illegible every representation of the body they could touch. In this way, they believed, the sin of idolatry would be rooted out of the world; and they forged ahead with their program of purification, to the immense detriment of England's visual culture. Christian oscillation between iconoclasts (image-wreckers) and iconodules (image-users) had been almost as old as Christianity itself. It had deep historical foundations because it was grounded in the faith's two opposed roots, Hebraic monotheism and Hellenistic humanism. Greece might swarm with gods and their representations, but from the fundamentalist Hebraic point of view there was only one God, unnamable and unpaintable. The sole true representation of God would be the Eucharist itself. A visual image could only lie about His nature. This was an extremely powerful belief and it had a long life, if a controversial one, in the West, even in Italy, the special home of human images of the divine. To see how close to the surface of collective anxiety it lay you need only look at the complete exclusion of pictures or sculptures of God and the saints from the great abbey churches raised by

the Benedictines of the Cistercian order in the twelfth century, or consider the success of the fifteenth-century Dominican priest Girolamo Savonarola in persuading the citizens of Florence to throw their religious art along with their profane and licentious books on the bonfires. That Savonarola's teachings could produce such crises of conscience in artists like Botticelli and Michelangelo, causing one to burn his works in public and the other to mutilate one of his sculptures, the Rondanini *Pietà*, argues that a deep uncertainty about the aims of sacred art existed even in the minds of some of its greatest practitioners. In any case, an artist's actual religious beliefs—assuming he had any—have never been an issue in the creation of devotional art.

Catholic theologians maintained—though to little avail—that sacred images in church had nothing to do with idolatry. One did not worship the image itself, or pray "to" this or that icon. Instead one prayed "through" it, to the transcendent reality beyond. Increasingly, however, I was convinced that there was no such reality—that only the icon counted and was real. The more great religious art I saw, the more sense this made to me. And so these years in central Italy were largely responsible for reintegrating me: for turning me from an acutely guilt-ridden young ex-Catholic, haunted by his inadequacies in the eyes of a strongly Catholic family and under the gaze of his father's ghost, into a relatively guilt-free agnostic, more at ease in the world and filled with delight at what its human and inanimate contents could mean, say, and create.

But there was still a problem. I was not a fully functioning writer—not yet. My Italian sojourn was teaching me a lot, but I still had to get serious about making a living. Moorehead saw this very clearly. He saw, and pointed out to me, that anyone of talent could talk away the substance of a book in a few days. I was in danger of slipping into an epicurean existence. Or, to put it more coarsely and realistically, of becoming an esthetic barfly. Living for beauty was all very well, but it wasn't going to put any spinach on the plate, let alone any butter on the spinach. In two years I had laid up a lot of honey in my comb, but I had actually written and published very little—and I was not likely to do more, leading a solitary existence in a culture whose language I didn't write or think in. "You admire Cyril Connolly," he said to me bluntly over the pasta one night. "So do I—who wouldn't? But how long is it since he published a solid book? Is that what you want? To try and live like

a writer who has a private income, when you don't have one?" A thin fissure of fear opened in my future. It was true: I hadn't come all this way to be clubbed down in my tracks by one of the various Enemies of Promise. Just as Alan had shown me when to leave Australia, now he was showing me that I must leave Italy. Not forever, perhaps, but certainly just for now. And so I stashed my meager possessions—papers, a few boxes of books, some Etruscan pots—in the Moorehead basement, bought myself a one-way coach-class ticket from Fiumicino to London, and left.

Joys of Radical Love

Rather to my surprise, I had little difficulty fitting into London and getting work there. I found a rented room in Belgravia with a telephone and use of the kitchen, and began hunting. I started by contributing to the *Sunday Times,* whose cultural editor, Jack Lambert, liked my work and allowed me to fill in for its regular art critic John Russell when he was away on his trips to Europe and America. Then, through the contacts Alan Moorehead had given to me, I was able to sell longer articles to John Anstey, the editor of the *Sunday Telegraph*'s color magazine. Anstey had the excellent sense not to use me just as an art writer.

He sent me on eccentric assignments, sometimes of a religious flavor. Once he dispatched me to do a story on Christmas in Bethlehem. Next, it was the cult of relics in Italy, including, of course, the various rival Holy Foreskins, and not forgetting a long, graceful, red tail feather from a South American macaw, which was solemnly exhibited as a feather from the wing of the Archangel Gabriel in an annex to the sacristy of a church on the side of the Tiber, sharing a glass case with a number of missals whose covers bore charred fingerprints; they had been gripped, a *cartellino* assured the visitor, by the red-hot fingers of repentant souls who manifested themselves from the pit of Purgatory during High Mass.

Shortly after that, he sent me to Lourdes. In my Catholic boyhood, I had of course heard of Lourdes. It was where the Virgin Mary had miraculously appeared to the peasant girl Bernadette Soubirous (as in the movie *Song of Bernadette*) near her home in a valley of the French Pyrenees, and caused a spring with healing powers to gush from a nearby rock. When I arrived in

Lourdes, and settled into a room in the Grand Hôtel de la Grotte, my obvious first stop was this miraculous site, and I soon realized that the miracle was not the appearance of the water, but the fact that there was only one miraculous fount and not twenty or a hundred. The sides of the valley through which the Gave de Pan ran were all sloping ledges of limestone, dripping abundantly with nonmiraculous runoff water from the Pyrenean slopes above. The whole area was as porous as a sponge, but just in case of emergency the Catholic Church, or perhaps the municipality of Lourdes, had installed a concealed pumping station, painted camouflage green and well screened by conifers, on the slope above the entrance to the sacred cave.

Every morning at six, rain or shine, a line of the sick and the crippled (who arrived en masse by train, coach, and car) would begin to form on the pavement outside the grotto. A low hum of Hail Marys, sounding like an immense swarm of bees, would ascend from the gathering throng. Sometimes, but rarely, there would be a shaking and thrashing inside one of the mackintosh-canopied bath chairs; a *grand malade*, believing that the Virgin had interceded for him, was trying to stand up. *Je suis guéri!* a voice would cry. But then, the person would crumple anticlimactically to the pavement, uncured, and be lifted back into his or her chair. It happened often enough to be a familiar sight, though no one seemed discouraged by it.

I stood in line, determined to experience the miraculous immersion in the Virgin's water. One shed all one's garments except, for decency, one's BVDs. The line crept forward toward the bath, which was a smallish rectangular cavity in the floor, about four feet by three. Its water was dark and had what looked like an iridescent streak on top—whether this was antiseptic or something worse I could not tell, but the man in front of me, I now queasily observed, had an unhealed and apparently suppurating fistula on one of his thighs. Too late to chicken out now. At the bath's edge I was grabbed on both sides by a pair of muscular *brancardiers*, the indispensable stretcher-bearers of Lourdes. Unceremoniously they lifted me up and plonked me in the water. It was near freezing; the shock blew all the breath out of me. They lifted me up and set me on my trembling legs on a patch of tiles. No showers or towels were provided; the holy water must dry on you to be genuinely efficacious. Shaking like aspic in my cold wet jeans, I made my way back to the Grand Hôtel de la Grotte and stood for half an hour under a near-boiling shower. But I should record that the slight case of sniffles I had on

arrival in Lourdes was gone the next day, so perhaps there was something to the *bain-marie* after all. Later, I stopped at a souvenir stall which sold plastic bottles in the form of the Virgin Mary; her crown unscrewed so that you could fill her with the *veritable eau de Lourdes,* and she came in quarter-liter, half-liter, and jumbo one-liter sizes. And for those who did not fancy risking Virgins full of water in their luggage, there were the *pastilles à l'eau de Lourdes,* sweetish white pills that, a brochure declared, had been condensed and distilled from the water of the Grotto and needed only to be dissolved in your local tap water to turn it into the true, thaumaturgic liquid.

Perhaps the best comment I heard on this theme park of religious mumbo jumbo came from an Irishman I met one day, on line at the Grotto. He was a quadruple amputee—I forget what had been the cause of his catastrophic accident, though he told me—and he reposed in a large wicker basket on wheels, with his head sticking out one end, not unlike a claret bottle. A green blanket, embroidered with a gold harp, was drawn over him, and his basket was pushed by one of his brothers. This, he told me, was his ninth visit to Lourdes; he came every year and had every intention of keeping up his visits. Eventually, with some hesitation, I got around to what seemed to me the crux of the situation. Did he really think the intercession of the Virgin was going make one or more of his lost limbs sprout again? He looked at me as though I were mad. "What sort of a fool d'you take me for?" he said sharply. "I come here because I like to be with me own class of people." It was the one completely logical explanation of Lourdes that I had heard, then or since.

In 1966 I wrote, for the *Sunday Times,* the first review that I can reread with pleasure, as though it were someone else's work. It was of a retrospective show of the work of Pierre Bonnard, at the Royal Academy. Until then I had not looked at Bonnard much and had lazily assumed, like many and, indeed, most people, that he was what the French condescendingly call a *petit-maître,* not a "major" artist like Picasso or Matisse: too domestic in subject matter, too intimate in scale, too lacking in public command. "It's not painting, what he does," Picasso had said to Françoise Gilot, who had faithfully recorded this arrogant stupidity; and in 1947, less than twenty years before, the most influential French art magazine, *Cahiers d'Art*—which never dared publish anything that might have met with the disapproval of Picasso and his circle—greeted the death of Bonnard at the age of seventy-

nine with the ferocious judgment that the esteem for Bonnard "is shared only by people who know nothing about the grave difficulties of art and cling above all to what is facile and agreeable." After two days' looking at the Academy's magnificent show I realized that this was nothing but rhetorical poppycock. It came from the notion, favored, I suppose, by Marxist intellectuals of a certain cast of mind, that art which strives to give and to record pleasure, on no matter how complex and nuanced a level of recollection, *must* be superficial in and of itself; that the sensuous *must* be of a lower order than the intellectual. I have never been able to agree with this fatuously categorical judgment, and it was the Bonnard show that really brought my objections into the foreground. In Australia I had seen one Bonnard only, but it was the early *Siesta* (1900), that golden nude of Marie Boursin lying face-down on the couch, which Kenneth Clark had bought for the National Gallery of Victoria and which was the best modern French painting in its collection; now it was possible to revel in the expanded and more lyrical palette of the later studies of his pathologically shy wife in the bath, floating like some wonderful sea growth, drowning in light. Bonnard had never been influenced, or even touched, by Cubism. But in its extraordinarily free and expressive color his work went far beyond Impressionism, too; in fact, it seemed quite unclassifiable in terms of the art-history "isms," a wonderfully original set of utterances worked out with fanatical modesty. This alone, I thought, entitled him to be put right up there as one of the twentieth century's greatest painters. Twenty years later, this estimate of Bonnard would be a commonplace; but I am still glad that I trusted my reactions back in 1966.

So, with freelancing I was able to scrape along in London, and my forays into art criticism became more frequent. I did not have a job, but that didn't matter; I had never had one.

I saw very little of the so-called Australian community in London. Few of them had been my friends, or even acquaintances, in Sydney, and I certainly hadn't come all this way to meet fresh Australians. Now and again I would have lunch with Clive James, my old friend from Sydney University days, when he was down from Cambridge; Clive at that time was completely absorbed in Cambridge and its particular systems of intellectual ranking, as well as in its Footlights Revue, which he had in effect taken over as presiding comic genius. He once warned me solemnly — this was after he saw my little

effort on Sidney Nolan on BBC2—that a smidgen of TV now and again was perhaps okay, but if I did too much of it nobody who mattered would ever take me seriously. I am glad that I ignored his advice, and happier still that he did.

But Australians per se I did not hang out with, and I have never really grasped why there should still be people who think that the main "expatriate" event, or institution, for Australians in London in the 1960s was a magazine named *Oz*.

It had originally been launched in Australia by an enthusiastic and mildly rebellious kid named Richard Neville. He moved to London, took *Oz* with him, and turned its editing into a partnership with two other Australians, Felix Dennis and Jim Anderson. It became for several years, to risk an oxymoron, the official gazette of the "underground" in London.

Then, since English conservatives were always bombinating about the danger that *Oz*'s espousal of soft drugs and mostly heterosexual sex posed to young people, Richard, Jim, and Felix had the brilliant inspiration of turning a whole issue of the magazine over to schoolchildren, mostly boys, to write, illustrate, and edit for themselves, with no adult interference. The resulting "schoolkids issue" was of an obscenity unparalleled in earlier *Oz*es. The Vice Squad descended with its big black boots on the *Oz* offices and confiscated everything they could find, and Richard, Jim, and Felix were hauled off to prison and thence to trial at the Old Bailey on criminal charges of publishing obscenity and corrupting the morals of minors. Since the minors in question had clearly been precorrupted, since it was they who, without adult suggestion, supervision, or interference, chose all the dirty stuff and put it in their very own issue of *Oz*, the result was an Ubu-esque legal farce. One of the complained-of images attained, if not immortality, a widespread fame: it was Rupert the Bear, hero of a widely popular child's comic, endowed with a long, stout, yet somehow winsome phallus. This caused much outrage among England's family-values supporters, even though decency precluded its reproduction in the very tabloids that spent the most space baying for the blood of the indecent Australians.

But this, and the editors' jail sentences, lay well in the future. Though Richard was certainly a friend, I was never more than loosely involved with

Oz. Once in a very long while, I would offer it an article that no one else wanted—dyspeptic reflections on the American moon landing in 1969, or a review (favorable, I am embarrassed to admit) of Eldridge Cleaver's grossly racist and sexist anti-white rant *Soul on Ice*. But I took no part in its editorial meetings—if it had any, which I doubt—and did not hang around the rented rooms that were its home in Palace Gardens Terrace, except occasionally to pick up a modest baggie of dope from some friendly part-time dealer.

Oz was essentially a student magazine for nonstudents. It reflected the gormless values of the Anglo-Australian underground, about three-quarters shapeless hippie optimism and one-quarter dimly anarchist or luridly apocalyptic blather about how all pigs and other persons in authority would vanish into the dump of history or simply be offed. It was shunned by the "hard" left as having no ideological line or content, which was not only quite true but perfectly fine with Richard and his friends. He once said to me, "I'm just a PR man for the Revolution," and this was so exact that I have never forgotten it. He was one of the sweetest-tempered people I have ever known; unlike most underground figures, unlike most people, in fact, he didn't have a mean bone in his body or a disparaging thought in his head; nor was he prone to the loony egotism that infected a number of the supposed "revolutionaries" of the day. But he did put up with it in others, and in my opinion he has now completely outgrown the editorial silliness of *Oz* by running one of the fiercest and best Internet blogs that exists, directed against the obscenities of globalization and Bush's brutally sanctimonious imperium.

His basic ethos forty years ago, however, was fairly well summed up in the title he gave his first book, *Play Power*. In it, he argued—though that is too strong a word for Richard's style of impressionistic burbling laced with mild ironies—that the old, rational world of the forefathers was over and out: Youth, blessed Youth, infallible in its instincts, angrily solicitous and possessive of its rights and indifferent to all notions of duty, had come up with a different set of social contracts, based on spontaneous hedonism, the joy of the marijuana high, spontaneous and uncommitted sex, the "togetherness" of crowds at rock concerts—the whole shtick, which seems so absurd and unpromising forty years later, but looked fresh and sweet and worth giving a go to back in the late sixties. "Bliss was it in that dawn to be alive / But to be young was very heaven." Wordsworth's line was about 150 years old, but the

sentiments it betokened seemed entirely new, as they are apt to do when they come round again. And who was reading Wordsworth anyway? The youth underground was culturally illiterate, ignorant of most things older than itself. Having so little sense of the past, its predictions about the future were baseless. Allen Ginsberg counted more than Dante or Byron. It was a time of collective self-importance, which masked—not very effectively—a striking indifference to the way the world actually did and might work. I hardly met a single person in the "underground" context who didn't, no matter how sexually available or amusing, turn out in the end to be ignorant and rather a bore. The depths of tedium that can be plumbed by sitting around half stoned, listening to people chatter moonily about reuniting humankind and erasing its aggressive instincts through Love and Dope, are scarcely imaginable to those who have not suffered them.

The London undergound, like so much of the general ethos of the sixties, was the product—a weak culmination, largely unaware of its own origins—of a train of thought, hope, and belief that had been present in England and in Europe generally for almost two centuries. It rested on confession, self-revelation and self-expression without set limits or inhibitions, and one of its principal sources was Jean-Jacques Rousseau (1712–78). Rousseau's *Confessions* set a standard of uniqueness for the imperfect, even the pathological soul. Here was a writer who prided himself on his sensitivity as the proof of integrity; who had done things which, by the standards of a previous day, were morally vile—notably, abandoning all his children to an orphanage—but which were somehow redeemed (in a secular parody of the Catholic sacrament of Confession) by admitting and describing them. This laying bare of the soul, this unabashed quest for the truth of the self, had become the principal form of Romantic utterance, whether in Coleridge or Byron, Hegel or Keats, Schiller or Goethe. It was to be elevated into a scientific and therapeutic principle by Freud, whose starting point may be said to have lain in Polonius' famous injunction to the wavering Laertes in *Hamlet*, "to thine own self be true," and further back in the Delphic motto, *gnothi seauton*, "know thyself." The individual preceded the State. In any society there must be room for the unbridled individual, the eccentric, the rebel, the visionary, and even (perhaps especially) the lunatic, since all of them were capable of touching truths that more "ordered" people felt bound to repress, not only in themselves but in others. And as individuality discovered its inner space and its

freedom, so the world would experience moral renewal. What a dead end this Romantic fallacy, this adoration of the unbridled truth of the self, proved to be! It took the twentieth century, with its limitless cruelty, its mad fantasies of social "reorganization," its deadly orthodoxies, and the limitless egoism of its rulers, to show what atrocious harm the idea of unrestrained personal expressiveness, in the hands of a Hitler, a Stalin, a Mao, or a Pol Pot, could do to hundreds of millions of ordinary people. To be true to oneself is one thing, but what mattered was the quality and nature of the self. This was a question which the "counterculture" preferred to skirt, for fear of sounding "moralistic" and thereby subverting its own immense capacity for narcissistic moralizing.

No good Australian writers were regular contributors to *Oz*. Germaine Greer gave it an occasional polemic, but never her best work. Her most vivid contribution to the magazine was not a piece of writing but a photograph, up close and full frontal, of her large and exuberantly hairy private parts, with her knees behind her ears; it was, I think, meant to advertise or commemorate something called the "Suck" festival in Amsterdam. Germaine meant it to be threatening, or at least confrontational, but I never enquired which. You could say that the lady had balls, even though she clearly did not. Doubtless there was some feminist rationale for this, but I forget what she said it was.

For my part, I had practically nothing to do with the Australian colonies in sixties London. I say "colonies," plural, because there were several. The one in Earl's Court, archetypally composed of the lowbrow beer-chuggers satirized by Barry Humphries in the strip (drawn by Nicolas Garland) about the adventures of an expat Australian in Kangaroo Valley named "Barry McKenzie," was not for me; they, and the robust girls they hung out with, bored me to distraction—why go all those thousands of miles to meet the very people I had gone to such trouble to escape?

But I disliked the Australian hippies even more. They fancied they had acquired some enlightenment from dope and perhaps a visit to Kathmandu. I saw no sign of it in these weakly blissed-out herbivores, with their bangles and bells, their sheepskin Afghan coats, their dull silences and droning monologues. The ones I met struck me as creeps. When, in 1969, I went to see *Easy Rider* (I have always loved motorbikes) I disliked the *nye kulturny* characters played by Peter Fonda and Dennis Hopper, found the scenes of

"enlightened" living in the commune painfully risible, and at the end, after those tedious acid-trip sequences in the New Orleans cemetery, almost wanted to stand up and cheer for the rednecks in the pickup who blasted both heroes off their choppers.

I have never had any patience with this kind of kitsch. I would rather, a hundred times rather, sit around with some new acquaintances over a bottle of Old Jockstrap, discussing the effectiveness of various streamer flies, than get all gooey and sensitive about karma with a bunch of hippies. One of the emblematically unpleasant moments of my life in the sixties came at a "human be-in" to which Danne Emerson, my future wife, took me on Hampstead Heath. She insisted on hanging around my neck, as a sign of peaceability, a small brass bell (from Nepal, she thought: where else?) on a leather bootlace. Tinkle, tinkle. Hark to the scribbling sheep. After a toke or two on a passed joint I felt ill with embarrassment. I discarded the bell behind a shrub.

The two things I liked about the English underground, and I liked them very much, were its opposition to the Vietnam war and its resistance to any kind of censorship. Neither of these was inspired by any kind of self-interest.

Australians of my generation were lucky when it came to wars. We were infants in World War II, undraftable teenagers during Korea, and then too old to be obliged to fight in Vietnam. I had done a kind of rudimentary cadet service when at school, marching around the parade ground in shiny boots while carrying an ancient Lee-Enfield .303 (the standard British rifle of the First World War) at the slope, and even being allowed — to my unmitigated delight — to fire a few rounds from a water-jacketed Vickers machine gun. I knew how to pipe-clay my canvas belt and gaiters for dress parade, and how to clean out the bore of my rifle by pouring boiling water through it, followed by a pull-through, with two four-inch by two-inch scraps of flannelette, a dry one and then an oily one. I had even once formed part of an honor guard, during the Royal Tour of Australia in 1954, the first visit of its kind by a reigning British monarch. The Queen and her consort, Prince Philip, were scheduled to drive across the Fig Tree Bridge, not far from Riverview. Accordingly, a detachment of thirty or so cadets was marshaled in full winter uniform, lining the bridge, ready to present arms in martial fashion when the royal Daimler glided by. But at the appointed hour, there

was no Queen. We stood and waited and stood and waited, sweating rivers beneath our woolen clothes, until someone decided the monarch wasn't coming and gave us orders to stand down. With intense relief, we loosened our ties, undid our collars and leaned our Lee-Enfields against the bridge railing. Some squatted on the pavement. At that moment, the royal limousine and its motorcycle escort came round the corner and swept past our unseemly rabble. I remember Elizabeth II's white-gloved hand, frozen in horror in mid-wave.

But of the serious discipline of military life, let alone actual combat, I had no experience at all, and never would. Now the Army couldn't touch me, even though our prime minister, Harold Holt, had committed Australian troops to Vietnam as a gesture of support for the Americans in the war begun by President Kennedy and continued, with ever-increasing deadliness, expense, and futility, by President Johnson.

Did I feel guilty or frustrated about being out of this, being the son of an indubitable war hero? Not for a moment. Nor did I, then or since, feel guilty about not feeling guilty. Unlike so many Americans, I did not affect to hate or despise the troops whose miserable fate it was to be drafted into this tropical holocaust in Southeast Asia; I did not revile them or think of them as "baby killers" or "murderers," though a few unquestionably were.

Nevertheless, I dutifully marched in a couple of demonstrations, one of which was an enormous affair that brought tens of thousands of people into convergence outside the American Embassy in Grosvenor Square. My only radicalizing experience on this occasion was getting jostled, not very painfully, by a police horse. Otherwise, all the demonstration taught me was that I should fear and avoid crowds of any kind, whatever the merits of the cause that brings them together may be. Certainly I felt no expectation that adding my molecule of the self to the crowd was likely to shorten the course of the Vietnam war by so much as a nanosecond.

As for censorship, I was not then and never have been a consumer of pornography. My onetime literary idol, Ken Tynan, was incredulous when I confessed this to him at dinner one night; I, in turn, was amazed (naïvely enough) that anyone of his intelligence could get as stirred up as he did over wank-and-slap magazines and dirty movies. I have never walked into a porno movie house and paid for a ticket, although some nights in foreign cities, alone on a lecture tour or a TV shoot, I have tried—not always suc-

cessfully, due to my almost Luddite ineptitude with the program-ordering system on the hotel TV—to summon up the moaning, licking, glossy-titted industrial phantoms classified as Adult Entertainment. But Ken attached an almost mystical importance to porn, and I do not. Memories of real sex, for which I am blessed with excellent recall, suit me just fine in its place, and they do not add ten dollars to the hotel bill. Nevertheless, it seemed insufferable that intrusive old men, not to mention priests, should have the right or ever be allowed to administrate people's sexual fantasies. Of course, I was replaying old resentments over Jesuit control of my reading (not, in truth, that this control was so strict; if it had been the Christian Brothers, I would hardly have been allowed to read the Sunday papers), and over Catholic censorship in general. But I can't claim to have felt militant about this. I did not wish to swap one set of pieties for another, and I never for a moment believed the promises of Revolution Now that were floating about—all that messianic drivel about changing the world by dropping out of it.

Where I did meet with the tone of the 1960s was, quite simply, in resentment of lies.

Our seniors had been lying to us, as politicians do, on an immense, industrial scale.

The Domino Theory—if Vietnam "falls" the rest of Asia must—was a deadly fantasy. The idea that propping up the terminally corrupt Thieu government in Saigon would keep Southeast Asia from "going red" was a delusion. The threat of Chinese intervention was a lie. The notion that Americans—and their little accomplices, the Australians, who hoped to get loyalty bonuses from Big Brother for helping them kill Vietnamese and, even more important, for enabling the Johnson administration to boast that it was "not alone" in fighting Ho Chi Minh—had the right to muscle in on what was essentially a civil war was the biggest lie of all.

Admittedly, none of these lies, though repellent in themselves, had the truly disgusting cynicism of the Big Lie that George Bush's administration would pump out forty years later to justify America's oil war against Iraq—the nonexistent "weapons of mass destruction" that Saddam Hussein was claimed, on the most perfunctory and, as it turned out, worthless evidence, to have amassed.

But they were bad enough in themselves, and they resulted in the destruction of hundreds of thousands of lives, including fifty-eight thousand Ameri-

can and an unknown but enormously larger number of Vietnamese ones, all for nothing. What benefits might have accrued to American society if the stupendous, incomprehensible sums squandered on those two defining boondoggles of the 1960s, the Vietnam war and the space program, had been turned to worthier and more humanly beneficial aims? Perhaps it is pointless to ask. It seems bizarre, but is nonetheless true, that history has repeated itself now, forty years on. No only is America stuck in a hideous quagmire in Iraq, unable to move forward or to extricate itself, wasting billions on billions of dollars and young American lives by the thousand (not to speak of hundreds of thousands of Iraqi ones) on a war that cannot be won; it is also saddled with a president of pitiably smaller intelligence than Lyndon Johnson or Richard Nixon, who likes to prate about his fantasies of space exploration—an American back on the moon by 2020, then an American on Mars. And to what conceivable purpose? The moon is dead, dull, and best seen from the great distance wisely interposed by Mother Nature. Certainly it was then, and still is now, a reliable emetic to hear some beady-eyed stuffed shirt in Congress, with a lobbyist's check in his pocket, declaiming once again about how man's destiny lies among the stars, while back on earth the slums were decaying, the rice fields were dying, and the waters were running with filthy chemicals. The stars, no doubt, are all very well for those who can afford to visit them, but nobody has, or probably ever will, and today it is hardly possible to think of any good that came to Americans, let alone to humankind in general, from the insane extravagance of the space race— unless one counts the enormous profits it generated for the various contracting companies who built its sometimes defective hardware. All this, to see if bean sprouts will grow in zero gravity? "The stars our destination"—what a colossal and arrogant confidence trick! As though the indubitable courage, even the heroism, of American and Russian astronauts created anything of permanent value to those of us whose real and necessary destiny is to live and die on earth!

Concerning the star figures of the international underground whom I met through O_7, the less said the better. Timothy Leary, when he made his appearances in London, was treated as a kind of holy sage. I thought he was more like a coarse, middle-aged Irish whiskey priest, anxious to be loved and spouting apocalyptic rubbish about salvation and transcendence. Leary's gospel of culture renewal through acid ruined a number of lives that I knew

of, and he never seems to have had the slightest qualms about it: these brains were the eggs that had to be broken in order to make the great omelet of the utopian future. But forty years later, the omelet is nowhere to be seen. My own acquaintance with psychedelics was, admittedly, slight. I took LSD three times, in the hope of keeping up with my wife Danne, who gobbled it incessantly. The Orange Sunshine gave me some very powerful hallucinations of a thoroughly banal kind, wildly distorting space and color. The effect was disturbing but not particularly revealing. I cannot think of any "truth" that was disclosed to me by the drug, or none that has seemed durable, and it did not change my perception of life, as so many others claimed it would and should.

I never met Abbie Hoffman, whom I think I might have liked— somewhat. But I did have the misfortune of encountering Jerry Rubin, self-described leader of the Yippies and author of a hectoring album of antiadult slogans entitled *Steal This Book*. Rubin was a perfect type of the low-level hustlers one encounters on the tackier perimeters of Hollywood. In fact, one reason I still so dislike visiting Los Angeles is that I recoil from meeting others like Rubin. He was a semieducated liar with invincible self-esteem, the attention span of a flea, and a disgustingly inflated ego to match. Abbie Hoffman's idealism, however warped, was at least genuine; Jerry Rubin's was entirely synthetic, like that of so many other American evangelists, Christian and Jewish, right-wing and left-wing, whose natural talents now have them ranting on cable TV and selling swampland in Florida instead of preaching fictions of Revolution Now.

It's curious, actually, how close some of these sixties revolutionaries were in rhetoric and attitude to more traditional, if no more palatable, American hucksters. Eldridge Cleaver, a bully who for a while achieved celebrity as one of the leaders of the Black Panthers, veered sharply Godward and to the right and ended up, before his death, trying to market a line of items of men's fashion for the black stud, including a codpiece ornamented, if I remember correctly, with crotcheted pubic wool. Then as now, America was full of debased promises and offers of salvation—the excreta of the original New World puritanism.

The *Oz* circle also attracted a smattering of black "radicals," mostly Jamaicans and Trinidadians posing as leaders of "minority groups" whose hopeful names ("The Notting Hill-Kingston Maoist People's Army for

Love and Vengeance," that sort of thing) generally betokened a membership of a dozen or at most twenty people. Radical action consisted mainly of writing placards and sitting around in Notting Hill pads getting whacked on ganja under a glamorous poster of Angela Davis, while the women stirred up a sinister-looking pot of goat's head soup, delicious but confrontational enough, with all those red peppers, to skin off your taste buds.

Oz magazine's favorite black was a Trinidadian named Michael who, such being the fashion of the day among aspiring black leaders, had jettisoned his surname as a "slave name" and, in homage to the recently murdered Black Muslim leader Malcolm X, had taken to calling himself Michael X. I only met him a few times but he seemed an amiable guy, devoted to hash and reggae and not at all the whitey-eater the English tabloid press made him out to be. He was a figurehead, and the London police, along with the papers, persecuted him as such. But among his various sidekicks, bros, and hangers-on was a quite exceptionally nasty maniac, formerly an enforcer for the numbers racket in Boston, who went by the name of Hakim Jamal.

Hakim had been more or less adopted by one of the best-known hip left families in London: the Redgraves, specifically Vanessa (then a red-hot Marxist) and her brother Corin (a white-hot one). Such was to be their personal contribution to the repeal of ancient slavery. At least, that was how Hakim sold it to them. Never was there a more convincing proof of the ancient adage that he who pays the Danegeld never gets rid of the Dane. Hakim was determined to wring every penny he could out of these worthy but naïve luvvies.

He was a raving paranoid with a pronounced persecution mania, and unfortunately these traits had their impact on me; my first wife (to whom we shall presently come) was an acid missionary, with a fixed belief in the enlightening power of psychedelics, and despite my entreaties, she gave Hakim his very first acid trip.

Having known already that he was a black warrior-hero—with everything but the leopard skin and the assegai—the post-acid Hakim now became convinced that he was a black god, a savior, a Messiah. As such, he had to have a John the Baptist who would go before him, crying his name in the desert wilderness of whities, explicating the world-altering thoughts that prophetic Hakim was too busy thinking up to write down. Since most of the people he knew were either illiterate or (wisely) occupied elsewhere, or else

so stoned that they couldn't have told a ballpoint pen from a water pistol, Hakim decided that this lucky person should be me, the husband of the white witch who had enlightened him.

He then took to turning up, uninvited, at all hours of the day and night at our flat in Regents Park, spouting his "philosophy" and expecting me to take it down. It was a mishmash in which, decades later, I recognized elements of the remedial pseudohistory preached by Afrocentrist "historians" like Cheikh Anta Diop and accepted by various deluded or merely opportunistic black academics, such as Leonard Jeffries and others, in the United States. It was based on the peculiar myth that the ancient Egyptians were African and therefore "black," that the ancient Greeks "stole" all they had of scientific and philosophical knowledge from these black Africans, alias Egyptians. So Greek culture was essentially a Negro invention, a fact concealed from whites by their repressively hegemonic but uninventive forebears. This kind of stuff was to history what the teaching of "Ebonics," meaning the effort to endow black street slang with the dignity of a parallel language by teaching it in schools, is to English usage. It is, in short, trash culture, pathetically conceived as remedial. However, it was by no means new, and in full flood Hakim sounded just like the Ishmaelian consul general in Waugh's *Scoop:* "Who built the Pyramids? Who invented the circulation of the blood? . . . Who discovered America? Who won the Great War?"

When he moved to more recent politics, Hakim's paranoia made even Michael X's parodies of Franz Fanon sound like Ernst Junger at his iciest. Seeing that I didn't sufficiently believe him, Hakim presently backed off and acquired a pretty, harmless white groupie named Gail, who actually did follow him around transcribing his thoughts in notebooks. Poor creature: Hakim took her to Jamaica with Michael X and a couple of acolytes, and there, on a communal farm outside Kingston, she was done to death with clubs and machetes. Michael X, who did not take part in her murder, was tried and hanged for it. Hakim, the killer, was not indicted; he went free and returned to the United States, where (I was later told) the Mob killed him. I cannot say this grieved me.

Richard Neville, a pleasantly skeptical though often sentimental kind of man, didn't believe a word of this pseudo-African rubbish and was quite content to make up a notion of the undergound as he went along, and to have it congeal in a loose, sloppy way in the pages of *Oz*. The result was a maga-

zine without any discernible editorial standards, and this was part of its gangling, silly charm. Of course it didn't pay contributors, firstly because it didn't have any money (office and printing expenses were to some extent defrayed by ads: sex manuals, a penis-enlarging cream named Magnaphall, and new record releases), and secondly because nothing it published was really worth paying for, and if it paid one it would have to pay the others, which would have been flatly impossible.

Oz was mainly remarkable for being very nearly unreadable. Even by the standards of the underground press it was excessively hard on the eyes: all that discordant color and tiny, blurred type on cheap paper. But then, its design was not meant to be read, but to be grooved on, preferably after a few tokes of hash. Perhaps it is not fair to judge it by the ocular requirements of middle age, since I doubt if anyone over the age of thirty (except, by 1969, some hostile magistrates and prosecutors) tried to read it. It was heavy with pseudo-Art-Nouveau artwork, whose sinuous and seaweedy lines were thought to approximate the form of hash or acid visions: unfortunately, practically none of this décor had the whiplash graphic elegance of real 1900 style, though it made clumsy stabs in that direction.

The only graphic artist of any talent who contributed original work to *Oz* was a young Australian named Martin Sharp. I had known Martin, not very well, for quite a long time. We had lived, not only in the same city (Sydney) and the same suburb (Rose Bay), but on different sides of the same street: I at 26 Cranbrook Road, he at 25a, where his widowed mother had a large house. I would hardly describe Martin as a graphic genius of the order, say, of Gerald Scarfe or Ralph Steadman, but of his talent there was no question, and one of his drawings, a bravura performance of fine cross-hatching and angry religious parody, acquired (and deserved) a fame well beyond the limited readership of *Oz*. It was entitled *The Madonna of the Napalm*, and it showed an enormous, levitating LBJ with diabolic black wings cradling in his arms a rotund little Harold Holt, prime minister of Australia and author of the then famous phrase "All the way with LBJ." This rapidly became one of the classics of sixties antiwar cartooning, which it thoroughly deserved to be. But alas, Martin did not retain his political edge for long, or develop it any further. He developed Cosmic Ambitions. It was not really LBJ that his inner self had to contend with, but LSD. He did lurid and elaborate album covers for such groups as Cream; he hung out with Eric Clapton, who

recorded a song he had written; he did Jimi Hendrix's head exploding in ganja-induced ecstasy; he did variant after variant on van Gogh's self-portraits. His work became a gallimaufry of would-be mystical and cosmological symbols, obscure and clichéd by turns.

He also developed a fixation on an American entertainer named Tiny Tim.

"Tiny," as his intimates called him, is still remembered by some as a "classic" sixties weirdo. His name was Herbert Khaury, from Brooklyn, and he was a most peculiar-looking bird, flabby and pale, with a dark-rimmed, exophthalmic gaze, cascading masses of greasy ringlets, and a weird little smirk. He accompanied his renditions of infantile classics like "Tiptoe Through the Tulips" on a plastic ukulele.

He had become famous initially by appearing on that groundbreaking TV show of the late 1960s, *Rowan and Martin's Laugh-In*. By the end of the decade, his celebrity had expanded to the point where, when he married his first bride, "Miss Vicky"—they had met in Wanamaker's Department Store when she asked Tiny to autograph a copy of his book *Beautiful Thoughts*—the nuptials were celebrated on Johnny Carson's *Tonight* show, on a set decorated with ten thousand Dutch tulips. Twenty million people are said to have tuned in to this ceremony, which meant that Tiny Tim achieved the second-highest-rated show of the decade, after the American moon landing. This tittering and androgynous oddity managed to sire a daughter on Miss Vicky, but they eventually divorced. He remarried in 1995 but died of heart disease, complicated by a headlong fall from the stage of the Ukulele Hall of Fame in the same year. He was sixty-four. Martin Sharp had been helping support him for years.

When everyone aspires to be a freak it is difficult to stand out as one, but Tiny did. "The voice you know already," rhapsodized the journalist Anthony Haden Guest, "that aery eldritch voice, like an arctic breeze . . . so, after the voice, you are dazzled by the hands. . . .This is Rasputin, or Percy Bysshe Shelley given Dracula's kiss of eternal life," and so on for the whole back page of one issue of *Oz*.

Martin, who by then had dropped many times more acid than is good for the human brain, was dazzled by this oddity. He convinced himself that Tiny was some kind of guru, a cultural visionary who held the world's musical key. Although a short film, *You Are What You Eat*, had already been made about Tiny—its producers were Michael Butler, who had done *Hair*, and

Peter Yarrow of the group Peter, Paul and Mary—Martin felt he had not been done real justice. He therefore set out to devote much of his time and inherited fortune to making a much longer film about his idol. This proved an expensive business, since Tiny Tim lived in Minneapolis and had to be flown to Sydney so that his rambling thoughts about life, art, spirituality, music, success, and other topics of interest could be recorded.

I doubt that Tiny was actually exploiting Martin; there was nothing cynical about his demented self-regard. He believed in himself and his mission to the world with the kind of unclouded and near-messianic faith that only the very worst artists, such as Julian Schnabel or Madonna, seem to have. He apparently felt that this world, or at least the part of it named Martin Sharp, owed him a living. Gradually the reels and tins of 16-millimeter stock piled up in the corners of 25a Cranbrook Road, mortgaged now to the eaves. Efforts were made to impose some kind of order on this embrangling mass of celluloid, but it must have been a hopeless task, worse than Laocoön's struggle with the Euxine sea snake. Gradually, Martin, like the rest of us, grew older. His hair became a gray thatch, his front teeth fell out. He came to resemble an elderly, cashiered Latin teacher. He divided his time between painting, the unedited footage of Tiny Tim, and the relentless, rather wistful pursuit of young girls, a testament—like Martin's own belief in the spiritual powers of psychedelics—to his own childishness. The film has not yet been made.

It's a curious fact that the London underground threw up no other graphic artists whose work was of interest. You would think that, given the emphasis on visual hallucination that went with the drug culture, it might have been otherwise, but no. The American underground press, inspired by the long and vigorous U.S. tradition of comic strips, had at least two exponents of the form. One was Gilbert Shelton, who for a time drew a hilarious strip, *The Fabulous Furry Freak Brothers,* about the doings of a trio of hippies whose signature line or mantra was "Dope will get you through times of no money better than money will get you through times of no dope." Shelton was fairly talented, but the indisputable genius (whose work sometimes appeared, in syndication, in *Oz*) was Robert Crumb, whose work I intensely enjoyed then and still do.

Crumb lives and, despite his beanpole appearance, expands. Instead of being confined to reproduction on the stapled-together pages of ephemeral

magazines—*Bizarre, Zap Comix, Motor City Comics, Yellow Dog, Snatch Comix*—he has spread and metastasized into real art galleries in France (where he is regarded as a hero of the history of the *bande dessiné*, with shows from Paris to Angoulême) and even in Germany, where the Ludwig Museum in Cologne organized a Crumb retrospective complete with solemn art-historical colloquia in 2004. A flood of books about him, mostly anthologies of his drawings, has come with the last few years; there are even plastic dolls, made under license in Japan, representing his grotesque characters. Films have been based on his work, usually to Crumb's own intense disappointment. (The Japanese audience loves him, or rather *a* Japanese audience loves him, but in Japan there seems to be a public of some sort for nearly everything.)

The big success, in film, has been about Crumb rather than by him: Terry Zwigoff's *Crumb*, released in 2001. It not only offered a very good sense of his work, but also described the enormous wound that lies behind some of it—the death of his deeply neurotic brother Charles, whose obsession with the comic-strip medium helped turn the younger Robert into a cartoonist. In some ways it was the best film I have ever seen about a living artist and his work, and I include the various ones I have made over the years. Besides, I was (briefly) in it.

You could almost think of Robert Crumb as a weird counterpart to Disney, except that he is entirely a one-man show—he has no staff of "Imagineers," inkers, and letterers. Crumb is a cottage industry, and a tiny cottage at that. The idea of corporate production is one of his particular nightmares, representing one of the aspects of modernity he most hates; and a "Crumbland," filled with tides of sperm and excrement, not to mention slavering old men and moist teenage pudenda, is not likely to open for business any time soon. (Maybe not, Crumb would no doubt rejoin, but it doesn't have to—it has been open all his life, with limitless free parking, and its name is America. Roll right up, folks!)

Why did Crumb survive the sixties, when so few others did? Because he didn't share the reigning fantasies of the time. He turned on, but he didn't tune in, much less drop out. He is by nature a pessimist and a skeptic: that is to say, a realist and an honest man, unlike the pretentious messiahs and fuddled creatures who were the accepted leaders of the pseudorevolution. If you view the popular underground culture of the time, in reality so far above

ground—the obsession with rock, mind-altering chemicals, and love-ins, the doomed and crazed expectation that (given the right political circumstances) the hidden nature of humanity would reveal itself in all its radiant cooperation, mutual affection, generosity, and sensuous freedom—you can't see it as anything but a renewed outburst of that utopianism which has always lurked right at the core of American culture. It was already there in the seventeenth-century fantasy that in the New World all renewals were possible, or ought to be. (This belief was the property neither of the left nor of the right; it went beyond all political alignments.)

Crumb never believed it. Or rather, he did, but only for about ten minutes. That was in 1967, when he was twenty-three and fled the iron triangle of job, marriage, family. He hitched a ride to California, like some post-psychedelic Okie, a Tom Joad joining the mass exodus to Haight-Ashbury. But then, having got all the sex he wanted in San Francisco (and Crumb has never made any secret about his extreme neediness, his dirty mind, and his Big Thing about girls with large, hard buttocks and sequoia-like legs), Crumb seems to have cottoned on quite early to the fact that all utopian promises were moonshine. Acid or no acid, the human animal was not about to change. It remained base, chained to its hopeless desires—irreformable. The really big sin was Original Sin. Having been through something like acid hell himself—"My mind would drift into a place . . . filled with harsh, abrasive, low-grade, cartoony, tawdry carnival visions . . . My ego was so shattered, so fragmented that it didn't get in the way"—he was not going to give much credence to the fantasy of social or spiritual renewal through psychedelics.

Instead, he was going to embrace his monsters and make sense of them through words and pictures. "Most of my popular characters—Mr. Natural, Flakey Foont, Angelfood McSpade, Eggs Ackley, Mr. Snoid, the Vulture Demonesses . . . all suddenly appeared" in early 1966, and have been appearing since. By now they are figures in a commedia dell'arte that is entirely of our time: we recognize ourselves, our relations with the world, with our lost parents, our present authorities, in them. It has been said, often and truthfully, that genius is nothing other than the ability to recapture childhood at will—but this has to include the terrors and desires of childhood, not just its Arcadian innocence.

That is where the singular power of Crumb's work shows itself.

We can never see things with the X-ray vision of Superman or the deductive brilliance of Dick Tracy, but we can sure as hell remember what it was like being stomped on by authorities, whether parents, cops, or some terrifying ogress of a nun, as little Robert was in his Catholic school nearly half a century ago—and we can share the bloody inventions of revenge set forth in his drawings. That's why Crumb is a genuinely democratic satirist, in the fierce over-the-top way of a James Gillray, hyperbole and aggression relieved by brief intermissions of tenderness. He gets into the domain of shared dreams and does so in a language that doesn't pretend to be "radically new." Why on earth should he pretend? If he did, people wouldn't know what he was drawing about. As he pointed out in an interview thirty years ago, "people have no idea of the sources for my work. I didn't invent anything; it's all there in the culture; it's not a big mystery. I just combine my personal experience with classic cartoon stereotypes." Rather than fitting him into some notion of an avant-garde, it is better to see Crumb as a dedicated *anti*modernist. His own list of the inhabitants of "R. Crumb's Universe of Art"—the fine artists who have influenced him—includes Bosch, Pieter Brueghel, Rubens (them Flaimish blondes with fahn big laigs), Hogarth, and Goya; among the modern ones are Edward Hopper, Reginald Marsh, George Grosz, and Otto Dix; but there are no living ones at all. Crumb's view of the contemporary art world is implacably jaundiced. He regards it as a saturnalia of phonies and fashion victims—which, 95 percent of the time, it is. When he was regarded solely as a cartoonist, he was angry about being left out of the category of "artist." Then tastes changed; Crumb became more desirable in the art world, not because of Pop Art, but because of the enormous influence on collectors and museum people of the "dumb" figuration of the late, great Philip Guston, which was itself largely based on comic strips such as George Herriman's *Krazy Kat*. Now that he has been "kicked upstairs" into the museum, Crumb professes not to get it. "I don't understand how they can fit me into the same mental space with Cy Twombly. It's a mystery to me." Presumably it is to Twombly, too.

But Crumb only appeared in *Oz* in syndication—which was certainly better than not seeing him at all, of course, but did not of itself distinguish *Oz* from a number of other underground magazines in which his work also appeared.

On the whole, though it was often fun, *Oz* didn't deserve a brilliant report

card as a magazine. No new writing of any merit; little in the way of good original illustration. With the exception of Greer, as noted above, none of the genuinely talented Australian writers and artists who were in London in the late sixties had anything to do with the magazine: not Sid Nolan or Arthur Boyd, not Colin Lanceley or Brett Whiteley, not Peter Porter, Barry Humphries, or Clive James. They had not come across the world to engage in fictive revolutions. They had come to engage with the past and the present, not with fancies about the future, and to find out how to deepen and enrich their work in a way that couldn't possibly be achieved in Australia. Australia in the early sixties was a backwater and nothing could be done about that. One could only concentrate on one's own work and its development. These days I am only sporadically in touch with Australia and its media, but I am told that the surge of neoconservatism that rose in the wake of John Howard's election, reelection, and re-reelection has produced a fashion for being "revisionist" about the Menzies years, as though, culturally and politically speaking, they weren't as bad as they were painted. That is hardly surprising, given that Howard's entire sense of political value was modeled on the Menzies regime. But in fact they were every bit as bad. They produced a coercive mood of numbed-down complacency. Twenty-four continuous years of Liberal/Country Party rule had produced an extraordinary degree of stagnation, in which everything that was wrong with Australian society—the racism, the lack of public imagination, the absurd reverence for monarchy, the groveling before an increasingly colonial United States and the inability to imagine other parts of the world, particularly Asia—was simply internalized as normal and inevitable. The stridency and silliness of *Oz* has to be seen against that background. Every Australian abroad who felt the tendency to independent thought (not that they all did, of course) carried in his or her memory a cage of lackluster conservatism, whose bars needed constantly to be rattled.

To me, there is no doubt that *Oz* had its value, even though from the viewpoint of a writer's development its cultural attitudes were frequently inane. That value was emphasized by the famous prosecution of the magazine's editors, which was almost as emblematic an event as the *Lady Chatterley* case had been a few years earlier. The Crown prosecutors did more to bring salutary ridicule and damage to English Puritanism by the conviction of Richard Neville, Felix Dennis, and Jim Anderson than could ever have

been brought by their acquittal: there was then, and still is, something so exquisitely silly, so Monty Pythonish, about the idea of prosecuting adults for corrupting the morals of minors when the minors themselves had produced and published the alleged obscenities, while the adults had merely left them free to do whatever they chose.

It was in the late sixties that I lost my beloved mentor, Alan Moorehead. He had been suffering attacks of faintness: nothing very serious, perhaps, but worrisome all the same. In the course of a checkup the doctor noticed a small constriction of the walls of the carotid artery in his neck, the artery that carried blood to his brain. This raised the possibility that the artery might narrow even more, and perhaps collapse, causing a serious occlusion. Thus he was a candidate for surgery. The procedure, he and the family were told, was a straightforward and, by the cardiological standards of the day, even a fairly routine one. It consisted of hooking his artery up to a bypass pump, snipping out the defective section and replacing it with an inch or two of plastic sleeve, and then turning the natural flow back on again. Nothing to worry about; the surgeon had done it many times, there was nothing experimental about the operation. So Alan went under the knife in a leading London hospital.

The bypass pump failed. It took several minutes to fix—a short time, but during it Alan's brain was starved of oxygen. He suffered the equivalent of a severe stroke. The damage was beyond repair. He was not yet sixty and at the height of his powers as a writer. The peculiarly awful thing about this misfortune was that Alan, who would never write again, was quite conscious of what had befallen him; he was not a "happy vegetable," lobotomized and unable to know what had happened, but an angry prisoner in the Bastille of the self, terrible in his frustration, boiling inside and still capable, or so I believe, of introspection. His predicament reminded me of William Blake's Tharmas, whose cry of illimitable despair is "Lost! Lost! are my emanations"—"emanation" being Blake's term for any power of self-expression.

Alan had only a few phrases. If he disliked something, or disagreed with a statement, it was "bloody awful." If the reverse, "bloody wonderful." For the sake of therapy, he took up painting—I think this must have been in imi-

tation of Winston Churchill, whom he had known well. His wife Lucy and their sons and daughter rallied around him with selfless devotion, good humor, and generosity. This cannot have been at all easy, since Alan's temperament had become much more melancholic since the unfortunate operation. It called forth great reserves of emotional strength from Lucy in particular: I cannot forget how, one winter night by the living-room fire in Porto Ercole when Alan was away, poor Lucy—who knew far more than Alan ever imagined about his infidelities—suddenly broke down into racking sobs of pain at the thought of that "bloody Australian bitch," the wife of a Melbourne financier whom Alan was visiting in a Rome hotel. But when Alan was helpless and unable to fend properly for himself, Lucy remained entirely devoted to him. I did what little I could to help by visiting him for chats and, in fine weather, pushing him in a wheelchair around Regents Park, where I lived. On these outings he would point and struggle to name things: "duck," "rose," "pretty girl over there—that—that—that."

We would look at the cavorting waterfowl, Alan sunk in gloom, the corners of his wide mouth turned down. I thought of him in Africa, with flocks and herds of wildlife all around; in Antarctica, on the polar ice cap, gazing with fascination at the emperor penguins. He had told me how, against the surrounding no color of the ice and snow, the bib of yellow feathers on these huge birds seemed to float free of their bodies, hovering weightlessly in the air. I had hoped to see this Matissean miracle one day, but I never have.

On one of these outings, as we paused on a narrow bridge over one of the canals, he turned to me, pointing to his head, and came out with the only complete sentence I had heard him utter in years. "If you only knew how *bored* I am. In here." The effort seemed to exhaust him and he relapsed into muttering "Duck. Duck." I thought my heart would break.

Later, I would dedicate my book on the colonization of Australia, *The Fatal Shore,* to the memory of Alan and Lucy, with a fragment from the *Inferno,* where Dante encounters the shade of his beloved teacher, Brunetto Latini, on the burning sand beside the waters of Phlegethon: *"che 'n la mente m'è fitta, e or m'accora, / la cara e buona imagine paterna / di voi ... / e quant'io l'abbia in grado, mentr'io vivo, / convien che nella mia lingua si scerna."* "The dear and good fatherly image of you is fixed in my mind and my heart ... and so long as I breathe air, my tongue must give the thanks that are your due."

Meanwhile I had become a father myself. I had launched into a marriage which brought me, along with early episodes of great delight and even a small ration of enlightenment, the most extreme and durable misery I had ever felt.

Her name was Danne: Danne Patricia Emerson. She had been born into a middle-class family in the Sydney suburb of Botany, on the very shores of Botany Bay, in 1942. Her upbringing had been Catholic; perhaps not as strictly Catholic as mine, but orthodox all the same. She had been an excellent student: head girl with top marks in just about every subject at the Brigidine Convent in Randwick.

She was to die in Australia in 2003, at sixty, of a brain tumor. She was enormously fat from the aftermath of a prolonged cocaine addiction from which her lesbian girlfriend had struggled, on the whole successfully, to free her. It was soon after the death of our only child, Danton Vidal Hughes (1967–2001)—dead by his own hand, having gassed himself with carbon monoxide from his car in his far older lover's house in the Blue Mountains, outside Sydney.

I miss Danton and always will, although we had been miserably estranged for years, and the pain of his loss has been somewhat blunted by the passage of time. I do not miss Danne at all, but for a long time I believed I could not possibly exist without her: that there was no other woman on earth who could offer me the same sexual and emotional intensity. Erratically and episodically, she cherished the same fantasy about me.

And it was just that: a mutual fantasy. If there was ever a misalliance between two emotionally hypercharged and wolfishly immature people, it was our marriage. I was as unsuited to her as she was to me. I could no more fulfill or even predict her needs than she could mine. We both walked into our relationship blind as bats, with our eyes open, impelled by a mutual need for security that was certainly heightened—though this was apparent to neither of us at the time, and our desire to be thought sophisticated wouldn't have let either of us admit it to the other—by the fact that we were both expatriates in a strange world. In our unadmitted insecurities, we kept undermining and then propping one another up. The result was a disaster so complete that even now, forty years and two marriages later, I shudder inwardly when I think about it, though I can't and wouldn't deny that we had some good times together—at first.

We met at a drinks party thrown by an expatriate Hungarian-Australian named Stefan Gryff, in his Notting Hill flat. It was full of other Australians, most of whom I had never seen before in my life. "Do you want to meet the best fuck in London?" the host delicately enquired. And he pointed to a sofa, on which sat a tall, rangy, square-jawed blonde, holding a glass of warm vodka. We were introduced. Things began to click, small cogs and then larger ones to engage. She had seen me in university revues, seen my writings and cartoons in *Honi Soit* and then in *Nation*, and even seen me briefly on English TV—BBC2. What did she do? I had no idea. This and that, it seemed. She had an Arts degree from Sydney University, which, as we both agreed, qualified you to do precisely nothing. She had just got to London. She was "hanging out," with no particular plans. She hadn't come all this way, coach class on Qantas, to do secretarial work in some fucking dentist's office. She hoped to make it to Italy before long.

Gauging my distance from this harsh-sounding beauty, I pounced. It just so happened, I said as casually as I could, that I was going to go there in a couple of weeks, on an assignment for the *Telegraph* color magazine. To Venice, actually, to do a several-page spread on Palladian villas of the Veneto. Did she think she might possibly find the time to come along? "Well, why not," she said. And then: "What's a Palladian villa, exactly?" Off we went to an Indian restaurant, so that the dropout from architecture school could explain Palladio over the lamb vindaloo to the girl from Sydney. There was such a lot of explaining to be done. Two weeks later we were off to Venice. And less than a month after that, she had moved with her few belongings into my flat in Cornwall Gardens, SW7: a neat little two-bedroomer, looking out onto a square of winter-bare trees.

We didn't care about the presence or absence of leaves. Except to pick up groceries and the mail, and occasionally to take in a movie or a play, neither of us stirred outside much for the first couple of months of 1967. We were both in a feverish and untiring rut, a sort of erotic trance: the first thing I bought for the flat was a king-sized bed, the first I had ever owned—I am not sure, but I don't think that king-sized mattresses even existed in Australia at the time. "This bed thy center is, these walls thy sphere," as John Donne put it. It seemed that there was hardly room for anything in the small flat except that bed and us.

I also made a big mistake. In the course of some conversation about life,

liberty, and the pursuit of happiness, I remarked that I thought there was no point in getting married unless you meant to have children. Me and my big mouth. A few weeks later, Danne announced that her period was late. By February, it was clear that she was pregnant.

I had, as far as I knew, only once made a woman pregnant before, and with deep tremors of guilt I had paid for the abortion; but this one we were definitely going to go through with. I felt quite irrationally pleased with myself, as though I had actually achieved something. And Danne, once she was sure that I wanted her to have the child, was thrilled. The hard edges, the skepticism, appeared to be gone. She was becoming, to my astonishment, a sentimental mother-to-be. Since all fears of pregnancy were now settled, we made love with even more hunger and abandon than before, and in places I had sometimes thought of but never tried, most of them downright uncomfortable: the last row of a cinema, the backseat of a taxi. She even, to my astonishment—for she had never felt the least interest in small furry animals before—began to show a recurring penchant for kittens and puppies.

So we were going to be married. It had all happened at warp speed, with an incomprehensible momentum; that tiny scrap of organized tissue in her womb was both growing very slowly and careering out of control; it seemed the clue to an extraordinary adventure, more exotic than going down the Amazon on a log. I felt both exhilarated and rather frightened.

I had never, in any real sense, been responsible for anyone else before; it was the end to my demi-paradise as the youngest of the family, as a semi-only-child. Wasn't I too young to get married? Of course not, I told myself; I was twenty-eight, the same age as my brother Tom had been. (This first marriage of his had clearly failed by then, but Danne's and mine, I told myself, hadn't and couldn't.) Now I could be a real man like Tom. The time-fused bomb so deeply implanted in me by my upbringing made a faint subliminal buzzing sound and then went off with a roar. Marriage: the only, the inevitable choice.

So who was going to hitch us, and where? The choice was very simple. It occurred to neither of us to have a civil ceremony, which, given the eroded state of our Catholic beliefs, might have seemed the natural choice. In any case, we were not anticlerical—just regular sinners. We had only one friend in the priesthood, a charming, intelligent, and liberal-minded Jesuit called Cyril Barrett, who had come into my life through his interest in contem-

porary art. He was attached to the Jesuit college in Farm Street, behind the Connaught Hotel, and this college had a chapel where, in the month of May 1967, he married us. Danne wore an off-white silk shift, done by one of her hip designer friends, which made allowance for the slight swelling of her pregnant belly. She reminded me of one of those late medieval beauties one sees in paintings of the period, with that outward curve of the stomach—the kind of girl who, in the words of the Elizabethan writer Thomas Nashe, "bare out her bellie as majesticall as an Estrich."

Our baby, a robust boy, was born on September 30, 1967. Danne and her friends made a great fuss at the time about the virtues of Scorpios, but I cannot remember what these were meant to be. It was enough for me that he wailed lustily, had all the required limbs and parts, and when happy (which was often) displayed an enchanting smile. I felt so proud of him, and of Danne, and of myself for being his father.

Naming him, however, was a problem. Among their other drawbacks, the late sixties were a time when hip people gave the most idiotic names to their infants. What has become of those children of the sun, now in their thickening and sagging forties, whom their flower-power parents condemned to be addressed as Wind or Fire, Phoenix or (in one case, I was told, though I am reluctant to believe it) Karma Tara Holy Rocking Jesus Gramophone? One never meets them anymore, whereas once there seemed to be one in every other cradle. They must have slid back into nominal orthodoxy. ("My name is Will-o'-the-Wisp Bernstein, but just call me Will.") Having considered and rejected the orthodox names, such as John or Giles or even Alan (Lucy and Alan Moorehead had presided at his christening, as his godparents), we decided to call him Danton after the French revolutionary. Danne had not heard of Danton before (she had never been strong on history, and a politician had to be black and armed with an AK-47, not a mere eighteenth-century whitey, to really engage her respectful interest), but she decided she liked the idea after I told her the well-known story of his last words from the scaffold of the guillotine. "Show it to the people," he declaimed to the executioner, tapping his head significantly with his forefinger. "It's worth the trouble." At least we were moderate enough not to call him Robespierre or Saint-Just.

We hired a Sicilian au pair, named Diletta Vollono. We moved into a larger flat. Given the stupendous rents landlords now charge in London,

today probably the most expensive city in the world, I should record that it was not always thus. There actually was a time when London was cheap, and this was it. Combing the classified ads one day, I came across a vacant mansion apartment in Park Road, NW1, just across the street from Regents Park. It had a living room, a dining room, a nursery, three bedrooms, three bathrooms, and a huge kitchen fitted out like the galley of an old Cunarder. The rent was seven hundred pounds every three months, a bargain then, unimaginable now. If you walked out the door and down a narrow alleyway overhung with trees you would be on the outer circle of Regent's Park, amid the chestnuts blooming with white conical bracts of sweet blossom, and the beds of roses and (in early spring) the huge drifts of yellow daffodils. It looked like urban heaven to me. We had practically no furniture except The Bed, but we signed the lease and installed ourselves. Thus we acquired a roof. And then another roof fell in.

Neither Danne nor I had any experience of looking after babies—she, like me, was the youngest of several siblings—and it wasn't too long before she discovered that on certain levels she hated having to. Diletta, the au pair, was a conscientious and motherly girl, but Danne was neither, and she began to alternate periods of intense involvement in Danton with lengthening stretches of partial and, at times, seemingly complete indifference to him. Naturally, the indifference was compounded by that Catholic speciality, guilt at being indifferent. The fact was that, almost from the start of our marriage, she felt trapped. Pregnancy had been a way to ensure getting married, but then marriage became a prison whose tyrannous jailer was Danton. If it hadn't been for him, she could have just walked away. So she decided to walk away anyway, and come back when she felt like it. I was a weak optimist and a bad strategist, and too dumb—for which the other word is "hopeful"— to figure out how far I was being manipulated, while Danne was too lazy to even think about working or contributing anything to the actual running of the disintegrating ménage. I kept telling myself that, after a painful period of rebellion against the precepts of her upbringing, she would work it out of her system and become, if not the kind of model wife held up as an example by, *The Australian Women's Weekly*—that wasn't on the cards, and I wouldn't have expected it to be, since this was after all the sixties—then at least a reasonable and, once more, a loving one. Fat chance. Danne, in the

words of Robert Crumb, had "enlisted in the army of the stoned." She didn't have something *in* her system. It *was* her system.

So our marriage began to disintegrate. It would continue to do so for the next ten years, with episodic reunions and periods of relative happiness. Somehow I managed to fool myself about this, in the short run. I thought that if we both hung on, things would right themselves, which of course they did not. My capacity for resolve had been weakened by my early Catholicism, which had taught me that divorce was morally intolerable, that it was a mortal sin, and that it would inflict real damage on the child. Also I was frightened by what might happen to Danton for merely financial reasons if Danne and I separated. I had little money, and certainly not enough to support two households. Danne had no working papers for England and absolutely no desire to work; nor was there any prospect of her finding a job, or so she repeatedly told me.

I thought it might be a good idea if Danne, Danton, and I got out of England entirely for a time.

We went, not back to Italy, but to Spain. I had never been south of Barcelona, except to Madrid, before. But the Lanceleys had gone there some time before, heading south from Granada, to the coastal district of Almería, where they had found a cottage in the village of Mojacar. They invited us to come and stay. So I got hold of a car, a somewhat scuffed and battered Fiat 1100 with room for two parents, au pair, and an infant—it would be a lot more scuffed and battered by the time we all got back to England—and set off.

Forty years ago, my notions of Spain and its society were largely formed by the left-wing literature of thirty years before that: the Civil War writings of Orwell, André Malraux, Gerald Brenan, and in general the people who lost the noble cause of democratically elected government in the Civil War. This literature was voluminous, often heartrending, and left no doubt in a twenty-five-year-old's mind that in visiting Spain one embarked on a journey tinged with moral dubiousness. One was a tourist (inescapable word) in a nation whose history had been frozen by terror, censorship, and a fiercely authoritarian alliance of Church, Army, and State since 1937. Some of my

older English friends, who remembered the Civil War as bitterly as some of my own generation remember Vietnam, refused to go to Spain at all, because spending money there seemed to them a way of giving tacit assent to Franco—as though the trivial sums spent by tourists were likely to make a difference in the context of the huge amounts poured into Madrid by Washington. As for me, I just wanted to see Spain.

FRANCO FRANCO FRANCO: black capital letters, bleached to gray by the Andalusian light, on an adobe wall by the road. They had been stenciled as a salutation by Franco's own Guardia Civil. You saw them everywhere. Then, more hastily scrawled by unofficial hands, MÁS AGUA PARA NUESTRA TIERRA—more water for our land. Then a gap in the wall, filled with flat-lobed prickly pear, in front of which a teenage peasant, brown as an Arab, brandished a handful of orange cactus fruit. I recalled lines from Eliot, memorized as a schoolboy: *Here we go round the prickly pear, prickly pear, prickly pear,* What desolation! Then the litany began again: MÁS AGUA MÁS AGUA MÁS AGUA—more water, more water, more water.

It was strange to see any slogan on any wall. Under the Caudillo, protest was illegal and praise superfluous, and in driving some five hundred miles south of Barcelona we had seen few reminders of anger against Franco: the mere existence of these Almerian graffiti betokened a misery I had not seen expressed on the walls of Catalunya, Aragón, or Castile. Everywhere one saw symbols of power, though: the black patent-leather hats of the Guardia Civil, and the red wooden ox-yoke and arrows, symbols of the Falange, which stand at the entrance to every village. Here and there, outside the arena of politics, one also saw what were then and, to a large extent, despite the efforts of sculptors like the Basque Eduardo Chillida, still are the most impressive public sculptures of twentieth-century Spain—the towering black silhouettes of steel bulls by the side of the road, some thirty feet high, silently advertising Veterano Osborne brandy.

But here in Almería, the cries for water could be seen in almost every village that perched on the gray eroded hills. Peasants had painted them there for a ceremonial drive that Franco made through the southern provinces of his realm in 1963.

The dictator refused to give any state aid to the farmers in this part of Spain—an extra twist of vengeance for the resistance his troops encountered from the Republicans of Almería.

So there were springs in the hills, but no money for dams. The baked arroyos flooded once a year but, there being nothing to hold the water, more earth was cut away and lost in the sea. By the late 1950s, whole communities of farmers were so reduced that, having torn down their roofs and sold the beams for firewood, they took to the road as *braceros* (day workers) and vagrants.

The empty mountains of the Almería coast were striped like ziggurats with the ruins of once fertile terraces. It seemed hard to believe that, under Arab rule in the fourteenth century, this district was once a flowering garden of orange and date palm, fully irrigated and rich with the mines that, for thousands of years, had supplied the cultures of the Mediterranean basin with bronze, silver, and gold. But we had visited the remnants of that culture, in Granada, where the exquisite fountains and courts of the Alhambra, with their tracery of stone and water and their hypnotic patterns of tile work, testified to the glory that had been al-Andalus, presently to be wiped out by the merciless hand of Ferdinand and Isabella in the *Reconquista*—an event that Franco's own propagandists liked to compare to his victory over the communists.

This expulsion of the Moors, and the creation of a whole class of absentee landlords clustered like parasitic insects around the court in Madrid, began the decline of the Spanish south; Franco merely intensified it. "The farmers here," one English resident remarked to me, "actually know far less about agriculture than the medieval Arabs did," and there was certainly some truth in that.

Mojacar, where we spent a month, was a textbook of this entropy. A huddle of white cubes overlooking the sea, it had been almost a ghost town in the late fifties and early sixties. Only a few years before that, I was told, the Moorish influence lingered so strongly that peasant women veiled their faces in black before visiting the town fountain to do their washing. No more than 150 people, mostly women, then lived in Mojacar: nearly all the men had migrated north to become factory *Gastarbeiter*s, sending their paychecks back home.

In 1962, the mayor of this failing community played his one card. Since there was nothing around Mojacar to attract tourists—no hotels and no money to build them with, and little to eat—he announced that any foreigner rich enough to build a house in or near the village could have free land

to put it on. This started a small land rush, headed by Sir Michael Adeane, secretary to Queen Elizabeth II, and followed by assorted movie writers (who lit on the coast after a neighboring and equally wretched village, Carboneras, was used as the set for Aqaba in David Lean's epic *Lawrence of Arabia*) and even a genuine war criminal, a sinister pederast who, as a former officer in the OAS enjoying Franco's political asylum, was wanted for murder and torture in Algeria and now ran a restaurant.

Encouraged by this small boom, the exiled natives of Mojacar began to flock back, setting up in business as impromptu builders, plumbers and—to the peril of the new holidayers—electricians. But the poor quality of new construction was offset by the red wine, at ten cents a liter, and the excellent tuna and flying fish (themselves covered with flies) which one could get in the market for twenty-five cents a pound. The sole Mojacan doctor, generous to the point of eccentricity, never sent a bill. This was a blessing to us, for Danton immediately broke out in a series of angry skin rashes. Everything and everyone seemed drugged by the relentless sun, even the Guardia Civil. Unfortunately, although Danne loved to stretch out in the sun and acquire as deep a tan as possible, I hated to, and Lanceley didn't enjoy it much either. He couldn't paint; I couldn't write, because every time I unzipped the case of my little blue Olivetti it would be the signal for some pointless family quarrel.

And there wasn't a great deal to see or do around Mojacar; even the trek down to the local *caja de ahorros* to see if the expected small draft of money had arrived from London lost its novelty after a while. At one point we were reduced to driving north to the nearby village of Palomares, distinguished only by the fact that in 1966 an American bomber had accidentally dropped two hydrogen bombs, one on the land close to Palomares and the other into the sea just off it. They were not, of course, fused and did not explode, although the first foreign journalist to arrive on the scene, an Italian Stalinist who wrote (I think) for *L'Unita*, perceiving the wilderness of abandoned, ruined mine buildings outside Palomares—the forty-year-old relics of failed mineral ventures—thought they had, and filed two thousand words of antinuclear terror before his editor in Rome set him straight. The Americans spent a fortune bringing in mini-submarines to search for the bomb in the sea, but couldn't find it; eventually it snagged a fisherman's net. The land bomb had broken apart and a small amount of radiation had leaked out,

however, and in the ensuing scare the Americans were obliged to clean up behind themselves. They did this with enormous bulldozers, which scraped off a foot of topsoil from the fields and somehow disposed of it—much to the impotent rage of the farmers. Thus the already lunar surface became almost wholly sterile. I was reminded of the glum words of Tacitus on the Roman legions: *"Solitudinem faciunt, pacem appellant,"* "They make a desert and call it peace."

But if you went down into the delta of the Río Antas, which joins the sea near Palomares, you entered a world of considerable archaeological interest. The very beach was strewn with worn Phoenician and Roman potsherds. No part of Spain is richer in traces of extreme antiquity than this part of Almería. Strangely enough, at least according to some archaeologists in the sixties, it is one of the places where England, as a civilization, may possibly be said to have begun. Twenty miles up the Río Antas is the hilltop of El Garcel—a flat mesa of loess, one of a maze of such hills separated by deep dry gorges.

This featureless plateau, perhaps three hundred by one hundred yards, was the home of a small Neolithic race known to archaeologists, from the shape of their pottery, as the Bell Beaker People. Their settlement there dates from about 1700 B.C. Not only did they make pots and knap flints, but they had an early knowledge of metal-casting technology, making weapons and small decorative objects from copper and, eventually, bronze. Over many generations, they had migrated north, across the Pyrenees, and eventually (in deerskin coracles, it is supposed) managed to cross the Channel. They left behind them on El Garcel a deposit of pots and flints that are exactly the same in style as those found in Neolithic sites in the south of England. It may well have been the Bell Beaker People who introduced metalworking to England. Colin and I spent many hours fossicking on this hilltop, filling our envelopes with fragments of flint knives, scrapers, and even whole arrowheads. Goatherds watched the mad *inglés*, looking for gold where there were only sharp stones. It was difficult, on the windy edge of El Garcel forty years ago, not to shiver a little at the irony whereby two H-bombs had fallen so close to the delicate, broken stone weapons of their makers' extreme ancestors.

At the summer's end, we made our way back to London. The main episode of the long drive was, for me, a week's stop in Madrid, where I was

able to drink my fill at the greatest museum of pure painting in Europe or the world, the Prado. I have never been able to answer the question I am sometimes asked, "What is your favorite museum?" It is like a vastly enlarged version of being asked the name of your favorite restaurant: simply unanswerable. (Actually, I have an answer for the latter: it is the kitchen of whatever house I am in with my wife Doris.) But I would hope never to contemplate a future in which I was unable to enter the Prado with some regularity. Like all great museums it is never completely seen; it is inexhaustible and, like the willow of crystal, the fountain with which Octavio Paz opens his sublime poem of love, passing time, despair, and ecstatic reconciliation "The Sunstone," "it is always arriving," *llega siempre*. But one must start any journey somewhere, and in my ignorant case there were three wholly unrelated paintings to start with. One, for the obvious reason that it was the 1960s, was Bosch's great and largely incomprehensible masterpiece, *The Garden of Earthly Delights*—a painting that has always reminded me how complete conceptual understanding of its imagery is not always essential to the enjoyment of a work of art—though no doubt it would help a lot, if we were granted such insights into the mind of the hermetic sectarian of 's Hertogenbosch. (One thing, at least, is certain: whatever Bosch was setting out, in his vast dramas of Hell, judgment, and paradise, he was not—as the hippies encamped before his work fancied—"stoned out of his fucking gourd.")

The second painting was Goya's *Execution of the Rebels on the Third of May*. When I saw it I had no idea that, forty years on, I would be trying to write Goya's life. Had such a task been suggested to me back then in 1966, I would have found it unimaginable. The painting thrilled me and, as sometimes but not often happens, moved me to tears. Even if you feel you should keep steady at the funerals of relatives, you should learn to weep in a museum. Earlier ages understood such matters. Men who could view the carnage-strewn fields of Waterloo or Albuera with outward impassivity, if not inner calm, were quite capable of blubbering at the sight of an Attic red-figure vase or the sound of Edmund Kean in *Macbeth*.

The third, inevitably, was *Las Meninas*.

The Prado today is not what it was forty years ago. The collection is pretty much the same. The public, however, is not. Very fortunately, mass tourism has not made visiting the Prado, even at peak-hour crush, the misery

that institutions like the Uffizi in summer have become. It can still be taxing, but it is seldom absolutely unbearable. What it will be like in another quarter century cannot be predicted, though it can certainly be feared. I, however, belong to a generation lucky enough to have conducted most of its esthetic education in empty museums whose echoing chambers were hung with works of art that not too many people really wanted to see. There is no point in pretending otherwise: when we go to see works of art, we want to be alone with them. Concerts and the theater benefit from being collective experiences; so do football matches and, of course, political rallies. One of the reasons Ludwig of Bavaria was called the "mad" king was that he built a private opera house and commissioned works from Richard Wagner for an audience of one: himself. Privately, I doubt that would really stand as proof of insanity, but if we are honest with ourselves we are all Ludwigs when it comes to the visual arts. I recoil from the sight of the busloads of people at Pompeii, and I am quite sure nobody in his or her right mind would rather look at a Botticelli through a grove of strangers' hairdos and armpits. The days when you could have great works of art more or less to yourself in public places are over, but I remember them, as grizzled white Kenyan guides remember the vast herds of eland or abundant lions that once roamed the hinterland of Africa but no longer do. So it was in the Prado. It had enough people in it to assure you that yours was not a mere solitary vice, but not enough to get in the way of the paintings. Much of the time, this is still the case.

So I stood in front of the *Meninas,* enraptured by its ordering, until a harsh, bird-like voice came cawing into my reverie. "Pardon, señor," it said with a sort of imperious semi-politeness, "but kindly move. My group cannot see the painting in the mirror."

I looked around and there was a Prado docent, a small, sparrowy woman dressed in brown, with a grim perfunctory smile on her face and behind her, a gaggle of a dozen or so museum visitors—Americans, by the look of them. Then, slewing my gaze further, I saw a mirror, presumably the one she spoke of. It was in a corner of the room where *Las Meninas* hung, angled so that a person just inside its doorway could see the painting reflected. The tourists were craning and shuffling to see the reflection of Velázquez's image. Then I remembered reading somewhere the long-discarded fancy of some Spanish art historian that the whole scene Velázquez painted was a

reflection in a mirror, so that one should see it in another mirror to reconstitute its "truth." Of course, it was not; the picture was a fictive construction of Velázquez's studio room in the Escorial, where he is seen working on a huge painting we do not see, accompanied by the little blonde Infanta, her maids of honor Doña Isabel de Velasco and Doña María Sarmiento (the *meninas* of the title), the dwarf Mari-Bárbola, and the big drowsy mastiff being teased by the cheeky foot of the midget Nicolás Pertusato. And who is "witnessing" this scene? Whose eyes do we see it through? None other than those of Philip IV and his queen, who have just entered the chamber. It is they whom Velázquez, the Infanta, and the maids are recognizing, they whom the dog is ignoring. And just to make sure you know, their reflections— grayed, blurred, but unmistakable—are seen in a *painted* mirror, on the distant back wall of the chamber, at the vanishing point of Velázquez's composition.

So who were the folk in the Prado's administration who decreed that the *Meninas* alone, out of all the thousands of paintings in there, ought to be seen reversed in a mirror? Apparently someone in charge believed this. No matter. I politely told the docent that the way to see the painting was as its creator intended: by standing right in front of it, as I was doing, and looking straight at it, ninety degrees to the picture plane. I might as well have been talking to a wall, and a bad-tempered wall at that.

"Señor, you must stand aside from that painting and let others see it in the mirror."

No way, José.

"Señor, where do you think you are? This is a museum!"

Oh right, forgive me, señora. Silly me, I must have thought it was a used-car lot or maybe a tapas bar.

"Señor, remember that you are in a museum. *And get away from that painting!*"

I have never forgotten this injunction.

Things with Danne only got worse back in London. Almost as soon as Danton was weaned, Danne announced in a way that would admit of no opposition that she needed to "explore," to "look around," to "experiment," with other lovers—a declaration that caused me, since I was still a Catholic

in some parts of my heart, an anxiety verging on dread. Now she set about her exploration in earnest, like some Magellan preparing for a voyage across the uncharted sea wastes of some sexual Pacific. I had wanted, by getting married, to reconstitute the safe haven that had been shattered in my childhood by Dad's death: the dream of untroubled certainty of a woman's love, which I would repay with my own coin of protectiveness. But Danne wouldn't admit that she wanted protection, and she interpreted my own desire for emotional security as a form of weakness. "I want to find my own fucks," she said once, with her accustomed brutal directness. "So should you." It was no use saying I had believed we both had. I thought of marriage in terms of commitment and faithfulness. This did not mean I was any kind of saint—only that I had hopes of peace and mutual fulfillment. The model before the eyes of my memory, always, was Mum and Dad, who never "experimented." Now, it seemed, by some malignant turn of fate I had married their exact opposite. Danne would find someone to fuck whenever she felt horny, or for that matter, quite often when she was not horny. For her, the search was the thing. She equated it with freedom, Grail or no Grail. Her ruthlessness in pursuit of this reduced me to stammering misery. Off she would go in the evenings, dressed to kill: a gauzy antique top embroidered with the iridescent wing cases of exotic beetles, which she had found somewhere in the King's Road; a pair of scuffed-up black German lederhosen, complete with the ornamental metal belt known as a charivari; high inlaid boots of various colored skins. A dish for some minor rock star or visiting American undergrounder. Where was she off to? Oh, to see never-to-be-named friends, or to a concert in which I would not be interested (that much was certainly true: I had no taste for the collective hysteria of rock concerts), yet another jiggle night at the Roundhouse. Don't worry, I'll be home to feed Danton. Or Diletta can do that. Don't *worry*, for Christ's sake. And off she would go; and come back, gray eyes blank, wide mouth twitchy, ill-tempered from the drugs, at ten the next morning. Or not come back for another day or two. It was like living with a deranged alley cat; moreover, an alley cat who ascribed her libidinal raging to ideological purpose. Once, when she fell into one of her fits of hysteria on entering the flat, I stroked her hair to comfort her and encountered a crusty patch of some stranger's dried semen.

She liked counterculture icons but generally tended to score mediocre ones. An exception was Jimi Hendrix. She did not tell me about this. Some

girlfriend of hers did. I think it was Hendrix who gave her a sentimental souvenir of their encounter in the back of a limo: the clap. She did not tell me about that, either, before passing it on to me. It was a nasty strain and it took months of antibiotics to shake it. Hendrix's clap almost outlasted Hendrix himself, who died of an overdose in September 1970.

The obverse of the passion she showed for me—which was real enough, since Danne was as incapable of feigning emotion as she was at repressing it—was a completely anarchic commitment to impulse with others. Intelligent but intellectually unformed, she was a sort of flying test bed for every "revolutionary" phantom she could pluck out of the London air, which was thickly populated with such phantoms. Extreme in all things, she finally declared herself to be gay, but she didn't merely come out of the closet; she burst its doors off their hinges. But that was for New York in the late 1970s. In the sixties and early seventies, she was mainly heterosexual, screwing with abandon most things that moved, as long as they were male.

I certainly was no anchorite then; partly in self-defense, and in the hope of a little emotional reassurance—for Danne's near-programmatic infidelity was devastating—I had several affairs with women myself during this time. But I am glad that I never bought into the absurd "fuck-and-you-shall-be-free" ideology that was so common in London and elsewhere at the time. I sensed then, and know with a fair degree of certainty now, that it is an illusion to suppose that sexual promiscuity helps create personal freedom. There is a huge difference between the condition of freedom and that of accepting no responsibilities to anyone.

Some people in the underground invoked the Surrealists on matters of love, but they had it all wrong. Hippie love was not Surrealist love. The Surrealists imagined love as exclusive, concentrated, and liberating *because* it was obsessive, once the free choice was made. The Surrealists were at least partly right, but the hippies were invariably wrong. Though I had no right to call myself a Surrealist and never did, I felt more in common with them—starting with my Catholic origin (for Catholicism was the great provocation of Surrealist revolt), than I did with the stupefied herbivores nattering about karma in late-sixties London.

Promiscuous by nature, Danne was also remarkably credulous. She subscribed to most of the modish superstitions, both spiritual and political. She paid a great deal of attention to the pseudoscience of astrology, and was

apt to base her attitude to total strangers, dead historical figures, and even to pets on what she imagined she knew of the planetary conjunctions, star signs, and other celestial accidents that had, according to this or that amateur sage, attended their birth. Did I know that Hitler was a Virgo? What was Beethoven's rising sign? Perhaps, if haruspication had been in vogue on the Kings Road, she would have busied herself excising and scrutinizing the livers of goats or sheep. She made pointless efforts to alter our diets in terms of the yin or yang content of various foods, such as lamb chops, artichokes, or porridge. In vain I would try to point out to her that some of the worst slaughterers in history, notably the Führer himself, had been vegetarians and therefore, in theory, full of peaceable yin. But, as she pointed out, that was just exactly the kind of thing a Fascist like me would say.

Like many other hip Londoners of the time, she was obsessed with the *I Ching*, or Chinese "book of changes" as a guide to behavior, and whole weeks would go by during which she could scarcely bestir herself even to go to the bathroom without casting the coins and scrabbling through her battered copy of the *I Ching* for the meaning of the relevant hexagram. Quite often, if the fall of the coins did not produce the prediction she wanted, she would throw them again and even again until it did. If the ancient Chinese themselves, I sourly reflected, were as irksomely incapable as Danne of moving a finger without consulting the coins or yarrow stalks or cracked bones or whatever they used in their predictions, no wonder that the Celestial Kingdom changed so gradually.

Yet this tolerance, not to say reverence, for archaic superstitions wrenched from their real cultural context did not extend to everything. This was shown to me with some clarity in 1971, when we were all en famille in Bali, staying with Donald Friend. Donald, in relating the wonders that the island held in store for the mentally prepared tourist, urged us to visit the sacred bat cave or temple of Klungkung, Goa Lawah. In this enormous cavern on the east coast of Bali lived countless millions of bats, which attracted thousands of tourists—not necessarily because tourists love bats, but because there wasn't much else to see in the area and the idea of a sacred space crammed with repellent little winged mammals seemed so intrinsically odd. Moreover, it contained a lingam or holy phallic pillar, around which, from time to time, there was coiled an enormous albino python. "And when it feels the pangs of peckishness, my dears, it just reaches out and *has a bat!*"

An instant shudder; a houseboy was called, and told to arrange a car and driver for us the next morning.

The cave was sixty miles up the coast road, reached by a slow weave through the tricycles, small lorries, and cattle that are the staple and curse of Balinese traffic. By the time we got to Goa Lawah I was feeling a little carsick, but not as ill as when the stench of the cave hit us. In that hot, humid air it was a miasmic wall: pure guano. In the cave were numerous small pagodas, each encrusted with bat shit. Its surfaces seemed alive, a rippling mass of bats clinging to one another and to the stone. The air was thick with them, flitting about and gibbering with inaudible resentment at our intrusion. The floor of the cave was carpeted with inches, perhaps feet, of their brown dung, sticky in consistency, like a peculiar form of toffee. At the entrance to the cave was a crudely lettered sign announcing, in English, that this was a holy spot and that "ladies having their monthly periodicals" were forbidden to enter, lest their presence defile it. Was there perhaps a menstrual inspector? Danne snorted with mirth and continued to advance into the cave. She switched on the flashlight Donald had lent us. And there, sure enough, was the holy lingam, planted on a rock, with the snake coiled round it. It was an impressive snake, too, and it seemed to be at least eight feet long—a constrictor of some sort and, as Donald had promised, dead white in color. Its little eyes shone creepily, reflecting the light. I instinctively recoiled. I have an aversion to snakes, even nonpoisonous and supposedly harmless ones. None of them look harmless to me. Danne, however, took a step forward. "Jesus Christ!" she breathed in awe. "What a pair of boots that thing'd make!"

Her big jump away from me was in 1969, when the Living Theater came to town. The Living, as hip people liked to call it, disbanded long ago, but in 1969 it was the sensation of London—indeed, of the theatrical world in general, especially among those who did not regularly go to plays.

It had been started in the late fifties by two experimental actor/directors, Judith Malina and her husband Julian Beck. In 1959 it had created a sensation with a production of a play by a young American dramatist named Jack Gelber: *The Connection*, a drama about drug addiction, extraordinarily powerful because of, or despite, what Ken Tynan called "the action—or rather, the

neurotic inaction" of its effort to reproduce the mystique of hard dope. *The Connection* became a hit, very largely due to Tynan's enthusiasm for it. He talked it up with unflagging zeal.

Some of the elements in certain of the Living Theater's early productions had a long afterlife in popular culture. An example was *The Brig:* one of its scenes, in which prisoners are seen ranked in their cells behind the "transparent wall" of an iron grid, became one of the great carceral metaphors of its time and was copied in a big dance sequence in Elvis Presley's *Jailhouse Rock*. Then, decades later, it was also copied in an even more elaborate passage in the film version of *Chicago*.

But more important, from the sixties' viewpoint, was Beck and Malina's shift away from scripted drama to a sort of loose ensemble acting, which relied greatly on improvisation, both verbal and physical. Few of the actors were professionals, and they relied more on "acting out" than stage acting in any disciplined sense. By the late sixties, when they took their theater on tour in Europe, the Becks had assembled a strange and motley troupe, some of them skilled thespians, but mostly supercharged freaks. The classical division between stage and auditorium was collapsed; in their biggest production, *Paradise Now*, the actors would go down into the audience, picking out individuals, stroking and patting and groping them: "Holy breasts," they would intone. "Holy hand. Holy belly. Holy lips." These contacts could be acutely embarrassing unless you hopped into the spirit of the moment, which not everyone could—or wanted to. One evening at a performance at the Roundhouse, one of the Living cast zeroed in upon, of all people, the publisher Sir George Weidenfeld, whose own moral and cultural ethos could hardly have been further from the Living Theater's, and started his holy-this-and-that routine. George was alarmed but did not lose his cool. He fished out his wallet and waved it at the intrusive actor, like garlic at a vampire. "Holy money," he said unflinchingly.

Danne fell in love with the Living Theater at the very first performance she saw, and shortly thereafter took up with one of its actors: a short, muscular American named Mel Clay. I never met him and knew little about him, except that a brief paragraph or two by him, ecstasizing about the effects of super grass, appeared in a now obscure anthology, *The Book of Grass*—charmingly Whitmanesque title!—edited by the Dutch drug enthusiast Simon Vinkenoog. (Twenty years later a still-short, still-muscular American

accosted me at a book signing in Chicago. "Hey man, remember me? How's Danne?" I was flabbergasted, and told him that she was now officially a lesbian. He, in turn, was flabbergasted, too.) Before long she had tried to move in with Clay, into the digs the troupe occupied during their London season: a boardinghouse in Paddington named, with rough irony, Witts End House. Clay resisted this move: on a certain level, Danne was too much for him, which was hardly surprising. She told me about one of their violent tiffs where she said he pushed her downstairs and she fell through a glass door in the lobby, proving her near-indestructibility by smashing it to shards but sustaining only minor cuts herself. Whatever actually happened, it, like the cuts she showed me on her arm, was a testament to the violence of their relationship.

Meanwhile, Diletta bravely continued to tend little Danton, and I went into a moping spiral of helpless, unassuageable jealousy. I was a cuckold, going cuckoo. I was bewildered, shellshocked, and lacking the necessary defense of indifference. Then, when *Le Living* (as the flea circus was called by adoring French culture radicals) moved on to Paris and thence to North Africa, Danne insisted on going too, leaving Danton, aged not quite two, behind. Since I was not confident of being able to fulfill his needs, I was immensely grateful when a motherly, nanny-equipped, and country-dwelling friend stepped in to offer him houseroom in her family nursery until Danne came to her senses and returned to England—if she ever did.

Her plan was to go to Algiers, where a radical pan-African congress was being held. She wanted to report on it for O_z. What Danne knew about sub-Saharan politics could have fitted comfortably on a postcard from Timbuktu, but on the other hand neither O_z nor its readers knew anything about them either. The real reason for going was that a group of Black Panthers were living there in a hotel, in temporary exile from America, reputedly stalking about festooned in bandoliers; led by Eldridge Cleaver, they regarded all white men as devils and all white women as hoes pining to be raped. Danne hoped to find what life with these paragons of indignant machismo was really like. But when, arriving in Algiers, she presented herself at Cleaver's hotel he sensed trouble and remained one of the few male radical celebs with whom, in 1968 and '69, she had not had sex.

Rejected, Danne went back to the Living Theater, which had just migrated for a bit of rest and recuperation to a place on the other side of

North Africa, a picturesque, sunstruck fishing port on the Atlantic coast named Essaouira. I realized where she was (though I had to look it up on the map) when a disjointed letter bearing its postmark arrived, accusing me of tyranny, patriarchalism, whiteness, and various other shortcomings but not asking how Danton was. Bliss with Clay was resumed, but then it evidently came unstuck again, because, after an absence of three months, she turned up in London, lugging with her a bundle of Moroccan textiles, a fringed Moroccan leather saddlebag, and a tiny Moroccan djellaba for Danton which, with its embroidered hood, made him look like a deranged pixie. She had also brought a small ugly Moroccan mirror, set in a thick leather-covered plaque about two feet square. It proved to contain an impressive brown brick of hashish weighing at least a kilo, which—because she had the luck of the devil, and the airports, in those days, had no sniffer dogs— she had managed to carry unmolested through both Spanish and English customs.

Some of this dope she kept, some she sold, and with a minuscule amount of it she baked a cake. During her long absence in North Africa I had struck up a relationship with a French girl in Paris, a student at the Sorbonne who supported herself by part-time modeling. Nicole was nervous, not to say prudish, about *les eepies,* but she was curious about dope; being rather a *jeune fille bien élevée,* a flower of the Sixteenth Arrondissement before the merry month of May 1968 had arrived, she had never actually tried any, for these were the early days of drug-culture among the middle-class kids of Paris. So I put the big hash cake in a delicately beribboned leftover pastry box from Fortnum's, packed it, and took off for Paris. On being shown the cake, Nicole recoiled slightly. How much hashish was in it? I didn't know, I said honestly; I hadn't been there when my wife baked it. Nicole gave me an extremely skeptical look. In the end we each ate a tiny morsel, smaller than a baby's pinkie, before setting off to dinner at a Burgundian restaurant she favored. I realized that something was seriously wrong when the first course of the evening, a thick rich slab of country pâté, was set before us. As I gazed at the surface of my portion I saw it separating out into its constituents. Tiny, perfectly formed molecular cows, pigs, and chickens, each complete in itself, pullulating in harmony. God alone knew what Nicole was seeing; she sat there, stoned to the gills, speechless and unable to move. The tiny amount of hash Danne had put in the cake was strong enough to stupefy the whole

Moroccan army. I made a feeble joke about Charles Baudelaire and the Club des Haschischins, rose to my feet, fainted, keeled over, and cut my forehead open on the corner of a table. Streaming blood, I was half-helped, half-bounced from the restaurant by some very hostile waiters muttering about *ces sales cons Anglais,* with poor Nicole bringing up the rear. I spent the rest of the night at her flat in Les Halles, but she would never see me again, not ever, and that was that. I have no idea what she did with the remaining cake. Probably she threw it out, but if the rats of Paris got it they must have had some merry nights.

Back in London, I remained too cowardly to go after a divorce, fearing that I would lose Danton—the almost invariable habit of the English law was to award custody and control of an infant to its mother, except in the case of moral turpitude. No doubt I could have proven moral turpitude, too—drugs, extreme promiscuity—but I didn't have either the guts or the moral conviction to do that; in any case, Danne, with her back to the wall, could undoubtedly have produced enough witnesses who had seen me smoking dope, and inhaling vigorously as well, to make me look turpitudinous enough for any judge. What then? Would Danton be taken away from both of us, and become a ward of the court? I couldn't face it.

What wrecked her life in the end, as it wrecks the lives of even the toughest, was her graduation to hard drugs, heroin and then cocaine, which she not merely inhaled but injected.

Some people are terrified of needles. I am one. When I was a child and the doctor in Sydney wanted to give me an injection, I would flinch in terror; dentists, sticking a needle in my gum with the mantra "It's just a little prick, it won't hurt," filled me with dread. (Nevertheless it became a useful phrase to repeat to myself when some critic, usually Australian, gave me a bad review.)

But there are people who positively enjoy the feeling of sticking themselves or being stuck with a hypodermic needle, and Danne was one. She got a sexual charge from it.

I have never been 100 percent sure who got her on the needle, but I think it was a friend of ours, a painter named Brett Whiteley. I had only known Brett casually in Australia, but our friendship began in London in the early 1960s. He was, beyond dispute, the golden boy of Australian art at the time. His work had been seen in the show organized by Bryan Robertson at the

Whitechapel Gallery in 1961, where it had brought down a small cataract of praise. The prestigious Marlborough Gallery had taken him under contract. At the time Brett and I became regular friends, he was living in a huge studio in Addison Road, W14, once the workplace of the great Pre-Raphaelite painter William Holman Hunt, John Ruskin's friend and ally, creator of *The Scapegoat* and other icons of the Victorian imagination. This was attested to by a plaque on a huge, gnarly tree trunk in the garden outside the studio door. "Sir William Holman Hunt, RA, PRB," it read, "used to play with his children around this tree." So did Brett, with his enchanting blond daughter, Arkie. He was engaged on a series of what his friends called his "Brides in the Bath"—delectably sexual nudes of his young and lovely wife Wendy in the shower, which for erotic content far surpassed any depictions of the human body previously done by an Australian artist.

These visions of happiness then modulated into something much less innocent, a sequence of paintings on the journalistic theme of the sex-murder of prostitutes. One of the all-time English celebrity perverts, John Christie, had poisoned girls with toxic household gas, raped and then dismembered them in his slum house at 10 Rillington Place in London. Later he stowed some corpses under the floorboards and buried others in the back garden. Among them was the wife of a dim young friend of Christie's, Tim Evans, who had the mental age of a not very bright child, and was wrongly indicted for some of these murders and hanged; his complete innocence, Christie's guilt, and the bizarre scale of his killings, were not discovered until later. All this had happened years before (Christie was eventually hanged) and had entered the domain of folklore: songs were written about it, including a ballad, "Go Down You Murderer," whose last verse ran:

> *They sent Tim Evans to the drop,*
> *For a crime he didn't do:*
> *It was Christie was the murderer,*
> *And the judge and jury too.*
> *Sayin' Go down, you murderer, go down.*

Brett was feverishly excited by this sordid, and very English, horror story. Perhaps unconsciously, he seized on it as a subject that would enable him to rival the one great folk ballad of Australian painting: Sidney Nolan's celebration of a criminal hero, Ned Kelly. (Brett didn't treat Christie as any kind

of hero, though; in fact, if the Christie of Brett's paintings looked like anyone else at all, it was the high-domed and clerkly Adolf Eichmann.) But it also allowed him (by no means unconsciously) to claim some psychic kinship with the figure he most admired among living English artists, Francis Bacon. Brett passionately envied Bacon's vision of evil, which was real and absolutely unforced. In Brett's eyes, filtered through art, it was also glamorous. Brett idolized this in the way that fans idolize champion stock-car drivers. He thought it had lessons to teach him about "existential" risk. That was how he rationalized his own growing addiction to heroin, and justified his stupidly aggressive belief that he had the right to judge whether smack was good for others, and to urge them to try it. He failed to persuade me, despite hours of proselytizing during a night in London when we were both stoned on hash and he wanted to get higher. But I strongly suspect, from hints she dropped to me, that he did persuade Danne, and this broke the back of our friendship, which I regretted, since a drug-free Whiteley could be delightful and even illuminating company. The shame of addiction, which can be very pressing, is apt to make junkies into missionaries. They like, and need, to drag others down with them. Such aggression compensates for their own weakness and dependency with drugs.

What I think Brett admired most of all about Bacon the man, rather than Bacon the painter, was his incontestable toughness, his ability to live right on the edge: the gambling, the enormous alcohol binges, the rough trade, the seemingly total disregard of his own psychic safety. What did Bacon think of Brett? I didn't know Bacon well enough to ask him; my acquaintance with him was limited to a few evenings of drinks in the Colony Room, a bohemian haunt in Soho run by a raddled, benign old creature named Muriel Belcher, of whom Bacon made several portraits over the years. But according to others who did know him well he thought of Brett as a sort of frisky pup, very talented, no question, but not tough enough to be particularly interesting as a moral being. And Bacon, despite his spectacular reputation as a libertine, was also a moralist—admittedly of an uncommon sort.

One thing is glaringly certain: Brett's addiction did his art no good at all. He thought it did, of course. Junkies often think that. He once defiantly inscribed the initials WS—"With Smack"—on one of his prizewinning Australian paintings, just so that those in the know would know. Whatever losses may be forced on junkies by their habit, they are apt to claim that these

have been net gains, compensating them in some measure by a deepening of their perceptions, and consequently of their art. Actually, this has never been provably so. The examples often cited for the defense—the classic one, of course, being the interrupted opium dream on which Coleridge's *Kubla Khan* was based—come nowhere near outweighing the countless malformations, abortions, and confusions of talent brought about in writers, painters, and musicians by the use of heavily addictive drugs. Can anyone who really knows music lay his hand on his heart and honestly swear that Charlie Parker's or Ray Charles's musical achievements were greater for the insights granted them by the needle? In writers and painters, whose work is even less the product of brilliant moments of improvisation, where it demands the steady elaboration of complex and even rational sequences, the benefits of heroin are even less arguable. And that does not begin to count the terrible toll addiction exerts on the equanimity, the inner strength of reflection and self-criticism that are essential to the creation of serious art. In Brett's work, as his addictions wore on, this confidence was replaced by a sort of pictorial cajoling and blustering, a harsh rhetoric of extremism and—reluctant as one is to use the words—a defensive vulgarity that for many people, myself included, rang false. The fact that it was often deeply felt didn't matter.

Brett could be a brilliant poet of sensation, but as a philosopher, which was how he aspired to be seen, he was mostly an Orientalizing dingbat, a poseur. His best pictures—though perhaps here I generalize too much, since they were by no means his only good ones—were his scenes of Sydney Harbor and the beach: that deep, dark-blue field of pleasure, sewn and stitched by the wakes of white yachts, traversed by the immense arc of the bridge; or that yellow sand with the Matissean bodies and inlaid towels twisted on it.

His worst were the ones in which he cranked himself up to make an Important Statement about the Meaning of Life, and of these the absolute nadir (at least to my own knowledge; there may have been worse ones, but I never saw them) was a gigantic affair, some fifty feet long, entitled *Alchemy*, which was purchased in a very mistaken moment by one of the heirs to the Packer fortune in Sydney. His appreciation of Zen Buddhism, which he talked about constantly—and not ad nauseam, either, for he could be quite witty about it—was basically no deeper than that of the American beats of a generation earlier—all rattle, no silence. No Zen adept would have endured

a life with as much ambient noise as Brett's, and of course the use of any kind of drugs was utterly contrary to the spirit of Zen.

Unfortunately, though, the Australian art market was hot to trot with a *poète maudit,* a parody van Gogh for the really rich and really vulgar—those on whom the market depended, there being so little informed connoisseurship in Australia. The more Brett's wild-boy reputation grew in encroaching middle age, the more his work was pursued by every kind of real-estate speculator and shady white-shoe operator on the Gold Coast: he was, par excellence, Australia's cultural mascot for the semi-cultivated, and he needed to be, because the first rule of addiction is that smack costs money. Very little of his late work shows more than traces of the fierce and consuming curiosity, the headlong linear grace of the early Whiteley; the style began to get sloppy and predictable, overcharged with reliably thoughtless mannerisms. Often I would think of Alexander Pope's couplet: "A fiery soul, which, working out its way / Fretted the pygmy-body to decay." With his frizzy red-blond curls, his bright eyes and questing nose, his swift movements and the black wool mittens that he wore, even in the heat of the Australian summer, to hide the needle tracks on the back of his hands, Brett looked like some marsupial emanation of the bush, a bandicoot perhaps, or a possum. The crowning absurdity came after his death, when his widow, long since divorced, in fact, managed to cut a tax deal with the New South Wales government to have a property in Sydney dressed up as Whiteley's studio, a sort of antipodean version of Delacroix's studio in Place Fürstenberg or the Frida Kahlo house in Mexico City. This became a minor place of pilgrimage. When I visited it, there seemed little point to it—a period-room evocative, at best, of only blurred memories. Yet I will never forget him, even though it is more than fifteen years since that bad night when, in a holiday motel on the coast south of Sydney, he shot one syringeful too many and so died, at fifty-two, unconsoled and alone.

Wading in Florence

In addition to writing, I now started appearing on British television. I had done little TV work before I got to London, although I had appeared, once or twice, on breakfast chat shows. The very idea seemed exotic and remote: I had never even owned a TV set. The medium was not part of my growing up. I saw my first television program—grainy black and white, a Western of some kind, its name forgotten—when I was twenty. Noeline's parents had a set and sometimes I would go over to their suburban house in Sydney and sit on the sofa with her; they generally retired to bed around ten o'clock, which left Noeline and me alone to neck in the flickering bluish light of the tube, desultorily watching imported American programs like *77 Sunset Strip* and a detective show named *Dragnet*, starring the grim, gnome-faced Jack Webb. The idea that I would ever appear on this peculiar and unpromisingly stupid medium, let alone make an income from it, never occurred to me.

This changed when I got to London—not through any intent of mine. It happened that Sidney Nolan was having a gallery show of recent work in London. The BBC wanted to do a short program on his work. Nobody there knew very much about it, and the only art critics who did seem to know something were, for one reason or another, hopeless on TV. Then someone (to my shame, I cannot remember who) mentioned to the producer of the cultural magazine program for which the item was scheduled that a Pelican book on Australian art was about to appear, and that its author, a young Australian in his twenties, had just moved to London from Italy. Wheels turned; phone calls were made. The producer very quickly ran me to earth.

Her name was Lorna Pegram, and we were to work together, on and off,

for the next fifteen years. Most of what I learned, and now know, about how to do TV I owe to her. She was my mentor, my mama-san, my dear and irreplaceable friend, and no one else has filled the gap her death left in my life. She could be a maddening woman—but only now and then. Some of the time, she found me hard to bear, too. I still miss her badly.

To get a look at her, you must imagine a rather stocky English blonde in her late thirties or early forties—I never asked her age. With her long, horsy upper lip she looked not unlike a softer, feminine version of the great French film comedian Fernandel. She was extremely articulate, insecure, motherly, vehemently loyal to her friends, and always afraid of small or large betrayals. Her love life, as I was to discover later, was usually disastrous, and she kept going much of the time on a combination of Valium and single-malt scotch. (I should perhaps add, in the interest of fair disclosure, that Lorna and I never had an affair, not even a one-night stand while away on location, in all the years we knew one another, and that this was just as well, given the havoc it might have inflicted on our working relationship.) If she had been allowed her druthers, she would have been a full-time fiction writer. But she had children to support, and although she had written several novels which won lukewarm approval as "serious" and "sensitive" from English newspaper critics, none sold at all well. Writing fiction in England—perhaps anywhere—is a métier in which only a few succeed in making a decent living, and the majority go to the wall.

So she had worked as a producer and director, mainly of cultural documentaries, for ten years before we met. She was now employed by BBC2, the "highbrow" wing of BBC television, which had been started in the sixties. Her kind of work had no relation to anything in American (or, needless to add, Australian) TV, because, like most of the products of the BBC in those days, it assumed and respected a certain intelligence in its viewers: an ethos directly transmitted from the BBC's founder, Lord Reith, who insisted that although numbers counted, quality counted for more. This held true all the way down the line. The years when the BBC would besmirch itself with imbecilic children's (or rather, fetus's) programs like *Teletubbies* or the sight of Rolf Harris, the Australian washboard virtuoso and author of "Tie Me Kangaroo Down, Sport," pretending to be Vincent van Gogh, mercifully lay far in the future. The BBC that I had wandered into in 1966 was more like the cultural pages of a quality Sunday newspaper. And like them, it was to a

great extent made and run by misfits, by exiles from rough-and-tumble jour-
nalism, by what Australian editors of Fleet Street tabloids unhesitatingly and
dead-accurately pegged as effete pseudo-intellectuals and bloody elitists: my
kind of folk, in short. It was a refuge for those who have never chased a star
or an ambulance in their lives, and would not even consider doing so.

Of course, doing things for BBC2 had its drawbacks. You did not, for a
start, get rich on it. I think I was paid fifteen guineas for my inaugural six-
minute piece on Sidney Nolan, rising to an average twenty guineas per "con-
tribution" after. Expenses were minimal; people in "real" TV might swill
heady vintages of Margaux, eat roast beef with *pommes soufflés* and ride
about in limousines, but at BBC2 the menu tended more toward lukewarm
lager and lamb vindaloo in an Indian restaurant. Beeb-Two was frugal in dis-
tributing its taxi vouchers, and (without saying so) preferred that you took
the tube. (There was a station of the London Underground conveniently
near the main entrance of BBC-TV at White City, the big circular building
around whose puzzling circular corridors the BBC employees would drift
and wander like, I often thought, the poor sodomites in the Inferno, forever
running on their ring of burning sand. But I was never able to find an Under-
ground station anywhere near the building in which BBC2 was housed.)

Lorna fitted into this environment perfectly. Her workplace had a bar,
where she would install herself. There, she would hold court, plan pro-
grams, and grumble sometimes about the rates of pay, compared to the earn-
ings of those who worked in American network TV. She disliked the glacial
movement of promotion within the BBC, but would she have been happier
in a more cutthroat business environment? I doubt it. She had a strong colle-
giate streak and sometimes reminded me of a she-don, with a camera instead
of a thesis subject. I cannot imagine her making television if Beeb-Two had
not existed. The mid-sixties was, in my recollection, a wonderful time for
intelligent and serious TV in England. In Beeb-Two, I never heard the word
"ratings" mentioned. It was simply assumed that you did your best to create
high-quality programming for reasonably intelligent viewers, to whom you
did not condescend. The saber-toothed technocrats who would presently
move in on the medium were not yet born, or at least not raised. The talent
in and around the organization was not ashamed of its aspirations or, as the
Murdoch boys and girls would call them now, its "pretensions." Its leading
lights, mostly in their thirties, included Tristram Powell, son of the novelist

Anthony Powell, who made some of the finest "literary" documentaries in the BBC's history; Melvyn Bragg, Gavin Millar—a small gang, who (however briefly) were not just allowed but actively encouraged to make genuinely literate television. And although I never made a film with him, I felt especially lucky to know and often see Julian Jebb.

Julian is now largely forgotten except by those who knew and loved him—which, since he died in 1984, is now a dwindling band. He was one of those slender and agile, sprite-like creatures whom, you would think, any institution would crush with its weight, and yet who managed to flourish in its cracks: Ariel, incongruous son of Leviathan. For he was the grandchild of that ponderously spouting bête noire of my Catholic childhood, Hilaire Belloc. His sister was a nun, and he had been educated at the great Benedictine college Downside, of which his brother was to become the abbot. So we shared both a Catholic culture and our rebellion against it: Julian's more intense than mine, since he was homosexual (not "gay," a word he hated worse than any other). Julian wanted to be a writer. It is not unfair to say that he was obsessed by this desire. And he did write—occasionally—but only short articles and reviews, never a book. The articles contained sparkling mots, sentences, indeed whole paragraphs, but they could not amount to an anthology. Among the people he was the first in England, or nearly the first, to praise in print were that great and implacable satirist Barry Humphries and the movie critic Pauline Kael. Among the people he did TV documentaries about and interviews with were Evelyn Waugh, Christopher Isherwood, John Osborne, and the Mitford sisters, Pamela, Diana, Deborah, and Jessica. But the book—the book never came. It (whatever it was to be: a novel, he hoped) was scarcely even started. And his diaries, which in any case were only irregularly kept, were all destroyed in a fire. When he remarked that "The Devil lays eggs in idle palms," he certainly knew what he was saying.

So very little remains of Julian, except in others' memory. He was a gentle monument of self-doubt and (occasionally) self-reproach. He loved to talk about nearly everything and did so with flashes of extraordinary brilliance, for there was practically nothing he had not read and little he really liked that he had not memorized. His mind was a memory palace of unpredictable associations, one chamber opening into another into another and into a fourth. His self-doubt had an epic quality.

On a good day, Julian looked like Peter Pan; on a bad, a very bad day, as one of his friends remarked, he more resembled E.T. He was said by another BBC friend, David Cheshire (also a suicide, alas), to have actually had himself certified as a dwarf to evade conscription. Nobody could have called him handsome, and this made his erotic life very unstable and uncertain: he had great difficulty, I think, in believing that he could truly be loved. But he was; he inspired affection because he spread so much of it about. He was not self-effacing, but to impose the hungry self on others seemed to him an intolerable act of aggression. So, living so long in America, I often think of Julian, who committed suicide in 1984 when he was just fifty (sleeping pills and Évian, I heard, no tap water for Jebb). I think of him when I hear some narcissistic dolt of an artist braying about his present originality and future place in history. I think of him when in the company of some oafish collector who just bought a Jeff Koons but thinks Parmigianino was a kind of cheese. I think of him when I see some upward-bound museum curator licking the boots of his future trustees. I think of him when I read or, worse, hear a critic spraying smelly droplets of jargon around. Do I miss him? Yes, still, and always.

My basic work for the BBC, for which I was paid as a freelancer, consisted of contributing shortish essays to cultural-magazine programs, all of them either produced or in some way overseen by Lorna Pegram. Generally the text would be printed out with an enormous typewriter on a scroll of yellow paper, which would unwind behind a system of mirrors in a box fitted in front of the camera lens. This enabled you to look directly into the camera, and thus speak to the viewer at home in a frank, spontaneous, and manly fashion while actually reading what you were saying. It was a tremendous boon to politicians and others in authority (one has only to imagine what a hash some verbally gangling and semi-dyslexic galoot like George W. Bush would make if he had to deliver a small policy speech without reading it from an autocue) and it was a big help to minor creatures like cultural reporters—its only drawback, for us, being that the autocues available in the sixties were too heavy and clumsy to be used in anything other than controlled studio conditions, so that you didn't have the benefit of them on the street.

We always had tiny teams—cameraman, sound, grip (who moved things around), lighting man, and director. Sometimes I would observe with envy,

not untinged with contempt, the relatively gigantic *équipes* of other broad-casting companies, especially the American ones, whose gear, gadgetry, and transport facilities were to our primitive setups what the U.S. Sixth Fleet was to a Grimsby trawler. But we didn't get to see these very often, since neither the "commercial" channels nor, of course, the American companies were even faintly interested in reporting on art exhibitions or interviewing writ-ers. What would have been the sense of that, for the General Public?

But at least we were mobile, though in tourist class. I did a report on kinetic art, the then-novel movement in Paris, interviewing Vasarely, Soto, Pol Bury. (I loved Bury's work, which had little stubs protruding from holes in a backboard; every so often an eccentric hidden mechanism of wires and strings hidden by the board would make one of these little shapes move, unobtrusively and unexpectedly, so that you wondered what you had seen and indeed if you had seen it at all. It was like watching a sea urchin on a rock, occasionally moving its spines in a quite unanticipated way.)

I did a program with Marcel Duchamp, to go with his retrospective at the Tate. (In the course of this I asked Duchamp if he would mind signing my catalog. Obligingly, the old gentleman did so. "So is this a readymade now?" I asked. (A "readymade" was a class of object, more or less invented by Duchamp, which is chosen by an artist for its esthetic or other interest and designated, by that artist, to be a work of art. Examples: the famous porce-lain urinal exhibited by Duchamp in New York as *Fountain*, or the spiky bottle-drying rack.) "Oh no, Monsieur Hughes," he retorted gently. "*You* chose it." The centerpiece of the show was an immensely careful devotional replica of the *Large Glass*, made by the English artist Richard Hamilton; the original, in Philadelphia, had been broken in shipping many years before, and Hamilton's version—which acquired its own peculiar authenticity by receiving Duchamp's blessing, although Duchamp had had no hand in mak-ing it—was identical in every way, glass, dust, lead foil, and all, except for the cracks in the glass, which had become iconic in the original but which were, of course, unrepeatable by mere chance. This, as far as I know, was the single most devoted act of copying by one artist of another's work in all of modern art. Such homages were not uncommon in the sixteenth and seven-teenth centuries, but in the twentieth Hamilton's was unique.

I got to meet, converse, and actually have a beer with the Surrealist Max Ernst, as great a thrill for me as meeting Scott of the Antarctic would have

been when I was twelve. I went to New York to do a program on Pop Art. Several of the people I interviewed are now dead: Roy Lichtenstein, Andy Warhol, George Segal. I had a lot of fun watching Jim Rosenquist paint in his Long Island studio, to the blasting sound of American groups I had not heard of before, and whose names I cannot remember now.

I saw few American artists in England. Occasionally some younger ones would turn up, under the auspices of either the Kasmin Gallery or the Robert Fraser Gallery. The few I did meet were epigones of Clement Greenberg and as far as I could tell the only English artist whose work interested them was the sculptor Anthony Caro. They were full of contempt for Henry Moore, whose mastery of solid form as distinct from open construction they regarded as hopelessly old-hat—"Old Fred Flintstone," I heard one of them call him. They tended—if one may so generalize—to behave like Roman legionary officers visiting conquered soil. They had a disagreeably arrogant *certezza* about them and projected the impression—which Greenbergians on tour were apt to do in the mid- to late sixties—that Europe was pretty well finished, and that the Mainstream of History had passed England by, leaving it to enjoy its marginal life as a sort of warm art puddle as best it could. This was claptrap and their work did not impress me very much.

I far preferred the paintings of English artists like Howard Hodgkin and Bridget Riley. Hodgkin had not quite pupated into the magnificent colorist he would become; and my friendship with him did not fully develop until the early 1980s. But I filmed with Bridget Riley, in whose company a lifelong admiration was born: this admirably intelligent woman, precise in speech, exact in movements, and clean as a hound's tooth, was (and remains) a great and lyrical artist. She had suffered badly from the brutal, opportunistic violation of copyright by "swinging" clothes and fabric designers who turned her designs into a form of eyebashing decoration, but she always maintained her dignity and that of her work. There was nothing snobbish about Bridget, but she abhorred sloppiness in others, especially when art was being discussed. We had long conversations, not about "Op Art," a term she disliked, but about Georges Seurat, whose paintings and granular black-on-white crayon drawings she regarded as the origin of her own.

I did not meet Balthus, a.k.a. Count Balthasar Klossowski de Rola (a completely phony title, not that it matters now), but his retrospective at the Tate, beautifully organized by John Russell of the *Sunday Times*, accidentally pro-

vided me with one of the most ferocious humiliations of my life. For there we were filming in the gallery on press day, and not a hundred feet away, across the shiny parquet, was my literary demigod: Old Man Palinurus himself, Cyril Vernon Connolly. Shall it be now? I asked myself. Or shall it be never? Quaking somewhat, I approached the dread presence and launched into one of those atrociously clumsy self-introductions that young Australians are so good at. I owed him so much, so very much. If I had not read (and read and reread) *The Unquiet Grave,* I could hardly have raised the gumption to leave Australia. This speech took rather a long time, and by the end of it I caught an icy glint in Connolly's froggy eyes. "I cannot believe," he said at last, "that I am to be held entirely responsible for the accidental effects of my juvenilia in remote colonies." Just like that, one sentence. It was the *remote,* hit with the clarity of a funeral chime, that got me. He then turned on his heel and walked away, leaving me to contemplate oblivion. It turned out that I had chosen just the right moment, too. The painting he had been contemplating—one of those naked Balthus nymphets, stretched on a chair and warming her cute, hairless pussy before a fire—had once belonged to him; he had bought it for three hundred pounds and sold it a few years before for three thousand, to settle some of his more pressing debts. It was, at the moment we met, worth perhaps three hundred thousand, and Connolly was still broke.

One of the more successful Beeb-Two productions had been a literary quiz game, which went to air in 1967, entitled *Take It Or Leave It*—a poor, if memorable, title for a good program. It was the brainchild of Tristram Powell and the broadcaster-novelist, later minister of the arts Melvyn Bragg. All manner of literary luminaries appeared on it: Connolly, sometimes, but also Iris Murdoch, Philip Toynbee, Anthony Burgess, Mary McCarthy, and various others. This gave Lorna an idea. Perhaps the same thing (identifying passages by unnamed authors read aloud, and then talking about those authors and their books) could be applied to the visual arts.

She came up with a program called *The Art Game.* Each week, a panel of experts—artist, critic, historian, museum curator, and so forth, though never a dealer—would be invited to sit down in a studio, with a moderator, me. On a screen a detail of a work of art would be shown. It might be a little bit of a Gabonese idol, or the left big toe of the Apollo Belvedere, or part of one of the crossbows from Uccello's *Battle of San Romano,* or the vaginal

slot left in some medieval Christ's side by some centurion's spear. My job was to jolly the guesswork along and keep the talk flowing. The only rule of presentation was that the detail had to be correctly oriented: you could not show, say, the wavy lock of hair from a quattrocento lady's portrait by Alesso Baldovinetti upside down. The panel's task was first to guess what it was, then where it had come from, then who made it, and finally—after the whole image had been revealed—join in a roundtable chat about the work's artistic and social significance. Some of the most learned and witty talking heads in England were brought in, people of the caliber of the sculptor Elisabeth Frink, the jazzman (and vintage Surrealist) George Melly, the Renaissance historian John Hale, and Michael Levey, the director of the National Gallery. The only "unknown" was myself. It says something for the esteem in which BBC2 had already come to be held that such folk were ready and even eager to come on a lowly quiz show like this one, but the English have always liked after-dinner party games.

The difficulty I found was not to cajole the panelists into speech, but to get them to shut up. Some of them were mighty talkers, and one of the strongest was Michael Ayrton, the English artist and author, who had already done a lot of radio and TV (the BBC again) and possessed a narrative fluency that would have reduced Coleridge's Ancient Mariner to silence. Once, we put up the image of an open book, lying on the floor, its pages weighted by a black glue pot with a brush stuck in it. It took Michael about three seconds to identify this as a still-life fragment from Velázquez's portrait (1645) of the court dwarf "El Primo," Don Diego de Acedo. He then launched into a discourse on dwarves, first Spanish ones (had anyone stopped to consider what the endless corridors of the Escorial might have looked like from an eye line of three feet?) and then English ones. He spoke, with feeling, of an English dwarf named Richard Gibson (1615–90), attached to the ill-fated court of Charles I and Queen Henrietta Maria.

Gibson had been a painter. He did portraits on playing cards in the manner of Sir Peter Lely. He attracted the notice of Charles I in 1639 when he was asked to do a miniature (dwarf?) copy of Titian's *Venus and Adonis*. He had the peculiar distinction of being the only court artist ever served up at a royal banquet inside a pie. (He was not, of course, actually baked in the pie; its crust, an architectural stodge-fantasy of sorts said to have been designed by the immortal Iñigo Jones, was baked separately, its pastry walls supported

within by bran, which was scooped out before Gibson was inserted by the royal pâtissiers. They carried the pie, Gibson and all, into the banqueting hall and set it down before the King. Then, amid general applause, Gibson pushed up the lid and emerged, racked with hiccups and sneezing helplessly—a residue of bran dust had got up his nostrils—and clutching a portrait of the Queen done on a playing card. After his royal patron died on the scaffold, Gibson moved on to painting portraits of (whom else?) his regicide, Oliver Cromwell. He married another dwarf, engendered no less than nine normal-sized children on her, and died at the patriarchal age of seventy-five. By the time Michael had finished this implausible but perfectly true tale, I and the rest of the panel were hysterical with laughter, and it was difficult to get the show back on track.

The friendship with Michael that was formed in the BBC studios ripened outside them. We do not, of course, always find ourselves genuinely liking those whom we admire. But I did greatly like Michael, and I admired his work—with reservations. He was an outsider and a curmudgeon. Significantly, his closest older friend and mentor when he was little more than a boy was that great contrarian Wyndham Lewis, the editor, novelist, critic, and painter, the inventor and soul of English Vorticism, who lived and died in undeserved poverty because of his intemperate attacks on what was considered *le beau et le bien* of local modernism. Bloomsbury had regarded him as the devil incarnate, and liberal opinion had tried to blacken his name as a Fascist—an enterprise rendered all the easier by some of Lewis's own gestures, such as (ironically) entitling one of his books *The Jews: Are They Human?* Lewis was never a Fascist, though W. H. Auden was memorably correct in calling him "the lonely old volcano on the Right."

Much the same might have been said of Michael Ayrton, whose own sense of the priorities of art was defiantly out of sync with most of what was "happening" in the 1960s. Lewis showed Ayrton how not to conform, and Ayrton absorbed the lesson with a will. Born in 1921, he had left school as a teenager to pursue a career as a painter. By the 1940s he was already exhibiting in London galleries and writing regular art criticism for the *Spectator;* he was a precocious figure on BBC Radio, and he knew everyone, or everyone who mattered, in the London cultural world, from very new arrivals like Lucian Freud up to formidable old dreadnoughts like Augustus John. (Michael was the source of one of the great John stories. One night, after much drinking

in a Soho pub, the two of them had repaired to the basement flat where Michael lived, John passing out on the sofa and Michael in bed. Suddenly, Michael was awoken by the sound of the air-raid sirens, heralding the German bombs. At that moment of fright he felt a beard in his ear and a massive weight on him: it was England's most famous living painter, now well into his sixties, trying to hump him. "Augustus!" Michael cried indignantly. "Augustus, what the hell are you up to?" An embarrassed silence. "Oh Michael, dear boy," said the abashed John in a small voice, "I am dreadfully sorry. So dreadfully sorry. I thought . . . you were my daughter.")

The event that confirmed and fixed my belief in the value of the Past in art, and the folly of speculations about its Future, happened in the later autumn of 1966. It was the Florence flood, a now remote event commemorated by small ceramic plaques that few tourists even notice: a wavy line, signifying water, and an inscription: *Qui arrivo l'Arno al notte de 4 Novembre 1966,* "The Arno came up to here on the night of 4 November 1966." Some of these are fixed to the wall so high above your head that you suppose, before passing on, that the message is a mistake. But it was not a mistake.

La maladetta e sventurata fossa, Dante Alighieri had called the river of his native Florence: "the accursed and unlucky ditch." It had never been altogether clear to me, reading the *Inferno,* just what he meant by that. I associated the river mainly with sunlight and always with the promise of esthetic pleasure. The Arno I knew and had generally seen, in the hot months, was a ditch all right: a mere trickle of water, hardly more than a series of linked pools, where kids splashed with shrill, gull-like cries and old men, sustained by God knew what inextinguishable optimism, dangled lines on long rods that never seemed to catch anything. Nothing could have been more peaceful or harmless. However, in the late autumn of 1966, the rains were heavy and incessant. They deluged most of Tuscany and, especially, the Arno valley. The river swelled. In places it backed up, because the relief channels installed decades before either didn't work or had been forgotten by the functionaries whose task was to open them and reduce the flooding pressure. Up came the river, turbid and roaring. Having demolished some upstream bridges north of the city, and inundated a few villages close to its banks, it now began first to gnaw at, and then to overflow, its parapets within the city

itself. By dawn on November 4, the water in the Santa Croce district of Florence, a particularly low-lying area next to the river, was more than six meters (twenty feet) above the pavement. And of course it wasn't placid water, either. It had come roaring into the ancient maze of alleys, narrow streets and cockeyed piazzas like a fire hose into a beehive. It created eddies and whirlpools, some of enormous force. It carried all sorts of debris before it. Cars were lifted up and dumped on other cars, like copulating pigs; they crashed through shopwindows, demolished doorways, and knocked statues over. The water cascaded into elevator shafts and down basement stairs, and filled the cellars where Florentine householders had installed their tanks of *nafta,* or heating-oil. These at once ruptured and released a thick scum of oil to float on the turbulent surface. Whole sectors of the ancient city were impassable. And the rain continued to pelt down in sheets.

When news of this debacle, which was rapidly turning into a disaster, reached London, nobody at first knew what to make of it—it was so fragmentary and often clearly untrustworthy. (One of the earliest accounts had the water of the Arno flooding the nave of the church of San Miniato, which is up on the hillside some three hundred feet above the normal river level, well over the top of Brunelleschi's dome on the cathedral; this would have put the whole town, like the drowned city of Lyonesse, under the waves for good and only within reach of tourists with scuba gear.) The only course was to go down and see for oneself—it was not something that could be reported from a distance. No television reports were coming out of Florence yet. So I asked my superiors at BBC2 if I could please go down there with a skeleton crew and make one. Rather to my surprise—in principle, being the poorest of Lord Reith's offspring, BBC2 was reluctant to spend money on anything much, including my own modest fees—they agreed, and assigned me a good friend, Mike Macintyre, to direct the little film—no more than twenty minutes, we were strictly told—for the magazine program *Release.* Mike assembled a scratch crew at the shortest notice. It did not include a lighting team; that would have to be hired from Rome, and join us in Florence. Feeling rather like the hapless William Boot preparing himself for Abyssinia with cleft sticks and a collapsible rubber boat in Evelyn Waugh's *Scoop,* I managed to borrow a pair of salmon waders from a good-natured Scots friend, added a waterproof jacket and hat more suitable for a herring-

netter than for a dashing cultural reporter, and joined the intrepid little band of BBC brothers at Heathrow.

We rented a Ford Taunus in Milan. After a nightmarishly long drive through drenching rain down the Autostrada del Sole, past Bologna and over the fogged-up Futa Pass, we arrived on the outskirts of Florence as night was falling. One autostrada exit after another was sealed off by carabinieri, but at last we found one that was open. Soon it was completely blocked by trucks and their frustrated drivers, milling irritably around in the face of more squads of carabinieri, in a darkness pierced only by high-beam headlights and flashing red signals. The squelching mud, the rain, the general chaos reminded me sharply of Tobias Smollett's description of his frustrated efforts to get across the Arno by horse diligence in a storm. None of the carabinieri seemed to have the least idea of what to do or even where they were: all of them, as it turned out, were auxiliaries brought up from Sicily, and none had been in Florence before. At last I managed to find an officer of carabinieri who, whether or not he was actually in charge, had a kindly face. My documents from the BBC and the Italian Consul in London were getting sodden wet, and he could only read them with difficulty, but at least they looked something like bona fides. Yet they were not going to get us into town. To enter the flooded city, he explained, we had to have a *permesso,* a permit. And where was I to get one? In Palazzo Pubblico, he said—the town hall. But, I wailed, Palazzo Pubblico is inside the city. *Ecco,* he said, spreading his hands palm upward in that immemorial gesture by which Italian officials acknowledge the world's perversity. *Ecco il problema, signore.* That's the difficulty.

Something snapped, or perhaps a penny dropped. I got back in behind the wheel of the Taunus, and popped it into first gear. "Then shoot us!" I exclaimed operatically. "But remember—if you shoot, you fire on the BBC itself. The BBC of *London!*" We crept forward; the officer stood aside; not a carabiniere moved to unsling his 9-mm. grease gun. We were through. I wonder if, forty years later, in a post-Berlusconi Italy, the name of the BBC would induce such respect. Somehow I doubt it.

Florence was a scary and unfamiliar sight. It was as dark as the pit. It had no electricity, no streetlights, and (eeriest of all) few pedestrians; here and there, in a window, you could catch the glow of an oil lamp or a house-

holder's flashlight moving about, but that was all. The streets, mostly narrow to begin with, had been reduced to the merest gullies by the piles of mud and debris on either side, everything from plastic bottles to the twisted remains of Fiats and carts. It was as though some fearful attack of *erysipelas* had broken out on the skin of a familiar and beloved face, rendering it barely recognizable.

We needed almost an hour to get to the city center, Piazza del Duomo. And there was an extraordinary sight: the shops around the Piazza had been burst open by the water and the plastic mannequins in their windows, stripped naked by the surge, had been cast in gesticulating heaps before the cathedral façade, like ridiculously stylized human sacrifices. It was difficult at first to realize, in the uncertain darkness, that these were not actual bodies; only their grotesque prettiness made them harmless. Inside the nave of the cathedral, archaeologists had been excavating for the foundations of the original church. As the water gushed in, the sides of this hole collapsed and a rubble of marble floor mosaic fell in, creating a hole about sixty by eighty feet, at whose bottom more mannequins lay. Very luckily, the water did not reach the Cathedral's great unfinished *Pietà* by Michelangelo, which stood on a plinth; but Baccio Bandinelli's carvings on the altar were soaked with water and oil. So was much of the collection of the Cathedral Museum; there, carvings by Arnolfo di Cambio and Donatello were submerged to a depth of eight feet. In all some one hundred sculptures were damaged, and the collection of original models for the Duomo, including Brunelleschi's irreplaceable wooden model for the dome and lantern, were smashed to flinders by the force of the inpouring water.

What was more, the floodwaters, racing in two opposed streams around the cathedral, had met in great boils and eddies between the cathedral façade and the front of its medieval Baptistery, whose tall bronze doors had been modeled and cast by some of the greatest sculptors of their time: those on the south side by Andrea Pisano, and on the side facing the cathedral, the so-called "Doors of Paradise," 1403–24, by Lorenzo Ghiberti. Later the priest in charge of the cathedral, Monsignor Poli, would describe to me what he had seen. A ten-foot wave of oily water had swept into Piazza del Duomo at about 7:30 a.m. It mounted against the Ghiberti doors (and the Pisano ones, which he could not see), which Poli saw bending about nine inches inward under the water pressure. From his vantage point up on the Duomo's

façade, he could see the doors trembling as the current buffeted them and floating pews from the cathedral bashed into them.

Then, suddenly, the Doors of Paradise burst inward. "At first I thought they had been torn off their hinges," said Monsignor Poli. "You see, it was so sudden. One moment my doors were there, and the next there was a big hole, and this terrible noise, like a scream. It was the bronze tearing apart. But I realized the doors were still upright and attached to the jambs when I saw the top panels falling out. It happened so slowly. They just fell out and dropped into the water."

The construction of the doors was simple: they were made of heavy bronze trays, each bearing its scene from the New Testament modeled in deep relief, held in bronze framing. As soon as the jambs and mullions of the doors were cracked by the repeated shaking and banging from the flood-waters, the trays, now loosened, fell out. All one could see, in the darkness, were those squares of vacant dark bronze, from which Ghiberti's exquisite narratives had been erased, like teeth bashed from a once perfect mouth. Then I got out of the car to look closer, and saw, sticking out of the pile of mud and gunk that had accumulated round the bottom of the doorjamb, a metal corner. I hauled on it and, with difficulty, out came one of the panels. I felt like a fool, there in the darkness, holding one of the more cher-ished masterworks of the Florentine Renaissance. What on earth was I to do with it? There was no one about, no one in charge. Eventually I left it where it was, in the mud, and went off looking for help. Four more missing panels were found by some Canadian students who were trying to salvage their Volkswagen Beetle, which had been swept into Piazza del Duomo by the water and stranded against the Baptistery wall. One of them broke his little toe on a panel, hidden in the mud.

We drove to Piazza della Signoria, equally empty, and walked down Vasari's arcade, which separated the two halves of the Uffizi Gallery and gave onto the Lungarno, the raised banking road that borders the river. In the uncertain light the surface of the Arno looked swollen and glossy, like a new burn, and running—a barely credible sight—only a foot or two below the tops of the arches of the Ponte Vecchio. Debris went tumbling by in the current, pirouetting slowly in its eddies. And strangest sight of all, there was the long tapering trunk of an evergreen tree, torn from its place in the earth upstream, which had collided roots-first with the windows of one of the

shops of Ponte Vecchio, rammed through the bridge, stuck, and now, like a leafy fishing-pole, protruded horizontally over the rushing water. On its end, as in a detail from a Purgatory by Hieronymus Bosch, a small dead pig was impaled. The public doors of the Uffizi gaped ajar and on the shallow stone stairs that rose into the dark building hastily salvaged objects were chaotically stacked. The museum staff, led by its director of conservation, Professor Luisa Becharucchi, and her assistant Dr. Ugo Procacci, had been frantically digging out works of art left for conservation in (where else?) the basement: paintings in worm-eaten gold frames with their faces to the wall, ceramic plaques, pottery jars, carvings. In my rubber waders I slipped in the oily muck on one of the steps and fell sideways, nearly but not quite on top of a familiar face—a head known from a score of reproductions: Donatello's blade-nosed painted terra-cotta bust of the fifteenth-century Niccolo da Uzzano. Along the walls, above the high-water line, were stacked dozens of ancient *cassoni*, armoires, chests, up-ended tables, carved and inlaid chairs, and cupboards elaborately decorated with intarsia, multi-hued inlays of thin wood veneer—cherry, ash, mahogany, chestnut, walnut, purpleheart, and Macassan ebony, each leaf of wood shaved down, cut to fit its tiny gap in the jigsaw puzzle that would become a face, a lute, or the shadowed curve of an arch, and then stuck in place with animal-hide glue. But all such glues are water-soluble and now the *intarsie* were warping, bending, cracking, delaminating; the substrate or wooden panel to which they had been glued was saturated too, but would dry at a different rate and warp to a different curvature; the panel paintings, on limewood or chestnut boards, were coming adrift and losing their patiently applied coating of fine plaster, and the paint that lay on top of it; all over Florence, on the ground floors, in the basements and sometimes even on the second storys of palazzi, museums, storehouses, and churches, a seemingly irreversible nightmare of conservation was beginning to grip the city and its infinity of treasures, which had once looked so solid but now were revealed as utterly vulnerable. And people died: twenty-nine Florentines, mostly women who could not be persuaded to leave their apartments, or men who were trapped in their cars on bridges or in the streets. If the flood had struck only three hours later, more people and more vehicles would have been on the streets and the toll of human life would have been enormously higher, so in that respect the city was lucky.

The worst-hit part of Florence was around Santa Croce, because it was

the lowest lying. Piazza Santa Croce itself looked like a bizarre junkyard, with scores of small cars (mostly Fiat 500s and 600s, since this was a workers' district) piled on top of one another by the floodwaters, all around the statue of Dante Alighieri in the center of the square. The three main historical buildings on the piazza were the church of Santa Croce, its attached museum, and the Pazzi Chapel, designed by Brunelleschi. All had been partly submerged by the flood.

Inside the church of Santa Croce, the water rose to sixteen feet. This building is the St. Paul's of Italy: among others, Michelangelo, Machiavelli, and Galileo are buried there. The water came level with the top of Michelangelo's sarcophagus. When we got there the water had drained away, but the church was still a sea of mud and rubble, the altar shattered, the tombs by Donatello and Desiderio da Settignano defaced, a continuous ring of high-watermark oil just below the Giotto frescoes in the Bardi and Peruzzi chapels—a black desolation lit by camera flashes. Outside, dimness at noon. Inside, gloomy obscurity. You could hardly see where you were going in the dank, cavernous spaces of Santa Croce, let alone find enough light to film by. The promised lighting crew had arrived from Rome, but they brought with them nothing more powerful than a handheld sun gun—a poor little battery-powered thing that wasn't much better than a large flashlight. I would take up my station in front of some suitably mud-and-oil-defaced bas-relief, and prepare to wring the viewer's withers with a description of what had gone on. *"Accendi!"* Mike Macintyre would command in his best (indeed, his only) Italian. The light would click on, revealing practically nothing in the gloom beyond the critic's concerned-looking face, with its becoming expression of serious cultural worry. Trying to combine the existential gravity of John Berger with the paternal authority of Kenneth Clark, I would launch into my heartfelt spiel about cultural loss. The camera would look, or rather, peer at the damaged masterpiece, and see darkness with a few vague bumps in it. *Smorza!* Mike would cry, and the light would go off, leaving nobody much the wiser. A whole afternoon of doing this, take after aborted take, with one's feet freezing in one's waders, was enough to make anyone long for a job as an extra in some moronic comedy starring Sandra Dee and set in Hawaii.

What made it even more irksome was that just outside, in the cloister, was a big red electric generator in perfect running order, mounted on the back of

a truck. Nobody appeared to be using it. It belonged to the *équipe* brought to Florence by the distinguished movie and opera director Franco Zeffirelli, who had announced to the world's media that he, being a Florentine and, what was more, the lineal descendant of Leonardo da Vinci (how, he did not explain), was going to make an *importantissimo* documentary on the tragic fate of his city. It would be narrated by his close and beloved friends, Elizabeth Taylor and Richard Burton, who were in Rome right now but would be arriving in Florence any moment; and when it went on the world's screens, it would provoke a worldwide deluge not of water but of compassionate aid for the stricken city. I think he finished the film, but I am not sure. I have a faint memory of Burton's rich voice intoning the opening three lines from the *Inferno*—*chè la diritta via era smarrrrita,* so perhaps it was broadcast. But that didn't do our puny effort much good.

The most spectacular damage done by the waters was not in the church but in its adjacent museum. The Museo dell'Opere di Santa Croce had double doors about fourteen feet high. The water rose well above the lintel of the door frame so that, for a while, it was impossible to see into the museum, let alone enter it. Father Gustavo Cocci, the parish priest of Santa Croce, had been in a fever of anxiety because, in addition to sundry other Florentine devotional paintings—frescoes by Andrea Orcagna and Taddeo Gaddi— the Museum contained one of the key works of Italian art history, the huge, tragic painted crucifix by Cimabue, Giotto's predecessor, whose gigantic and agonized yet somehow boneless figure of the Redeemer in agony was once vividly compared by Francis Bacon to "a worm—a worm crawling down the cross." In the museum the floodwaters had submerged it to the hairline and, hidden as it was by the water and the early predawn darkness of November 5, there was absolutely no way of seeing it, let alone of estimating the damage it had undergone. Unable to get into his church, Father Cocci found his way to a local sports-and-toy shop. It had been gutted by the water but, inside, there was a little rubber boat, the kind you might use in a swimming pool. With much huffing and puffing, the desperately anxious priest managed to inflate it enough to bear his weight. He grabbed an oilskin for further protection and set off, wading at first and then clumsily paddling across the piazza. When he reached the portal of his museum he saw that the water was still too high to permit entry. So he had no choice but to paddle his rubber ducky across the courtyard to the steps of his church and wait there,

shivering unhappily in the still falling drizzle, until the water level had fallen far enough to enable him to get in under the top of the door frame. What he saw, in the gradually withdrawing darkness, filled him with horror. The head and torso of Jesus were now exposed. But patches of them were not there. Several hours' immersion in the water had dissolved the bond between Cimabue's gesso foundation and the wood beneath. Now, as the water fell, the plaster began to peel away, taking Cimabue's paint surface with it. The oily, mucky water surface was dotted with soft porous flakes which had recently been part of God's body. Father Cocci, as he later told journalists, was perfectly ignorant of picture conservation, but he did know that, whatever the chances of restoring the crucifix to some semblance of its former self might be, they would be much less if this stuff were lost. So he swiveled his duck around, trying not to disturb the water, and paddled back to the church. Then he made his way back to the sports store where, sure enough, he found the tool he needed: a net for catching insects, on a long wooden handle. Armed with this Nabokovian instrument, and by now joined by a pair of restorers, he managed over the next several hours to rescue quite a lot of Cimabue's peeling gesso, carefully depositing it—for want of any better surface—on a large, dirty china plate. They sieved up as much of the colored gunk as they could.

Father Cocci's legs were dreadfully cramped from hours of crouching and balancing. He badly needed to sit down on something firm. A wooden chair had been floating about; he seized it, set it on its four legs, and sat down, staring glumly at the wreck that had once been Cimabue's crucifix. Then when his legs felt more able to carry his weight, he stood up, placed the china plate and its sad load of gesso on the chair, and limped off in search of a dry change of clothes and a warm place to sleep.

He and the restorers found a telephone that worked—it must have been the only one in the whole Santa Croce district—and somehow got through to the overloaded authorities in the town hall, alerting them to the disaster inside the church museum. It was essential, everyone agreed, to get the Cimabue out of there, to a relatively warm and dry spot—the right place would be the heated, 350-foot long Limonaia, or lemon greenhouse near Palazzo Pitti, on the far side of the Arno—where conservators could begin their work of stabilization and surgery. So a truck and a crew were sent, as a matter of first priority, to get the crucifix off the wall. It took hours of care-

ful supporting, hacksawing, and lifting: the thing hadn't been moved in several lifetimes, it was attached by old and rusted iron ringbolts, and the crew had been told to avoid, at all costs, any bumping or jarring of the ancient, fragile, extremely heavy wooden structure. At last it was free, and lifted down. We filmed it from above as it was carried out to the lorry, looking like a crashed airplane, enormous and pathetic in the sodden half-light. A tarp was drawn over it and, very slowly and carefully, the truck drove out of the cloister and began its journey to the Limonaia. Father Cocci, completely exhausted by now, tottered off to bed. Several of the crew remained behind in the museum to start cleaning up. None of them had had time for lunch. Anyway, no bars or restaurants were open anywhere near Santa Croce. But one of the men had a hefty salami and a knife. And there was a lone plate sitting on a lone chair in the museum. It had what appeared to be lumps of colored mud on it. But nobody was in a mood to be picky, and these were easily wiped off. When Father Cocci woke up and heard this story he was said to have laughed, and then wept, uncontrollably.

Not everything sustained this level of chaos, but below the second stories of Florence not much was spared, either. In the city's principal sculpture museum, the Bargello, about a third of the antique arms collection was ruined; but though the room containing such masterpieces as Michelangelo's *Bacchus* and his tondo of the Madonna and Child was flooded to a depth of twelve feet, and its floor subsided drastically in the middle, its contents were not permanently hurt. On the other side of town, ten feet of water entered the church of Santa Maria Novella, but luckily it only rose to within three inches of the bottom of Masaccio's fresco of the Trinity. Unluckily, however, it wholly inundated the church's *Chiostro Verde* or "Green Cloister," with its frescoes (of such biblical subjects as, ironically, the Flood) by Paolo Uccello and his assistants. When I visited the cloister, six days after the flood, a team of restorers had been flown in from America. They were swabbing at six-inch areas of the immense oil-defaced wall with Q-tips dipped in solvent. At most, one square foot an hour. It suggested an insane mathematical problem. If one restorer can clean 144 square inches of one fresco in one hour, how many restorers and hours will be needed to clean twenty-five frescoes, each twenty feet by twelve feet, before the oil soaks so deeply into the plaster that restoration becomes impossible? On such parodies of schoolchild math the fate of Florence's heritage seemed to be strung.

And of course not all the imperiled art was on walls. By mid-November there were about five hundred pictures on wood panels from the thirteenth, fourteenth, and fifteenth centuries undergoing emergency treatment in the Limonaia, but this was only a fraction of the material that had been soaked by the Arno and, according to the director of the Uffizi, Ugo Procacci, the great fear among restorers and curators was frost. Winter was coming on and, Procacci told me, "If the temperature in Florence drops below freezing, the losses will be unimaginable. If the water turns into ice it will expand, whole paint surfaces will be cracked off the panels, and the surfaces of marbles will be lost." This time the fates, niggardly with Florence up till then, did intervene: the freezing weather did not come.

In some museums, the damage done by the floodwaters was almost incomprehensible. The Pitti was too high to be touched by the water, and the Uffizi was relatively lucky: most of its collections were on the second floor or higher, although some of the material in the basement had to be written off in the hasty triage of works of art that the sheer dimensions of the flood, and the shortage of skilled conservators to deal with the crisis, made necessary. But what happened at the other extreme—in the Archaeological Museum, for instance—was a very different matter. Florence's Archaeological Museum is one of the more important collections of antiquities in Italy, but it was short of "signature" objects, at least in comparison to the enormous riches of, say, the museum of the Villa Giulia in Rome. Other than scholars and specialists, most people went and still go to Florence for its Renaissance and later paintings, frescoes, sculpture, and buildings; in those days (I don't know about now, but I doubt if the proportions have changed much), there must have been a thousand tourists who passed through the Uffizi for every dozen visitors to the lonely rooms of the Archaeological Museum. Consequently, the latter was always understaffed and chronically under-subsidized. It was partly a museum and partly—below street level— a crowded, confused dump for thousands of objects which, dug up in Italy in the recent or remote past, were the property of the Italian state but were considered less than second-rate and therefore essentially homeless, having no place inside the museum to be shown. It was a problem that could have only had one solution: an enormous and rigidly controlled garage sale of minor Roman, Greek, and Etruscan antiquities. But that would never have been politically possible. Selling off any part of the *patrimonio culturale* would

have raised a fearful stink and, not incidentally, turned any loophole in the laws restricting the export of works of art into a wide-open gate through which all the horses might escape to Sotheby's. So the Museo Archeologico di Firenze retained the classic form of so many Italian museums—an iceberg, of which only a tenth, at most, was even notionally visible to the general public.

But though it was a fairly confused and confusing place before the flood, it became utterly chaotic when the Arno poured in. The basements and sub-basements, of course, filled first, but with the catastrophic speed of the inundation, not all the air trapped in them could escape in time. Thus, much of the ground floor exploded upward. Then the beams and floorboards lapsed down into the basement and most of the display cases slid with them, their glass panels breaking as they went, their contents cascading out. Everything finished on the basement floors in a sodden pile of shards and flinders— broken Greek red-figure ware, smashed bucchero, stone ash chests cracked to pieces, fragments of statues reduced to smaller fragments, everything on top of something else. It was impossible to pick one's way through this desolate, drained aquarium, this smelly mud pudding with antiquities stuck in it like raisins and currants, without breaking even more of the pots and vases invisible underfoot. Buried, exhumed, and now buried again—and as nameless as they had been in the earth of Tuscany and Latium: for of course the labels they once had, mostly from the later nineteenth century and written in ink on cards, had been effaced by the water. What was even worse, most of the index catalogs, thousands of cards also handwritten in ink, turned out to have been stored (where else?) in the basement, so they too were largely erased.

Of course, it wasn't only museums that suffered in this way. For libraries and archives, in which Florence is so rich, the flood was an unmitigated disaster. For instance, fifty miles of bookshelves in the National Library— whose stacks, like most libraries', were in the basement—were destroyed; by the month's end, estimates of the losses varied between three hundred thousand books (the official one) and perhaps one million volumes (the estimate of the students who flocked to Florence to do the dirty work of salvage). Recent material suffered worse than old volumes. Modern papers—the kind of pulp paper on which newspapers and magazines are printed—is unstable

and dissolves. Old rag paper is tough, and old oak-gall ink does not easily dissolve. So there were enormous losses in the post-1875 newspaper archives of Florence—thirty thousand bound volumes destroyed—whereas most of the forty thousand vellum-bound folios in the State Archives in the Uffizi, and the fifty million or so ancient documents they contained, were not ruined by their submersion. This was fortunate, as no copies had ever been made and the Archivio del Stato is the main source for the last nine hundred years of Florentine history.

Other forms of print and handwriting vanished, too.

For years I had had a favorite restaurant, called the Buca Lapi, in the basement of Palazzo Antinori. Forty years ago it was a subterranean bastion of conservative, traditional Florentine *vino e cucina*. I loved its thick, parmesan-clogged minestrone and its bruschetta of chicken livers and its plump, egg-yellow pumpkin ravioli, but its great dish, for those who could afford it (which only episodically included me) was the classical *fiorentina*, short for *bistecca alla fiorentina*, the mighty, long-aged beefsteak at least two inches thick which, rubbed with oil and sprinkled abundantly with sea salt (and nothing else: pepper could come later), would be flung on a raging-hot grill like the martyred St. Lawrence, searing it almost black on the outside but blue-red and still veined with white fat within. You could not dispose of a *fiorentina* single-handed unless you were Gargantua himself, or perhaps one of those formidable, long-dead mercenary leaders with horseback names like Giovanni Acuto or Castruccio di Castracane. Because it took two to eat it, it was, despite its size, an intimate dish, and definitely not one for delicate appetites, especially since it came garnished with a mound of potatoes, boiled, cut up into irregular chunks (no effetely exact parallel slices, please), and sautéed to a golden crust interspersed with garlic, and another mound of spinach moistened with glugs of Tuscan olive oil. Simple and direct, but one gets the point. Whenever I ate one of the *fiorentine* of Buca Lapi I thought disparagingly of the barbies of my Australian childhood. Not that there was, in principle, anything wrong with barbecuing as understood in Australia in the forties or fifties. It's just that the art wasn't understood. It was based on thin flaps of rump steak, seldom thicker than half an inch, and therefore incapable of being charred outside and juicy within. The laws of physics were against you. On the smoking iron grill of Buca Lapi, with the exhaust

fan roaring overhead like the antiquated engine of some Mussolini-era bomber made by Fiat in its less democratic days, those laws were definitely working for you.

Once the Arno had been pumped out of the Buca Lapi and the place was dried out and running again—a process that took less than ten days, despite the doom-laden prognostications of its more elderly waiters—there was no more trouble with the food. The problem was with the wine, which had undergone much the same indignities as the contents of the Archaeological Museum. As befitted a place that did business below the palace of the Antinori, a family that had been producing excellent red and white wines in the Val de Chianti since the late sixteenth century, Buca Lapi's *enoteca* was quite renowned, both for the variety of its contents and the august age of some of them. There probably wasn't a better list of Italian wines in Italy, or at least in Tuscany. Unfortunately, just as in the Museo Archeologico, the water not only rendered illegible the master list of wines—which had long been kept in pen and ink by a succession of sommeliers—but also dissolved the glue that held the labels onto the bottles themselves. So when the restaurant staff and the cleanup helpers were able to enter the pumped-out basement of Palazzo Antinori, they were confronted by thousands of bottles in racks and hundreds more lying broken on the muddy stone floor, no more than one in six still bearing its label. Some of these anonymous bottles dated back to the forties, the thirties, perhaps even the twenties, but no one—not even the head sommelier, who contented himself with rending his sparse locks like some ancient from the Old Testament and uttering a string of (to me) incomprehensible oaths and *bestemmie* in a thick, guttural Tuscan patois—seemed to have much idea which was which. So the management of the Buca Lapi allowed its familiar clientele, which luckily included me, to take potluck on the wine at very low prices. The advantage of this was that one got to drink some distinguished bottles at bargain rates. The disadvantage was that I had scarcely any real idea what I was drinking, so it did nothing for what wine snobs call the "palatal memory." But as I have never had such a memory, and to this day know practically nothing about the finer points of wine discussion—most of that chitchat about robust noses and fruity finishes being as meaningless to me as the more rarefied forms of art jargon are to sensible people outside the art world—blind tasting in the depths of the

Buca Lapi did not teach me as much as it might have taught more wine-literate folk. It did, however, lead to some memorably drunken afternoons, during which I learned a little about the Florentine art of blasphemy.

Bestemmia—blasphemy—is an Italian speciality, and nowhere, or so one would be told, is it brought to greater heights of obscene, contorted, and elaborate perfection than in Tuscany. (Naturally, the Romans, Neapolitans, and others vigorously dispute this.) Since by its very nature it entails insulting the sacred personages of the Catholic religion, the Father, the Son, the Holy Ghost, the saints and, most frequently of all, the Madonna, there is no such thing as *bestemmia* outside Catholic countries; there is no great sin without great belief. It has declined miserably in France since the Enlightenment, but in Tuscany in the mid-1960s it was still going hot and strong. Some of its forms were fairly trivial: to exclaim *Porca Madonna!* ("Pig Madonna!") when a tire goes flat is not an ingenious utterance. But some that I heard, particularly in the aftermath of the '66 flood, were of a truly staggering inventiveness and rose to the height of superior folk poetry. Thus one workman, after a greasy mass of mud-soaked books slipped his grasp on the way up the staircase from the flooded stacks of the National Library, was seen to raise his eyes to the roof as though directly addressing his Maker and exclaim: *"La Madonna e una botta con tutti santi dentro, e Dio come tappo . . . in culo"*: "The Madonna is a barrel with all the saints inside, and God like a cork . . . in her ass." One does not just make such things up on the spur of the moment. The simplest and truest *bestemmia,* however, was spoken to me by a priest as we were looking at the wreckage and filth inside the Baptistery. *"Il piu grande vandalismo e quello di Dio,"* this worthy and despairing man said. "The worst vandalism is God's own."

The film we brought back to the BBC was limited and, in places, grayed-out almost to invisibility by the general lack of light. But it did something to mobilize public sentiment for the city, and I was proud of that. It also, I was told, helped encourage students and other young people to go there and help in the cleanup after the disaster. And indeed they did come in the hundreds, as they would later converge on political demonstration sites in Europe. These kids were not skilled, and not necessarily even art students, but they did heroic amounts of unpaid donkey work: nothing as glamorous as saving Leonardos or Botticellis, but lugging mud-soaked volumes up narrow stairs

from basement archives or squeegeeing floors—filthy labor, which they did until they dropped from exhaustion and slept in corners. The people of Florence gratefully nicknamed them the *angeli del fango,* the mud-angels.

I went back to Florence to join these generous young workers later in the winter, and in the course of that trip I made two discoveries that could, with honesty, be called life-changing. The first was an encounter with a work of art—not a Florentine one, or even Italian. I had chosen to head south from England with a photographer friend in his car, and I planned a route that would take us through Alsace and then Colmar, to which I had never been before. It is the rarest of towns, in that it contains only one work of art of real note. But that painting is one of the most vivid and terrible utterances ever made by an artist. It is the so-called Isenheim Altarpiece, finished in 1522 by the German painter Matthias Grünewald. It was commissioned by the Antonian monks of Colmar, to whose monastery a hospital was attached. Its function was to harbor and succor the ill and the dying—and especially those who were suffering from the last stages of a disease that had recently made its way to Northern Europe, syphilis. Few people in the late twentieth century—certainly not I, whose worst encounter with venereal disease had been a few bouts of the clap, soon enough vanquished by antibiotics—can have any idea of the dread induced by full-blown syphilis. In the nineteenth century, it had become a sort of cultural obsession; it was the specter of syphilis that created the mythology of the *giftmadchen* or "poison maiden," sowing inexorable death among those who could not resist her; it was to syphilis that literature, and painting too, owed a whole procession of "fatal women," slaying as they conferred a brief and illusory ecstasy on their victims; a series of literary archetypes, such as Keats's "Belle Dame Sans Merci," whose merest touch reduces the errant knight-in-arms to a helpless shade, owed their origin to *Spirochaeta pallida.* Syphilis was the AIDS of the nineteenth century. And the most powerful expression of the terrors induced by the disease in the early years of its rampage through Europe was undoubtedly the Isenheim altarpiece, in which the human body—Christ's own body, with all its latent powers of transcendence—was depicted as the ruined, defiled victim, covered in wounds and strange obscene sores, as though some atrocious but unknown poison were working its way outward from inside. This was the broken redeemer of the biblical text *Ego autem sum vermis et non homo,* "I am a worm and no man"; a creature so brutalized in its

sacrificial excess that you could not imagine touching his flayed skin. And yet such was the power of this image that I realized that it did indeed have something in common with the ecstatically conceived Virgin of Duccio's *Maestà* in Siena. It was addressed to a whole community which, in a deep sense, it represented. Just as the inscription on the *Maestà* implored the Virgin to be a cause of peace to Siena and a source of life to Duccio himself "because he painted you like this," so Grünewald's terrible wreck of a Christ, with which no hale and healthy person could possibly feel anything in common, must have been meant to inspire feelings of mutuality with the cripples and the wretchedly infected in the Antonian hospital in Colmar. Not only the Crucifixion centerpiece but the many other panels of the altarpiece—which were turned for you, like the huge pages of a ponderous book, by a shriveled attendant—depicted a world gone hideously wrong but, at the same time, incontestably real. That is why the morbid freaks of Grünewald's diabolic fancy stay with me as tenaciously as those of Hieronymus Bosch. Just as the golden Virgin in Siena held out to her visitors the possibility that such reconciliation and stasis could be theirs forever, so the ghastly Christ of Colmar assured the sick and dying that they, too, had something in common with Jesus; that they, too, had God in them, despite the marks of mortal sin that were hideously inscribed on their bodies.

I had never seen such a frightening picture before. Of course, as in Bosch, its repulsive powers were wound into the very fabric of the skill with which it was executed. But could one imagine the Isenheim Altarpiece hanging in a church or an infirmary back in Australia, where art never spoke of real pain, let alone grotesque sickness or deformity? Would there be any public place for it in America, or anywhere else in the modern world? It was only then, gazing on Grünewald's enormous and deliberately wrought masterpiece, that I realized how deep the roots of euphemism and evasion were sunk in modern life; how alien, as a result, the entire "Expressionist" tradition in modern art had been to me having grown up in Australia—and would also have been had I grown up in North America. In Australia I had, of course, grown up without seeing a Grünewald. But neither had I seen anything more than the occasional stray print by a modern "Expressionist" artist, by Max Beckmann, for instance, or Otto Dix. Almost all I knew of past art, and that imperfectly, was its Apollonian tradition, which spoke of order, idealism, satisfied Eros. Somewhere beyond and below that stretched another conti-

nent of esthetic experience which had somehow to be discovered, and it was probably true that my life had been too happy and healthy for me to really grasp it. This, too, was part of the reason I had had to leave Australia and come to Europe. The proof of it was to be seen in Colmar.

The second thing I found out from this trip was, if anything, even wider. After those days and weeks in Florence, I was never again able to join in the chorus of cultural fantasy that one heard so often in the sixties—the idea that there was something inherently repressive about old art, as though the past were a dead weight that new art, young art, had to shake off. Of course culture changes, but the idea that it simply reinvents itself, like a snake shedding its skin, is dreadfully naïve. But that was, and to a certain extent still is, built into the ideas that modernism had about itself. By "modernism" I mean only a certain area of modern culture: an aggressive and noisily militant wing, as it were, committed to the Oedipal project of killing the father. It was typified by the Futurist impresario Filippo Tommaso Marinetti, calling for the destruction of Venice, whose long-accumulated deposits of masterpieces he held to be a drag on postscientific, modernist invention, mere irrelevant survivals in the age of carburetors, machine guns, and beautiful, inspiring dynamite: "Turn aside the canals to flood the museums! O the joy of seeing the old canvases bobbing on the water, discolored and shredded!" Well, I had seen something like that in Florence, and it wasn't a joy but a horror. No wonder an Italian skeptic—I forget his name, but it deserves to be remembered—replied, when some admirer of Marinetti's asked whether the Futurist was not truly a genius, replied: *"Non e uno genio, e uno cretino fosforescente"* ("He's not a genius, he's a phosphorescent cretin"). And of course the special irony was that not even the masterworks of Futurism were immune to the history their promoters clamored to destroy. The finest sculpture made by Umberto Boccioni, for instance, was the striding, powerful figure entitled *Unique Forms of Continuity in Space,* 1913. And it is nothing other than a version of the second-century B.C. Greek marble which stands at the head of the entrance stairs of the Louvre, the *Winged Victory of Samothrace.* The past is pervasive; it seeps into everything; it is the very air that artists and their public breathe. And yet because the past is irreplaceable and cannot be done again, it was that very past, not the present or the future, that was so delicate, so vulnerable, so dreadfully easy to erase. At the same time, the past was the realest thing we had; the present was still to some degree hypotheti-

cal, the future nonexistent and therefore, at least in the realm of culture, unreal. Scientists could hypothesize about the future, and indeed it was a necessary part of their work to do so. But not artists. Artists, I came to believe, are not prophets and should not imagine themselves to be, for that is merely a form of pomposity. Their work does not "foreshadow" later paintings or sculptures, as in an act of divination or clairvoyancy; instead, it becomes the basis of later works by being used, imitated, learned from by later artists. In other words, it becomes part of the past and assumes the value that we associate with the past. To the extent that it is radical, it is only so in the literal sense of the Latin *radix*, a root; it absorbs nourishment, gives support, and offers rootedness and a degree of security in an otherwise bafflingly hypothetical future. It may be that what you call "conservative" I might call "radical," but that does not preclude the possibility that both of us are looking at something new. The truly radical work of art is the one that offers you something to hold on to in the midst of the flux of possibility. Thus Piero della Francesca's *Baptism*, in London, or Rembrandt's sublimely inward-looking *Bathsheba*, in the Louvre, is radical in a deep way that no Damien Hirst could ever be—which is why even mentioning them in the same sentence is faintly comical.

I began to realize—not that it came on me with a flash, for rather it crept up on me bit by bit—that the future could look after itself, and that to try to direct its course was no part of a critic's responsibility. All such attempts by critics were to be discouraged, because History would laugh them off anyway. Over in America in the latter sixties, one bunch of critics—the Dionysiac ones, so to speak—were busy proclaiming the necessary end of reason and measure in art, and the gallivanting, galumphing reign of total spontaneity. While another bunch, the epigones of Clement Greenberg, were announcing in true post-Marxist style that there really was an Inevitable Future and it lay with abstraction, with thin but huge watercolory washes of lyric acrylic on unprimed duck, in the manner of Helen Frankenthaler, Morris Louis, Kenneth Noland. *That* was the consummation of painting; it opened, as one Greenbergian academic (Michael Fried, I think) said, "unimaginable possibilities" for the art; and of course it turned out to be a dead end once its first exponents had done their stuff, some of which was quite beautiful on its own admittedly limited terms.

What the Florence flood drowned in me was a belief in the potency of the

avant-garde. I have never regained it, and today, looking at the ever-more-feeble efforts on the part of the art world to designate its latest products as "cutting-edge," "edgy," "radical," etcetera, I am not in the least sorry to have lost it. Some new works of art have value of some kind or another. Others, the majority, have little or none. But newness as such, in art, is never a value.

I first met my publisher-to-be, George Weidenfeld, through a picturesque denizen of Port Ercole and London, Geoffrey Keating. Keating was one of Moorehead's many friends; he, too, had been a correspondent in the war, and they had gone all over Northern Europe together, following the inexorable advance of the Allied armies. Geoffrey was afraid of nothing, and his reputation for limitless chutzpah preceded him. He liked to live well, and it irked him that the Allied officers and general staff always managed to get the best hotel rooms when the occupying army marched into a city, driving the Germans in confusion before them. As the Allies were advancing upon one occupied city—was it Rotterdam? I forget—Geoffrey had decided to reverse this trend. Flashing the pips to which his rank as a war correspondent entitled him, he managed to commandeer a spotter plane, a tiny, unarmed, fabric-covered Auster with an engine not much bigger than that of a suburban lawn mower. He then persuaded, or bluffed, its understandably terrified pilot into flying this machine into the center of Rotterdam and landing on a strip of park bordered by two boulevards. Somehow the pilot evaded the trees and the overhead trolley wires and stopped, more or less intact, outside the grandest hotel in Rotterdam. "Wait here," ordered Geoffrey, and hopped out of the Auster, making his way in his British uniform through the German military traffic (tanks, armored cars, staff cars, all bristling with anti-personnel guns) that was heading out of the city in the general direction of home. He skipped up the steps of the grand hotel and confronted its manager in the lobby. "I have reservations to make," Keating announced. He made them, left, and somehow the pilot took off from the grass strip and flew unmolested back to the Allied lines. And so it came to pass that when the main body of the Allied army entered the now Wehrmacht-free city, the top brass sent their adjutants to commandeer the hotel and found, to their intense irritation, that the two best floors of it had already been taken over by Keat-

ing, Moorehead, and their correspondent friends, who were about to enjoy their first proper hot baths since crossing the Alps and would not have given up their suites for Winston Churchill himself.

Though the Geoffrey I came to know two decades later was bald, pink, rubicund, and stout, his effrontery was quite unimpaired. He had become the chief PR officer of British Petroleum, where he was known behind his back as "Florence of Arabia"; his chief duty was to keep the rather primitive sheikhs of the Gulf happy when they came to London, arranging hotel suites, whores, and high-level social contacts for them. This, due to what is conventionally called "the clash of cultures" (remember, it was forty years ago), did not always run smoothly. On one occasion he was faced with the problem that a potentate who was unusually rough-edged even by Gulf standards, a certain sheikh, had decided to have a little traditional desert hospitality in the suite at a luxury Mayfair hotel that Geoffrey had arranged for him. The Sheikh's underlings, more used to roasting sheep on the sands of the Empty Quarter than ordering from room service, considerably rolled back the worn Aubusson in the living room of his suite, but then built a fire on the bare floorboards and were beginning to barbecue a small goat (purchased from Harrods' *boucherie,* which stocked them for visiting Arabs) when the floor manager burst in, frantically gesticulating and followed by a squad of hotel staff with red fire extinguishers, covering the fire, the goat, the Sheikh, and his party with white chemical foam.

Geoffrey perceived that I did not have a publisher—my failure to deliver on *Irrational Imagery* had, inevitably, put Hamish Hamilton off any further dealings with me. But *he* had a publisher for me. This was his friend George Weidenfeld, the head of Weidenfeld & Nicolson—a knight now, thanks (it was rumored) to a lavishly generous advance, never to be recouped, that he had paid to Harold Wilson, the prime minister, for his unwritten memoirs. (He was not yet Lord Weidenfeld of Chelsea, a rank to which he would be elevated some years later.) How to get the two of us together? Simple: Sir George had just married his third wife, the exceedingly rich Sandra Whitney of that American ilk. They had installed themselves in a gigantic Victorian pile at Hyde Park Gate. The new Lady Weidenfeld had flung herself into redecorating it, with a will. Next week there was to be one of a series of housewarming parties, to which *le tout Londres* had been invited. It would be a simple matter, said Geoffrey, to slip me into the throng of revelers. There

was one small problem. It wasn't that I knew nobody there—though I didn't—or that I had met neither the host nor the hostess, which I hadn't. Rather, it was that, like Cinderella, I had nothing to wear to the Weidenfeld ball. But Geoffrey, as a resolute fairy godmother, fixed that. He lent me his spare dinner jacket. We were much the same height, but since at the time he weighed about 250 pounds and I 150, there seemed to be a problem, which Geoffrey pooh-poohed and waved aside. With all that fine black cloth hanging from my cadaverous frame in loops and swags and wrinkles, with the trousers cinched in like the envelope of an underinflated blimp, and my neck protruding like a scrawny chicken's from the wing collar of Geoffrey's piqué evening shirt, I cut a peculiar figure, but when we got to Hyde Park Gate the crush was so intense that nobody seemed to mind, or even to notice. There, at the top of the steps, stood Sandra, Lady Weidenfeld, a tall figure glittering regally in dark puce velvet and blinding sparklers, greeting the guests. "And you!" she effused as she took my hand. "You must be Mordechai Richler! Oh, welcome, *welcome!*" We got that straightened out, but then it turned out that, though I wasn't the distinguished Canadian Jewish novelist, we had been assigned seats at the same table in the Weidenfelds' enormous palm-court dining-room. Neither of us knew anyone else at this table, though when we looked around the room nearly everyone else in it seemed vaguely familiar from photographs in the papers and magazines. "This has to be the bums' table," said Mordechai with morose pleasure, and so it was.

Sandra's husband and I, initially at least, seemed to get on very well. "I am boiling and bursting with ideas for you, Robert," he announced without pre-amble, when we sat down for a few minutes at one of the spindly gilt rental tables in his palm court. No publisher had ever thought to approach me in those terms, and there was something peculiarly fitting about the image of the rotund and pop-eyed Sir George, like a steam boiler in immaculate white linen, emitting little jets of high-pressure vapor in his enthusiasm. Had I ever thought about Leonardo da Vinci? Well, of course. Good; then I must turn these thoughts into a book. I was Catholic (Geoffrey had primed him on that, I suppose), so I must have thought about Heaven and Hell. All the wonderful, terrible frescoes I must have seen in Italy! All the miniatures and panel paintings, the Isenheim Altarpiece at Colmar, the Last Judgment in the Campo Santo in Pisa: no Protestant, no Jew, could possibly understand the full import of such images. What was needed, what Weidenfeld wanted to

publish as a service to the world and to comparative religion, was a book in which all the torments, and let us not forget the sublime joys, of the Afterlife would be set forth, laid out, compared, and assessed. And who better equipped to do that than me, a young ex-Catholic, a Jesuit boy who had stepped outside the constrictions of his dogmas but in whom all the terrors of prospective damnation were still as fresh, as it were, as daisies? And then there was Leonardo! *Leonardo da Vinci!* What artist could be more interesting to the general public than Leonardo? And how little (relatively speaking, of course) had been written about him in English for that public! If you wanted to know, really know, about the great Sphinx, what books on him were currently in print? (Answer, practically none, except Kenneth Clark's.) Was it not time to see Leonardo afresh, through the eyes of my generation, as Clark had created him fresh for his?

By this time I was on about my sixth glass of nonvintage Krug and my ego, never entirely unresponsive to massaging, had expanded like a Montgolfier balloon. Of course I could do George a book on Heaven and Hell, and on Leonardo, too, and on anything else I knew very little about, such as practical topiary for amateurs or a history of the kabbalah. George did not exactly whip a blank contract and a gold Parker from his inner pocket, like Mephistopheles nailing a victim—he was too cunning an old stager for that—but within a couple of weeks I was signed up for both books.

One of them I actually finished, and more or less on time. *Heaven and Hell in Western Art* was the first full-scale book I had completed since *The Art of Australia*. It appeared in 1969. *Heaven and Hell* was a success, as such things go. It sold few copies and made little money, which was par for the course with art books; but it garnered good reviews, some of them better than it deserved. I researched and part-wrote it in the British Museum Reading Room, under that storied and magnificent dome by Sydney Smirke, where countless other authors had added their grains of sand to the illimitable dune of knowledge.

It made me feel grown-up to be doing this: perhaps a mere ant crawling on the rock face, but at least an adult ant. I was delving back into my doctrinal past, finding at every turn how preposterous much of it was: the cruel obsessions of long-dead churchmen and divines, elaborating the most obscene and crazy torments for heretic outsiders and dissenting sinners, all in the name of the merciful God they cherished. The promise of Heaven and the

threat of Hell, in the days when the realities of both were unquestioned, must have supplied the clergy with a sense of its own power that no other gratification could exceed. I had never before studied eschatology (knowledge of the Four Last Things: Death, Judgment, Heaven, and Hell), and what brought me up short was discovering, in detail, how nakedly this immense accumulation of mythology had always been used by the Church as a means of social control: before they were anything else, both Heaven and Hell were in a real sense political artifacts.

So I think that, to the extent that I needed any further impulse away from the Catholic Church, working on *Heaven and Hell* supplied it. Only two decades before, Europe had emerged from a period of unimaginable suffering whose distinguishing feature, whose archetype, was the death camps organized and run by the Nazis. But long before, as long before as the death of Adam and Eve, if you were to give credence to the various Catholic apologists who had written on the subject, God had been instituting his own concentration camps, from which there was no escape and no remission of torment, in which souls were tortured not vindictively (for vindictiveness was below the majesty of the Divine Nature). You could imagine groveling hopelessly before such a being. But praying to it? Taking moral lessons from it? How could such a god be worshipped? You might as well sink to your knees before Rudolf Höss, the commandant of Auschwitz. Perhaps it had been a long time since I was, in the real sense, an adherent of the faith in which I had been raised. But the writing of *Heaven and Hell in Western Art* made me realize that I could no longer call myself anything but an ex-Catholic. It did not get all the Church out of my system—realistically, nothing ever would—but at least it made explicit what had been subliminal.

It was also the last book I would write for ten full years. The next, *The Shock of the New,* came out in 1980. How could I have been so unproductive? The answer, I am afraid, was marriage—or, rather, the character of my marriage to Danne. It left no emotional energy for anything else, except small bursts of mainly critical writing. There are marriages and partnerships that fill both the room and the soul with oxygen. There are others that burn up all the air in the room, and my first marriage was one of those. Without Danne my life seemed a wilderness; but with her, it was a sticky encumbering mess from which, due to my own cowardice and ineptitude, I could not

escape. I was thirty. I made a show of being a confident writer, appearing on TV, acting as a "spare man" at dinners to which Danne refused to come on the grounds that they were social and therefore hopelessly square. But in reality I was like a man trapped beneath an overturned boat, who tries to survive on the small amount of air caught in the capsized hull but knows it will soon be used up and lacks the courage to subdue his panic, dive deeper, swim clear, and free himself.

It was in this confused and irresolute frame of mind that I set out on my second book for Weidenfeld, the biography of Leonardo da Vinci. In some respects this was an unwise project. It could even have been termed idiotic. Today I would call it merely foolish. My Italian was reasonably good, but by no stretch of the imagination could I have claimed to be a Renaissance scholar, and I had no academic credentials whatever. All I had going for me was a sort of unsupported enthusiasm, and a great deal of curiosity about a man who, as artist, thinker, scientist, and writer, was one of the most intensely mythologized figures in cultural history: which had to mean, I reckoned, that he must have been greatly misunderstood. The idea that I should start out by gathering all the data about Leonardo before writing a sentence on him made no sense to me; it never has, in anything I have written.

By now, I realized that my main impulse for writing a book was to force myself to find out about things I didn't know. It has always been like that; the reason for this memoir is the same, to excavate and bring into the light things I had forgotten or repressed, along with the stuff that remained at the front of my awareness. Otherwise, why do it at all? Somewhere underneath all that shit, as the little boy says in the tag line to the childish joke, there *has* to be a pony. With Leonardo, I thought I should perhaps begin in the middle and somehow write my way into him, starting with reflections on the peculiar nature of his fame, of which the quintessential peculiarity was the fame of the *Mona Lisa:* how on earth did this portrait of an unknown woman become the most celebrated painting in the whole history of Western art? Things do not become famous of their own free will; images *have* no volition.

The *Mona Lisa* was certainly not famous in its own time. It was scarcely known. In the eighteenth century, after it had passed into the collection of

Louis XIV's chief minister, Antoine Coypel, it was not much esteemed; its access of fame, strangely enough, did not arrive until the nineteenth century and was caused by Romanticism and the cult of the "fatal woman," a fixation with which the original Lisa del Giocondo, whoever she really was, can have had nothing to do. This presentation of a slightly fleshy Tuscan upper-middle-class wife as a blend of Sphinx and vampire was surely one of the great misreadings of an image in all cultural history, and if the Gioconda could be mythologized in this way, so could her author. Leonardo, with his many interests, was taken as the prototype of the "Renaissance Man," but actually few major figures of the Renaissance were polymaths: they tended, naturally enough, to specialize, a habit to which Leonardo was the outstanding exception.

He paid a heavy price for this. One phrase that he repeated gave it away. When one cut a new pen from a quill, one tested it by scribbling a few words. Leonardo's test phrase, repeated innumerable times in the thousands of pages of his manuscripts, with abbreviations and variations, was *Dimmi, dimmi se mai fu fatta cosa alcuna*—"Tell me, tell me if anything ever got done." This doubt, this uncertainty of the value of his own probing, speculation, and research, was (sadly enough) entirely justified. So little of Leonardo's work ever came to fruition. He dreamed up great projects but could not complete them. Sometimes they were subverted by his own passion for technical experiment: so it was with the *Last Supper* in Milan, which, due to its unorthodox and untested techniques, is now a barely legible wreck. The giant bronze horse he worked on as a monument for his patron Francesco Sforza (c. 1485) was never cast, and its full-sized clay *modello*, twenty-four feet high, reverted to mud in the open air, destroyed by rain and the French archers who used it for target practice, like the Lilliputians shooting at the prostrate Gulliver. He was esteemed as an architect but none of his designs were ever built. His flying machines never flew, and most of his war machines, such as a limpet-like tank propelled by human muscle power, could not have worked. Leonardo was not merely hampered, but terminally frustrated, by the impossibility of high-ratio energy conversion—a problem not solved until the age of steam. The crowning sadness in this life of superinventive failure was that, even in areas such as human anatomy, where his researches could have had a great effect on the advancement of science,

they did not do so because his notebooks were never set in order, let alone published; broken up, dissipated through numerous hands, their contents remained essentially unknown until his discoveries were made all over again by other, later minds.

But the chief obstacle to writing a life of Leonardo, or so I found, was his lack of sympathetic qualities as a human being. Of his genius there was no doubt; it has often, perhaps too often, been said that if anyone deserved to be called a genius it was this illegitimate son of a notary, sired on a peasant woman about whom nothing is known except her name, Caterina, and her home, the obscure Tuscan hamlet of Vinci. But in all the thousands on thousands of pages that Leonardo wrote, there is not a sentence that betrays any fondness, let alone love or even need, for another person. Sentimental slush is always disgusting, and it is depressing to be inundated by it, as we all are today; but there is something almost frightening about the extent to which Leonardo embodied its opposite. He was as cold as a fish, as aloof as a mountain. He did not recognize any fellowship with his fellow men, and still less his fellow women. A Florentine, he had little or no sense of local patriotism; he worked for Ludovico Sforza, the duke of Milan and no friend of Florence, and for one of the Florentine republic's most ruthless enemies, Cesare Borgia; and of course he died an expatriate, in distant France. As for family connections, the value he put on them can perhaps be judged from an extraordinary letter he wrote to his brother Domenico, whose wife had just borne him a son, "which circumstance I understand has afforded you a great deal of pleasure." Normally this would be an occasion for family congratulation. Not for Leonardo. On hearing that Domenico had been filled with joy, Leonardo wrote, he had realized that he had been wrong about him all along, "that I was as far removed from having an accurate judgment as you are from prudence." All Domenico had done was "to engender a watchful enemy, who will strive with all his energies after his liberty, which can only come into being at your death." It is a pity that Sigmund Freud, who wrote a useless essay on Leonardo based on a mistranslation from Italian (which Freud could not read) into German, was not aware of this stunning Oedipal disclosure.

The involuntary conditions of being human—eating, lusting, excreting—filled Leonardo with disgust. The human body, he noted at one

point, merely served as a "filler-up of privies." He loathed all smells emanating from it, and one may call his power to resist and overcome this revulsion in the interest of knowledge truly heroic. When I asked a leading dissector at the Wellcome Museum, London's chief collection of medical specimens, about Leonardo's anatomical work, he pointed out that some of the dissections he performed on structures of the human body required weeks of intensive labor, and there were no preservatives like formalin in the fifteenth century—only alcohol. For someone as almost neurotically fastidious as we know Leonardo was, such work must have required enormous detachment and self-discipline.

There is little doubt that Leonardo was homosexual. But there is no evidence that he ever had a male lover; the only possible candidate was a studio assistant called Salai, a thieving brat, about whom we know exactly nothing beyond the fact that he sometimes irritated Leonardo past endurance and had beautiful, curly hair. What Leonardo loved was not any one person, but Nature, not because it was a manifestation of God's will and being—as thinkers in the Middle Ages saw it—but because of its own immense, self-sufficient, and inexhaustibly marvelous complexity. (The idea of God hardly figures in his writings at all, and one senses that when it crops up it does so for merely conventional reasons. As for the cult of saints, centered around devotional images, Leonardo held it in undisguised contempt. "Men shall speak with men who shall not hear them; their eyes shall be open and they shall not see; they shall speak to them and there shall be no reply.") His obsession, which became a recurrent leitmotif of his work, was the movement of water—currents, spirals, cataracts, sluices—which was repeated in many other natural forms, from the waving growth of grasses to the irksome Salai's ringlets. But if water created the world, if water shaped and nourished it, water would also destroy it. Here one came to the aspect of Leonardo that is most frightening and perhaps least sympathetic of all. His imagination was truly apocalyptic. His little-studied *Profetie* ("prophecies" or "dreams"), and the weirdly sadistic riddles and jokes he liked to write down are an indication of this:

Many children shall be torn with pitiless beatings out of the very arms of their mothers, and flung upon the ground and then maimed. ("Of Nuts, Olives, Acorns, Chestnuts and the like.")

But the truly extreme examples of it are in his drawings: those tiny, detailed studies of universal death and disaster known as the "Deluge" drawings. "But in what terms," he wrote, "am I to describe the abominable and awesome evils from which no human resource can save us? Which lay waste the high mountains with their swelling and high-rising waves, cast down the strongest banks, tear up deep-rooted trees, and with ravening waves laden with mud from crossing ploughed fields carry with them the unbearable labors of the wretched tillers of the soil?" It is as though Leonardo had been granted, not once but obsessively, a vision of tsunamis, although no such seismic horrors had taken place in the Mediterranean of his time. He could and did put the end of the world on sheets smaller than a quarto page, through a process of absolutely relentless abstraction. Leonardo's vision was, it seems, the most extreme utterance of catastrophic imagination in all art. More extreme, even, than Lear's immortal diatribe:

> *Blow, winds, and crack your cheeks! rage! blow!*
> *You cataracts and hurricanes, spout*
> *Till you have drench'd our steeples, drown'd the cocks!*
> *You sulphurous and thought-executing fires,*
> *Vaunt couriers to oak-cleaving thunder-bolts,*
> *Singe my white head! And thou, all-shaking thunder,*
> *Strike flat the thick rotundity o' the world!*
> *Crack natures moulds . . .*

The despair Leonardo felt on contemplating man's power of ecological destruction and reciprocal murder strikes a peculiarly modern note, which must have been even less comprehensible five hundred years ago than it was until recently. Here he is on the ghastly spectacle:

> These shall set no limits on their malice . . . There shall be nothing remaining on the earth or under the earth or in the waters that shall not be pursued and molested or destroyed, and that which is in one country taken away to another; and their own bodies shall be made the tomb and conduit of all the living bodies which they have slain. O Earth!— what restrains you from opening and hurling them headlong into the deep fissures of thy huge abysses and caverns, and no longer to display to the sight of heaven so savage and ruthless a monster?

I think I might be able to write about Leonardo now, though I am not completely sure. What is quite certain, however, is that I was not equipped to do so forty years ago. He was beyond my grasp. I did my best to get hold of him, of course. I carefully looked at every picture he had painted (except for that unhappy wreck the "Benois Madonna," with her bloated infant, in Leningrad; I could not afford a trip to Russia). I got as much access to the drawings in Windsor Castle and to the *Codice Atlantico* in Milan, among other notebooks, as I possibly could. I invested heavily in books of reproductions, collections of essays on Leonardo studies, out-of-print monographs. I interviewed historians of medicine, of technology, of military invention, of botany, etcetera, etcetera, and again etcetera. I passed weeks and then months in Florence, with side trips to his native village of Vinci. Slowly and irregularly, more in disconnected spurts than in a steady stream, the pages of manuscript accumulated. But I kept fighting off the ominous feeling that my heart wasn't in this project. There were so many things about Leonardo that I found fascinating, beginning with the peculiar fact of his cultural fame: apart from the qualities of his paintings and drawings, why did he evoke such strenuous reactions from so many nineteenth- and early-twentieth-century writers, and why did they take the form they did? But that was a matter of cultural anthropology—it didn't take you much closer to the Great Arcanum, which was how Leonardo *himself* thought, acted, and reacted. And probably no one will ever have the answer to that. In short, I had failed to come to grips with him, and that failure was going to haunt and embarrass me for years to come: I couldn't bring myself to write a superficial (though no doubt quite publishable) book on Leonardo, and I wasn't able to write the kind of book he deserved. This, in due course, would test my powers of evasiveness to the utmost, and give me a permanent sympathy with all young writers who, for one reason or another, find they have bitten off more than they can chew.

Going to America

Italy was not the only place across the Channel in which I got absorbed in the late 1960s. Until then I knew little of Spain or of Spanish art, beyond a rather formal and distant acquaintance with the major figures of the 1600s, the "Golden Century": Velázquez, Ribera, Zurbarán, Sánchez Cotán, Murillo— and, a hundred years later, Goya. I spoke little Spanish and, when I tried to utter a passable sentence, I kept slipping into Italian. Almost all my energies had been monopolized by Italy, and France took whatever was left. (Not that I have ever been all that crazy about France or the French, but that is another matter.) However, that was to change soon enough, and the person who caused that change was the Catalan sculptor Xavier Corbero.

Xavier is the closest friend I have ever had. His only rival for that uncertain honor would be Colin Lanceley, but Colin lives in Australia, and so we have seen each other all too seldom since the 1960s. But I have been lucky enough to have known Xavier for forty years. During that time, each of us has seen two marriages crash and burn; we have, sometimes knowingly and sometimes not, shared the same girls in Europe and America; I think I have shown him a few things, and I know that he has revealed a great deal to me. He is four years older than I am, born in 1934, nursed in the whirlwind of the Spanish Civil War. To say he is "like a brother" to me would be insufficient; I have never had the deep sense of comradeship and mutuality with either of my blood brothers that I felt, almost from the start, with Xavier. We have disagreed about a lot of things but never fought about anything. When, as sometimes happens, an Australian asks me what, other than art, I got from

living abroad that I couldn't have found at "home," I think first of my wife the painter Doris Downes, and then of the sculptor Xavier Corbero.

We first met, not in Spain, but in London. The year was 1966. I have mentioned it usually seems to happen that I cannot remember just where or how I met the most significant people in my life, and Xavier was no exception to this irksome rule. I think we were introduced by his blond and very pretty English wife.

I do remember the second time we met, though. It was at a dinner party where, somewhat drunk after dinner, I had been holding forth on the subject of the Catalan architect Antoni Gaudí i Cornet.

At the time, Gaudí was not only the best-known Spanish architect outside Spain—he was probably the only one whose reputation had extended beyond the Pyrenees. However, although his name was familiar, ignorance of his work among non-Catalans was profound, except among a few specialists—and even they weren't much help. The only building of his that nearly everyone, including myself, had heard of and seen (at least in photographs) was the Templo Expiatorio de la Sagrada Familia, the Expiatory Temple of the Holy Family, that huge, bizarre-looking, and as yet roofless structure, with its pierced bulging spires and façade dripping with a profusion of sculptures that resembled, in photos taken from afar, the melted accumulation of candle wax on a Chianti bottle that had been heaved out of the ground in Barcelona.

In the early sixties, knowing so little about Gaudí, I had gone along with and parroted the line on him taken by French critics: that he was a kind of Surrealist *avant la lettre*, designing structures of a mad, disconcerting, and rather naïve originality, perhaps a bit like the Surrealists' favorite "primitive" architect, Ferdinand Cheval, the obsessive postman of Hauterives, but certainly outside the "mainstream," however you might try to define it, of modern architecture. I was warming to this stupid theme when I noticed that Corbero, who had come in after dinner, was staring quizzically at me.

Corbero's face, even in repose, has dubiety written all over it. He looks like a tobacco-skinned, bony, and fiercely skeptical Gypsy. Even then, he stood out in a room full of jeans, long hair, and tie-dyed *schmates*, the uniforms of sixties nonconformism, by his dress: a beautifully tailored suit in a rather loud windowpane check, obviously handmade brown shoes that enclosed his small, goatish feet like highly polished purses. His hair, instead

of being long and hippyish, was slicked straight back with brilliantine. And always a cigarette: untipped English Players.

"It is good that you like Gaudí so much," he remarked in his growling, staccato Catalan accent, "even if you seem to know so little about him."

The upshot of the evening was that we argued, I was defeated, and Xavier, who really cared whether people understood about Catalunya or not—and at the time, who did care except the Catalans themselves?— invited me to come to Barcelona and stay as his guest, so that I could see something of Gaudí and his context at firsthand. What, indeed, did I know of him—or of Barcelona itself? John Olsen, who had lived for a time in Majorca, had talked to me about the city, back in Australia. I had a romantic picture of it, a mélange of George Orwell's *Homage to Catalonia* (but that was already three decades old) and Olsen's dithyrambs in praise of some of its artists, chiefly Antoni Tàpies and Miró. But this turned out to be nothing like the modern reality of the city, and though my real discovery of it belonged to the 1970s and '80s, everything I found out about it from the start owed something to Xavier.

His house was a few miles south of the city, toward Tarragona, in a village named Esplugas (in Catalan, Esplugues) de Llobregat. It was in most ways the strangest house I had ever stayed in. Its name meant "the house of the snail," which must have been an allusion to its winding character, up and down, around and about, resembling the helical convolutions of a snail shell. Or perhaps one of its owners had an inordinate liking for snails, one of the chief delicacies of Catalunya's agrestic diet, especially when scented with thyme and eaten with *allioli*, thick garlicky mayonnaise, or *salsa romesco*.

Either way (or both, perhaps), it was quite an architectural treasure, because it was one of the very few examples left in or around Barcelona of a real Catalan *masia*, otherwise known as a *casa pairal*, the patriarchal farm-house of the Catalan countryside. Only three, I think, survive in Barcelona itself; but since Esplugas de Llobregat has now been more or less absorbed by the outward expansion of the city and is no longer so distinct from the Eixample, its core, the Can Cargol made four.

The *casa pairal* was a very distinct and identifiable type of building. In its bricks and stones it expressed two prime social desires, both linked: family solidarity and defense against intruders. Its center was the *llar de foc*, or hearth, where the family gathered. This was a kind of living room within

the communal room, as much as fifteen feet wide, with a fire sending its smoke up an enormous funnel, with iron dampers and chains and a great black turning spit—sometimes powered by a large family dog running within a wheel—that could accommodate a goat or even a medium-sized pig. Benches and chairs were grouped around the *llar de foc* and, in old rural Catalunya, these were occupied by family members in a strict order of precedence, ranging from the *avi* ("ancestor," or grandfather) down to the children. This canonical and traditional expression of family began to die out in the nineteenth century as the city replaced the farm as the focus of Catalan social life, but the imagery of the communal hearth in the *casa pairal* hung on, supplying (among other things) the conservative "family-values" politics of even the Catalan cities with a powerful fund of metaphor.

The house around the hearth was built strong enough to resist, literally, an invasion, whether by Moors, Castilians, or hostile *xarnegos* (a brutally insulting term for foreigners) who lived in the next valley but might as well have been Martians: thick walls, small, deep-set windows, and a great thick layer cake of a terra-cotta-and-mortar roof. Outside, the *casa pairal* had the aspect of a fort. Inside, it was dark and cool, solidly reverberant and cosy.

In addition, the Can Cargol had subterranean refuges—a warren of tunnels and caves below floor level. These were part of the system of limestone grottoes that gave Esplugas de Llobregat ("the caves of Llobregat") its name. Most of them seemed natural, although centuries of use by farmers had expanded them and adapted them for storing oil, grain, and silage: there were huge terra-cotta pots sunk in some of their floors, that resembled—and may originally have been—ancient Roman storage jars. Xavier had installed a few dim and flickering bare-bulb electric lights, but most of the caves were pitch-dark, the abode of spiders and cockroaches, and being scared of darkness and insects I did not explore them. However, I was there when a Corbero family friend in the wine-growing district of Penedes presented Xavier, not with a mere few cases, but with about a thousand bottles of both red and white wine, some of it excellent. It had to go in the caves below the house, but there were no racks, nothing to lay the bottles in—and, when the delivery truck came rolling down Calle Montserrat and stopped at the door of Can Cargol, no time to install any. So Xavier took the most direct route and had the delivery men simply dump the bottles on the floor of the caves. There they lay for years, being gradually consumed, in disorderly

piles, while insects chewed and damp obliterated the labels. It was like my post-flood guesswork in the cellars of the Buca Lapi in Florence; you didn't know what you were getting. For me, this added a pleasant touch of uncertainty to our meals.

The house was full of treasures. Not the traditional fine *antigüedades* of the Spanish upper middle classes—Xavier was too poor to buy such things—but a profusion of objects from the then-abundant flea markets of Catalunya, which an adroit bargainer with a sharp eye could pick up for rather less than a song.

I think he had two exemplars in the art of collecting. One was Salvador Dalí, who was of course a Catalan—his lair was to the north of Barcelona, in Figueras, where Xavier would sometimes visit him—and the other was a Catalan too, named Frederic Marès i Deulovol. Dalí collected all manner of luxurious exotica and erotica, seeking to create a *Wunderkammer* of dream stuff. Marès, on the other hand, was a sculptor, a mousy, only marginally successful art teacher who had worked for decades at the National Art School of Catalunya. He had genius, but it all went into his obsessive activities as a pack rat. During the 1930s, and especially during the Civil War, he had amassed what was probably the greatest private collection of religious sculpture in Spain. The Reds were infamous church-burners, and Marès always seemed to know when and where a church or a monastery was to be immolated; he would turn up, spin the local commissar a yarn about how he had taken on himself the duty of taking away a particular sculpture or *retablo* that would eventually form part of a People's museum of discredited superstitions; and more often than not he would jolt away with it in his little truck. Sometimes he would go directly to the priest before the Reds got there and, displaying his credentials as a teacher at the National Art School, would offer him a few compensatory pesetas to let him "save" a Madonna or a crucifix from the advancing vandals and hide it in a safe place until the terror was over. Marès was perfectly sincere in this. He really did want to help save his country's patrimony, and it would never have occurred to him to make a profit on it. In any case, the bottom had fallen out of the market for Spanish religious art.

But Marès's greater claim to fame was in his obsessive and unquenchable thirst for what was regarded as junk: the innumerable relics of bourgeois and artisanal family life, uprooted from their homes and recirculated by death or

need through the flea markets, costing (in those distant years) next to noth-ing. He was Spain's greatest example of the pure collector. He wanted to reconstitute a lost world, that of Spain in (roughly) 1800 to 1900, by reassembling its scattered bones and making them live through sheer insis-tent repetition. He was not interested in "information," the archival aspects of history, but in its actual appearance; the things that people used, wore, bedecked themselves with, gave to one another. Some collectors have had no concern with the beauty of the objects they amassed: there have been men who devoted their lives to acquiring thousands of lightbulbs or glass eyes. But there was a strong esthetic component in Marès's collecting. An artist, he wanted to celebrate and help others rejoice in the creativity of all those thou-sands of men and women whose skills, incarnate in every sort of object, live on without their names, and which, even then, were passing into oblivion in an age of mechanical production.

He collected buttons and bows, veils and ribbons, lace kerchiefs, collars, bow ties, cuff links, embroidered slippers, buttoned ladies' boots, and collar studs. He amassed case after case of cigarette holders and tobacco pipes, carved into every imaginable configuration, from the head of a leopard to two tiny Negroes of black coral having sex, from a corncob to a caricature of Mazzini, and in every material from briar root to ivory and amber. He collected chessmen, draughts boards, playing cards, Parcheesi sets and mah-jongg tiles. His collection of walking sticks, shepherds' crooks, canes, orna-mented crutches, umbrellas, sword sticks, parasols, and the like ran into thousands of items. So did his cigarette cases, matchboxes, powder com-pacts, etuis, rouge pots, toothpicks, thin silver spoons for getting wax out of your ears, nail clippers and beautifully chased scissors for trimming the eye-brows and the *bigotis*, the moustaches, without which no elegant Catalan's life was possible. And here we have not even begun to touch on the keys, the penknives, the Arcimboldesque table decorations made of thousands of tiny shells glued together, the turnip watches, paperweights, decanters, goffering irons and, for want of a sufficient word, all the rest. Frederic Marès left his collection to the city of Barcelona, which, in gratitude, awarded him a cata-log an inch thick and a large medieval palace in the Ciutat Vella where quite a lot, though by no means all, of his collection is displayed. Xavier and I would sometimes visit the Museu Marès, or *museu sentimental,* as it is rather charmingly known, and come away in raptures. The pleasure was not pol-

luted by envy; you could no more envy the achievements of Frederic Marès than you could those of King Ludwig II or the pharaoh Rameses. You could only marvel at them, and wonder where on earth the things were kept before Barcelona gave them a palace.

Nor did Corbero seek to emulate Dalí and Marès, but they inspired him, and he combed the flea markets with a most discerning eye, bringing back things that weren't necessarily related to his own work but had a peculiar, offbeat charm, an elegance of making, that overcame their old and battered appearance: things from the time of the *Renaixença*, the name Catalans give to the period between 1860 and 1910, when there was a strong anti-Madrid current of Catalanist independence flowing through Barcelona; when its culture was genuinely internationalist and closer to Paris and Germany than anything in the rest of a relatively provincial Spain. And other things, more modern: I remember an enviable collection of tin windup toys from the 1920s and 1930s, toys of every sort from clowns to toreros to Hispano-Suizas. He collected at an angle to current taste in Barcelona: thus, because most Catalans were not at all interested in Japan, anything Japanese was cheap, whereas, due to Catalan Anglophilia, anything English was unafford-able; Corbero secured some beautiful old *tansu* chests, made of figured hinoki cypress. One of the major industrial ceramics firms of the late nine-teenth century had had its kilns not half a mile away from the Can Cargol; it had gone out of business, but its abandoned site was littered with tiles, including color-test tiles fired for the projects of the ceramists who worked for such architects as Domènech i Montaner and Antoni Gaudí. Like a beachcomber picking up shells, Xavier scavenged among these and tiled his kitchen walls with his finds, which made a fascinating collage. But the whole house was a collage, and it would become more of one as time went by. It expanded. Over the years, Xavier began to buy up both sides of the narrow, crooked street in Esplugas, devising arched arcades, terraces, basements, pools, raised gardens, all concealed behind high walls. His mania for build-ing was matched only by his enthusiasm for container gardening: palms and yuccas and eucalypts now stand everywhere, and he has, by his count, five thousand terra-cotta pots with roses, succulents, mimosas, cacti, and even grevillea flourishing in them.

In the sixties, Xavier showed me a Barcelona I would not otherwise have seen, which he knew like the back of his hand because he was virtually its last

dandy. He was like Rafael Puget, the hero of Josep Pla's fascinating evocation of a vanished city, *Un Senyor de Barcelona*—except that Puget was not a creative artist and Corbero completely is. He was the city's memory man. There were, of course, others, but either I never got to meet them or their English was not good enough to compensate for the inadequacy of my Spanish and Catalan.

One of them, whom I dearly wish I had known better, was a psychiatrist named Mariano de la Cruz, who, because psychotherapy was so uncommon in Spain (though slightly more familiar in Barcelona, the least Catholic and most "European" of Spanish cities), was the man to whom artists and intellectuals who felt destabilized would resort, as more devout people would seek the absolution of a favorite priest in the confessional. Since few of his patients had much money, they paid in paintings, prints, and drawings, and he ended up with a handsome collection that crammed the walls of his modest flat in the Eixample. There would have been nothing so very unusual about this except that Mariano was also a passionate and erudite aficionado of the bullring, of which Barcelona had two, and led what was more or less a second life as the bullfight critic of *La Vanguardia*. Am I right in thinking that this elderly charmer, who looked like a rubicund peach with a fringe of white hair, was the first and only man in the world to make his living half from Freudian/Lacanian analysis and half from tauromachy? I hope so. Certainly he was the only shrink at whose table (and he was a great gourmet, too, courted, feared, and respected by the restaurants of Barcelona, and famed for his version of the festive boiled-meat dish known as *escudella*) one might conceivably have met El Cordobés or, years before, Ignacio Sánchez Mejías, the torero whose death inspired García Lorca to write his lament with the refrain *At five in the afternoon*.

Corbero, being a flaneur as well as a diabolically hard manual worker (which sculptors must be), had several Barcelonas.

Some of them were high, some low. The high could be almost petrified by its altitude: there on the Ramblas, for instance, was the city's opera house, the Liceu, built by private subscription in the nineteenth century: a wonderful, rather kitschy piece of grandiosity, foaming with gold leaf and sub-Tiepolesque murals. But it was at least public, whereas immediately next door to it was the Club del Liceu, the Opera Club, which those same patrons had built for themselves, and it was emphatically not. Indeed, when Xavier

(who belonged to it, of course) took me there for dinner one night, I had the strong impression that all the members must have died, leaving us alone in its fantastically decorated *modernista* chambers, lit by the dim glow of stained glass and gold leaf, redolent of the ancient, delicate after-aroma of years and years of Partagas and Carunchos, and featuring a cycle of paintings of fashionable life in Barcelona circa 1890 by its leading society painter, Ramon Casas, one of which depicted a vintage—but then, of course, brand-new—De Dion-Panhard open tourer plunging straight at you out of the wall, driven by a Catalan Gibson Girl. In the background you could make out the pavilion that the society of rich patrons who built the Opera House had erected for the 1888 Barcelona World's Fair; in front of it, Casas put the silhouette of its chief conductor, leading his orchestra in an open-air performance.

In real life, the girl behind the wheel had been Casas's mistress and model, some twenty-five years younger than he, once a flower seller of uncertain reputation, but *muy salada,* sulky, outspoken, and funny—an Eliza Doolittle to his Henry Higgins. It is not certain that she knew how to drive, or that Casas would have let her do so alone. Casas was famous in his time for his sense of style, which showed itself in everything he did; he even owned the first sports car in Barcelona and was the man whom the Dadaist Francis Picabia, with his mania for fast expensive machines, most wanted to imitate.

The steward who ushered us into this room pressed a switch and the headlamps of the car lit up. This must have been the first use of electricity as a component of an artwork, a long time before semi-Pop figures like Chryssa, Martial Raysse, and Jim Dine in the 1960s.

I was enchanted by the whole place. Even the dining room felt like a time warp, with its empty tables and empty cane chairs and glacially white linen; we were the only diners in it, and we were served roast lamb *al inglés* and a beautiful dish of fresh, sweet, new peas with diced Serrano ham by waiters as old-looking and slow on their feet as Galápagos tortoises. The vernal green of those peas against all that whiteness of linen stays with me. Where, I asked Xavier, were all the members of this club? "The fathers are all at home dying," he said abruptly, "and the sons are all in discotheques."

Xavier had an unquenchable nostalgia for this semi-lost world: his art might be modern, and indeed it was, and his social range and curiosity were both large, but his tastes were of a kind that was beginning to die out even

then and hardly exists today. He once took me to a huge *modernista* apartment that was for sale in the Eixample. It had been constructed in the 1890s for an *indiano,* one of the Catalans who had gone to South America and made a fortune, whether in tobacco or slaves or machinery, and then returned to cut a figure in his home city. One could tell it must have been an *indiano,* Xavier pointed out, because of an amazing screen, some eight feet tall, that divided the main salon. Into its twining Art Nouveau glass panels were sandwiched the iridescent wings of South American morpho butterflies, scores of them, each the size of a dessert plate, preserved like specimens on laboratory slides from the passage of nearly a hundred years, gleaming unearthly cobalt and turquoise.

Xavier was convinced, and easily persuaded me, that this singular place could be bought for not very much money and converted into a profitable cathouse. He said he knew how and where the girls could be recruited. I felt sure he did: at the time, to my mingled mystification and enjoyment, the Can Cargol held a floating migrant population of young strippers who worked at the Crazy Horse in Paris, and would descend twittering on Esplugas because their mother hen at work was a Catalan girl named Agathe who had married a famous young Catalan architect named Ricardo Bofill, who in turn was an *amic* of Xavier's. They had a liking for silvery wigs, not in imitation of Andy Warhol, but because they liked Barbarella. Some of them, though not all, were rather proper. So you never knew whom you might meet in those interlinked rooms, or what might happen when you did. But the dream of high *proxénétisme*—that formal term in French legal jargon that means pimping—was not fulfilled. Neither Xavier nor I had any money, let alone enough to buy the future brothel, and now I cannot even remember its address or guess what happened to that exquisite butterfly screen.

As for the low Barcelona, for me it was epitomized by an institution called El Molino.

It was a music hall, built on the Parallel (as this street was called, though what it was actually parallel to I was never able to discover) down by the port, below the end of the Ramblas.

El Molino was clearly named after that archetypal music hall in Paris, the Moulin Rouge. It had grown up from the general bohemian enthusiasm for things French in the time of Casas, Rusinyol, and the very young Picasso, in the late 1890s. As late as the 1950s it was still regarded by "good" Barcelonan

families as rather a *mauvaise lieu;* Xavier first went there when he was eleven, daringly dressed up in what he thought was an adult costume, with long pants—but the long pants were plus fours, so he must have looked rather like a swarthier version of the French schoolboy in Hergé's immortal comic strip *Tintin et Milou.* He got a seat in the front row below the stage—and found, to his horror, that he was sitting right next to his grandfather, who was also alone but refused to address a single word to him all evening and left without offering him a ride home.

There were, before I got to Barcelona, two music halls on this part of the Ramblas. The other, opposite El Molino, was called Arnau, in homage to a famous medieval Count of Barcelona. Its entertainments, however, were unlike anything available in the Middle Ages. The star turn was a man named Camillo, who would appear onstage wrapped in a black cloak, just like a human-sized *rat-penat* ("feathered rat," Catalan for bat, one of the heraldic animals of Barcelona for historical reasons too complicated, and perhaps too implausible, to go into here). Then, with arpeggios from the piano and a clash of cymbals, he would throw wide his arms. Camillo was stark naked under the cape and (most nights) had a long, thin erection, as stiff as a chopstick. An invisible wire plucked him from the stage and flew him over the auditorium, blowing kisses to the delighted audience, which mostly consisted of elderly pensioners. They loved their Camillo.

Like other music halls, El Molino is gone now; its very type of entertainment is extinct in Spain, as it has long been in England, where it flourished so brilliantly and grossly through the 1930s, '40s and even into the '50s. Television killed it, and there can't be many people left alive who remember seeing its stars, like Max Miller. But El Molino lasted longer than most, because of the irrepressibly vulgar traditions of Barcelona, its sheer caricatural dirty-mindedness. It was a place where nearly everyone went, except for nuns and priests—people in the garb of nuns and priests were, from time to time, seen in the audience, but they were assumed to be transvestites.

Alas, having no Catalan, I was not able to really appreciate what went on there. But it seemed wonderful all the same. The tickets didn't cost much, and a couple of hundred extra pesetas slipped into the hand of a wizened usher called Johnston (which cannot have been his real name) got you a box near the stage. When Johnston was not looking after the seating he sometimes appeared onstage dressed as a *langosta,* a lobster, vigorously waving

his cardboard antennae. But in his capacity as usher he looked exactly like the corpse-white Herman in *The Munsters* and wore a shiny, rather greasy *frac*, or tailcoat. He would show you to a box. It was hung with green velvet hemmed with bobbles and tassels, as old and ill-maintained as that *frac*. If you chose you could draw these curtains and grapple tenderly with your girl-friend or boyfriend (the management of El Molino did not make invidious distinctions) in as much darkness as you wanted while the riotous fun, or *rauxa*, went on onstage. A thousand pesetas, perhaps less, would get the usher from *The Munsters* to bring you a bottle of sweetish inferior *cava*, a brutally hangover-inducing fizzy wine that was supposed, incorrectly, to resemble champagne: this stuff was a classic leg-opener, like the fortified and flavored plonk that sank a half million virginities back in Australia, Barossa Pineapple Pearl. Dry *cava* cost more, and whiskey (distilled, probably, within sight of the Ebro, but produced in Johnny Walker Red Label bottles) a fortune.

The acts were basically of two kinds: songs and monologues. The songs, performed by highly painted ladies and elderly gentlemen dolled up to look like Rudolph Valentino, sometimes against a background of wobbly palms (and do I remember a cardboard camel?), were to song what the *cava* was to champagne: syrupy, trilling equivalents of moon, June, croon, swoon, accompanied by much fluttering of Sevillian fans. The human ear could take only so much of this, and it was a relief when the sheikhs and burdensome nymphs made their exit and the comic acts came on. I could not follow these skits, which evoked gales of laughter from the audience, but the memorable characters were two.

The first was El Maricón, "The Fairy," who sashayed and pranced around the stage in the most hysterical parody of homosexuality I have ever seen; what he was saying, Jesus only knows, but he had the customers in fits—not just some of the time, but all of it. Such an act would never be allowed in modern Barcelona, where it is illegal and, in fact, severely punishable by fines to call people *maricones, mariquitas*, or any of the dozen other traditional names for the various declensions of the third sex, and boringly obligatory to refer to them as *los gays*.

The second, not to be confused with the first, was El Inglés, "The Englishman." He was played by a tall, rubber-legged, morose actor in a gin-ger suit of hairy tweed, topped off by a bowler hat. He carried a hickory-

shafted golf club, with which he made energetic pokes and swings at empty air. Looking back on him, I think he looked—apart from the poor cut of his suit—somewhat like the adult Prince Charles, but this could hardly have been foreseen in the mid-sixties, let alone in the early forties, when this act was probably born. He stalked around, precisely enunciating, in an accent apparently modeled on Lord Haw-Haw's, what Xavier told me were almost unbelievably filthy jokes, mostly about horses. Australians often made jokes about Pommies, for that was part of our colonial heritage. But it had never occurred to me before, strangely enough, that an Englishman could be so broadly comic a figure, like the ice-cream-selling Italian, the incomprehensible kilted Scot, or the Mexican dozing in the shade of a cactus. This was a valuable lesson in itself. You must always remember, if you crudely laugh at others, that others are certainly laughing crudely at you.

You could run into almost anyone at El Molino. Clearly this did not include the future king Juan Carlos II, or the reigning Pope. But at least one Nobelist went there quite often. This was Camilo Cela, who recently won the Nobel for literature. I have never been a fan of Cela's—his award seems even less comprehensible than Dario Fo's, though both are indubitably funny men. But then, the award of the Nobel has never been a reliable guide to literary quality: think of Pearl Buck. Cela, however, had what one might call a major *afición* for whores, almost rivaling Xavier's own. One night, Xavier took Cela to El Molino, and introduced him to an extremely pretty Plaça Reial sex worker of whom he, Xavier, was very fond. The girl had heard of Cela, but she wasn't sure why. "What do you do?" she asked, blowing cigarette smoke at him like a siren in a forties film. "I," said Cela grandly, "am a member of the Royal Academy of the Spanish Language." "Oh, no shit," said the young lady. "D'you need a cook?"

It would be wrong if I were to give the impression that most of the time I spent in Barcelona, then or later, was spent in pursuit of the louche. The history of the city, and of Catalunya in general, is long; and the place is almost unbelievably rich in monuments of the Romanesque period (the tenth to thirteenth centuries). In fact, nowhere else in Europe is it possible to see so much Romanesque painting of the highest quality, much of which— thanks to a massive and concerted effort of conservation that started in the 1920s, and concentrated on saving the mural frescoes in crumbling churches between Barcelona and the Pyrenees—was on display in the National

Museum of Catalan Art up on the hill of Montjuic, between the city and the sea. I have written something about these astonishing works in my *Barcelona* (1992), and need not repeat it here, except to say two things. First, that the museum has the best examples, not only of Catalan Romanesque fresco painting, but of Romanesque painting of any kind, in the world. The grandeur of those vertical saints and hypnotically staring Pantocrators was, and still is, overwhelming; these Catalan paintings, usually done by anonymous traveling artists on the walls of remote churches, are to the art of fresco what the works in Ravenna are to that of mosaic. Second, their impact on the development of later Catalan artists can hardly be overestimated. It is not, of course, literally true to say, "No Catalan frescoes, no Miró." But it is somewhere near the truth, and it was in that museum that I received the most vivid impression of old art feeding into new art, and of the continuity of regional traditions, that I had ever had.

Xavier was not a political person. But it was hardly possible, and certainly not desirable, for any Catalan to be completely apolitical in those days. Spain was still ruled by *el Caudillo,* General Francisco Franco Bahamonde, and in 1966 he still had ten years of life and of absolute rule to go. You could buy copies of the London *Times* and even, sometimes, *Playboy* on the newsstands in the Ramblas, but never a paper in Catalan.

Franco disliked and distrusted the Catalans, who had put up a bitter defense of the Republic against his troops in the Civil War. Like his predecessors, the centralist monarchs of Castile, who had crushed Catalunya's brave but ill-generalled attempts at revolt in 1714, all notions of Catalan self-government were to him merely subversive moonshine. Catalunya would never again be an independent realm, as it had been up to the fifteenth century. Its destiny and nature were to be part of Spain, and Spain—in the famous words of Ortega y Gasset—was *"una cosa hecha por Castilla,"* "a thing made by Castile." The official Falangist line on the Catalan language was that it was merely a degenerate dialect of Castilian, not a separate tongue in its own right, with its own uniquely valuable history and literature. It therefore had to be suppressed. Spoken Catalan sounded like a dog barking: hence the contemptuous slogan *"Perro Catalán, habla en Cristiano"*— "Catalan dog, speak Christian." It was not to be used in the schools or universities. Books—especially school and university textbooks—must not be written in it. Catalan newspapers could not publish. In this way, Franco

and his cultural bureaucrats expected, Catalans would be prevented from thinking separatist Catalan thoughts; they would be driven out of their linguistic hiding places. Exactly the same policy was pursued by the occupying Castilians in the eighteenth century, and with much the same lack of success. In fact, by the late sixties there had been some relaxation in the severity of Franco's anti-Catalan censorship: collections of poetry written in Catalan, and even some fiction, were being published without restraint. But Catalan students, intellectuals, and writers were deeply offended and rebellious at the general suppression of their language. For them, anti-Franquism was not solely a cultural affair—Falangist political censorship and police intrusion, torture and clandestine murder threatened every Spaniard—but cultural issues of Catalan identity were at least as important to them as the question of what America, to which none of them belonged, was doing to people they had no historical connection with in a part of Southeast Asia they had never been to. What concerned them much more was, first, freedom from Franco and second, what Catalans called *autodeterminació*—self-determination. This was to produce some fairly absurd by-products: some Catalanist educators, for instance, tried to insist that when the great moment of liberty from Madrid came, *only* books written in Catalan should be used for teaching in schools and universities—a restriction that would have made much higher education flatly impossible, since nobody had been writing textbooks on molecular biology or astrophysics in that language.

But the moment seemed indefinitely delayed. Franco, for a potbellied little Gallego, was incredibly tenacious of life, though he suffered from a succession of disorders and organ failures that would have killed most men much sooner. The famous story of his end (not true, alas) was that as he lay in his intensive-care room in the hospital in Madrid, with dozens of tubes running in and out of him and relays of nurses around, he heard the faint voices of a band of old loyal Falangists, gathered in the square below. "Adiós, Caudillo," they chanted reverently. "Adiós, adiós." At this the old dictator's rheumy eyes were seen to half-open; the crusty lips moved. *"Y aquellos, dónde van?"* he whispered. "And where are *they* going?"

Being anti-Franco gave almost all the young people in Barcelona in the sixties something in common: communists with Catalan nationalists with socialists, and so through the political spectrum. One of the bravest anti-Franquists was very much a conservative himself—Jordi Pujol, who would

emerge as the cunning and powerful leader of Convergència i Unió, the party that dominated the Generalitat or state government of Catalunya for many years: Pujol became famous for the *fets del Palau*, the "deeds of the Palau," in which he and a group of other Catalanists seized the moment of an official visit by Franco to make a sensational but peaceful gesture against him. Franco and his party had attended a concert at the Palau de la Música Catalana, that sumptuously ornate *modernista* hall designed by the great patriot-architect Domènech i Montaner. At the end of the official program, Pujol and his friends rose unexpectedly in the stalls and sang in chorus some verses from Catalunya's national anthem, *La Senyera* ("The Standard"):

> *O bandera catalana*
> *Nostre cor n'es ben fidel:*
> *Volaras com au galana*
> *Pel damunt del nostre anhel—*
> *Per mirar-ti soberana*
> *Alcarem els ulls al cel.*
>
> *(O flag of Catalunya /*
> *Our hearts are true to you /*
> *you will fly like a gallant bird /*
> *above our desires and hopes—/*
> *To see you triumphant /*
> *Let us raise our eyes to the sky.)*

Franco regarded this as a cultural ambush, lèse-majesté, and punished Pujol with several years in prison for singing a song. Nothing could have helped Pujol's career more.

Even if you disagreed with certain policies of Pujol's CiU, and found the man personally stodgy and his conservative local nationalism overplayed, it was impossible not to respect his guts, integrity, and cunning, and all the younger Catalanists I met through Xavier did. (Catalanism has always been at root a conservative movement, inherently opposed to Madrid centralism and, even more, to the transnational ideologies of Marx.) Some of these people were politicians in embryo, others were economics graduates, others writers, architects, historians. They included Narcis Serra, the future minister of

defense; Pascual Maragall, grandson of Catalunya's greatest *modernista* poet Joan Maragall, who would go on to be elected mayor of Barcelona; Margarita Obiols, his main assistant, who became the dearest of friends to me; the architects Oriol Bohigas, Beth Gali, and Ricardo Bofill. What they had in mind, of course, was something other than Pujol's soil-and-race Catalanism. They envisaged Catalunya, with Barcelona as its spiritual center, as "the North of the South": the omphalos, as it were, of a modernized and Mediterraneanized Europe, the technological and esthetic, if not the political, capital of Spain, and the country's essential link to the North beyond the Pyrenees. This was a tall order, but who is to say—forty years later—that their vision was not to at least some degree successful?

One thing was quite certain: "alternative" culture in underground London wasn't a plausible alternative to the status quo, but in Barcelona it was. Little or nothing was built on the London version, all dope, rhetoric, be-ins and powdered bullshit. "Swinging London," that invention of the American media, was a mere will-o'-the-wisp that vanished at a breath, while the notion of "Play Power" was the sort of folly that could only appeal to the apolitical and the historically ignorant.

English "rebellion" of the sixties sort was childish stuff because there was so little English repression. Spanish dissent, however, was justified and essential—as much so as Czech or Hungarian refusal of the deadly orthodoxies of colonial Marxism.

Not long ago, a conservative politician in George Bush's government asked me, rather superciliously, if I could name a single example of "terrorism" that produced praiseworthy political results. I suggested that there were at least three. One was the American Revolution, which would unhesitatingly have been classed as "terrorist" by the British authorities and the many Loyalist Americans if the term had existed then. The second was the creation of the Israeli state, which could hardly have happened without the acts of murder and terror against the British, such as the bombing of the King David Hotel in Jerusalem, carried out by the clandestine organization Irgun under the command of, among others, Menachem Begin. The third was the killing of Franco's designated successor as dictator of Spain, Admiral Carrero Blanco, who was blown to shreds in Madrid by a bomb detonated beneath his car in the winter of 1973. By this indubitably "terrorist" act, Spanish democracy was saved. But of course, the American political savant

would have none of this. Jewish terrorism, to him, was never terrorism but always morally justified self-defense. People slaughtered by Hamas's suicide bombers were the victims of Palestinian atrocities. People slaughtered by Arik Sharon's tanks were either regrettable collateral damage or else mere fictions cooked up by Palestinian propagandists. And he had never heard of Carrero Blanco—Spanish history wasn't his field, and he didn't find the details of it particularly relevant.

My experience in Barcelona over these and later years helped to confirm my growing suspicions of the falsity of much of the talk about the "center" of Western culture, especially of Western art, and where it was supposed to be. Historically, since a feeling of internationalism began to be felt in art, there had been two imperial cultural centers. One was Rome in the seventeenth century, when the tremendous impaction of prototypes in the Eternal City, especially the classical marbles excavated from its earth and the collections of them being formed by Pope and patron, made it the essential place for an artist to go and learn. Without Rome and its growing community of immigrant artists all feasting on its visual source material and competing for its patronage like ants on spilt sugar, there would have been no Poussin, no Rubens, no Caravaggio. Each artist added mass to the gravitational field of the center. And then, when a similar process began in Paris toward the end of the eighteenth century, a new center began to form; Paris became the essential finishing school, the great switchboard, storehouse, and information-exchange of ideas about art, architecture, and their possibilities, and the *École de Paris* was the school of the world for another hundred years. Now, conventional wisdom—especially American wisdom—insisted, there was a third imperial center (though of course, one didn't say "imperial"). It had come into existence after 1945, when the cultural centrality of a Europe depleted and exhausted by war had passed to the world's savior and victor, the U.S.A. What Rome had been to the seventeenth century and Paris to the nineteenth and early twentieth, New York now was to late modernism. And there was just enough truth in this rather crude schema to make it attractive, credible. After all, New York had *the* great modernist collections, especially that of the Museum of Modern Art, without exaggeration the Louvre of the twentieth century. More and more, New York was not only where the big American art reputations were made, but where the international ones were confirmed and eventually canonized.

But didn't this have an automatic bias built into it? You bet it did. Wasn't it unreasonable to assume that artists who for one reason or another didn't fit into the Manhattan taste structure, who didn't meet the often ill-defined criteria of a few New York critics, dealers, collectors, and curators, were ipso facto lesser than those who did? For sure it was. But try saying so. The mantra so often recited in the Manhattan art world in the sixties was that Europe was "over," that it could not generate any more great artists. It turned out that this was a received idea, like any other—but received widely and on a very large scale.

It entailed insistent overpraise of American reputations, starting with Jackson Pollock's and those of other Abstract Expressionists like Mark Rothko and Willem de Kooning; an uncritical acceptance of even the most meretricious aspects of Pop Art, in the name of art-historical "progress"; an imperious belief—not so much argued as assumed—that color-field abstraction (Noland, Louis, Frankenthaler, and others) had been the next inevitable step in the "progress" or "evolution" of art history; a subtle, and sometimes not so subtle, downgrading of contemporary European artists; and, of course, a complete indifference to anything done at the outer fringes of the art-historical empire, like Australia. The thought that a landscape-based painter like the Australian Fred Williams (1927–82) might actually, and for a number of good reasons, be considered a more interesting artist than, say, the American Kenneth Noland, could hardly have arisen, because it was, to all intents, unthinkable—by anyone, including most Australians. The truth, which became quite evident during the 1980s and 1990s, was that there *was* no "third center," and that the day when any art could meaningfully be described, let alone dismissed, as "provincial" was passing—had, in fact, passed.

What had changed things? Enhanced communication: the increased speed at which knowledge of works of art circulated in the world, by means of reproduction, traveling exhibitions, museum loan programs, art fairs, and commercial dealers' shows—in sum, the whole apparatus of the international "art world" as it evolved in the last third of the twentieth century. Just as my experiences in Italy had shown me that there is, and should be, no conflict between the past and the present, that one feeds into and generously nourishes the other without the slightest need for Oedipal hostility or claims of a more "evolved" culture, a more "radical" future, so Barcelona showed

me that all the talk about what was or might be the "center" of contemporary culture was hot air: that there is no center, only one big periphery, a range of points scattered around a network. No place was, or should be, in a position to dictate to any other. But I would not be able to fully appreciate or experience this until I went to New York itself—which, as yet, I had no means of doing.

I had to return to London; that was where my life had to be, for the time being at least. Despite the continuing upheavals at home, I was able to finish and deliver *Heaven and Hell in Western Art,* and at least make a start on Leonardo. But when *Heaven and Hell* appeared, in 1968, one thing in particular became crystal clear to me: only rarely does an author make a living by writing books about art, and mine was certainly not one of those cases. Despite the nice and sometimes enthusiastic reviews, *Heaven and Hell* sold so few copies that I never even received a sales statement from Weidenfeld & Nicolson; probably the publisher's profits would not have defrayed the postage. Nevertheless, an energetic New Yorker named Sol Stein bought the American rights to it, and published it in New York at the end of 1969.

There, too, it was a *flop d'estime;* if I remember right, Stein's sales did not break the magic level of 2,500, although most of the reviews he sent me were also enthusiastic, if short. But it was certainly not worth the cost of bringing me to America, let alone of sending me on the peculiar and expensive purgatory of a book tour. In today's climate of superheated American piety, *Heaven and Hell* might have garnered some sales, if only by mistake; but in a culture of secular American humanism, it didn't have a snowflake's chance in, well, Hell.

But as it turned out, the sales didn't count a bit. What changed my life irrevocably and for the better was the copies that were given away. Or to be precise, *one* of those review copies, which Stein & Day sent, more out of habit than in any expectation, to *Time* magazine.

In those days, *Time* was a different magazine. It was more literate and, as the career of Alwyn Lee testified, it always kept at least one regular book reviewer. Every week it would run a lead review and several smaller ones, which, though not as long or as detailed as those in, say, the *New York Times,* were not without significance for the book trade, even though (like everything else in the magazine) they were unsigned. It would also, less frequently, run pieces on art, on theater (by a short, heavy-drinking but

knowledgeable Greek-American named Ted Kalem), and articles about classical music, both recorded and live. It even occasionally did a piece on opera—its editor's enthusiasm for the brilliant and exuberant talents of Beverly Sills got her on the cover, which would be unimaginable for a real diva (as distinct from a fake, pop one like Madonna or Beyoncé) today. It did not have a lax, prostrate obsession with TV, pop music, and the celebrity industry they serve and fuel, and did not treat movies—as, alas, it does now—as the chief American art form, though of course it took them seriously. (And how could it not, since it had until recently employed James Agee as its film critic, and now had the admirable Richard Schickel? But to take movies seriously means denouncing trash as trash, and Time Warner today, by its very nature as an entertainment conglomerate, has difficulty doing that.) In sum, old *Time* in 1969 was as far from current *Time* in 2006 as cheese from chalk; its cultural priorities were far wider ranging, it claimed and exercised a general sense of cultural responsibility, and its cultural priorities still reflected those of its founder, Henry Luce, and its then managing editor, Henry Anatole Grunwald. Dwight McDonald, a former alumnus of *Fortune,* could make all the pissy cracks he wanted to about the Luce magazines—"*Life* for the folk who can't read, *Time* for the ones who can't think"—but he had not been granted a premonitory glimpse of what they would eventually become: *Life* dead, *Time* increasingly dumb. What effected and enforced the change, of course, was the explosive growth of TV and the Internet. Faced with these two enormous and swelling competitors where none had been before, the mighty administration of Time (or Time Warner, to give it its name of disgrace after the wretchedly ill-conceived merger with the entertainment colossus Warner Bros.) made the mistake of their lives. Instead of keeping their heads they panicked and decided to try and compete with the Internet and TV, to go way down on the scale of intelligence, to embark on a policy of cretinous impressionism. Perhaps if *Time* had made up its mind to stick to its original guns and do what its rivals couldn't do, providing a viable alternative to the mushy celebrity-obsessed blithering of network and cable TV, concentrating on a certain integrity and intelligence of voice, on intelligent interpretation of events and ideas through real reporting, it might have pulled through. But it did none of these things and so it is now a mere shell of the magazine that I had the good fortune to join back in 1970.

If *Time* mattered a lot more in those days than it does now, a small indicator of this was the room in which the incoming review copies were kept. There were thousands of books in that room, a melancholy and disordered library full of volumes that were all new and almost equally fated never to be reviewed. Now and again, predatory *Time* staffers would sneak into this mass burial chamber with its gray bays of slotted metal shelving, past the not too vigilant glare of the secretary at the gate, and carry home a briefcase full of volumes that they could be fairly sure would not form the *données* of future articles.

Time never, or not as a general rule, reviewed cookbooks (although I think it once did a cover on the great Julia Child) or gardening manuals or, except in a clump of twenty-five-line shorties all together just before Christmas, books about art. If you were the proud author of *Uncertain Destiny: King Farouk and Egyptian Foreign Policy in the Middle East*, or of *Thanks for the Mammary: The Tits 'n Bums Annual 1970*, there was little chance that your opus would make it into *Time*.

But very occasionally, once in a very long while, it could happen that your book might be reprieved from its exile in the back room by a curious, scavenging staffer and set before a senior editor as a "possible."

This was what happened to the copy of *Heaven and Hell in Western Art* that Stein & Day had, without hope or expectation, posted off to the book section of *Time*.

It was rescued from the oubliette on the twenty-fourth floor of the Time-Life Building by the senior editor in charge of the book section, whose name (of blessed and, if possible, eternal memory) was Tim Foote.

Foote, as it happened, knew something that few other people in the building did. It was that *Time*'s managing editor, Henry Grunwald, wanted to see about getting a permanent art critic. This post, until then, had been neither exactly vacant nor exactly occupied. The magazine had what was for convenience called an art *writer*—basically, a reporter on the visual arts and matters related to them. But the art writer was not really an art critic: he or she was hired to report on art matters, not to set forth opinions about them.

The present incumbent was a youngish woman of Hungarian extraction whom, because she herself wrote anonymously, I shall call Jane Molnar. She had been with the magazine for some years, and was always besieging the managing editor with proposals for cover stories on one artist or another.

These were not accepted, but the one that came closest to making it onto the cover—a huge promotional coup in those days, the equivalent in America of inclusion in England's New Year Honours list, and probably much more profitable—was a profile of Helen Frankenthaler, formerly the lover of Clement Greenberg and now the absolute doyenne of post-Pollock American color-field painting. What went on at this point remains somewhat obscure in my mind, and not a little murky. I can only relay the version that was later told to me, without swearing a solemn oath as to its truth.

Henry Grunwald was not a particularly visual person: his great esthetic passion was music (he was the son of a well-known Viennese composer of light opera), which guaranteed not infrequent cover stories on composers— Aaron Copland, Leonard Bernstein—and such *eminentissimi* of the concert hall as Sviatoslav Richter and Herbert von Karajan. But although he was certainly not hostile to the idea of having a painter or a sculptor on the cover of *Time,* it was not one of his priorities. Jane Molnar, however, was sure that she could persuade her boss of the imperative need to do Frankenthaler on the cover, and set to work researching and writing the piece without actually getting the green light from the twenty-fifth floor. This took a lot of time, what with the interviews and looking at Frankenthaler's paintings; the peg for the cover story would be a retrospective Frankenthaler was due to have at the Whitney Museum. In those days, a Whitney retrospective was considered a signal honor for an artist, a recognition of full creative maturity and achievement. Since the eighties this has not been the case, due to the intellectual and financial corruptions of the art market, and the museum's kowtowing to them; but back in 1970, such events still mattered. So the combination of a Whitney consecration and a *Time* cover story was the kind of double whammy that any American painter (and especially, in those prefeminist days, a female American painter) could well be glad of. Not that Frankenthaler, the daughter of a most eminent jurist and a card-carrying Jewish princess to the very tips of her talons, would have doubted her own entitlement to it for a second; but in the art world, as in the real world, to feel entitled was not necessarily to get.

These plans came unstuck. Not just unstuck but, in the phrase of the late Robert Burns, they went agley. Whether Grunwald disliked Frankenthaler, or Frankenthaler's work, or didn't know it, or simply didn't care about it one way or another, remains uncertain. Or perhaps he didn't like Jane Molnar's

story, when it reached his desk. Whatever the reason, he made it plain that Frankenthaler was not going to be on the cover of *Time*, and that was that. Molnar argued and then threw fits—I never met her, but I am told she was an emotional person—but to no avail. Grunwald, like many equitable men, was hard to budge when he had made up his mind. Then Molnar faced the disagreeable task, worse than any confrontation with Henry Grunwald, of breaking the news to Frankenthaler, who was more than miffed; she was livid, and let her lividity be known. Poor Molnar, caught between the proverbial rock and a hard place (and Frankenthaler, as all who have incurred her displeasure can attest, could be a very hard place indeed, as I was later to learn from my friendship with her ex-husband Robert Mother-well), then played her last card, and told Grunwald that if Frankenthaler didn't get on the cover, she would resign. It was neither a wise nor a well-timed ultimatum, and so it came to pass that Grunwald was looking for an art critic.

The suitable ones in America weren't available, and the available ones didn't seem suitable. It was at this point that Tim Foote passed to Grunwald his copy of *Heaven and Hell*, with a commendatory note. Grunwald took it home, read it, and liked it. "How could I not try to hire someone," he wrote much later, in his memoirs, "who could write that 'God did not live in Hampstead and was not expected to act like a liberal'?" A bit of digging, with the help of the files in Time-Life's London bureau, produced more stuff of mine, clippings from the *Spectator*, the *Observer*, the *Sunday Tele-graph*. Grunwald's interest and curiosity grew. He sent one of his semi-legible memos to the chief back-of-the-book editor, A. T. Baker, directing him to track me down in London.

Easier directed than done.

A whole Atlantic Ocean away, I was quite unaware that any of this was going on. And although Grunwald, like the Etruscan king Lars Porsena of Clusium in Macaulay's *Lays of Ancient Rome*, bid his messengers go east, west, and north (there was little point in sending them south; I was unlikely to be in Mexico) to summon me, nobody at Time-Life had any real idea of where I might be. It was guessed, correctly, as it happened, that I was in London; but there was no Robert Hughes in its telephone books (or rather, there were several, but none of them was me). There were several good, not to say pressing, reasons for my uncontactability.

The first was that I didn't want to talk to anyone. I was sunk in irritable and lethargic depression, for Danne, after a brief reunion on her return from North Africa, had once again grown tired of family life (or what passed for it on this branch of the Hughes tree) and vanished with some raggle-taggle Gypsy or other, this time to Paris. By now I was utterly sick of matrimony, and almost of human company.

The second, a corollary of the first, was that I had no desire to answer the phone, if it rang, or to call anyone else.

The third, a modification of the second, was that the phone never rang anyway, because it could not. It had been cut off for nonpayment of past bills. These had been distended by my fruitless long-distance calls to various sand-blighted parts of North Africa, seeking my absent beloved. At first I could not ring out; then, when this failed to make me disgorge a check—there was next to no money in my account—the telephone company blocked my incoming calls. Peace, perfect peace, with loved ones far away.

Diletta loyally stayed on and looked after Danton. My BBC engagements dwindled to few, and then none. The modest advance from Weidenfeld on *Leonardo* was long since spent, and I had only delivered a fraction of the book—a pretty good fraction, I felt, but not enough to justify asking for more money. My agent, Murray Pollinger, a sweet and patient man, was close to the point of signing off in despair. What on earth had his client Moorehead been thinking of, when he dumped this drug-addled, evasive cuckoo in his nest? I was completely stuck, and spent most of my time alone grumpily smoking hash and downing as much single-malt scotch as I could afford. My main solace was Colin Lanceley, who had moved into the flat next door at Hanover Gate Mansions, which he shared with another artist from Australia, Leonard Hessing.

The last reason for my withdrawal from the world was that I owed it, or parts of it—not just the phone company—too much money. In England, when you owed serious sums for a long time—anything, say, above twenty-five pounds—and all reminders, begging letters, and final threats had failed, the bailiffs were sent to your door with a court order to "distrain," as the phrase went, upon your possessions.

To anyone who knows his Victorian literature, the very word "bailiff" has a menacing ring. It suggests coarse, bestially ruthless men flinging the baby's crib into the snow and the baby after it, while the wife leans helplessly

against the door frame of the tottering tenement, racked with consumptive sobs as the debtor takes swig after swig from the fatal bottle.

It was not like that in late-sixties London. The bailiffs themselves were rather jolly fellows; they called you sir, sympathized with your financial plight, assured you that they knew it was only temporary, and would go away taking nothing with them if you gave them a cup of tea and a down payment of five or ten pounds, even if it was in the form of a check, which, as they must have known as well as you did, would probably bounce. There were, all in all, good things to be said about the English class system as it existed, residually, in the late sixties. But on the whole I preferred not to meet these paragons of courtesy face to face, and so I very seldom answered an unexpected knock on the door.

Meanwhile, the Time-Life Bureau in London, having contacted the editors of some of the magazines in which my work had appeared and craftily obtained my address and telephone number, had tried to ring, but with no result. Then it sent a messenger not once but several times—all to no effect.

So it was a stalemate. But then, with singular cunning, the Time-Life people discovered through some network or other that there was, indeed, an Australian artist friend of mine living in the next-door, ground-floor flat at Hanover Gate Mansions: Leonard Hessing. They contacted him. Yes, he confirmed, Robert Hughes did live next door. Then Hessing, knowing that I was unlikely to come to the door even if he knocked, clambered out the back window of his studio onto a communal balcony above the coalhole shared by the flats, scrambled across to my window and knocked on it. He explained about the call he had received, as much as he knew, which wasn't much. But he stressed that he was not going to come out of his back window and in through mine like some bloody messenger-fairy every time there was a telephone call for me on his phone, especially since he didn't like heights. And that he had arranged for these people—this time it would be someone nameless in America who had somehow found out his address and telephone number, which, since he was an émigré from Czernowitz, at the time in Communist Rumania, made him feel slightly alarmed and intruded-upon—to ring back at eight p.m., three in the afternoon in New York. By then, said Hessing, I would be waiting by his phone. And we would do this just once, because the phone was in his studio and he wanted to get on with his painting without a critic hanging around.

I had no idea what this was about. I knew very few New Yorkers, and none of them could have had such urgent business with me, unless Sol Stein had sold the movie rights of *Heaven and Hell* to MGM, which seemed distinctly unlikely. This could only be bad news. In fact, I decided as Hessing made his exit through the window and I relit a bogarted joint to armor myself against what looked to become a stressful evening, I feared I knew what it was. The fear grew to a near certainty after I made my way to Hessing's studio and sat down, puffing intermittently, to await the call.

My elder brother Tom, back in Australia, had become the attorney general in Harold Holt's cabinet. As such, he had vigorously promoted the drafting of military-age boys into the Army, so that as allies of America they could go and repel the Communist menace in Southeast Asia. I, on the other hand, had taken part (half-heartedly, to be sure) in demonstrations against the American war in Vietnam. This had been picked up by the Australian press, and given rise to some stories: fierce elder Tom the hawk, younger Bob the dove. Perhaps this had come to the attention of officials in America. Perhaps I was already being classed as persona non grata by the Great Satan. Perhaps my name and life story were already inscribed on a spool of tape, clicked onto the front of a putty-colored, refrigerator-sized computer in Washington, D.C. Whirr forward, clack, whirr backward, stop, and there he is: Hughes the Security Risk. The mysterious call from America must be connected with this.

There was no limit to the self-importance of semi-wannabe-more-or-less radicals in the sixties, especially when stoned.

The phone rang.

Hessing picked it up. "It's for you," he said.

The man on the other end had a strong American accent, and he did not introduce or identify himself. He sounded weird. (A. T. Baker, as I found out afterward, was one of the world's nicest and most considerate editors, but he liked to get stewed at lunch: this was still the day of the three-martini expense-account feast, and Bobby, as all who knew him called him, considered a day ill-spent if it passed without two.) "Jesush, you're hard to get hold of," he said without preamble. "I just want you to come over here and shee how we like you, and how you might like working for ush, if you shee what I mean."

Of course I saw what he meant. I saw exactly. Working? For "us"? My

fuddled brain cleared into an access of quite limpid, cannabis-induced para-
noia. This nameless man on the other end of the transatlantic cable: what
could he be but CIA? So this was how it happened. This was how the vast
tentacles emanating from Langley, Va., worked their way into the minds of
decent liberals, recruiting them, turning them into warped instruments of
the international American conspiracy. I couldn't believe my luck. Now I
could make a stand—and I had Lenny Hessing, if not God, as my witness.

In a measured and dignified way, I told this spook exactly what I thought
of the American imperialism whose tool he was, of American policy in Viet-
nam, of American perfidy. It was quite a little performance. I then, secure in
the knowledge of a good day's work compressed into a couple of minutes,
hung up in his ear.

Very luckily for me, A. T. Baker rang back a few minutes later. I shudder
sometimes, when I think what might have become of my life had he not done
so. Back to Australia? An inglorious end as the art critic of the local paper in
Albury, New South Wales, sometimes being given a second-class return
ticket to Sydney and a couple of nights at the Rex in King's Cross as a special
treat, so that I could do an article on that year's Archibald Prize for portrai-
ture? But we got things straightened out. I was to meet with *Time*'s main
correspondent on matters cultural in England and Europe, and we would see
if we liked one another.

This person turned out to be a boyish looking, slender, gently spoken
New Yorker named Christopher Porterfield, and we liked one another well.
So well, in fact, that we were to become as professionally inseparable as Mutt
and Jeff, Abbott and Costello, or the fin de siècle clowns Chocolat and
Footit: in the decades to come, although other people stood in for Chris as
my senior editor when he was away or out sick, he edited almost every one of
the many hundred articles I wrote for *Time* and did it with such elegant
lightness of touch, such a perfect intuition of what I had been trying but not
quite managing to say, that when the edited version came back to me I was at
a loss to know what he had cut or where, only that it was clearly much better
than the copy I had handed in. We never had a quarrel about anything. No
harsh words passed between us, in the more than thirty years that our work-
ing relationship was to endure. At that first lunch, which was at a West End
restaurant called the Gay Hussar, Chris set all my doubts at rest. In point of
fact I was so ignorant of *Time* and of American journalism in general that I

didn't have any doubts. It seemed premature to discuss salary or terms. In any case I had never earned a salary before, and had no idea what to ask for. Chris suggested that I should go to New York and try out for a few weeks. This I eagerly agreed to. He asked, almost apologetically, if I had any objection to flying coach, since that was standard for people not on staff, and for most staffers too. Object? I would have swum there if I had to. I timidly asked a few questions. Would the executives at *Time* make me sell my motorcycle and buy a Ford sedan instead? Absolutely not, said Chris; he couldn't think, offhand, of anyone the magazine had ever hired who could be called a biker, let alone possessed a black leather jacket with fringes and studs, but as far as he knew there was no dress code at 1271 Sixth Avenue and I need not worry. Still, if I had a suit and tie it might be a good idea to bring it. And anything else, if they signed me on: clothes, furniture, possessions, and, of course, my family. *Time* would take care of all my relocation expenses. In the good old days, the magazine was said to have shipped a full-size Chinese junk back to Connecticut for a homecoming executive, returning from long service in Hong Kong. This was said to have happened by mistake, after the executive had asked if the magazine would mind "bringing my junk home," meaning his furniture and effects. But one could no longer automatically count on corporate gestures of this kind. Better not to push the envelope too far, elastic though it still was.

When I jubilantly told my friends at the BBC and elsewhere about this bolt from the blue, they were shocked. Instead of rejoicing with me, they all agreed with one another, nodding their heads in wise unison. Without doubt, this job, if I was hired, would be the end of me as a serious writer. Who ever heard of anyone obeying and surviving the peculiar, padded rigors of writing for the Luce press? I would be stripped of my independence. My politics, mildly left as they were, would be totally unsuitable: everyone knew that *Time* was the official journal of American capitalism in its most saber-toothed form. It was the house organ of the Republican Party. It was the goad and support for America's ventures in Vietnam. It had been made so from the top, by its cofounder Henry Luce. In recent years his rightward leanings had been amplified by a managing editor of such fearsome conservatism that even some English journalists, normally quite ignorant of American magazines and those who ran them, spoke of him with awe. This had been Otto Fuerbringer, known in the trade as "Otto Fingerbanger," and

inside the Time-Life building as "the Iron Chancellor," whose politics were somewhere to the right of Louis XIV. He was famous for his way with new employees: once, it was said, in the course of interviewing some liberal-minded Ivy League greenhorn who was hoping for a job on *Time,* he glared at the callow youth and growled, "I hope for your sake you do not imagine that this is the midtown branch of the *New Republic.*"

Worst of all, there was "*Time*style," that weird, vivid, and peculiarly stylized prose—"Said balding, hen-shaped power-broker Fiorello La Guardia, 62"—which, it was supposed, all *Time* writers had to master and use. How was I going to enjoy seeing my nice declarative sentences twisted into that kind of institutional lingo? No, no, said my friends, if I joined *Time* it would mean finis to my career; some train of internal gears and rollers in Rockefeller Center would mesh, chatter briefly, and spit me down the chute as unrecognizable, nameless pulp.

Happily, I ignored all this British rubbish.

A couple of days later, with her infallible instinct for turning up when something seemed about to happen, Danne reappeared from Paris. I told her about *Time.* Far from being alarmed by it, she was thrilled. London was losing its steam. It was no longer the center of the world. As for Paris, it was fucked. (Danne liked to boast that French was her "second language." Indeed, it did run her English a very distant second, but she conveyed a lot with shrugs.) New York was where the action was. We must go there at once. She loved me. She had missed me so much in Paris. I must not brood about her lovers, for they would be all in the past. (Yeah, dead sure, I thought, and shortly to be replaced by others, in the future.) We would discover so much more about ourselves, and one another, in Manhattan. And of course I half believed her. There was practically nothing I would not believe if Danne told it to me with enough promise and conviction. Marital love, the great stupefacient.

Not yet, I said. There was no deal yet. But I was going to go to New York for a month, on my own, and see how things worked out. And then, if they did work out, we could see about moving her and Danton over to New York. So saying, I clambered on board a British Airways 747, coach as stipulated, and left for Manhattan, where things did indeed work out. In London, editors had been somewhat languid in their response to my contributions: interested, even encouraging, but languid. New York, and *Time,* were not like

that. I was immediately assigned as senior editor the same A. T. Baker who had spoken to me on the phone. He proved to be a bluff, weatherbeaten salt with a quarter century's experience of the Time-Life Building under his belt. He had an office on the twenty-fourth floor. Its perforated sound-tile ceiling bristled, porcupine-like, with red and green pencils, which he was in the habit of throwing upward to see if they would stick, as they usually did. They looked like something from the last Venice Biennale. He sat me down and explained that he was not going to send me out to find an exhibition to review; he had a packet of 4 x 5 color transparencies of the work of someone I had never heard of, a decorative artist named Felix Kelly, whose work, he pointed out with emphasis and regret, was a particular favorite of Clare Booth Luce, the founder's widow, who now lived in state in a seaside villa in Honolulu, and whose dining-room walls were liberally hung with his work. He was having a show in San Francisco. I would not, Baker added, be expected to fly over to see it. I could work from the transparencies, which were excellent. Mrs. Luce would read my copy closely and with interest, since Kelly was a particular friend of hers. I think he used the word "walker," which I had not heard before. Felix Kelly turned out to be a stage designer, whose speciality was pretty-as-a-picture late-Surrealist perspectives—late Dalí and eau-de-cologne—punctuated with stranded boats, Roman ruins, and tottering, picturesque New Orleans–style tenements, embellished with much wrought-iron lace. From the moment I saw the photos I was convinced he was an Australian artist, a clone of Loudon Sainthill with overtones of Russell Drysdale. I don't know if I was right, but I turned in 120 lines of falsely enthusiastic copy, unsigned of course. Those were the days. Mrs. Luce was gratified, and sent a note to Henry Grunwald urging that this new candidate be hired forthwith. And I was, at what seemed to me to be the munificent salary of $20,000 a year, plus expenses.

The expenses were important, because you could almost live on them and it was entirely, as Bobby Baker explained to me, a cash business. You filled out a little brown form requesting, say, two hundred dollars, got your senior editor to initial it (which was almost automatic), and then ran it past the Dragon Lady in the cash department, a sharp-eyed Chinese person named Harriet Watt, who (if she was in a good mood, which was often, if not always, the case) countersigned it. You then took it to a little barred wicket in the corridor of the twenty-seventh floor, pushed it at the cashier, and

received your money. There was no fixed theoretical limit on how much cash you could be advanced, but God help you if you failed to fill in the expense report at the end of each month. The monthly expense report was not a very demanding document in those days. You had to produce a receipt, or preferably an Amex counterfoil, for every expenditure over twenty-five dollars, so *Time* writers (including me) ran up an unsurprising number of lunches that came out at just $24.50, a sum which actually could buy lunch for two at a reasonable French or Italian restaurant back then. You could buy all the books and catalogs you wanted to, and write them off to "Research." You could take taxis everywhere, though limos were the prerogative of persons higher up the totem pole.

But if you failed to get your expense report in on time, you were in the doghouse. Then Harriet Watt would direct her steely glare at you, reject your impertinent cash-advance form, roll her eyes like Madame Chiang Kai-shek in a snit, and in general seem to be on the point of calling down on your presumptuous and wormlike head the vermilion fires of heaven. Only paperwork could mollify her. But this was certainly a lot better than trying to wring five measly quid out of the accounts department of the BBC, and in any case, I greatly liked Harriet and her Last Manchu Empress routine.

The week always had much the same shape. Nothing in the back of the book (culture, generally: books, music, theater, movies, art, and so forth) happened on Monday. Tuesday would bring an editorial conference, at which the subject of your article for that week would be raised, briefly discussed, and decided. You then went away and wrote it on a typewriter, either at home (an Olivetti Lettera 32) or, preferably, on the Royal upright in your office (*Time*, untouched by the bull-pen mania of later efficiency experts, had real offices with windows that looked out over New York, and doors that closed and could even be locked from inside, so that you could work in peace, take a nap on the exiguous sofa or even, depending on the circumstances, get laid). You would then hand it to Bobby Baker, who would make his mild emendations and pop it in the pneumatic tube. From there it traveled to the typists, and from them, in the form of a document on coarser yellow paper with numbered lines, to the Dread Presence of Henry Grunwald. Henry disdained line editing—he had done enough of that on the way up to the managing editorship—but he would scribble a few illegible comments of a general sort in the margin, and send the palimpsest back to the senior

editor and the writer, who would have to decipher and decode them. Once these were dealt with, a last version was typed and would arrive with a whoosh and a kla-chunk through the pneumatic tube. Written on the top would be the final line count, which would enable the piece to fit exactly on the *Time* page. You then did the fine tuning, losing or gaining a line here or there, eliminating "widows" or short lines consisting of only a word or two at the end of a paragraph. By now it was Thursday night. The wait for final-edit copy could, and often did, go on for hours. It would be extended by the process of copy-checking: every name, every form of spelling, every asser-tion of fact, and of course every quote had to be checked by one of the large staff of researchers, all of whom were women, all of them as tenacious as bulldogs. Each checkpoint would be marked by a dot, and there were no exceptions. If this was tedious—and sometimes extremely challenging for a sloppy writer—it must have been exhausting work for the researchers. All this was new to me; I had never encountered such a meticulous system any-where in England, still less in Australia. But once it was over, it was over. You were free. And no one, at any point, had suggested that I write in any-thing like the mythical *Time*style.

Earlier, *Time*style had not been mythical. It was a peculiar kind of diction largely formed by one of the cofounders of the magazine, Briton Hadden, who had studied classics at Yale. It was a pseudoheroic metalanguage based, oddly enough, on the epic Greek of Homer, with its honorifics, double epi-thets, and inversions. "Thus spake golden-haired Achilles of the shining greaves." *Time*'s version of it was memorably parodied by Wolcott Gibbs: "Backward ran sentences until reeled the mind." *Time* had loved to invent neologisms, often by buckling together compound words: "cinemactor" (first used of Lon Chaney) and its cognate "cinemactress" (ditto, Gloria Swanson). It had resurrected disused archaisms like "tosspot" and "mop-pet." Some of these words stuck in usage: "socialite" was one. Others, like "cinemalefactor" for movie villain, inevitably vanished. Then there were words, like "neophyte," that *Time* didn't exactly invent, but did popularize. In any case, this oddly contorted manner had been on the way out for a long time, and clearly had no future under Henry Grunwald. Or just possibly, like the character in Molière who realizes to his joy that he has been speaking prose all his life, I had been writing in *Time*style without knowing it. Either way, there was no problem that I could see.

I found this routine easy to get used to, and decidedly invigorating. I had never before, in years of freelance writing, had the feeling of being part of a team. But now I was, at least as a postulant, and the team was singularly skilled and efficient. I felt lucky to know its members, and I wanted to be on it. And whatever doubts I might have had were stilled by the Americans I mentioned them to. "Do you honestly imagine," snorted Brendan Gill, the witty and worldly drama critic of *The New Yorker,* at dinner one night, "that you would ever forgive yourself for not trying this? You would reproach yourself for the rest of your life." As for my fears that I couldn't measure up to New York, "This is a job you will grow into. Nobody ever feels equal to the task at first. Of course New York is scary. Would anyone want to come here if it weren't intimidating? But the whole point of New York culture," and he drew a deep breath, "is that *everyone here is from someplace else.*" His manifest certainty convinced me.

So after my tryout, which lasted five weeks, I accepted *Time* and *Time* accepted me, and I headed back to London in high spirits. It would take a little while at the British end to get our affairs wound up—a euphemism for paying some very overdue bills—and a little more in New York to find a suitable place and settle into it. All in all, I told Danne, she and Danton couldn't plan on joining me there for another six months. (Danton had no immediate plans of his own; he was only two.) In the meantime, I would live in a hotel or in furnished digs, settle into *Time,* and send money back as millions of lucky emigrants to America had done before. And for the moment, it was the start of September, the summer season in Italy was drawing to its close, so why didn't we think of taking a trip south so that I could say a temporary farewell to Europe?

It didn't take much thought. It was a long time since I had been south of Naples, and we headed toward Positano in the furious, baking heat of that late summer of 1970, creeping along the hairpin bends of the Amalfi peninsula in a little rented Fiat and finding a room in a small, cheap hotel that had been built on the edge of a near-vertical cliff. The view was framed by painfully spiny vegetation, thornbushes and prickly pear. Far below glittered a blue pie-slice of Mediterranean, corrugated by wind, with the leaning red sails of fishing craft. It made us both feel horribly insecure, afraid of Danton falling through the balcony, afraid of falling ourselves. Neither of us was in a good frame of mind. We both suspected (wrongly, as it turned out) that

there might be no more travel shared between us. I had met another woman in New York, an erudite and demanding Jewish girl, herself an art writer of some standing; I had told Danne about her—not the whole truth, only some of it—and I had no idea how that might eventually play out.

One morning I took the white breakfast plate from my *piccola collazione* and tossed it, like a Frisbee, out into the blue gulf below. That could be me, I thought briefly, spinning downward to invisibility between the skyscrapers, like some brittle ephemerid falling into trout waters. One day we drove out to Paestum, to see those architectural prodigies the Greek coastal temples with their Doric columns, those squat, almost crushing, cylinders of stone. This would be my last glimpse of the ancient world for some time. The obdurate lastingness, the sullen weight: would I feel such things in America? I didn't know. And what was stranger, I didn't want to know. A peculiar indifference, one that I had not felt before about Danne, had settled over me. I had begun to contemplate the possibility of a life entirely without her. It seemed possible. It didn't even seem such a bad idea. Whether it would be manageable, of course, was entirely another matter. But I was no longer as clogged with emotion as I had been. Or so I fancied.

Before long it was time to drive back to Rome, from which I would be flying to New York. I said goodbye to Danton, with sorrow, and to Danne, with relief, at the door of the Albergo Nazionale and took a taxi to the airport.

On the way I made the driver stop at a fruit-and-vegetable stall. I bought one ripe peach: the glowing, rotund, fuzzy fruit of the late summer, whose taste, I was sure, could never be duplicated in America. In its brown paper bag it went with me on board the plane, and soon after we were in the air I looked out of the window and saw the unmistakable form of the Argentario Peninsula passing below, a dark shape like a fruit bat clinging to the flank of the Maremma. I saw Porto Ercole, Giannutri, Orbetello, all my old haunts. I took out the peach and bit it. I felt and tasted the last of the Old World trickling down my throat, as the Argentario was sliced cleanly out of sight and into the past by the aircraft's wing.

ALSO BY ROBERT HUGHES

BARCELONA

Barcelona is Robert Hughes's monumentally informed and irresistibly opinionated guide to the most un-Spanish city in Spain. Hughes scrolls through Barcelona's often violent history; tells the stories of its kings, poets, magnates, and revolutionaries; and ushers readers through municipal landmarks that range from Antoni Gaudí's sublimely surreal cathedral to a postmodern restaurant with a glass-walled urinal. The result is a work filled with the attributes of Barcelona itself: proportion, humor, and *seny*—the Catalan word for triumphant common sense.

History/Culture/978-0-679-74383-5

THE FATAL SHORE
The Epic of Australia's Founding

The Fatal Shore is the history of the birth of Australia, which came out of the suffering and brutality of England's infamous convict transportation system. "In his marvelous . . . history, [Hughes] brings convict Australia to life both in his own words and those of the inhabitants. . . . The idiosyncratic voices of the individual convicts he quotes imbue the narrative with the spark and savor of real life in all its chaotic, intimate detail. This kind of history is as exciting and entertaining as a good novel" (*Chicago Sun-Times*.)

History/978-0-394-75366-9